GREEK
ETRUSCAN
&
ROMAN
BRONZES
in the
Museum of Fine Arts
Boston

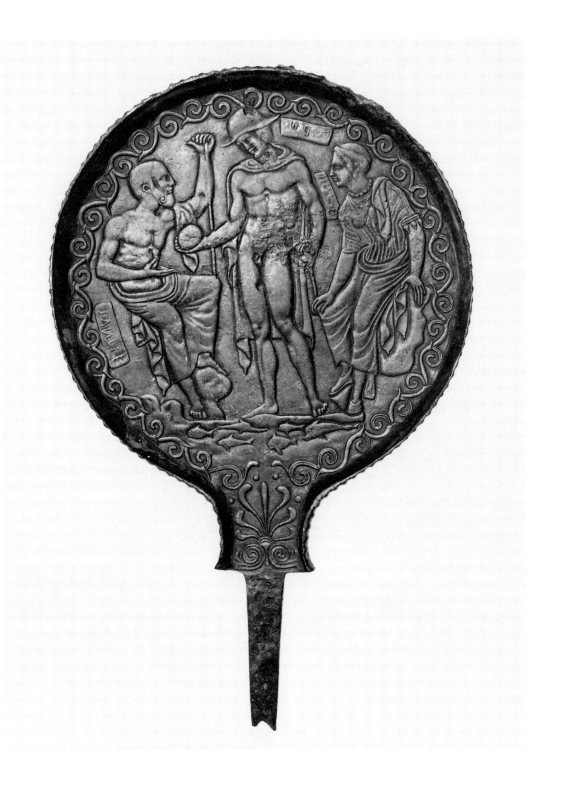

GREEK

ETRUSCAN

&

BY MARY COMSTOCK & CORNELIUS VERMEULE

ROMAN

BRONZES

in the

Museum of Fine Arts

Boston

Distributed by New York Graphic Society • Greenwich, Connecticut

FRONTISPIECE:

376A

MIRROR AND HANDLE
Etruscan, circa 400 B.C.
L.: 0.29m. DIAM.: 0.188m.
William E. Nickerson Fund No. 2 1971.138

There is a small piece broken off the upper rim,
and one tip of the handle is missing. Brown
and green patina, with some areas of corrosion.

The design in relief has been interpreted as
showing the seated King of Lacedaemon,
Tyndareos, contemplating an egg which is held
by Hermes standing in the center. At the right
Leda is seated in the rockwork landscape. Fish
swim beneath their feet. Inscriptions in
Etruscan identify the three figures as ''Tuntle''
(Tyndareos), ''Turms'' (Hermes) and ''Latva''
(Leda). The scene is framed by interlocking
acanthus tendrils with a palmette at the base.
There is another palmette on the reverse, also
at the base. The outside edge is enriched with
an ovolo moulding in relief.

For other representations of this myth
compare Gerhard, *Etruskische Spiegel*, II,
pl. 189; IV, pl. 370; V, pls. 75-77.

Table of Contents

Introduction

Many of the Greek, Etruscan, and Roman bronzes in the Museum of Fine Arts are well known and have appeared in general and specialized publications for decades. Others, often of equal quality and importance, have been scarcely noticed anywhere. Save for a few items of no importance at all, this catalogue aims at being complete to the date of going to press. Recent additions have sought to give the collection a completeness commensurate with its aesthetic quality and importance. Descriptions have been kept to a minimum, since the art of the photograph has advanced sufficiently to complement rather than parallel the printed word.

Many persons have contributed to this catalogue over the past eighty or more years, visitors to the collections and members of the Department. Edward P. Warren, who collected most of the masterpieces, and his colleague John Marshall provided extensive notes. Curators from Edward Robinson and Bert H. Hill to Lacey D. Caskey and George H. Chase also left notes of importance or published articles on pieces. In recent years, Hazel Palmer and others have brought many of the old records up to date. The photographs are mostly the work of Edward J. Moore, John J. McQuade, and their colleagues, but some go back to the days of their predecessor Baldwin Coolidge. Herbert Hoffmann, David G. Mitten, and William J. Young have made useful observations. Dietrich von Bothmer has improved the contents in many varied ways. Suzanne Chapman has drawn a number of the bronzes.

The difficult task of checking many aspects of the work has fallen to Penelope Truitt. She has also compiled the Bibliography and labored over countless references. Julia Green prepared the photographs for publication. Both have been collaborators in every stage of final work on the typescript.

M.B.C./C.C.V.

The Catalogue and the Collection

Classical bronzes have always exerted exceptional appeal because they are durable, varied, and portable witnesses to the beauty of ancient art. The sum, a complete statuette, or the parts, a handle from a vessel, can carry the message of Greek refinement, Etruscan vigorousness, or Roman commercialism to perfection. A catalogue preoccupied exclusively with one material can have excessive limitations, but ancient bronzes range all the way from statues larger than life through ceremonial containers of all sizes and shapes down to tiny works of personal adornment, such as pins and rings. The span of time represented in these pages reaches from about 2100 B.C. to about A.D. 1000, or later. The geographical areas are equally comprehensive, bronzes from Roman Britain or Greek Spain appearing beside creations found in the Crimea, Armenia, and the Sudan.

Any system of classifying such diverse works of art is bound to be arbitrary. Division by types of object seems natural, with freestanding figures, personal ornaments, utensils, weapons or armor, and tools forming major categories. Here some alternate choices can result, for a statuette that is an artistic entity in itself could have been mounted on a small chest or a vase's lid. The historical or artistic divisions should be self-evident, although several categories represent traditional archaeological practices.

Bronzes of the Bronze Age (about 2100 to 1000 B.C.) are relatively few, and they are arranged under diverse headings, Minoan, Mycenaean, or Cypriote. Etruscan bronzes by strict definition are only made between about 700 and 200 B.C. by the peoples living from the Tiber valley northwest to the hills around the Po. The related pieces known as Italic also find their place in comprehensive sections devoted to the arts of northern and central Italy in the centuries before all bronzes made in Italy and Sicily reflected the latest fashions of a world controlled by Roman masters but dominated by Greek artists. The terms "Graeco-Roman" and "Roman" define, as far as titles can, this civilization in which Roman patronage was served by Greek creativity. The resulting progress to Late Antique art, the Byzantine world, and the Middle Ages in western Europe is thoroughly documented in countless histories of art. These regional chronologies have been set forth according to pertinent sections of the catalogue.

Many great collections of bronzes in Europe reflect extensive excavation at famous sites. The museum in Naples is filled with works of Graeco-Roman art from Pompeii and Herculaneum, and the National Museum in Athens exhibits treasures from Olympia, Dodona, and the Athenian Acropolis. Museums in the United Kingdom, France, and Germany can also display bronzes found locally. American institutions, naturally, have had to rely entirely on external sources, and each collection in the Western Hemisphere is in a sense a monument to patrons and employees who have directed works of art to its doors. The Museum of Fine Arts benefited by mass purchase of Cypriote bronzes from General Cesnola's collection and by gift of a few minor bronzes from the Archaeological Institute of America's excavations at Assos. Other excavated groups were acquired, from the shores of Lake Nemi or Praeneste (Palestrina) for instance.

Generally, however, selective purchase of individual pieces built the collections, and Edward Perry Warren made his major contribution as donor and unofficial purchasing agent at a time when his exceptional eye could single out Greek bronzes of prime quality.

There are glaring gaps in what the world can regard as a comprehensive collection of Greek, Etruscan, and Roman bronzes. No lifesized statue appears here, only fragments, and fine Greek hydria handles cannot be complemented by a single complete monumental vessel of this classic shape. Many compensations more than redress the balance. Archaic statuettes from Greece, and Greek mirrors of all forms are among the strengths. Several of the Etruscan or Italic figures are famous, and the Graeco-Roman or Roman bronzes include masterpieces that belong in every history of art. This catalogue hopefully should allow a wide audience to revalue the collection according to the tastes and interest of many future years.

Bibliography

J. Addison	*The Boston Museum of Fine Arts*, Boston, 1910.
W. Agard	*Classical Myths in Sculpture*, Baltimore, 1951.
A. dell'Agli	*Ricerche storiche su Giarratana*, Giarratana (?), pref. 1886.
Å. Åkerström	*Der geometrische Stil in Italien*, Leipzig and Lund, 1943.
E. Akurgal	*Die Kunst Anatoliens von Homer bis Alexander*, Berlin, 1961.
Fest. Amelung	*Antike Plastik*, Berlin and Leipzig, 1928.
E. A. Armstrong	*The Folklore of Birds*, London, 1958.
B. Ashmole	*Greek Sculpture in Sicily and South Italy*, Oxford, 1934.
S. Aurigemma, N. Alfieri	*Museo Nazionale Archeologico di Spina in Ferrara*, Rome, 1957.
L. Banti	*Die Welt der Etrusker*, Stuttgart, 1960.
P. Barnard	*The Contemporary Mouse*, New York and Toronto, 1954.
J. Barron	*Greek Sculpture*, London, 1965.
P. Baur	*Centaurs in Ancient Art*, Berlin, 1912.
J. D. Beazley	*Etruscan Vase-Painting*, Oxford, 1947.
	The Lewes House Collection of Ancient Gems, Oxford, 1920.
G. Becatti	*Oreficerie antiche, dalle minoiche alle barbariche*, Rome, 1955.
M. Bieber	*The History of the Greek and Roman Theater*, Princeton, 1939, (revised, enlarged edition) 1961.
	The Sculpture of the Hellenistic Age, New York, (revised edition) 1961.
H. Bloesch	*Antike Kunst in der Schweiz*, Zurich, 1943.
C. Blümel	*Antike Kunstwerke*, Berlin, 1953.
	Sport der Hellenen, Berlin, 1936.
J. Boardman	*The Cretan Collection in Oxford*, Oxford, 1961.
	Greek Art, London, 1964.
E. Boehringer, et al.	*Neue Deutsche Ausgrabungen im Mittelmeergebiet und im Vorderen Orient*, Berlin, 1959.
	Greifswalder Antiken, Berlin, 1961.
British Museum	*Greek and Roman Life*, London, 1929.
F. Brommer	*Antike Kleinkunst*, Marburg, 1955.
W. L. Brown	*The Etruscan Lion*, Oxford, 1960.
H. Bulle	*Die Silene in der archaischen Kunst der Griechen*, Munich, 1893.

E. Buschor	*Frühgriechische Jünglinge*, Munich, 1950.
E. Buschor, R. Hamann	*Die Skulpturen des Zeustempels zu Olympia*, Marburg an der Lahn, 1924.
A. W. Byvanck	*De Kunst der oudheid*, vol. II-III, Leiden, 1949, 1957.
C. Carapanos	*Dodone et ses ruines*, Paris, 1878.
C. Carducci, et al.	*Ori e argenti dell'Italia antica*, Torino, 1961.
S. Casson	*Descriptive Catalogue of the Warren Classical Collection of Bowdoin College*, Brunswick (Maine), 1934.
J. Charbonneaux	*Les bronzes grecs*, Paris, 1958.
	Greek Bronzes, trans. K. Watson, New York, 1962.
G. H. Chase	*Greek Gods and Heroes*, Boston, 1962 edition, revised by H. Palmer. (see Fairbanks)
	Greek and Roman Sculpture in American Collections, Cambridge (Mass.), 1924.
A. Ciasca	*Il capitello detto eolico in Etruria*, Florence, 1962.
J. T. Clarke, et al.	*Investigations at Assos*, London, Cambridge and Leipzig, 1902.
D. Comparetti	*La Villa Ercolanese dei Pisoni*, Turin, 1883.
M. Comstock, C. Vermeule	*Greek Coins, 1950 to 1963*, (Museum of Fine Arts) Boston, 1964.
L. Congdon	*Greek Caryatid Mirrors*, Diss., Cambridge (Mass.), 1963.
A. B. Cook	*Zeus, A Study in Ancient Religion*, vol. II-III, Cambridge, 1925, 1940.
R. Delbrueck	*Spätantike Kaiserporträts*, Berlin and Leipzig, 1933.
W. Deonna	*Les "Apollons archaïques,"* Geneva, 1909.
P. Devambez	*Grands bronzes du Musée de Stamboul*, Paris, 1937.
E. Diehl	*Die Hydria*, Mainz, 1964.
H. Diepolder	*Die Attischen Grabreliefs*, Berlin, 1931.
D. Dunham	*The Royal Cemeteries of Kush*, vol. IV, *Royal Tombs at Meroë and Barkal*, Boston, 1957.
F. Endell	*Antike Spiegel*, Munich, 1952.
H. Eydoux	*Les grandes dames de l'archéologie*, Paris, 1964.
A. Fairbanks	*Greek and Etruscan Vases*, Cambridge (Mass.), 1928.
	Greek Gods and Heroes, Boston, 1915 edition. (see Chase)
L. R. Farnell	*Cults of the Greek States*, vol. I-V, Oxford, 1896-1909.
H. N. Fowler, J. R. Wheeler	*Greek Archaeology*, New York, Cincinnati and Chicago, 1909.
E. Franck	*Griechische Standspiegel mit menschlicher Stützfigur*, Diss., Berlin, 1925.

K. Friederichs	*Kleinere Kunst und Industrie im Altertum*, Düsseldorf, 1871.
W. Froehner	*La Collection Tyszkiewicz*, Munich, 1897.
A. Furtwängler	*Kleine Schriften*, vol. I-II, Munich, 1912, 1913. *Masterpieces of Greek Sculpture*, New York, 1895. *Neue Denkmäler antiker Kunst*, vol. I-III, Munich, 1897.
A. García y Bellido	*Esculturas Romanas de España y Portugal*, Madrid, 1949. *Hispania Graeca*, Barcelona, 1948. *Los Hallazgos griegos de España*, Madrid, 1936.
E. N. Gardiner	*Athletics of the Ancient World*, Oxford, 1930.
E. Gerhard	*Etruskische Spiegel*, vol. I-V, Berlin, 1840-1897.
F. Gerke	*Griechische Plastik*, Zürich and Berlin, 1938.
G. Q. Giglioli	*L'Arte etrusca*, Milan, 1935.
S. Glubok	*The Art of Ancient Greece*, New York, 1963.
F. R. Grace	*Archaic Sculpture in Boeotia*, Cambridge (Mass.), 1939.
A. Greifenhagen	*Griechische Eroten*, Berlin, 1957.
Fest. Grenier	*Hommages à Albert Grenier (Collection Latomus, vol. LVIII)*, ed. by M. Renard, Brussels, 1962.
A. Hagemann	*Griechische Panzerung*, Leipzig and Berlin, 1919.
E. H. Hall	*Vrokastro*, Philadelphia, 1914.
R. Hampe	*Die gleichnisse Homers und die Bildkunst seiner Zeit*, Tübingen, 1952.
G. M. A. Hanfmann	*The Season Sarcophagus in Dumbarton Oaks*, vol. I-II, Cambridge (Mass.), 1951. *Classical Sculpture*, New York, 1967.
S. Haynes	*Etruscan Bronze Utensils*, (British Museum) London, 1965.
B. V. Head	*Historia Numorum*, Oxford, (new, enlarged edition) 1911.
K. Herbert	*Ancient Art in Bowdoin College*, Cambridge (Mass.), 1964.
R. A. Higgins	*Catalogue of the Terracottas*, (British Museum) London, 1954.
N. Himmelmann-Wildschütz	*Bemerkungen zur Geometrischen Plastik*, Berlin, 1964.
R. F. Hoddinott	*Early Byzantine Churches in Macedonia and Southern Serbia*, London, 1963.
H. Hoffmann	*Kunst des Altertums in Hamburg*, Mainz, 1961.
J. C. Hoppin	*Handbook of Attic Red-Figured Vases*, vol. I-II, Cambridge (Mass.) and London, 1919.
P. Jacobsthal, A. Langsdorff	*Die Bronzeschnabelkannen*, Berlin, 1929.
U. Jantzen	*Griechische Greifenkessel*, Berlin, 1955.

L. H. Jeffery	*The Local Scripts of Archaic Greece*, Oxford, 1961.
R. J. H. Jenkins	*Dedalica*, Cambridge, 1936.
R. Joffroy	*Le trésor de Vix*, Paris, 1954.
F. P. Johnson	*Lysippos*, Durham (North Carolina), 1927.
M. Johnston	*Roman Life*, Chicago, 1957.
F. F. Jones	*Ancient Art in the Art Museum, Princeton University*, Princeton, 1960.
A. Joubin	*La sculpture grecque*, Paris, 1901.
I. Jucker	*Der Gestus des Aposkopein*, Zurich, 1956.
V. Karageorghis, C. Vermeule	*Sculptures from Salamis*, vol. I, Nicosia (Cyprus), 1964.
Fest. Kekulé	*Bonner Studien*, Berlin, 1890.
O. Keller	*Die antike Tierwelt*, vol. I-II, Leipzig, 1909, 1913.
A. E. Klein	*Child Life in Greek Art*, New York, 1932.
K. Kluge, K. Lehmann-Hartleben	*Grossbronzen der Römischen Kaiserzeit*, Berlin and Leipzig, 1927.
P. Knoblauch	*Studien zur archaisch-griechischen Tonbildnerei in Kreta, Rhodos, Athen und Böotien*, Diss., Wittenberg, 1937.
H. Koch	*Apollon und "Apollines,"* Stuttgart, 1930.
R. L. Koehl, et al.	*Athens in the Fifth Century B.C.*, Mass. Institute of Technology, 1950.
T. Kraus	*Hekate*, Heidelberger Kunstgeschichtliche Abhandlungen, vol. V, 1960.
E. Kunze	*Kretische Bronzereliefs*, Stuttgart, 1931.
W. Lamb	*Greek and Roman Bronzes*, London, 1929.
E. Langlotz	*Frühgriechische Bildhauerschulen*, Nuernberg, 1927.
Fest. Langlotz	*Charites*, ed. by K. Schauenburg, Bonn, 1957.
H. Lechat	*Pythagoras de Rhégion*, Lyon and Paris, 1905.
P. W. Lehmann	*The Pedimental Sculptures of the Hieron at Samothrace*, New York, 1962.
H. Licht	*Sittengeschichte Griechenlands*, vol. I-III, Dresden and Zurich, 1925-1928.
Festschrift für James Loeb	Munich, 1930.
(London) Spink	*Greek and Roman Antiquities from Famous Private Collections and Recent Excavations*, London, 1924.
R. Lullies	*Eine Sammlung Griechischer Kleinkunst*, Munich, 1955.
	Die Typen der griechischen Herme, Königsberg, 1931.
	(and M. Hirmer) *Greek Sculpture*, New York, (revised edition) 1960.

J. Marcadé	*Eros Kalos*, Geneva, 1962.
	Roma Amor, Geneva, 1961.
F. H. Marshall	*Catalogue of Jewellery*, (British Museum) London, 1911.
G. Matthies	*Die Praenestinischen Spiegel*, Strassburg, 1912.
F. Matz	*Geschichte der Griechischen Kunst*, Frankfurt am Main, 1950.
	Die Lauersforter Phalerae, (BWPr 92) Berlin and Leipzig, 1932.
Fest. Matz	*Festschrift für Friedrich Matz*, ed. by N. Himmelmann – Wildschütz and H. Biesantz, Mainz, 1962.
H. Menzel	*Die Römischen Bronzen aus Deutschland, Speyer*, Mainz, 1960.
Metropolitan Museum of Art	*Early Greek Art, A Picture Book*, New York, 1939.
A. Michaelis	*Ancient Marbles in Great Britain*, Cambridge, 1882.
J. S. Milne	*Surgical Instruments in Greek and Roman Times*, Oxford, 1907.
E. H. Minns	*Scythians and Greeks*, Cambridge, 1913.
H. Möbius	*Antike Kunstwerke aus dem Martin von Wagner-Museum*, Würzburg, 1962.
V. Müller	*Frühe Plastik in Griechenland und Kleinasien*, Augsburg, 1929.
D. Mustilli	*Il Museo Mussolini*, Rome, 1939.
K. A. Neugebauer	*Antike Bronzestatuetten*, Berlin, 1921.
	Antiken in Deutschem Privatbesitz, Berlin, 1938.
	Bilderhefte zur Kunst-und Kulturgeschichte, vol. II (*Bronzegerät des Altertums*) Bielefeld and Leipzig, 1927.
	Studien über Skopas, Leipzig, 1913.
H. G. Niemeyer	*Attische Bronzestatuetten der spätarchaischen und frühklassischen Zeit*, (Antike Plastik III, 1) Berlin, 1964.
	Promachos, Bayern, 1960.
Ny Carlsberg Glyptothek	*Bildertafeln des Etruskischen Museums (Helbing Museum)*, Copenhagen, 1928.
P. Orsi	*Sicilia Bizantina*, Rome, 1942.
J. A. Overbeck	*Griechische Kunstmythologie*, vol. I-III, Leipzig, 1873-1878.
M. Pallottino	*Art of the Etruscans*, London, 1955.
H. Payne, G. M. Young	*Archaic Marble Sculpture from the Acropolis*, London, 1936.
H. Payne	*Necrocorinthia*, Oxford, 1931.
	Perachora, Oxford, 1940.
P. Perdrizet	*Fouilles de Delphes*, vol. V, Paris, 1908.
E. Pernice	*Hellenistische Kunst in Pompeji*, vol. IV-V, Berlin and Leipzig, 1925, 1932.

K. Pfeiff	*Apollon*, Frankfurt am Main, 1943.
F. Poulsen	*Catalogue of Ancient Sculpture in the Ny Carlsberg Glyptotek*, Copenhagen, 1951.
D. Randall-MacIver	*Villanovans and Early Etruscans*, Oxford, 1924.
E. Richardson	*The Etruscans*, Chicago, 1964.
G. M. A. Richter	*Ancient Furniture*, Oxford, 1926.
	Ancient Italy, Ann Arbor, 1955.
	Archaic Greek Art, New York, 1949.
	A Handbook of Greek Art, London, 1959, (revised edition) 1960.
	Kouroi, London, 1960.
	The Portraits of the Greeks, vol. I-III, London, 1965.
P. J. Riis	*Etruscan Art*, Copenhagen, 1953.
Fest. Robinson	*Studies Presented to David Moore Robinson*, vol. I, ed. by G. E. Mylonas, St. Louis, 1951.
E. Rosenbaum	*A Catalogue of Cyrenaican Portrait Sculpture*, London, 1960.
M. C. Ross	*Catalogue of the Byzantine and Early Mediaeval Antiquities in the Dumbarton Oaks Collection*, vol. I-II, 1962, 1965.
B. Rowland, Jr.	*Ancient Art from Afghanistan*, New York, 1966.
A. Ruesch	*Guida* (Museo Nazionale di Napoli), Naples, n.d.
A. Rumpf	*Griechische und Römische Kunst*, Leipzig, 1931.
K. Schauenburg	*Helios*, Berlin, 1955.
	Perseus in der Kunst des Altertums, Bonn, 1960.
M. Schede	*Meisterwerke der türkischen Museen zu Konstantinopel*, Berlin and Leipzig, 1928.
K. Schefold	*Die Bildnisse der antiken Dichter, Redner und Denker*, Basel, 1943.
	Die grossen Bildhauer des archaischen Athen, (Griechische Plastik I) Basel, 1949.
	Untersuchungen zu den Kertscher Vasen, Berlin and Leipzig, 1934.
Fest. Schuchhardt	ΘΕΩΡΙΑ, *Festschrift für W.-H. Schuchhardt*, ed. by F. Eckstein, Baden-Baden, 1960.
K. Shepard	*The Fish-Tailed Monster in Greek and Etruscan Art*, New York, 1940.
J. Sieveking	*Antike Metalgeräte* (Hirth's Bilderhefte zu Kunst und Kunstgewerbe, part 2), Munich, n.d.
W. Skudnowa	*Skythische Spiegel aus der archaischen Nekropole von Olbia*, Leningrad, 1962 (in Russian).
A. H. Smith	*Catalogue of Sculpture*, (British Museum) vol. I-III, London, 1892-1904.

W. S. Smith	*Ancient Egypt,* (Museum of Fine Arts) Boston, 1952, 1960.
O. von Stackelberg	*Die Graeber der Hellenen,* Berlin, 1837.
C. G. Starr	*The Origins of Greek Civilization,* New York, 1961.
Collection Hélène Stathatos	*Les objets byzantins et post-byzantins,* Limoges, 1957.
E. S. Strong	*Art in Ancient Rome,* vol. I-II, New York, 1928.
J. Strzygowski	*Catalogue général du Musée du Caire, Koptische Kunst,* Vienna, 1904.
J. Sundwall	*Die Älteren Italischen Fibeln,* Berlin, 1943.
D. B. Thompson	*Miniature Sculpture from the Athenian Agora,* Princeton, 1959.
R. Thouvenot	*Catalogue des figurines et objets de bronze du Musée Archéologique de Madrid,* Bordeaux-Paris, 1927.
A. D. Trendall	*Phlyax Vases,* (Institute of Classical Studies Bulletin, Suppl. 8) 1959.
G. Ucelli	*Le navi di Nemi,* Rome, 1940.
G. Vallet	*Rhégion et Zancle,* Paris, 1958.
I. Venedikov	*The Thracian Chariot,* Sophia, 1960 (in Bulgarian).
C. Vermeule	*Aspects of Victoria on Roman Coins, Gems, and in Monumental Art,* London, 1958.
	European Art and the Classical Past, Cambridge (Mass.), 1964.
	Greek and Roman Portraits 470 B.C.—A.D. 500, (Museum of Fine Arts) Boston, 1959.
F. Vian	*Répertoire des Gigantomachies,* Paris, 1951.
W. F. Volbach	*Mittelalterliche Bildwerke aus Italien und Byzanz,* Berlin and Leipzig, 1930.
W. F. Volbach, M. Hirmer	*Early Christian Art,* New York, 1961.
A. J. B. Wace	*An Approach to Greek Sculpture,* Cambridge, 1935.
C. Waldstein	*The Argive Heraeum,* vol. I-II, Boston and New York, 1902-1905.
H. B. Walters	*Catalogue of the Greek and Roman Lamps in the British Museum,* London, 1914.
Fest. Weickert	*Festschrift für Carl Weickert,* ed. by G. Bruns, Berlin, 1955.
T. Wiegand, H. Schrader	*Priene,* Berlin, 1904.
P. Wolters, G. Bruns	*Das Kabirenheiligtum bei Theben,* vol. I, Berlin, 1940.
L. Woolley	*Digging up the Past,* (Penguin Books) Baltimore, 1967.
P. Wuilleumier	*Tarente,* Paris, 1939.
	Le Trésor de Tarente, Paris, 1930.

O. Wulff *Altchristliche und Mittelalterliche Byzantinische und Italien-*
ische Bildwerke, Berlin, 1909.

R. S. Yeoman *A Guide Book of United States Coins*, Racine (Wisconsin), (19th
edition) 1966.

Short Title Index

MONOGRAPHS AND CATALOGUES

Amelung, Vatican *Cat.* W. Amelung, Die Sculpturen des vaticanischen Museums, vol. I-II, Berlin and Leipzig, 1903-1908.

Babelon-Blanchet, *Bronzes* E. Babelon, J.-A. Blanchet, Catalogue des bronzes antiques de la Bibliothèque Nationale, Paris, 1895.

Baldes, Behrens, *Birkenfeld* H. Baldes, G. Behrens, Kataloge West-und Süddeutscher Altertumssammlungen, Part III, Birkenfeld, Frankfurt, 1914.

Basel Exhibition, 1959 (Schefold-Cahn, *Meisterwerke*) K. Schefold, Meisterwerke griechischer Kunst, Basel, 1960.

Bieber, *Cassel* M. Bieber, Die Antiken Skulpturen und Bronzen des Königl. Museum Fridericianum in Cassel, Marburg, 1915.

Blinkenberg, *Fibules* Chr. Blinkenberg, Fibules grecques et orientales, Copenhagen, 1926.

Blümel, *Tierplastik* C. Blümel, Tierplastik. Bildwerke aus fünf Jahrtausenden, Berlin and Leipzig, 1939.

von Bothmer, *Catalogue* D. von Bothmer, Greek, Etruscan, and Roman Antiquities, An Exhibition from the Collection of Walter Cummings Baker, Esq., New York, 1950.

Bulle, *Schöne Mensch* H. Bulle, Der Schoene Mensch im Altertum, Munich and Leipzig, 1912.

Burdett, Goddard, *E. P. Warren* O. Burdett, E. H. Goddard, Edward Perry Warren, The Biography of a Connoisseur, London, 1941.

CAH Cambridge Ancient History

Caskey, *Catalogue* L. D. Caskey, Catalogue of Greek and Roman Sculpture, Cambridge, 1925.

Caskey-Beazley III L. D. Caskey, J. D. Beazley, Attic Vase Paintings in the Museum of Fine Arts, Boston, Part III, Boston, 1963.

Catling, *Cypriot Bronzework* H. W. Catling, Cypriot Bronzework in the Mycenaean World, Oxford, 1964.

Chase, *Antiquities* G. H. Chase, Greek and Roman Antiquities, A Guide to the Classical Collection, Boston, 1950.

Revised as Greek, Etruscan & Roman Art, The Classical Collections of the Museum of Fine Arts, Boston, 1963.

Chiurazzi Chiurazzi, società anonima, fonderie-ceramica-marmeria, Napoli. Catalogo, Compilato da Salvatore Chiurazzi, Naples, n.d.; Current Price list, Naples, 1929.

Daremberg-Saglio	C. Daremberg, E. Saglio, Dictionnaire des Antiquités grecques et romaines, vol. I-V & index, Paris, 1875-1929.
Edgar, Cairo *Bronzes*	C. C. Edgar, Greek Bronzes (Catalogue général des antiquités égyptiennes du Musée du Caire), Cairo, 1904.
FR	A. Furtwängler, K. Reichhold, Griechische Vasenmalerei, vol. I-III, Munich, 1904-1932.
van Gulik, Allard Pierson *Bronzes*	H. C. van Gulik, Catalogue of the Bronzes in the Allard Pierson Museum at Amsterdam (Allard Pierson Stichting, Archaeologisch-historisch bijdragen VII), Amsterdam, 1940.
Hampe, *Frühe Griechische Sagenbilder*	R. Hampe, Frühe Griechische Sagenbilder in Böotien, Athens, 1936.
Handbook 1964	Illustrated Handbook, Museum of Fine Arts, Boston, 1964.
Hill, Walters *Bronzes*	D. K. Hill, Catalogue of Classical Bronze Sculpture in the Walters Art Gallery, Baltimore, 1949.
Jacobsthal, *Pins*	P. Jacobsthal, Greek Pins and Their Connexions with Europe and Asia, Oxford, 1956.
Jantzen, *Bronzewerkstätten*	U. Jantzen, Bronzewerkstätten in Grossgriechenland und Sizilien (*JdI*, Ergänzungsheft 13), Berlin, 1937.
Kansas City *Handbook*	Handbook of the Collections in the William Rockhill Nelson Gallery of Art and Mary Atkins Museum of Fine Arts, Kansas City (Missouri), 1959.
Lévêque, *Musée de Mariemont*	P. Lévêque, Antiquités Grecques, in Les Antiquités Égyptiennes, Grecques, Étrusques, Romaines et Gallo-Romaines du Musée de Mariemont, Brussels, 1952.
Lippold, *Handbuch*	G. Lippold, Handbuch der Archäologie, vol. III, part 1, Munich, 1950.
Lippold, Vatican *Katalog*	G. Lippold, Die Skulpturen des Vaticanischen Museums, vol. III, part 1, Berlin and Leipzig, 1936; part 2, Berlin, 1956.
(London) Soane Museum, *Catalogue*	C. Vermeule, A Catalogue of the Classical Antiquities in Sir John Soane's Museum, London, 1953.
Magi, *La raccolta Benedetto Guglielmi*	F. Magi, La raccolta Benedetto Guglielmi nel Museo Gregoriano Etrusco, Parte II, Bronzi e Oggetti Vari, Vatican City, 1941.
Mendel, *Cat.*	G. Mendel, Musées Impériaux Ottomans, Catalogue des sculptures grecques, romaines et byzantines, vol. I-III, Constantinople, 1912-1914.
Micali, *Monum.*	G. Micali, Monuments antiques . . . de . . . l'Italie avant la domination des Romains, Paris, 1824.
Mitten-Doeringer, *Master Bronzes*	D. Mitten, S. Doeringer, Master Bronzes from the Classical World, Cambridge, 1967.
Montelius	O. Montelius, La civilisation primitive en Italie, vol. I-II, Stockholm, 1895-1910.

Neugebauer, Berlin *Bronzes*	K. A. Neugebauer, Katalog der Statuarischen Bronzen im Antiquarium, vol. I, Berlin and Leipzig, 1931; vol. II, Berlin, 1951.
Olynthus X	D. M. Robinson, Excavations at Olynthus, Part X, Baltimore, 1941.
Perdrizet, *Collection Fouquet*	P. Perdrizet, Bronzes grecs de la Collection Fouquet, Paris, 1911.
Pfuhl, *MuZ*	E. Pfuhl, Malerei und Zeichnung der Griechen, vol. I-III, Munich, 1923.
Picard, *Manuel*	C. Picard, Manuel d'archéologie grecque, La Sculpture, vol. I-IV, Paris, 1935-1963.
Reinach, *Rép. rel.*	S. Reinach, Répertoire de reliefs grecs et romains, vol. I-III, Paris, 1909-1912.
Reinach, *Rép. stat.*	S. Reinach, Répertoire de la statuaire grecque et romaine, vol. I-VI, Paris, 1897-1930.
Renard, *Musée de Mariemont*	M. Renard, Antiquités Romaines, in Les Antiquités Égyptiennes, Grecques, Étrusques, Romaines et Gallo-Romaines du Musée de Mariemont, Brussels, 1952.
Richter, *Animals*	G. M. A. Richter, Animals in Greek Sculpture, New York, 1930.
Richter, Met. Mus. *Handbook*	G. M. A. Richter, The Metropolitan Museum of Art, Handbook of the Greek Collection, Cambridge (Mass.), 1953.
Richter, New York *Bronzes*	G. M. A. Richter, Greek, Etruscan and Roman Bronzes, The Metropolitan Museum of Art, New York, 1915.
Richter, *Sculpture*	G. M. A. Richter, The Sculpture and Sculptors of the Greeks, New Haven and London, (new revised edition) 1950.
De Ridder, Acropolis *Bronzes*	A. de Ridder, Catalogue des bronzes trouvés sur l'Acropole d'Athènes, Paris, 1896.
De Ridder, Louvre *Bronzes*	A. de Ridder, Les Bronzes antiques du Louvre, vol. I-II, Paris, 1913-1915.
De Ridder, Société archéologique d'Athènes *Bronzes*	A. de Ridder, Catalogue des bronzes de la Société archéologique d'Athènes, Paris, 1894.
Schefold-Cahn, *Meisterwerke*	see Basel Exhibition, 1959.
Schumacher, Karlsruhe *Bronzen*	K. Schumacher, Beschreibung der Sammlung antiker Bronzen, Karlsruhe, 1890.
Stuart Jones, *Conservatori*	H. Stuart Jones, *et al.*, A Catalogue of the Ancient Sculpture Preserved in the Municipal Collections of Rome. The Sculptures of the Palazzo dei Conservatori, Oxford, 1926.
Tarbell, *Bronzes*	F. B. Tarbell, Catalogue of Bronzes, etc. in Field Museum of Natural History, Reproduced from Originals in the National Museum of Naples, Chicago, 1909.

Walters, British Museum
Bronzes

H. B. Walters, Catalogue of the Bronzes, Greek, Roman and Etrus-
can in the Department of Greek and Roman Antiquities, British
Museum, London, 1899.

Züchner, *Klappspiegel*

W. Züchner, Griechische Klappspiegel (JdI, Ergänzungsheft 14),
Berlin, 1942.

EXHIBITION CATALOGUES

Andover (Mass.), *Classi-
cal Art*

Addison Gallery of American Art, Phillips Academy, Classical
Art, March 5 – April 8, 1935

Basel Exhibition, 1959
(Schefold-Cahn, *Meister-
werke*)

K. Schefold, Meisterwerke griechischer Kunst, Basel 1960

Brooklyn, *The Pomerance
Collection of Ancient Art*

The Brooklyn Museum, The Pomerance Collection of Ancient
Art, June 14 – Oct. 2, 1966

Buffalo, *Master Bronzes*

Buffalo Fine Arts Academy, Master Bronzes, Selected from Mu-
seums and Collections in America, Buffalo 1937

Cambridge (Mass.), Fogg
Art Museum, *Ancient
Art in American Private
Collections*

Fogg Art Museum, Ancient Art in American Private Collections,
Dec. 28, 1954 – Feb. 15, 1955, Cambridge 1954

Cambridge (Mass.), Fogg
Art Museum, *Greek Art
and Life*

Fogg Art Museum, Greek Art and Life, March 7 – April 15, 1950

Cambridge (Mass.), Fogg
Art Museum, *Norbert
Schimmel Collection*

Fogg Art Museum, Norbert Schimmel Collection, ed. by Herbert
Hoffmann, Nov. 15, 1964 – Feb. 14, 1965, Mainz 1964

Cambridge (Mass.), Fogg
Art Museum, *Master
Bronzes*
(Mitten-Doeringer,
Master Bronzes)

Fogg Art Museum, Master Bronzes from the Classical World,
Dec. 3, 1967 – Jan. 23, 1968; City Art Museum of Saint Louis,
March 1 – April 13, 1968; The Los Angeles County Museum of
Art, May 8 – June 30, 1968, Cambridge 1967

Corning (New York),
*Glass from the Ancient
World*

The Corning Museum of Glass in the Corning Glass Center, The
Ray Winfield Smith Collection, A Special Exhibition 1957

Dayton, *Flight Fantasy,
Faith, Fact*

Dayton Chamber of Commerce and Dayton Art Institute, Flight
Fantasy, Faith, Fact, Dec. 17, 1953 – Feb. 21, 1954

Detroit, *Small Bronzes of
the Ancient World*

The Detroit Institute of Arts, Small Bronzes of the Ancient
World, March 23 – April 20, 1947

Fort Worth (Texas),
Horse and Rider

Fort Worth Art Center, Horse and Rider as seen by artists
throughout the ages, Jan. 7 – March 3, 1957

Hartford, *The Medicine Man Medicine in Art*	Wadsworth Atheneum, The Medicine Man Medicine in Art, Oct. 13 – Dec. 12, 1954
Houston (Texas), *Space and Fantasy, A Selection*	Museum of Fine Arts, Space and Fantasy, A Selection, Jan. 24 – Feb. 14, 1963
London, Burlington Fine Arts Club, *Ancient Greek Art*	Burlington Fine Arts Club, Exhibition of Ancient Greek Art, London 1903; revised edition, London 1904
New York, Metropolitan Museum, *Ancient Art from New York Private Collections*	Metropolitan Museum of Art, Ancient Art from New York Private Collections, Dec. 17, 1959 – Feb. 28, 1960, New York 1961
University of Pennsylvania, University Museum, *What we don't know*	University Museum, What we don't know, An Exhibit from private collections in honor of The Fourth International Congress of Classical Studies, Aug. 24 – 29, 1964
Princeton, *The Theater in Ancient Art*	The Art Museum, Princeton University, The Theater in Ancient Art, Dec. 10, 1951 – Jan. 6, 1952
Queens College, Paul Klapper Library, *Man in the Ancient World*	Queens College Art Collection, Paul Klapper Library, Man in the Ancient World, Feb. 10 – March 7, 1958
Waltham, Rose Art Museum, *Art of the Late Antique*	Rose Art Museum, Brandeis University, Art of the Late Antique from American Collections, Dec. 18, 1968 – Feb. 16, 1969, Waltham 1968
University of Wisconsin Memorial Library, *Rome An Exhibition of Facts and Ideas*	University of Wisconsin Memorial Library, Rome An Exhibition of Facts and Ideas, April 27 – July 16, 1954
Worcester Art Museum, *Masterpieces of Etruscan Art*	Worcester Art Museum, Masterpieces of Etruscan Art, April 21 – June 4, 1967
Zurich, Kunsthaus, *Kunst und Leben der Etrusker*	Kunsthaus, Kunst und Leben der Etrusker, Jan. 15 – March 31, 1955, Zurich 1955

SALE CATALOGUES

Collection Bammeville	Paris, Hôtel des Commissaires-Priseurs, 12 – 16 June, 1893 (Froehner).
Collection Borelli Bey	Paris, Hôtel Drouot, 11 – 13 June, 1913.
Collection Brummer, part 2	New York, Parke-Bernet, 11 – 14 May, 1949.
Dattari and Lambros Sale	Paris, Hôtel Drouot, 17 – 19 June, 1912.

Collection Durighello	Paris, Hôtel Drouot, 17 – 19 May, 1911.
Classical Works of Art	New York, Emmerich Gallery, Feb. 4 – March 5, 1966 (Emmerich, Cahn).
Ferroni Sale	Rome, April, 1909.
Forman Sale	London, Sotheby, I, 19 – 22 June, 1899 (C. H. Smith); II, 2 – 5 July, 1900.
Collection Fouquet	Paris, Galerie Georges Petit, 12 – 14 March, 1922 (P. Perdrizet).
Collection Gréau	Paris, Hôtel Drouot, 1 – 9 June, 1885 (W. Froehner).
Galerie Helbing	Munich, 22 Feb., 1910. Munich, 28 – 30 October, 1913. Munich, 5 Dec., 1929.
Bedeutende Kunstwerke aus dem Nachlass Dr. Jacob Hirsch	Lucerne, A. Hess and New York, W. H. Schab, 7 Dec., 1957 (Langlotz).
Collection H. Hoffmann	Paris, Hôtel Drouot, 28 – 29 May, 1888 (W. Froehner).
Collection H. Hoffmann	Paris, Hôtel Drouot, 15 – 19 May, 1899.
Paul I. Ilton Collection	New York, H. M. F. Schulman, 21 Nov., 1959.
Instruments de chirurgie gréco-romains, Propriété de la Fondation Hardt	Geneva, N. Rauch, 7 – 13 June, 1961.
Vente Lehmann	Paris, Hôtel Drouot, 11 June, 1925 (Feuardent).
Northwick Park Collection, Antiquities	London, Christie's, 21 – 23 June, 1965.
Antiken aus dem Nachlass des Prof. Mirko Roš, *et al.*	Lucerne, Galerie Fischer, 5 Dec., 1963.
Gerd Rosen, Auktion XXXI	Berlin, 24 – 29 Nov., 1958.
A. Sambon Collection	Paris, Galerie Georges Petit, 25 – 28 May, 1914.
Sambon-Canessa Sale	Paris, 18 – 20 March, 1901.
Saulini Sale	Rome, 24 – 26 April, 1899.
Collection Tyszkiewicz	Paris, Hôtel des Commissaires-Priseurs, 8 – 10 June, 1898 (W. Froehner).

Abbreviations

Periodicals can mostly be found in the form included here in *American Journal of Archaeology* 69 (1965) 201ff. For monographs see D. K. Hill, *Catalogue of Classical Bronze Sculpture in the Walters Art Gallery*, Baltimore 1949, 129ff.

PERIODICALS AND SERIAL PUBLICATIONS

AA	Archäologischer Anzeiger
ActaA	Acta Archaeologica
AJA	American Journal of Archaeology
AJP	American Journal of Philology
AM	Mitteilungen des Deutschen Archäologischen Instituts, Athenische Abteilung
Annali dell'Inst.	Annali dell'Instituto di Corrispondenza Archeologica
Ann. Rep.	Annual Report, Museum of Fine Arts, Boston, 1886 to date.
ANSMN	American Numismatic Society, Museum Notes
AntJ	Antiquaries' Journal
ArchCl	Archeologica Classica
ArchEph	Archaiologike Ephemeris
ArchEspArq	Archivo Español de Arqueologia
ArtB	Art Bulletin
ArtQ	Art Quarterly
AZ	Archäologische Zeitung
B Ant Beschav	Bulletin van de Vereeniging tot Bevordering der Kennis van de Antike Beschaving
BCH	Bulletin de correspondance hellénique
BdA	Bolletino d'Arte
BIABulg	Bulletin de l'Institut archéologique bulgare
BMFA	Bulletin of the Museum of Fine Arts, Boston, 1903 to date.
BMMA	Bulletin of the Metropolitan Museum of Art, New York
Bonn Jahrb	Bonner Jahrbucher
BSA	British School at Athens, Annual
Bull. dell'Inst.	Bullettino dell'Instituto di Corrispondenza Archeologica
BWPr	Winkelmannsprogramm der Archäologischen Gesellschaft zu Berlin

CJ	The Classical Journal
CRAI	Comptes-rendus de l'Académie des Inscriptions
EA	Einzelaufnahmen
FastiA	Fasti Archaeologici
GBA	Gazette des Beaux-Arts
IG	Inscriptiones Graecae
ILN	Illustrated London News
JARCE	Journal of the American Research Center in Egypt
JdI	Jahrbuch des Deutschen Archäologischen Instituts
JEA	Journal of Egyptian Archaeology
JHS	Journal of Hellenic Studies
JOAI	Jahreshefte des Österreichischen Archäologischen Instituts
JRS	Journal of Roman Studies
JWalt	Journal of the Walters Art Gallery (Baltimore, from 1938)
JWarb	Journal of the Warburg and Courtauld Institutes
MAAR	Memoirs of the American Academy in Rome
Mem Soc Ant	Mémoires de la Société Nationale des Antiquaires de France
MonAnt	Monumenti Antichi
Mon. dell'Inst.	Monumenti Inediti pubblicati dall'Instituto di Corrispondenza Archeologica
MonPiot	Monuments et mémoires, Fondation E. Piot
MusHelv	Museum Helveticum
NSc	Notizie degli Scavi (Rome, from 1876)
Num Chron	Numismatic Chronicle
OpusArch	Opuscula Archaeologica
Opus Rom	Opuscula Romana
Oud Med	Oudheidkundige Mededelingen
PAPS	Proceedings of the American Philosophical Society
Proc Irish Acad	Proceedings of the (Royal) Irish Academy
RA	Revue archéologique
REA	Revue des études anciennes
RM	Mitteilungen des Deutschen Archäologischen Instituts, Römische Abteilung
SBPreuss	Sitzungsberichte der königlich preussischen Akademie der Wissenschaften
SEG	Supplementum Epigraphicum Graecum

TAPS Transactions of the American Philosophical Society

UPMB University of Pennsylvania Museum Bulletin

STATUES
&
STATUETTES

Greek

1

VOTARY
Middle Minoan III to Late Minoan I (circa
1700 to 1450 B.C.)
H.: 0.045m.
Otis Norcross Fund 64.2173
From Crete by way of London.

Slight encrustation and green patina.
 Her right hand is raised to her head. She
wears a flounced skirt with double belt, tassels
on the right side.
 Compare the examples in Oxford, Herak-
lion, and Berlin: J. Boardman, *The Cretan
Collection in Oxford*, 8ff., nos. 23f., pl. 4;
W. Lamb, *Greek and Roman Bronzes*, 26,
pl. 7. The statuette in the Ashmolean Mu-
seum comes from the Dictaean Cave. This fig-
ure, the votary in Berlin (which is 0.19m.
high), and its two counterparts in the Herak-
lion Museum have the V-shaped skirt in front.

Vermeule, *Ann. Rep. 1964*, 32; MFA, *Calendar of
Events*, March 1965, 1, illus.; Vermeule, *CJ* 62
(1966) 100, fig. 5.

1

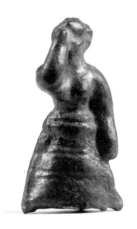

2

2

ZEUS AND HERA (?)
800 to 700 B.C.
H.: 0.08m.
Gift of Leslie Hastings, Esq. 63.2755
Acquired in the nineteenth century by Mr.
Hastings' grandfather, who had shipping in-
terests. Possibly from Olympia.

Dark green patina.
 The two figures are cast together with a
small base. The male figure wears a heavy
belt and long, pointed cap, and the female
sports a domed, brimmed hat.
 It has been suggested that the "Lord" with
his look of possessive pride is Zeus, and his
consort is Hera. The costumes and "the amus-
ing stop-sign hand" are characteristics of
early bronze figurines from the sanctuary at
Olympia.
 Other critics have felt that this group could
have been made in Syria in a period corre-
sponding to the early Geometric in Greece.
A bronze pair of a god and goddess in the
Louvre shows certain similarities, but style
and details are palpably Near Eastern, very
different from the Hastings bronze (see
Encyclopédie photographique de l'art, II
[Paris, 1937], 109, G).

H. Palmer, *BMFA* 56 (1958) 64-68, figs. 1-3;
Vermeule, *Ann. Rep. 1958*, 33; *FastiA* 13 (1958)
87, no. 1370; Vermeule, *Ann. Rep. 1963*, 37;
D. Mitten, *BMFA* 65 (1967) 11f., fig. 11.

E. Kunze, *Olympiabericht* 8 (1958-1962) 224, note 24; J. Boardman, *The Cretan Collection at Oxford*, 78, footnote 2; N. Himmelmann-Wildschütz, *Bemerkungen zur Geometrischen Plastik*, 18, note 38.

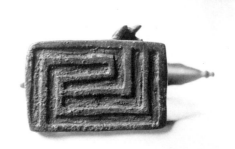

3

DEER AND FAWN
800 to 700 B.C.
L.: 0.042m. H.: 0.072m.
H. L. Pierce Fund 98.650
E. P. Warren Collection.
From the Kabeirion at Thebes.

Dark, olive patina with slight corrosion.

The deer is nursing the fawn. A bird is perched on the back of the former. Small, concentric circles are incised on the animals' bodies, and on the deer's horns; her eye is a similar circle. On the under side of the base, a maeander.

There are other comparable groups: see De Ridder, Louvre *Bronzes*, I, 19, no. 85, pl. 10; *Mem Soc Ant* 55 (1895) 160, fig. 1; Reinach, *Rép. stat.*, III, 220, no. 11 (from Boeotia and then in a private collection, Paris) and the deer and fawn in Athens: Lamb, *Greek and Roman Bronzes*, pl. 14b. Hampe comments on the mother deer's borrowed horns and misplaced ears. Hill compares the group with Baltimore, Walters no. 54.2382.

E. Robinson, *Ann. Rep.* 1898, 24; *AA* 1899, 136; Beazley, in Burdett, Goddard, *E. P. Warren*, 358; B. Segall, *BMFA* 41 (1943) 74f., fig. 8; Chase, *Antiquities*, 16, fig. 15; 2nd edition, 28f., 33, fig. 26; P. Barnard, *The Contemporary Mouse*, 34f., illus.; H. Palmer, *BMFA* 56 (1958) 67f., fig. 7; *Handbook* 1964, 44f., illus.; D. Mitten, *BMFA* 65 (1967) 12ff., figs. 12-15.

De Ridder, Louvre *Bronzes*, I, 19, under no. 85; K. Neugebauer, Berlin *Bronzes*, I, 27; Hampe, *Frühe Griechische Sagenbilder*, 43, pl. 30; *idem, Die gleichnisse Homers und die Bildkunst seiner Zeit*, 36, pl. 17, fig. 17a; K. Schefold, *Griechische Plastik I, Die grossen Bildhauer des archaischen Athen*, 8, pl. 4; D. K. Hill, *AJA* 59 (1955) 40, note 14; E. A. Armstrong, *The Folklore of Birds*, pl. 8a; Brunnsåker, *Opus Rom* 4 (1962) 187, 192; Boardman, *Greek Art*, 34, ill. 21; Barron, *Greek Sculpture*, 9, illus.; H.-V. Herrmann, *JdI* 79 (1964) 29, note 52; G. M. A. Hanfmann, *Classical Sculpture*, fig. 18, 304; Rolley, *Monumenta*

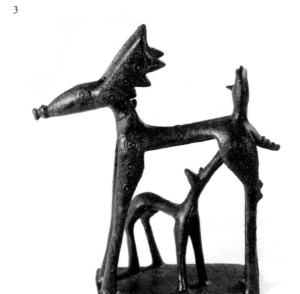

Graeca et Romana, V, fasc. 1, 3, no. 25, pl. 7; M. Weber, *Städel-Jahrbuch*, N. F. 1 (1967) 13f., fig. 15, 17, note 33; N. Himmelmann-Wildschütz, *Abhandlungen der Geistes-und Sozialwissenschaftlichen Klasse, Mainz* 7 (1968) 321f., note 3, 6; W. Eisenhart, *Artnews*, September, 1969, 35, illus., 68.

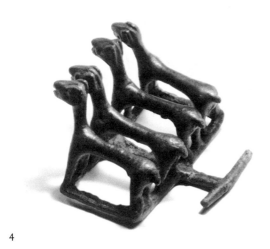

4

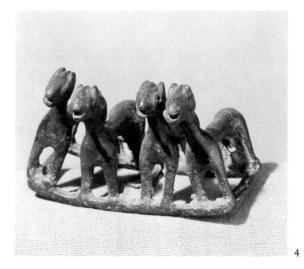

4

4

Four Sheep
800 to 700 B.C.
H.: 0.045m. W.: 0.07m.
Samuel Putnam Avery Fund 58.1189

Dark green patina with spots of light green corrosion.

They are mounted side by side on a thin rectangular frame with one cross bar running between the two middle sheep. Behind the frame there is a T-shaped extension.

The subject is very rare, there being no comparable bronzes among the hordes of Geometric figurines found at Olympia, Delphi, and elsewhere. The nearest parallel is provided by the group on the top of a votive pastoral staff found at Delphi and probably dedicated in the Hermeion there. Here we see a Geometric shepherd, perhaps Hermes Nomios, driving a single sheep to market, to pasture or to sacrifice (*BCH* 48 [1924] 477f., fig. 10). The group on the top of the staff serves to explain the T-shaped bar behind the sheep discussed here. There were once, no doubt, two shepherds represented as herding their charges along the road, much as one might see the same scene in Greece today.

Vermeule, *Ann. Rep.* 1958, 31; *idem, CJ* 55 (1960) 193f., fig. 1; *FastiA* 15 (1960) no. 671; D. Mitten, *BMFA* 65 (1967) 10f., fig. 10.

HORSE

Geometric, circa 750 B.C.

H. (max.): 0.08m. L. (max. at base): 0.055m.
w. (max. at base): 0.03m.

William E. Nickerson Fund, No. 2 65.1316
Said to come from near Elis.

Greenish patina with black areas and earth
encrustation. Breaks on right upper thigh and
across the top of the tail, also at the left hind
hoof.

He is standing with four feet and tail on a
rectangular platform, the latter pierced by
triangular cut-outs. Five horizontal lines are
incised either side of the lower part of the
neck; pairs of similar incisions appear on the
outsides of all four legs.

This is the standard type of Geometric
horse, with alert ears, "piggy" snout, and re-
versed hocks on the forelegs.

Compare G. M. A. Richter, *Met. Mus.
Handbook*, 173, pl. 13e.

Vermeule, *Ann. Rep.* 1965, 67; *idem, CJ* 62 (1966)
101f., fig. 8; D. Mitten, *BMFA* 65 (1967) 5ff., fig. 3.

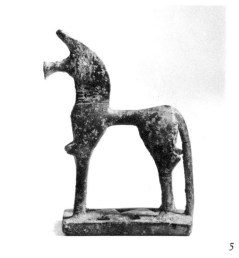

5

5

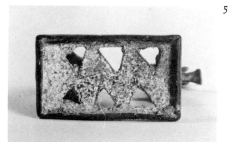

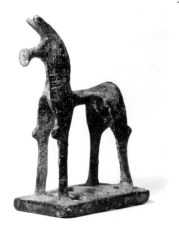

5

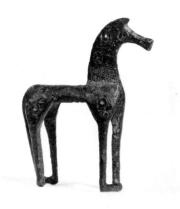

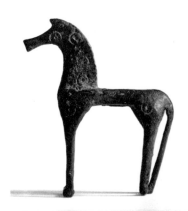

6

6

6

HORSE
Circa 750 B.C.
H. (max.): 0.057m. L. (max.): 0.053m.
Samuel Putnam Avery Fund 65.1292
Art Market in Athens.

Dark to medium green patina, hard and with earth encrustation on it. The crossbar at the front legs is joined on to the front of the hooves; the bar at the back runs from the back of the left hoof only as far as the tail, where the latter touches the bar and the right hoof.

He stands, alert, on his four straight legs; his blade-like neck rises in an elegant curve, suggesting a mane like a rooster's comb. An incised concentric circle marks the eye and is repeated for dapples on neck, shoulder, and flank. The blunderbuss head and long tail are characteristic, the latter joining the bar running between the hind hooves. The lack of ears is unusual.

This type of horse, with the small circles, occurs at Olympia and, in later form, has been attributed to a Corinthian school of Geometric craftsmen (H.-V. Herrmann, *JdI* 79 [1964] 30f., fig. 13). These horses, with their unarticulated legs and very simple platforms, are rare. It is hard to date this piece earlier, for it has the feeling and general style of a Geometric bronze from northern Greece, probably from Thessaly.

Vermeule, *Ann. Rep.* 1965, 67; idem, *CJ* 62 (1966) 102, fig. 9; D. Mitten, *BMFA* 65 (1967) 5ff., fig. 2 and cover.

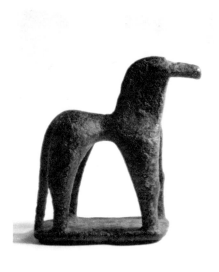

HORSE
Circa 750 B.C.
L. (max.): 0.051m. H. (max.): 0.053m.
John Michael Rodocanachi Fund 62.511
Swiss Art Market.

Black-green patina.

His ears lie forward, and his tail joins the stand. He has thick flanks, low mane, tubular nose, on a plain, rectangular stand. The underside of the stand has an inset pattern. Compare D. K. Hill, *AJA* 59 (1955) 39, no. 1, pl. 29, 1-3 (colt in Baltimore) and refs.; Hanfmann, *AJA* 58 (1954) 226, pl. 38, 9-10; Basel Exhibition, 1959, no. 55; Bowdoin College: K. Herbert, *Ancient Art in Bowdoin College*, 117, no. 416, pl. 40.

Vermeule, *Ann. Rep.* 1962, 30; idem, *CJ* 60 (1965) 289f., fig. 1; D. Mitten, *BMFA* 65 (1967) 5ff., fig. 1.

M. Weber, *Städel-Jahrbuch*, N. F. 1 (1967) 11, 16, note 18a.

7

7

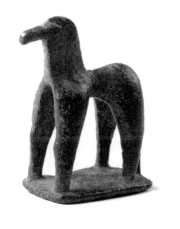

7

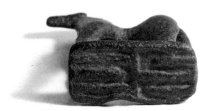

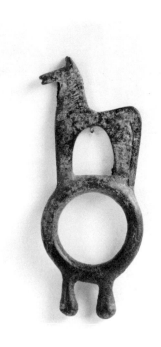

HORSE STANDING ON RING
Circa 750 B.C.
H. (max.): 0.07m. H. (of horse): 0.034m.
L. (of horse): 0.03m.
Outer diameter of ring (horizontal): 0.03m.
Thickness of ring: 0.004m.
John Michael Rodocanachi Fund 65.101
Boston Art Market.
Said to have been found at Elateia (Drachmani) in Phokis.

Dark green patina, with light green encrustation on right rear flank of horse.

Probably cast in one piece; horizontal striations are visible on the left side of the horse, and on the lower parts of the legs (reworkings of the cast?).

The horse is a standard, voluminous silhouette. The mouth and ears, curving forward, are incised. A simple, incised line delineates the tail. The ring on which the horse stands has two drop-shaped pendants suspended from the bottom; these are 0.01m. long and 0.007m. apart.

This is probably a northern Greek ornament, perhaps related to the succession of men and animals who perch atop openwork spheres, bronzes found in Thessaly and Macedonia. The object may have had a use, as a pendant, a ring, or one of a pair of bridle attachments. For the ring with drop pendants, surmounted by opposed bird heads, see W. Lamb, *Greek and Roman Bronzes*, pl. 13, b, lower left; also New York, Metropolitan Museum, no. 54.137.2, which is a ram on top of a similar ring. Athens, National Museum, no. 15536, by way of contrast, is a flat bird on a double ring with only one pendant below.

Vermeule, *Ann. Rep.* 1965, 67; *idem, BMFA* 63 (1965) 210f., illus.; D. Mitten, *BMFA* 65 (1967) 8, fig. 4.

WATERBIRD
Circa 750 to 700 B.C.
H.: 0.024m. L. (max.): 0.028m.
Gift of Dr. Leo Mildenberg 66.972

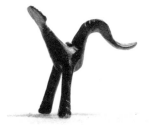

9

9 A

Green and blackish patina.

This waterbird has a flat, spoon bill and a flaring tail with serrations to indicate feathers. There are pairs of incised lines behind the head and (V-shaped) just before the tail. Similar pairs of wedge-shaped incisions define the feet.

This bird is a votive offering, probably connected with the Sanctuary of Zeus at Pherai; the hole through its body was either to suspend it by a string or set it on a pin. The incised lines decorating its neck, tail, and feet are typical of northern Greece, as is the whole lyrical quality, less naturalistic than Peloponnesian counterparts who stand firmly on their feet.

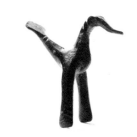

Compare Biesantz, *Die Thessalischen Grabreliefs* (Mainz am Rhein, 1965) 109f., pl. 53, L 73 (lower right).

Vermeule, *Ann. Rep.* 1966, 54; D. Mitten, *BMFA* 65 (1967) 8, fig. 5.

9A

WATERBIRD
Circa 750 to 700 B.C.
H.: 0.026m. L. (max.): 0.025m.
Gift of Miss Mary B. Comstock 67.1024

Dark green patina.
There is a hole, vertically, through the body. Double bands (lines) are incised on the neck and the back just before the fantail. There are double chevrons on the lower outsides of the legs.

Compare M.F.A. no. 66.972.

Vermeule, *Ann. Rep.* 1967, 47.

WATERBIRD ON STAND

Circa 750 to 700 B.C.

H.: 0.045m.

Gift of Heyward Cutting 63.1397

Even green patina.

There is a hole for suspension diagonally from the middle of the back to just under the breast. The bottom of the stand is concave.

The long, curved bill leads W. Lamb to term this type of bird a "duckling" *(Greek and Roman Bronzes,* 36, pl. 13). Compare also R. Lullies, *Eine Sammlung Griechischer Kleinkunst,* 70, no. 209, pl. 76; van Gulik, Allard Pierson *Bronzes,* 62, no. 89, pl. 19; Schefold-Cahn, *Meisterwerke,* no. 64.

A bird close to this, with the bottom of the stand missing, is in the Volos Museum, from the temple at Pherai (Velestino). Another is in the Tegea Museum, although the type is probably northern Greek.

Vermeule, *Ann. Rep.* 1963, 37; *idem, CJ* 60 (1965) 290, fig. 2; D. Mitten, *BMFA* 65 (1967) 10, fig. 6.

11

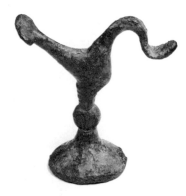

BIRD

700 B.C.

H.: 0.065m.

Otis Norcross Fund 64.1460

Crusty green patina.

This fat waterbird has a duck's bill and a broad tail. Unusual little feet, as well as the conventional loop above the back, support the figure. A hole runs through the hollow body, from side to side, and another open area, left just behind the neck in the process of casting, is rectangular.

Waterbirds of this type are rarer than the Geometric fowl long known in numbers from Olympia and other sites in the Peloponnesus. These puffy birds are evidently a northern Greek manifestation, or perhaps survival, of the Geometric tradition: compare D. K. Hill, *AJA* 60 (1956) 36f., pl. 28, figs. 2, 3; *idem,* Walters *Bronzes,* 119f., no. 274, pl. 51.

Vermeule, *Ann. Rep.* 1964, 32; *idem, CJ* 61 (1966) 290ff., fig. 3; D. Mitten, *BMFA* 65 (1967) 10, fig. 7.

Mitten-Doeringer, *Master Bronzes,* under no. 24.

Соск
700 B.C. or later
H. (with base): 0.045m.
Gift of C. Granville Way 72.4449
Hay Collection.

Encrusted.
Stands on a round base; wings raised, head
lowered, in attitude of crowing. Beak pierced
by a round hole.

There are other comparable vignettes of the
Geometric barnyard, also probably votives
to male divinities such as Apollo or Hermes:
compare De Ridder, Acropolis *Bronzes*, 267,
no. 737, pls. 1-2; Metropolitan Museum, *Early
Greek Art*, no. 7 (termed a peacock, but per-
haps a pre-Persian barnyard rooster with
elaborate plumage).

The style is curious, with rough indications
of the feathers on the bottom edges of the
wings. This bird is a late and rather provincial
manifestation of Geometric art. Otherwise, it
is conceivable that the piece is Coptic, that is
Late Antique from Egypt or the Upper Nile
area, rather than Geometric. Most items in the
Hay Collection came from Egypt. Compare
van Gulik, Allard Pierson *Bronzes*, 62, no. 90,
pl. 18. The circular piece of metal beneath the
area on which the feet stand would then be
the top of a pyxis or comparable utensil.

12

12

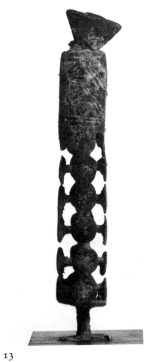

13

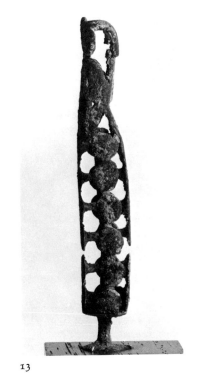

13

14

13

END OF A PIN OR A PLUG
Geometric, about 750 B.C.
H. (max.): 0.095m.
Gift of Dr. Elie Borowski 67.742
From Thessaly.

Green and brown patina. Broken and mended where neck of figure joins body.

An uncertain creature, resembling a monkey or even a grasshopper, sits in the framework of a shaft enriched with a series of buttons or studs set in pairs opposite each other. The shaft terminates in a round base.

These figures in their curious foliage have been termed daimons, and they appear to be eating. An example in the Bernoulli Collection in Basel is said to come from Dodona (Schefold-Cahn, *Meisterwerke*, 9, 127f., no. I 50). A number of similar objects are known, and they show as much stylistic (or chronological and regional) variation as the Geometric horses (see the references given by G. Hafner, in Ars Antiqua, Auktion II, 1960, 36, under no. 80, pl. 37). This example is unusual because of its metallic, cut-out quality, the crowning design growing out of shaft and studs in a thin plate and struts. (See especially U. Jantzen, *AA* 1953, 56ff., figs. 4, 5, 11.)

Vermeule, *Ann. Rep. 1967*, 47.

14

14

CRESTED BIRD ON STAND
Late Geometric (?)
H.: 0.033m.
Gift of Richard R. Wagner 65.1180
From Istanbul and probably ultimately from Anatolia.

Light greenish, blue patina.

The stand is in the form of three turned, bell-shaped knobs. The bird has a small, serrated crest and therefore may be considered a cock of some species.

Vermeule, *Ann. Rep. 1965*, 68.

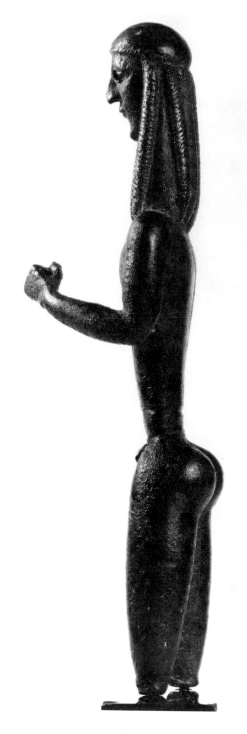

15

15

16

Mantiklos ''Apollo''
Circa 700 B.C.
H.: 0.203m.
Francis Bartlett Collection 03.997
E. P. Warren Collection; Tyszkiewicz Collection.
From Boeotia (Thebes), perhaps from the Ismenion.

Green patina with earth encrustation.

The right arm, lower parts of the legs, and the accessories are missing.

The front of the thighs of this standing nude male figure are inscribed in archaic Boeotian characters (see below). There are marks of attachment on the top of the head and a hole for attachment in the forehead. The hole in the left hand has been identified as support for a bow. It has been suggested also that the figure was a warrior, wearing a helmet and carrying a spear in the left hand and a shield on the right arm. This would help to explain the position and arrangement of the lettering. "Mantiklos dedicated (this) from his tithe to the Far Darter of the Silver Bow; do thou, Phoebus, grant gracious recompense."

The bow as attribute would confirm the figure's identification as Apollo. Since a spear and shield would be somewhat unusual for the "Far Darter of the Silver Bow," the alternative is to imagine that this orientalizing early kouros is Mantiklos himself. The combination of elongation and emerging human proportions, or strong characteristics of a forthright male, has given this statuette rightful place as one of the cornerstones of proto-archaic Greek art. Hawk-like nose, heavy strands of carefully braided hair, and a decisive thrust of the left arm with clenched fist are manifestations of positive artistic individuality within an archaic formula explored here for nearly the first time in sculpture. The piercing eyes of the Mantiklos "Apollo" haunt us not only for what he is but for what Greek sculpture reveals as its future.

B. H. Hill, *Ann. Rep.* 1903, 59f.; *AA* 1904, 194; *AJA* 8 (1904) 382; *BMFA* 2 (1904) 6; J. Addison, *The Boston Museum of Fine Arts*, 275; Beazley, in Burdett, Goddard, *E. P. Warren*, 358; Chase, *Antiquities*, 28, fig. 30; 2nd edition, 46, 58, fig. 41; *Handbook* 1964, 46f., illus.; D. Mitten, *BMFA* 65 (1967) 16f., figs. 16-18.

Froehner, *MonPiot* 2 (1895) 137-143, pl. 15; idem, *Collection Tyszkiewicz*, 40ff., pl. 45 (Sale Catalogue, 46f., pl. 13, no. 133); Farnell, *Cults of the Greek States*, IV, 329f., pl. 22; W. Lamb, *Greek and Roman Bronzes*, 74, pl. 20C; H. Goldman, *Festschrift James Loeb*, 71f., fig. 4; H. Koch, *Apollon und ''Apollines,''* 1ff., fig. 1; E. Kunze, *AM* 55 (1930) 160, note 1; Neugebauer, *Berlin Bronzes*, I, 62; Hampe, *Frühe Griechische Sagenbilder*, 36; Picard, *Manuel*, I, 136f., fig. 35; idem, *Les origines de l'art grec*, 248, fig. 592; V. Müller, *Frühe Plastik in Griechenland und Kleinasien*, 86; F. R. Grace, *Archaic Sculpture in Boeotia*, 49f., fig. 65; P. Knoblauch, *Studien zur archaischgriechischen Tonbildnerei in Kreta, Rhodos, Athen und Böotien*, 27; R. J. H. Jenkins, *Dedalica*, 27; S. Benton, *BSA* 40 (1939-40) 55 (under no. 33); Richter, *Kouroi*, 41, figs. 8-10; idem, *Kouroi*, 2nd edition, 26, figs. 9-11; S. Casson, *AJA* 39 (1935) 511ff., fig. 1 (inscription); D. K. Hill, *JWalt* 2 (1939) 25ff., figs. 4-5; idem, *Walters Bronzes*, 106, under no. 237 (found with it); *AJA* 44 (1940) 371; *FastiA* 5 (1950) no. 1203 cites G. Niebling, *Zeitschrift für Kunst* 2 (1948) 91-99, fig. 35; Pfeiff, *Apollon*, 23f., fig. 1, pl. 2; Lippold, *Handbuch*, 39; Matz, *Geschichte der Griechischen Kunst*, 157f., pl. 66; R. Lullies, M. Hirmer, *Greek Sculpture*, 24f., pl. 3; Richter, *Handbook of Greek Art*, 175, fig. 252; *Encyclopedia Universale del' Arte*, pl. 79; L. H. Jeffery, *The Local Scripts of Archaic Greece*, 46f., 90f., 94, pl. 7; M. Ervin, *Deltion* 18 (1963) 73; H. Karydi, *AA* 1964, col. 273; C. G. Starr, *The Origins of Greek Civilization*, pl. 20b; Barron, *Greek Sculpture*, 10f., illus.; *Arion* III, no. 4 (1964) cover; H. Jucker, *Kunstwerke der Antike in Bieler Privatbesitz*, 10 March 1962, 4; Bezerra de Meneses, *Dédalo, Revista de Arte e Arqueologia* 1 (1965) 23, fig. 1; D. E. Strong, *The Classical World* (New York and Toronto, 1965) 48, fig. 29; G. M. A. Hanfmann, *Classical Sculpture*, fig. 29, 305; Rolley, *Monumenta Graeca et Romana*, V, fasc. 1, 3, no. 31, pl. 8; M. Guarducci, *Epigrafia Greca*, I (Rome, 1967) 145-146, figs. 33a, 33b; G. Becatti, *The Art of Ancient Greece and Rome* (New York, 1967) 44f., fig. 30; G. Kaulen, *Daidalika* (Munich, 1967) 203, B 8 (and refs.).

Exhibited: Buffalo, *Master Bronzes*, no. 65, illus.

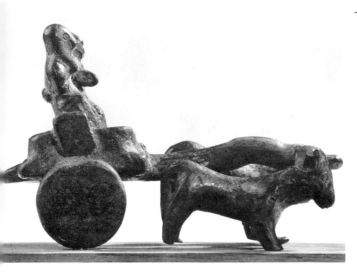

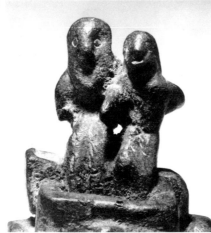

16 16

16

MAN AND WOMAN IN OXCART
Circa 600 B.C.
H.: 0.063m. L.: 0.107m.
John Michael Rodocanachi Fund 58.696
Found in Çesme, near Smyrna; probably part of a group of votive objects from a local sanctuary.

Shaft broken and repaired. Dark green patina, with some light green corrosion and earth encrustation.

A man and woman are seated in a cart. His left arm is extended toward the heavily yoked oxen; her left arm appears to be behind her back; his right forearm is missing. The cart has a right sideboard and an axle.

In publishing the examples from the Çesme find in the British Museum, D. E. L. Haynes made the tempting suggestion that the hoard of bronzes to which this example belonged might have been deposited at a shrine to the Asiatic goddess Cybele, and that this bronze (then lost), the man and woman in a cart, might turn out to be Cybele and her consort Attis. The other figurines included men ploughing, animals, fish, serpents, and mythological creatures (see also, Cambridge [Mass.], Fogg Art Museum, *Ancient Art in American Private Collections*, 30, nos. 193f.: the Morgenroth ploughing group, now in Berlin). Identification as Cybele and Attis seems obviated by the fact that the man turns out to be the larger figure and is bearded. Zeus and Hera come to mind as mythological alternatives, although the pair could be Zeus and Cybele. Both had cults well established among the Greeks of Lydia in the early sixth century B.C.

Without the mythological context, the pair could be merely a farmer and his spouse driving up to the shrine or off to market, as in the case of the group of four sheep (above, no. 4). The superficially Geometric quality of the group is to be attributed to primitive workmanship, not to early date. Haynes has pointed out that some of the mythological creatures, mermen, sphinxes and sirens, are too sophisticated for Greek art of an earlier period.

Zeus here has the large round eyes and spade beard of early Archaic art. The shape of his skull and nose recalls that of Herakles on the Nessos amphora in Athens, generally dated about 610 B.C.

Vermeule, *Ann. Rep.* 1958, 31; *idem, CJ* 55 (1960) 194f., fig. 2; *FastiA* 15 (1960) no. 671; Chase, *Antiquities*, 2nd edition, 47, 60, fig. 46.

On group: D. E. L. Haynes, *JHS* 72 (1952) 79f., with following references: G. Finlay's ms. *Num. Cat.*, 1864, 241, no. 9; H. P. Borrell Sale, Sotheby, 26 Aug. 1852, lot 1541; Purnell B. Purnell Sale, Stancombe Park, Glos., Sotheby, 8 May 1872, lot 628 (Schmidt). U. Gehrig, *Berliner Museen* N. F. 14 (1966) 3f., figs. 5, 6.

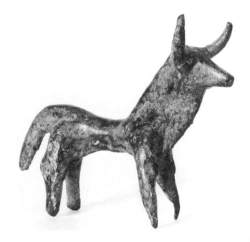

17

BULL
Circa 700 to 600 B.C.
L. (max.): 0.05m. H. (max.): 0.035m.
Bequest of Miss Laura K. Dalzell 67.282
Acquired in Greece.

Green patina with earth encrustation.
He is of a conventional type that marks a transition from Geometric to Archaic and may have been made in parts of Greece down to 500 B.C. Compare, for example, the series of votive animals illustrated in *Olympia* IV, pl. 10ff., especially nos. 120, 121, and 184, also the following.

Vermeule, *Ann. Rep.* 1967, 47; D. Mitten, *BMFA* 65 (1967) 10, fig. 9 and cover.

ArtQ 30 (1967) 266, 271, illus.

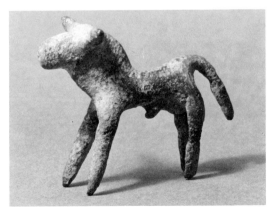

17

18

GREEK BOVINE WITH LONG HORNS
Circa 600 B.C.
H.: 0.061m.
Otis Norcross Fund 64.1461

Green patina, with slight corrosion.
Presumably a bull, this animal is a good specimen of a fairly common type of timeless bronze in the Geometric tradition. Usually these bulls are dated by the degree of naturalism involved, and they were certainly made in rural Greece as late as the end of the Archaic period. Examples found at Olympia come from the altar area southwest of the Metroon (Neugebauer, Berlin *Bronzes*, 42, no. 100, pl. 12; *Olympia* IV [*Bronzen*], pl. 11, nos. 165, 166).
For various very sound reasons, D. K. Hill has dated a somewhat earlier, certainly more "Geometric" bull in Baltimore around 700 B.C. (*AJA* 59 [1955] 41, 43, pl. 30, 10). This animal, therefore, might well be as late as 600 B.C., or even the sixth century. Since these animals are often found in groups, a wealthy farmer might very probably dedicate a number of them at a local shrine, for the propagation of his herds.

Vermeule, *Ann. Rep.* 1964, 32; *idem, CJ* 61 (1966) 295, 292, fig. 6; D. Mitten, *BMFA* 65 (1967) 10, fig. 8 and cover.

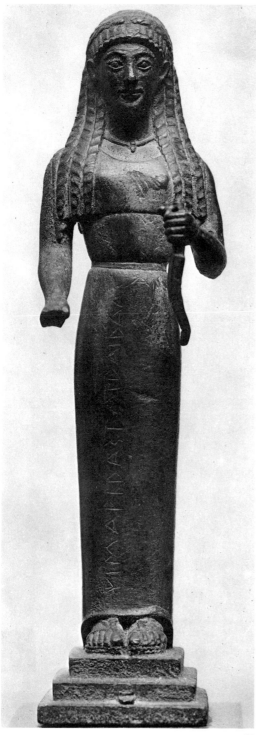

19

ARTEMIS

Circa 525 B.C.

H. (with plinth): 0.192m. (of figure): 0.176m.

H. L. Pierce Fund 98.658

E. P. Warren Collection; Tyszkiewicz Collection.

From Mazi, near Olympia.

Part of bow and fingers of right hand are missing. There is also a hole in the left hand, beside the bow; it is possibly for an arrow.

The goddess stands on a plinth of three steps. The inscription is incised on the front of the chiton. (See photograph.)

Dedicated by Chimarides to Artemis Daidale, this statuette has been identified as Laconian on the grounds of style and the neat Laconian lettering. Her way of wearing the peplos, with the full skirt brought around the back in pleats, was fashionable in the Peloponnesus at the time when Athenians were producing the Peplos Kore, circa 540 to 530 B.C. (no. 679; Payne, *Archaic Marble Sculpture*, pls. 29-33). The same costume is found in various small bronzes, both earlier and later in style, that are thought to have been made in or by Laconians. Arrangement of the hair and braids, and the cast of the face, are paralleled in silver appliqué heads of goddesses found at Tarentum, produced at this period in the Laconian tradition.

E. Robinson, *Ann. Rep.* 1898, 26ff.; *AA* 1899, 136; *AJA* 3 (1899) 569; *BMFA* 1 (1903) 15; J. Addison, *The Boston Museum of Fine Arts*, 275; Chase, *Antiquities*, 29f., fig. 33; 2nd edition, 47, 60, fig. 44; H. Palmer, C. Vermeule, *Archaeology* 12 (1959) 3, illus.; *Handbook* 1964, 50f., illus.

Furtwängler, *Neue Denkmäler antiker Kunst*, 57, 3f., fig. 5; Reinach, *Rép. stat.*, III, 93, 5; *ibid.*, IV, 183, 10; Froehner, Tyszkiewicz Sale, *Catalogue*, 50f., pl. 15, no. 139; *AJA* 5 (1901) 230; Furtwängler, *Kleine Schriften*, II, 463f., fig. 5; Neugebauer, *Antike Bronzestatuetten*, 43ff., 128, pls. 18f.; V. Müller, *AM* 46 (1921) 52; E. Langlotz, *Frühgriechische Bildhauerschulen*, 87, no. 27, pls. 44, 47; Lamb, *Greek and Roman Bronzes*, 90, pl. 35d; Picard, *Manuel*, I, 503, fig. 160; Lippold, *Handbuch*, 24, note 3; E. Meyer, *Neue peloponnesische Wanderungen* (1957) 46; Charbonneaux, *Les bronzes grecs*, 69f., pl. 7, 2; idem, *Greek Bronzes*, 90, pl. 7,

2; Jeffery, *Local Scripts of Archaic Greece*, 191, 202, pl. 39; M. Gjødesen, *AJA* 67 (1963) 342; Tsirivaku-Neumann, *AM* 79 (1964) 117; Richter, *Korai* (London, 1968) 65-66, 87, 97, 319, no. 144, figs. 456-459.

Exhibited: Buffalo, *Master Bronzes*, no. 66, illus.; Detroit, *Small Bronzes of the Ancient World*, 9, no. 57, 30, illus.

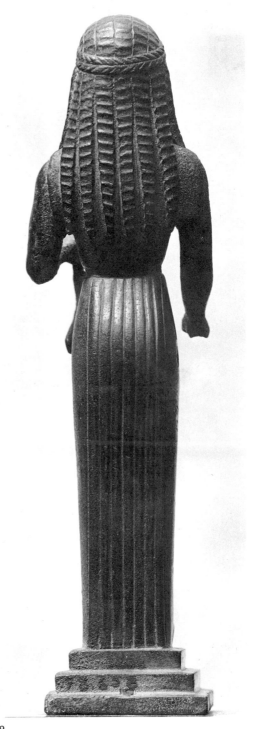

19

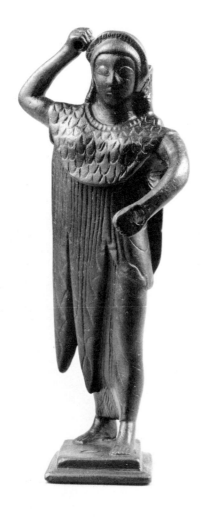

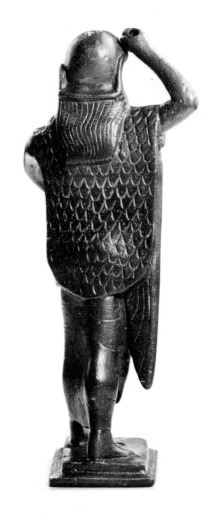

20

20

20

Athena Promachos
Circa 510 to 500 b.c.
h.: 0.106m.
William E. Nickerson Fund No. 2 54.145
Vivès Collection, Madrid; Ramis y Ramis
Collection, Minorca.
Found on Minorca, before 1833.

Spear (in right hand), shield (on left) and crest of helmet, also cast separately, missing.

Athena stands on a rectangular, two-part base. She wears an ample aegis over the long overfold of her chiton.

This is one of the three or four most important works of Greek art found in Spain. At first glance one might say that the Athena was a provincial imitation of Attic art, but this is a superficial impression created by the tubular shape of the limbs and the deep, decisive incision of aegis, chiton and himation.

The closest parallel for the bronze, in fact its twin in every respect, is an example found on the Acropolis in Athens and preserved in the National Museum (De Ridder, Acropolis *Bronzes*, 306f., no. 789, fig. 295 = Nat. Mus. no. 6456; see also De Ridder, 302, no. 783, fig. 290). The next closest piece in every respect is the Athena Promachos in the Oppermann collection in the Bibliothèque Nationale, Paris; this bronze was also found on the Athenian Acropolis, in 1836 (Babelon-Blanchet, *Bronzes*, 68, no. 149). One is led to the conclusion that the Athena from Minorca was made in Athens and exported westward at some subsequent date. The figure is the counterpart in bronze of the Athena, trademark of the city, on Panathenaic amphorae of the late Archaic and Classical periods. This group of bronzes probably copies the late Archaic Athena Promachos destroyed by the Persians when they sacked the Acropolis in 480 B.C.

BMFA 52 (1954) 74; *FastiA* 9 (1954) nos. 302, 308; H. Palmer, *Ann. Rep. 1954*, 6; Vermeule, *CJ* 55 (1960) 195f., fig. 3; *FastiA* 15 (1960) nos. 671, 1333; *Handbook 1964*, 56f., illus.

A. García y Bellido, *Los Hallazgos griegos de España*, 52f., no. 13, pls. 24, 25; *idem, Hispania Graeca*, II, 100f., pl. 31; *idem, AEArq* 33 (1960) 156-157, 2 figs.; H. G. Niemeyer, *Promachos*, 27ff., fig. 6; *idem, Antike Plastik*, III, 10, 12, 18; C. Rolley, *RA* 1968, 40ff., figs. 14-16.

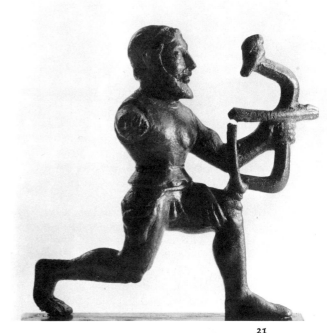

21

21

HERAKLES SHOOTING HIS BOW
Circa 550 B.C.
H.: 0.07m. L. (at bottom): 0.063m.
H. L. Pierce Fund 98.657
E. P. Warren Collection.
From Macedonia, near Amphipolis.

Right arm and hand, and part of bow-string missing. Dark greenish brown patina.

Ornament from the rim of a vessel (?); the place of attachment on the left side shows that the figure was to be seen in profile to the right and was applied to a curved surface.

Herakles is in the archaic running, kneeling posture. The hero is bearded and wears a tight-fitting cloth cap (or his hair in a rolled fillet) and a small cuirass with cloth belt around the waist. His lion's skin is worn as a tunic *under* the cuirass, the animal's head coming down on the right thigh and the paws on the left.

E. Robinson, *Ann. Rep. 1898*, 26; *AA* 1899, 136; G. H. Chase, *Greek Gods and Heroes*, 61, fig. 64; 1962 edition, 78, 80, fig. 67.

HERMES KRIOPHOROS
520 to 510 B.C.
H.: 0.167m.
H. L. Pierce Fund 04.6
E. P. Warren Collection.
From Arcadia.

Hermes's left foot, the left hind foot of the ram, and the kerykeion in the god's right hand are missing. Greenish gray patina.

He is bearded, with tight curls over the forehead. He wears a broad-brimmed pilos, close-fitting chiton with incised fringe around the neck and belt around the waist, and heavy boots. He holds a young ram under the left arm and extends the right.

The recognized close parallel to this Hermes is the Hermes-shepherd in the Stathatos collection (Kunze, *loc. cit.*; D. K. Hill, *loc. cit.*). The presence of the small ram in the god's left hand, as well as the iconographic similarity to no. 23, indicate this Hermes is a votive offering to the god as protector of flocks. Unlike the following presentation of Hermes, the wings on the feet are not shown. That these bronzes represent the god of flocks and the herald of the gods rather than merely a shepherd is evident by comparison with the Watkins shepherd from Haghios Sostis in Arcadia (Cambridge [Mass.], Fogg Art Museum, *Ancient Art in American Private Collections*, 31, no. 211, pl. 65; D. G. Mitten, Fogg Art Museum *Newsletter*, vol. 3, no. 3 [Feb. 1966] 3f., 2 figs.; Mitten-Doeringer, *Master Bronzes*, 61, no. 48, illus.).

B. H. Hill, *Ann. Rep.* 1904, 57; *AJA* 9 (1905) 369; *AA* 1906, col. 261; Beazley in Burdett, Goddard, *E. P. Warren*, 358, illus. opposite 218; *Handbook* 1964, 54f., illus.

Neugebauer, *AA* 1922, col. 72; Langlotz, *Frühgriechische Bildhauerschulen*, 31, pl. 20a; Reinach, *Rép. stat.*, IV, 96, 4; Lamb, *BSA* 27 (1925-26) 137, no. 4; Neugebauer, Berlin *Bronzes*, I, 68; Kunze, *BWPr* 109, 1953, 9f., figs. 1, 2; D. K. Hill, *Gnomon* 27 (1955) 34; Richter, *AJA* 62 (1958) 236.

Exhibited: Detroit, *Small Bronzes of the Ancient World*, 10, no. 60, 33, illus.; Cambridge (Mass.), Fogg Art Museum, *Greek Art and Life*, no. 8.

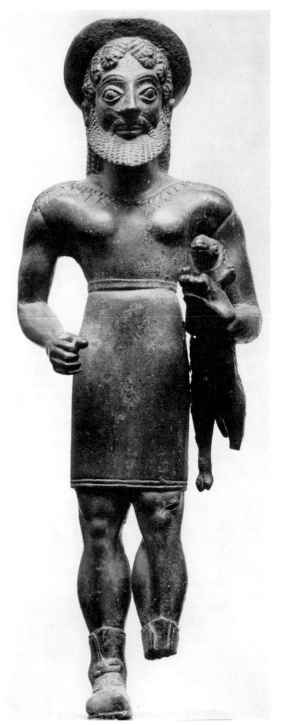

22

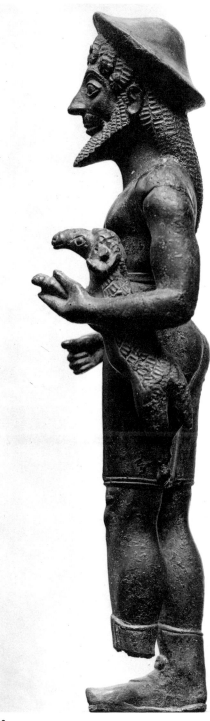

22

HERMES KRIOPHOROS
520 to 510 B.C.
H.: 0.25m.
H. L. Pierce Fund 99.489
E. P. Warren Collection.
From Sparta.

A hole is drilled through the right hand; the greater part of the wing on the right foot is missing. Remains of four metal tangs for attachment into another base have been filed down. E. P. Warren thought these were feet but they seem to have been too thin for this. There are two flat plates on the hollowed out inside of the base for attaching the plinth to the feet. These have been pierced in modern times with threading in connection with the present mounting on a wooden block. Thin patina of green and brown.

As with the previous, the kerykeion was held in the right hand. Several persons have held that this is a Roman (Archaistic) bronze because of its smooth grasp of all the Archaic elements. It has even been suggested that, like the Hermes Propylaeus of Alkamenes, it is a work of about 440 B.C. in the Archaic tradition. Most critics, however, accept this statuette as work of a very refined master in the last years of the sixth century B.C.

E. Robinson, *Ann. Rep.* 1899, 36f.; *AA* 1900, 217; *AJA* 4 (1900) 510; *BMFA* 1 (1903) 15; Chase, *Greek and Roman Sculpture in American Collections*, 21, fig. 23; idem, *Greek Gods and Heroes*, 37f., fig. 33; 1962 edition, 50f., fig. 38; idem, *Antiquities*, 29, fig. 32; 2nd edition, 47, 59, fig. 43; Beazley in Burdett, Goddard, *E. P. Warren*, 358; *Museum of Fine Arts, Boston, Western Art* (Japanese edition, Tokyo, 1969) pl. 12, 152, no. 12; W. Whitehill, *Museum of Fine Arts, Boston, A Centennial History* (Cambridge [Mass.], 1970) 160, illus.

Bulle, *Schöne Mensch*, col. 82, pl. 38; Neugebauer, *AA* 1922, col. 72; idem, Berlin *Bronzes*, I, 68; Reinach, *Rép. stat.*, IV, 96, 3; H. Licht, *Sittengeschichte Griechenlands*, I, 216, illus.; Lamb, *BSA* 27 (1925-26) 137, note 1; Langlotz, *Frühgriechische Bildhauerschulen*, 31, no. 27, pl. 2; Lamb, *Greek and Roman Bronzes*, 223, pl. 88b; Byvanck, *De Kunst der oudheid*, II, 412, pl. 104, fig. 401; Richter, *Archaic Greek Art*, 150, fig. 236;

idem, AJA 62 (1958) 236; *idem, Handbook of Greek Art,* 178f., fig. 263; Agard, *Classical Myths in Sculpture,* 28, fig. 14; Kunze, *BWPr* 109, 1953, 9f., figs. 3, 4; Hill, *Gnomon* 27 (1955) 34; E. Simon, *Charites, Studien zur Altertumswissenschaft* (ed. K. Schauenburg, Bonn, 1957) 40, note 18; Charbonneaux, *Les bronzes grecs,* 72, 74; *idem, Greek Bronzes,* 93ff. (dated 520-510); J. H. Young, *AJA* 64 (1960) 293; Eckstein, *Gnomon* 33 (1961) 404; Chittenden, *AJA* 66 (1962) 110; B. S. Ridgway, *Antike Plastik* 7 (1967) 59 and note 107; E. Homann-Wedeking, *The Art of Archaic Greece* (trans. by J. R. Foster, New York, 1968) 143, 146, illus.

Exhibited: Buffalo, *Master Bronzes,* no. 69, illus.; Basel Exhibition, 1959, no. 180, 178, 181, illus.

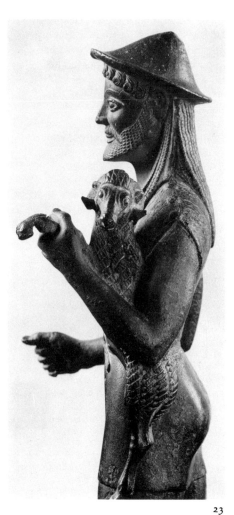

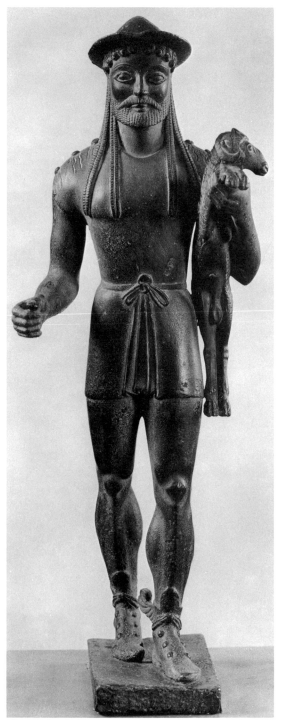

23 23

HERM

About 500 B.C.

H.: 0.09m.

Gift (Subject of Life Interest) of Norbert Schimmel

George Ortiz Collection; E. Langlotz Collection; E. P. Warren Collection; Zogheb Collection.

Found at Haghios Sostis, near Tegea in Arcadia, together with the bronzes Berlin 166-174.

Rich, even green patina. Pit-marks from casting. The rectangular plinth is slightly bent at the corners and is broken off at the right edge. There is a hole through the left arm of the herm.

Bearded, ithyphallic herm on a flat, rectangular base with one step. The eyes are deeply set; the hair and beard are rendered by vertical fluting.

This masterpiece belongs to the earliest group of herms. They begin at the end of the sixth century, probably under the influence of Hipparchos, who, in the years about 520, placed many herms on the roads leading to Athens.

Another, also late Archaic but in a slightly more Ionic style, is in the Istanbul Museum. The counterpart in marble is Athens, Agora, no. 3728, which is one-third lifesize. Other miniature herms in bronze and terracotta have been found in the Agora.

H. Licht, *Sittengeschichte Griechenlands*, I, 217, illus.; E. Langlotz, *Frühgriechische Bildhauerschulen*, 81, pl. 41c; R. Lullies, *Die Typen der griechischen Herme*, 13, 1; Crome, *AM* 60-61 (1935-36) 303, note 3, pl. 107; Monnaies et Médailles, Basel, Vente Publique XI (1953) no. 293, pl. 10; Eckstein, *Gnomon* 31 (1959) 646; D. G. Mitten, *Antichità viva*, no. 3 (1965) fig. 14; idem, Fogg Art Museum *Newsletter*, 3, no. 3 (Feb. 1966) 3f.

Exhibited: Cambridge (Mass.), Fogg Art Museum, *Ancient Art in American Private Collections*, 31, no. 210, pl. 62; Basel Exhibition, 1959, 221-222, no. 251, illus.; Cambridge (Mass.), Fogg Art Museum, *Norbert Schimmel Collection*, no. 14, 2 illus.

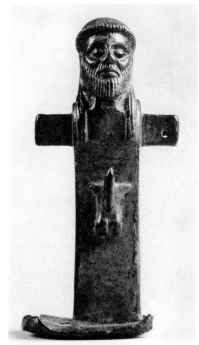

24

24

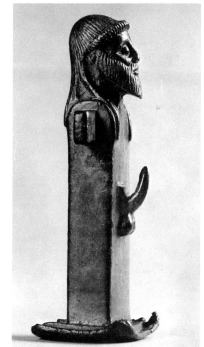

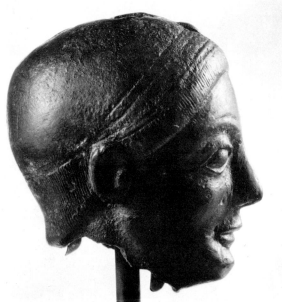

HEAD OF A YOUTH
Circa 540 B.C.
H.: 0.069m.
Perkins Collection 95.74
E. P. Warren Collection.
Bought in Athens; said to have been found at Sparta.

The point of the cap or helmet is missing. Greenish, brown patina.

This head from a small statue of a young warrior is hollow cast, with a vent or pour hole above the forehead. Its Laconian characteristics of ovoid shape, large eyes, and strong nose are also found in a bronze in the Louvre (De Ridder, Louvre *Bronzes*, I, 30, no. 156, pl. 17) from Sparta and a nude Spartan girl in Vienna (Homann-Wedeking, *loc. cit.*). See also the head in Kassel (Möbius, *ArchEph* 1937, 374ff.).

25

E. Robinson, *Ann. Rep.* 1895, 25; *AA* 1896, 97; *BMFA* 1 (1903) 15; Beazley in Burdett, Goddard, *E. P. Warren*, 358.

Furtwängler, *Neue Denkmäler*, I, 112ff., pl. 1; idem, *Kleine Schriften*, II, 429f., pl. 44; *AJA* 3 (1899) 290; Langlotz, *Frühgriechische Bildhauerschulen*, 88, pl. 53d, e; Lamb, *Greek and Roman Bronzes*, 91; Picard, *Manuel*, I, 454f., fig. 130; Ashmole, *Greek Sculpture in Sicily and South Italy*, 11, pl. 1, 5, 3; Wace, *An Approach to Greek Sculpture*, 18; H. Möbius, *ArchEph* 1937, 375; M. Gjødesen, *ActaA* 15 (1944) 180, note 64; Hill, *Walters Bronzes*, xiii, xxxiv, notes 22, 23; Richter, *Archaic Greek Art*, 88, figs. 151-152; Buschor, *Frühgriechische Jünglinge*, 85ff., figs. 95f.; Lippold, *Handbuch*, 32, and note 16; Homann-Wedeking, *Antike und Abendland* 7 (1958) 65ff., pl. B, fig. 3a and cover; de Luca, *ArchCl* 11 (1959) 24, pl. 16, 4; Charbonneaux, *Les bronzes grecs*, 9; idem, *Greek Bronzes*, 26; N. Himmelmann-Wildschütz, *JdI* 80 (1965) 128ff. (ca. 530 B.C.); E. Kunze, *V. Bericht über die Ausgrabung in Olympia* (Berlin, 1956), 98ff.; G. Kaulen, *Daidalika* (Munich, 1967) 201, B5.

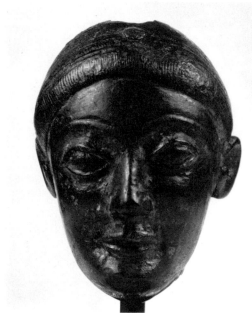

25

YOUTH

Circa 540 B.C.

H.: 0.095m. (including plinth and projection);
0.085m. (without projection)
Frederick Brown Fund 34.211
Found at Pheneos in Arcadia.

Right arm is missing.

He is standing on a small plinth, with right
foot advanced and left hand on hip. He wears
a short tunic belted at the waist, ornamented
with a zigzag pattern at the neck, and with
short sleeves. His hair, bound with a fillet, falls
down the back in a triangular mass. On the
underside of the plinth there is a rectangular
projection, perforated near the top and de-
signed to be fastened into the base by means
of a pin or dowel.

A replica of this statuette, classified by
Langlotz as Spartan, was once in the posses-
sion of Humfry Payne. Langlotz suggested
that it was designed to be seen in profile, and
that it may have belonged to a larger votive
offering with several walking figures. In 1963
there was another replica (or perhaps Humfry
Payne's) in the Art Market in Athens. This
example seems to be a forgery, made after
the Boston or a similar piece.

L. D. Caskey, *BMFA* 34 (1936) 53f., 2 illus.; *idem,*
AJA 40 (1936) 309f., fig. 3.

Lippold, *Handbuch,* 89f., note 15.

Exhibited: Andover, (Mass.), *Classical Art.*

27

YOUTH

Circa 540 B.C.

H.: 0.166m.

Francis Bartlett Collection 03.996
E. P. Warren Collection.
From Olympia.

Only the accessories or attributes are missing.
Brownish patina with blue and green encrusta-
tion. The statue stands on a rectangular foot-
plinth, with two holes at opposite corners for
fastening to a small base.

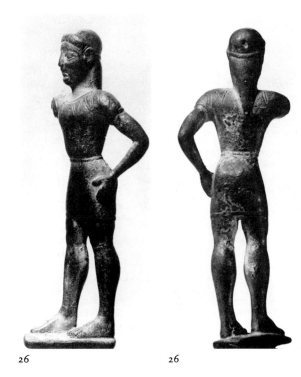

26 26

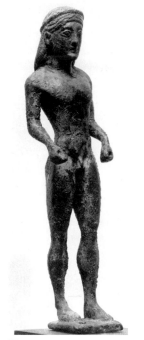
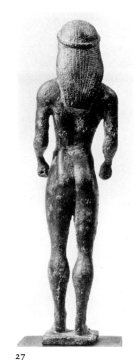

27 27

The youth recalls Attic kouroi, but his large, broad head and sloped-back shoulders, the generally top-heavy effect, suggest work in a neighboring Peloponnesian center. Payne spoke for Corinth; Langlotz connected him with Kleonai; and Furtwängler compared him to the "Apollo" of Tenea.

B. H. Hill, *Ann. Rep.* 1903, 60; *AA* 1904, 194; *AJA* 8 (1904) 382; *BMFA* 2 (1904) 6; Chase, *Antiquities*, 28f., fig. 31; 2nd edition, 46f., 58, fig. 42; Vermeule, *AJA* 63 (1959) 147.

Reinach, *Rép. stat.*, II, 783, 4; *idem*, IV, 42, 7; Furtwängler, *Neue Denkmaler*, I, 118-122, pl. 2; *idem, Kleine Schriften*, II, 433ff., pl. 44, 1; *AJA* 3 (1899) 290; Deonna, *Les Apollons archaïques*, 272, no. 93; Buschor, Hamann, *Die Skulpturen des Zeustempels zu Olympia*, 33; Langlotz, *Frühgriechische Bildhauerschulen*, 69, 74, pl. 35a; Neugebauer, Berlin *Bronzes*, I, 74; Payne, *Necrocorinthia*, 219, 238; Raubitschek, *BIABulg* 12 (1938) 132f.; Richter, *Kouroi*, 24, 142f., no. 62, pl. 55, figs. 198-200; *idem*, 2nd edition, 86, no. 76, figs. 261-263; Hill, *Walters Bronzes*, 79f., under no. 172; Lippold, *Handbuch*, 28, note 2; D. von Bothmer, *Ancient Art from New York Private Collections*, 34, under no. 133; Buschor, *Frühgriechische Jünglinge*, 86ff., figs. 101f., publishes him as in Athens, National Museum; Worcester Art Museum, *Masterpieces of Etruscan Art*, 26, under no. 11; W. Hermann, *RM* 73-74 (1966-67) 242.

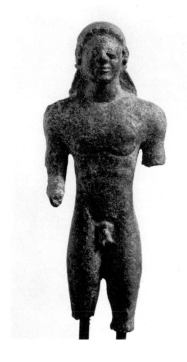

28

28

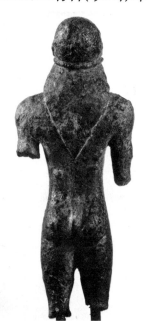

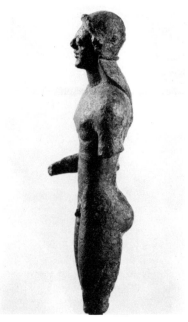

28

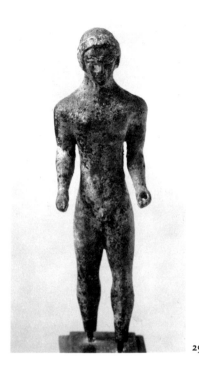

29

29

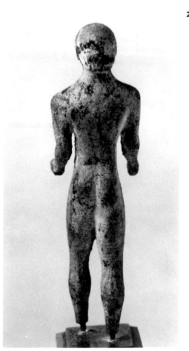

YOUTH
Circa 530 B.C.
H.: 0.098m.
H. L. Pierce Fund 99.488
E. P. Warren Collection.
Bought in Athens.

Right hand, left arm from above elbow and both legs from knee are missing. Surface somewhat corroded. Dark green patina with lumps from casting.

The hair of this kouros is arranged in one row of tight curls over the forehead. It is tied with a straight fillet across the lower back of the head and is arranged in a deep V plait down the back.

The high, prominent chest muscles, thin body, and prominent profile of the buttocks suggest Attic or near-Attic work in the "Melos Group" of kouroi (compare Richter, *Kouroi*, 2nd edition, no. 109: head from Thasos; no. 116: from Paros; etc.).

E. Robinson, *Ann. Rep. 1899*, 35f.; *AA 1900*, 217; *AJA* 4 (1900) 510.

29

YOUTH OR APOLLO (?)
510 to 500 B.C.
H.: 0.11m.
Purchased by Contribution 01.7481
E. P. Warren Collection; Forman Collection.

Both feet are missing. Corroded. Dark green patina.

There was an attribute or similar object in the left hand, for it is grasped around a circular hole. The right hand may have held something with a slightly thinner shaft. A bow and arrow comes to mind. The hair is bound by a fillet around the crown and is caught up in a double loop behind.

Perhaps from one of the eastern islands (Samos?).

E. Robinson, *Ann. Rep. 1901*, 36; *AA 1902*, 131; *AJA* 6 (1902) 377.
Forman Sale II.

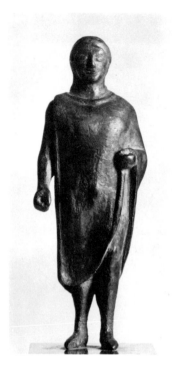

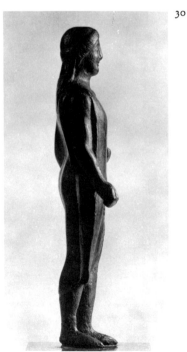

YOUTH

Circa 500 B.C.

H.: 0.091m.

Harriet Otis Cruft Fund 66.251

Capt. E. G. Spencer-Churchill Collection.
Bought in Paris, 1928.

Smooth green patina. Slight brown
encrustation.

He wears a long chlamys and pointed foot-
gear. Probably he held a bow in his lowered
right hand, an arrow in his left. He may repre-
sent the god Apollo, or a youth offering these
objects to the divinity. The hair, tied with a
fillet, is arranged in back in the long, pleated
fashion of eastern kouroi. He has the broad
(eastern) face characteristic of the sculptures
from the Heraion on Samos in the years after
550 B.C. The proud stance, broad chest, strong
buttocks and forcefully-modelled arms are
the essence of Ionian sophistication.

Vermeule, *Ann. Rep.* 1966, 54, 34, illus.; *idem,
CJ* 62 (1966) 102f., fig. 10.

Northwick Park Collection, Antiquities, Lot 473
(as Etruscan).

Exhibited: Cambridge (Mass.), Fogg Art Museum,
Master Bronzes, no. 52.

30

30

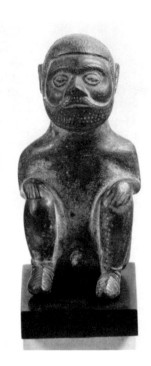

31

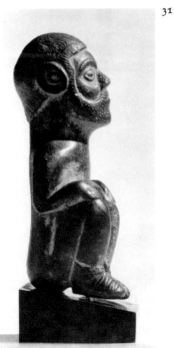

31

MAN SQUATTING ON HIS HEELS
500 to 490 B.C.
H.: 0.063m.
Purchased by Contribution 01.7477
E. P. Warren Collection.
Bought in London; said to come from
Vodhena, Macedonia.

Dark green patina. A hole in the bottom of the
figure is partly filled with lead to accommo-
date the modern pin for mounting.

The hair is incised, and the beard is shown
by punctured dots.

Although unusual, such men exist in terra-
cotta, as an example in the National Museum,
Athens, or the satyrs in the British Museum
(R. A. Higgins, *Catalogue of the Terracottas*,
I, 74, nos. 161-165, pl. 31, from various
areas). One in the Sparta Museum comes from
the sanctuary of Artemis Orthia.

E. Robinson, *Ann. Rep.* 1901, 36; *AA* 1902, 131;
AJA 6 (1902) 377.

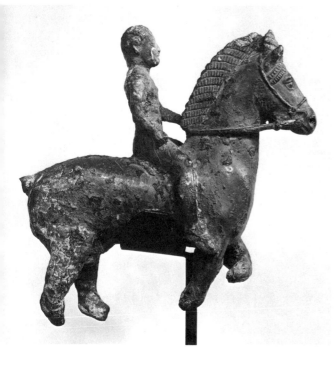

YOUTH ON HORSEBACK
Circa 525 B.C.
H.: 0.115m. L.: 0.124m.
Francis Bartlett Collection 03.993
E. P. Warren Collection.
Bought in London; from Mantineia.

Feet and tail of horse, left foot of youth, and object held in right hand are missing. Olive-green patina. Some corrosion.

The youth is nude and rides with his bridle in the left hand, right hand on his thigh.

Despite the obvious desire to classify this as a Peloponnesian bronze, it is worth noting a comparable statuette was found in a well below the Acropolis in Athens (*ILN*, 28 Aug. 1937, 360, fig. 1; O. Broneer, *Hesperia* 7 [1938] 203-208, figs. 38-40). The example in Princeton, dated in the early fifth century, appears to come from the rim or lid of a large lebes or cauldron.

B. H. Hill, *Ann. Rep.* 1903, 60; *AA* 1904, 194; *AJA* 8 (1904) 382; *BMFA* 2 (1904) 6; J. Addison, *The Boston Museum of Fine Arts*, 275; M. Comstock, C. Vermeule, *Apollo*, December, 1969, 468-469, figs. 2-3.

Reinach, *Rép. stat.*, IV, 338, 3; Jantzen, *Bronze-werkstätten*, 72, pl. 37, 152; *Olympiabericht* 3 (1938-39) 141, note 3; F. F. Jones, *Ancient Art in the Art Museum, Princeton University*, 38f., under no. 48-8; Mitten-Doeringer, *Master Bronzes*, under no. 58.

32 32

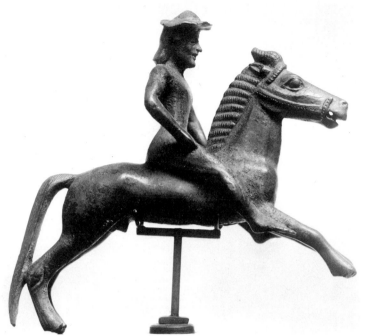
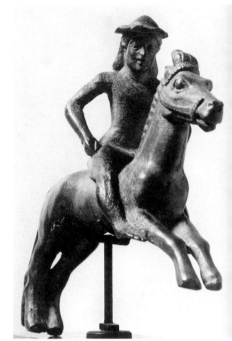

33 33

33

YOUTH ON GALLOPING HORSE
Circa 520 B.C.
H.: 0.10m. L.: 0.112m.
H. L. Pierce Fund 98.659
E. P. Warren Collection.
Bought in Athens; said to have been found in Thessaly.

Feet of horse and reins are missing. The left hand of the rider and the horse's mouth are pierced to hold the reins. Lustrous light green patina.

He wears a floppy petasos and perhaps a close-fitting chiton, with a form of trousers over the foreparts of the legs. The horse's bridle shows the leather stitching elaborately represented by incised dots.

The Olympia excavators imply, by comparison, that this statuette came out of a Corinthian workshop. It could be work of an atelier in Leukas, Corinth's leading colony on the western mainland.

E. Robinson, *Ann. Rep. 1898*, 28; *AA* 1899, 137; *AJA* 3 (1899) 570; *BMFA* 1 (1903) 15; Vermeule, *BMFA* 64 (1966) 131f., fig. 11; *idem, Antike Plastik* 8 (1968) 10, figs. 7-9.

Reinach, *Rép. stat.*, IV, 337, 1; *Olympiabericht* 3 (1938-39) 141, note 3; *FastiA* 12 (1957) no. 297; Glubok, *The Art of Ancient Greece*, 28, illus.; D. G. Mitten, S. F. Doeringer, *Fogg Art Museum Acquisitions 1968*, Harvard University, Cambridge, 1969, 40.

Exhibited: Buffalo, *Master Bronzes*, no. 67, illus.; Fort Worth (Texas), *Horse and Rider*, no. 101, illus.

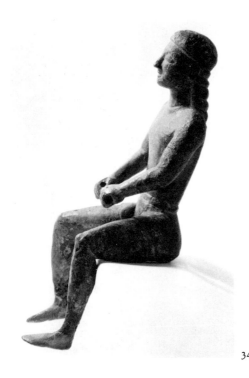

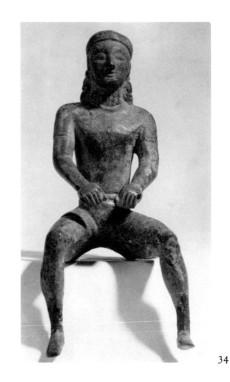

34

34

34

34

34

HORSEMAN
Circa 540 B.C.
H.: 0.154m.
Purchased by Contribution 01.7486
E. P. Warren Collection; Forman Collection.
From Grumentum in Lucania.

The hands were pierced for the reins. The feet
have been restored. Pale green patina.

He wears a tight cap over his long plaits of
hair (which fall down on his shoulders), and
a tight chiton with short sleeves and short
trousers. There is a belt around his waist.

Compare De Ridder, Acropolis *Bronzes*,
277f., no. 752, fig. 260 and, especially, *idem*,
Société archéologique d'Athènes *Bronzes*,
156, no. 860, pl. 2 (from near Sparta-Megalop-
olis). Also the inscribed statue found in a
well on the North Slope of the Acropolis: see
above, under no. 32, also Richter, *Archaic
Greek Art*, 75, fig. 117, with sharper, more
Ionian features in profile; more pointed, Ori-

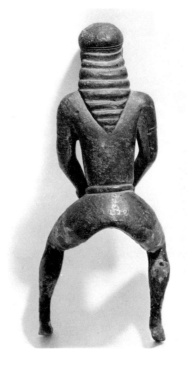

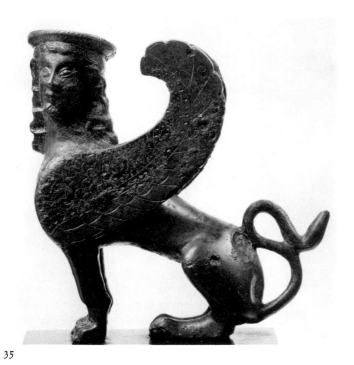

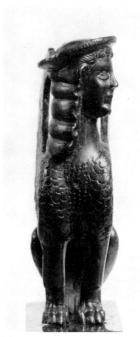

35

35

ental Greek features are contrasted in the horseless rider from Samos: *loc. cit.*, 169, figs. 257f., which also has a somewhat eastern headdress.

E. Robinson, *Ann. Rep.* 1901, 36; *AA* 1902, 131; *AJA* 6 (1902) 377.

Smith, Forman Sale I, *Catalogue*, 7, lot 54 (with alleged earlier history), pl. 2, cites: Braun, *Annali dell' Inst.* 1853, 113; *Mon. dell' Inst.* 1853 (V) pl. 50; Reinach, *Rép. stat.*, II, 533; Duruy, *Hist. Rom.* I, 595. Jantzen, *Bronzewerkstätten*, 26 (Tarentine workshop).

35

SPHINX

Circa 540 B.C.

H.: 0.082m.

Frederick Brown Fund 51.2469

Prof. Vladimir G. Simkhovitch Collection.

Dark green patina, with some corrosion and encrustation.

The sphinx wears a flat petasos. Feathers are represented by lines and dots of incision.

This sphinx can be linked with two examples in Baltimore (Hill, Walters *Bronzes*, 122, nos. 280-281, pl. 54), from the Lambros and Dattari Sale (1912, nos. 206, 208) and thus said to come from Cumae. This example may be Lambros-Dattari no. 207. Miss Hill observes that they stood on a curved surface, perhaps the rim of a bowl. Compare also the earlier example from Perachora: Richter, *Archaic Greek Art*, 83, figs. 143f.

G. H. Chase, *Ann. Rep.* 1951, 30; *idem*, *BMFA* 50 (1952) 27-29, fig. 1; *FastiA* 7 (1952) no. 1102.

36

36

GRIFFIN

Circa 625 B.C.

H.: 0.107m. L.: 0.068m.

Gift of E. P. Warren 96.665

From Elis, perhaps from Palaeopolis.

Right eye missing, as is the left foot. The left eye may be missing also, or else is encrusted. Encrusted. Green patina.

The feathers of the wings are represented by incised lines and patterns.

Besides the comparable griffin found at Olympia (Furtwängler, *Olympia* IV, pl. 48, no. 818 = Reinach, *Rép. stat.*, II, 698, 6), another example has found its way to the Bibliothèque Nationale (Babelon-Blanchet, *Bronzes*, 337f., no. 774).

These pleasant, walking animals, with their mighty nose-warts or globes above the beak, are examples of the developed iconography of the griffin at the outset of the archaic period. That they circulated freely around Greece and Anatolia at this time and in the following century is evidenced by the griffins preceding horsemen on the painted terracotta plaques of a building complex near Düver in Phrygia, in southwest Turkey (*JHS, Archaeological Reports for 1964-65*, 65ff., figs. 4f).

E. Robinson, *Ann. Rep. 1896*, 29; *AA 1897*, 73.
Reinach, *Rép. stat.*, IV, 442, 2; *Olympiabericht* 2 (1937-38) 118, note 2.

37

BOVINE

Greek (Anatolian), 600 to 500 B.C.

L.: (max.): 0.058m.

Gift of Richard R. Wagner 65.1343

From Istanbul.

Very dark green patina, with brown encrustation.

He has pointed horns, heavy and pointed legs, and a stubby tail curving into the body.

Compare, also from Asia Minor: Ars Antiqua Sale, IV, Lucerne, 7 Dec. 1962, no. 88, pl. 32, and ref. (dated too early).

Vermeule, *Ann. Rep. 1965*, 68.

38

BOVINE

Greek (Anatolian), 600 to 400 B.C.

L. (max.): 0.065m.

Gift of Richard R. Wagner 65.1342

From Istanbul.

Very dark green patina, with brown encrustation.

He is standing, with stubby legs, short tail, and thick, conical horns.

Vermeule, *Ann. Rep. 1965*, 68.

39

38

37

39

FRAGMENT OF A LIMESTONE PEDESTAL IN THE SHAPE OF A CAPITAL

Archaic, circa 500 to 490 B.C.

L.: 0.235m. W.: 0.15m. Bronze plate;

L.: 0.075m. W.: 0.045m.

H. L. Pierce Fund 01.8214

E. P. Warren Collection.

Found at Taranto proper.

The limestone pedestal is broken on one short side. Green patina with brown spots and earth encrustation on the bronze plaque.

This is part of a pedestal with widely projecting top and concave sides. In the top there is a bronze plinth which probably supported a statuette. There is an incised inscription:

ΠΟΛΥΛΟΣ ΑΝΕΘΕΚΗ
ΕΥΠΙΔΑΣ ΕΠΟΙΕ

"Polylos dedicated it. Eupidas made it."

For comparable pieces, see De Ridder, Acropolis *Bronzes*, nos. 575-613.

E. Robinson, *Ann. Rep. 1901*, 36.

Wuilleumier, *Tarente*, 657, note 1; D. K. Hill, Walters *Bronzes*, xxxvii, note 71; Jeffery, *The Local Scripts of Archaic Greece*, 281, 284, no. 4, pl. 53; D. K. Hill, *The Muses at Work*, ed. by C. Roebuck (Cambridge, Mass., 1969) 77-79, figs. 6-7.

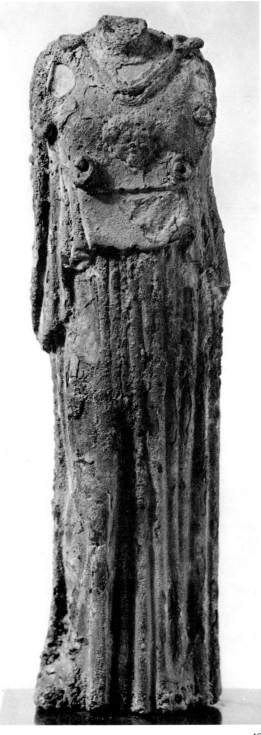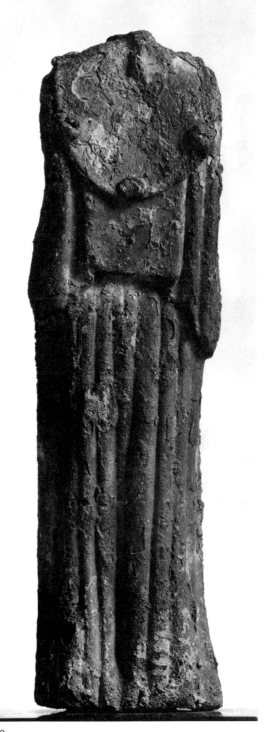

40 40

40

Athena

Circa 440 B.C.

H.: 0.155m.

H. L. Pierce Fund 98.670

E. P. Warren Collection: "From Count
Tyszkiewicz. He had it from the Bammeville
Collection" (Froehner, *Catalogue*, no. 292).

Head and arms missing; surface corroded.

The goddess wears a Doric chiton, over
which is the aegis with Gorgoneion in the
center.

A similar bronze, also headless, was in the
Athens market in 1960. For the statue-type
with Corinthian helmet, compare Burlington
Exhibition, 1903, *Ancient Greek Art*, 1904, 43,
no. 25, pl. 45 (a Roman copy found at Bor-
deaux).

E. Robinson, *Ann. Rep.* 1898, 31; *AA* 1899, 137
(as a contemporary copy); *AJA* 3 (1899) 571;
Chase, *Antiquities*, 86, fig. 96; 2nd edition, 122,
132, fig. 112.

Picard, *Manuel*, II, 341 (this?—related to the
Pheidian Athena *Enhoplos* on the Acropolis, of
which the Athena Medici may be a reduction);
H. G. Niemeyer, *Promachos*, 92.

41

Warrior

Circa 440 B.C.

H.: 0.169m.

Purchased by Contribution 01.7507

E. P. Warren Collection.

Bought in Athens.

Left hand missing. The left arm has a rivet for
the shield. A bent pin makes two holes
through the right hand, like a little hook. On
the top of the helmet are a pin and two holes in
a semicircle. Dark green patina.

He wears a Corinthian helmet, pushed up
on his brow. There are traces of an inscription
mostly on the right side: ΑΓΑΑΓΙΟ (?).
The pin through his left elbow could only have
been for attaching a shield. The object on the

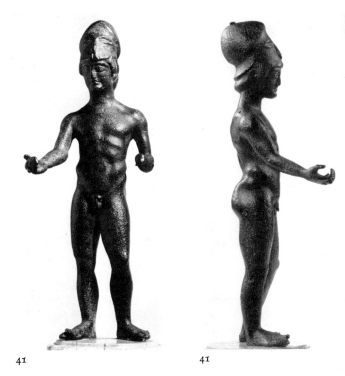

41 41

bent right hand could have been a weapon
rather than a phiale. His body has a slight
quality of unarticulated provincialism about
it, and his chest lacks the solid, barrelled con-
struction of Polykleitan figures. The sculptor
has made much of the hipshot pose, even to
the position of the largish feet at awkward
outward angles.

E. Robinson, *Ann. Rep.* 1901, 36; *AA* 1902, 131;
AJA 6 (1902) 377; M. Comstock, C. Vermeule,
Apollo, December, 1969, 470, 472, figs. 7-8.

Kunze, *BWPr* 109, 1953, 15, 31, note 46 (as north-
east Peloponnesian); D. K. Hill, *Gnomon* 27 (1955)
35; N. Himmelmann-Wildschütz, *Marburger
WPr* 1967, 35, note 28.

DISKOBOLOS
Circa 480 B.C.
H.: 0.149m.
Purchased by Contribution 01.7480
E. P. Warren Collection.
Bought in Paris from an Athenian dealer.

The right leg has been broken at the knee and
repaired. The fronts of both feet are missing.
Corrosion, especially on the front of the body.

He is slightly crude in detail, eyes and
hands being overly large. The hair is a heavy
cap formed of incised lines.

For comparable figures, see Reinach, *Rép.
stat.*, II, 544, no. 5 (Capua); III, 153, no. 6
(=Forman *Cat.*, I, no. 77); and IV, 343, no. 2
(cited as Ferroni, pl. 60). E. N. Gardiner *(Ath-
letics of the Ancient World*, 164f., fig. 128),
in illustrating the comparable bronze from the
Wyndham Cook collection, demonstrates that
the downward swing (the backward motion)
of the discus thrower is shown here.

His somewhat provincial face suggests a
minor workshop in Southern Italy, perhaps
near Naples (Capua?). Such a workshop would
have exported extensively to Etruria. Against
this, there are the strong indications of a
Greek source and the fact that E. Kunze re-
ports (1967) a similar Diskobolos from the ex-
cavations at Olympia.

E. Robinson, *Ann. Rep.* 1901, 36; *AA* 1902, 131;
AJA 6 (1902) 377; Chase, *Antiquities*, 72f., fig. 79;
2nd edition, 94, 115, fig. 95.

von Massow, *AM* 51 (1926) 44f., fig. 2; Kern,
Oud Med 38 (1957) 49f., fig. 15.

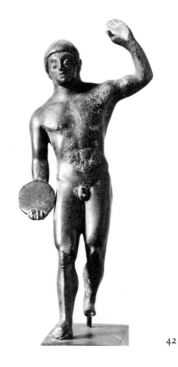

42

42

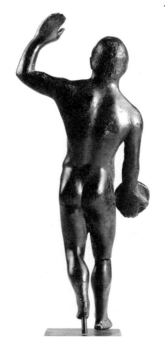

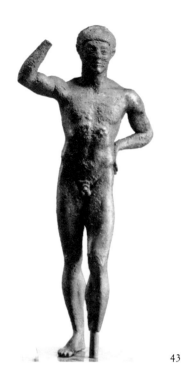

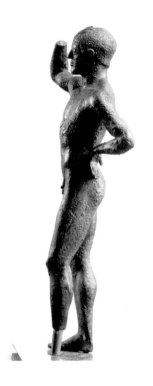

43

43

43

DISKOPHOROS (SUPPORT FOR A MIRROR)
Circa 470 B.C
H.: 0.19m.
Perkins Collection 96.706
E. P. Warren Collection.
Said to come from Croton.

The right hand, left foot and ankle are miss-
ing. Traces of the mirror-holder are visible
on top of the head. Rough green patina.

He held the discus in his raised right hand.

This athlete is one of the most satisfying
manifestations of the high transitional style
that has survived among bronze statuettes.
The youth's hair has the arrangement in close
curls creating an overall cap-like effect that
is characteristic of the "Blond Boy" from the
Acropolis. Solid construction of the chest, a
bulge at the top of the ribcage, and prominent
buttocks when seen in profile all hold together
through strong, rounded muscles and a fine
finish to the surfaces. The thrusting chin and
heavy jaws are evidences of the severe style
that led to the early work of Myron and the
pedimental figures at Olympia.

E. Robinson, *Ann. Rep.* 1896, 28; *AA* 1897, 73;
BMFA 1 (1903) 15; J. Addison, *The Boston Mu-
seum of Fine Arts*, 295; Chase, *Greek and Roman
Sculpture in American Collections*, 41f., fig. 43;
Beazley in Burdett, Goddard, *E. P. Warren*, 359.

Furtwängler, *Neue Denkmäler*, I, 124, pls. 3-4 =
Sitzberichte München II (1897); idem, *Kleine
Schriften*, II, 436ff., pl. 45; *AJA* 3 (1899) 290;
Reinach, *Rép. stat.*, II, 817, 5; idem, *Rép. stat.*, V,
331, 6; Joubin, *La sculpture grecque*, 123f., fig. 36;
Lechat, *Pythagoras de Rhégion*, 119; Bulle, *Schöne
Mensch*, col. 84f., 2 illus., pl. 39, 1; Norton, *JHS*,
34 (1914) 75, fig. 2; Buschor, Hamann, *Die
Skulpturen des Zeustempels zu Olympia*, 39; E.
Franck, *Griechische Standspiegel mit menschlicher
Stützfigur*, 59, 103ff., 142, no. 83; E. Pfuhl, *JdI*
41 (1926) 133, note 6; Lamb, *Greek and Roman
Bronzes*, 156f.; Jantzen, *Bronzewerkstätten*, 47, no.
12, pl. 21, 85-88; V. Poulsen, *Der strenge Stil*,
ActaA 8 (1937) 100, 103; Lippold, *Handbuch*, 107,
and note 10; Richter, *Ancient Italy*, 17, figs. 72,
73; Möbius, *Charites*, 51, note 25, 55, note 46;
Mitten-Doeringer, *Master Bronzes*, under no. 86.

DISKOBOLOS
Circa 430 B.C.
H.: 0.18m.
Perkins Collection 95.69
E. P. Warren Collection.
Found in Etruria.

Patina mottled dark green.

The base is modern, including smaller square section below the column's shaft.

This is the top of a "kottabos" stand, terminating in the figure. The lowered right hand holds the discus, and an attachment for the dish is in the raised left.

If this bronze was not made in Etruria, then it belongs to a related atelier near Naples.

Similar diskoboloi appear on Etruscan cistae (see Reinach, *Rép. stat.*, IV, 323, no. 4).

The face has the pinched, somewhat schematic look of Etruscan or Campanian youths of the post-transitional period. The forms of the body betray Polykleitan influence, but they have been softened and even blurred by the local artist. Thighs and legs are perhaps made thicker than artistic proportions warrant because of the functional nature of the figure.

E. Robinson, *Ann. Rep.* 1895, 24; *AA* 1896, 97.

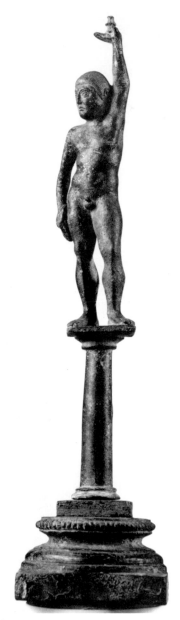

44

YOUTH

Circa 430 B.C.

H.: 0.13m.

H. L. Pierce Fund 98.666

E. P. Warren Collection.

Athens, Art Market.

The right hand is broken off above the wrist.
Olive green patina with areas of slight cor-
rosion.

His hands are extended, and the left held a
small object (a die according to Robinson).
The head is noteworthy for being turned to
one side.

Compare Furtwängler, *Neue Denkmäler*,
II, *SBAkad* 1899, 566ff. and the Apollo from
Lousoi, where the head is straight.

Provincial charm is the chief characteristic
of the Warren youth. The head is too large for
the body, and the latter has the broad com-
pression of upper torso characteristic of other
late archaic or classical statues and small
bronzes from the northeastern Peloponnesus.

E. Robinson, *Ann. Rep.* 1898, 29f.; *AA* 1899, 137.

Reinach, *Rép. stat.*, III, 154, no. 11, after Sieve-
king, in Arndt, *EA*, no. 1288 (Peloponnesian).

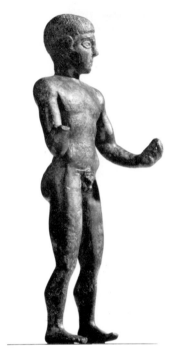

45

45

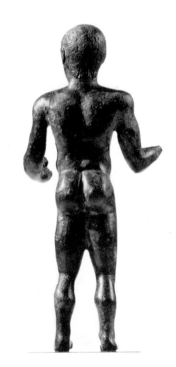

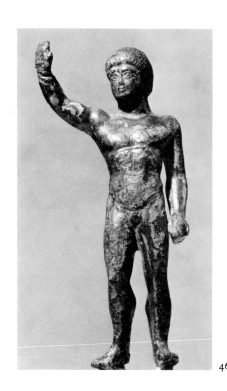

46

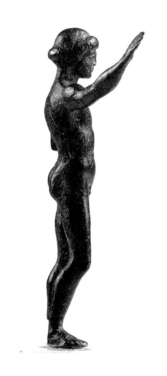

47

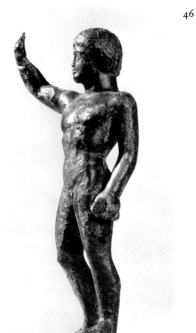

46

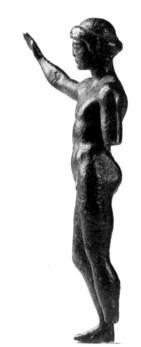

47

46

Youth Taking an Oath
Circa 400 b.c.
h.: 0.102m.
Purchased by Contribution 01.7475
E. P. Warren Collection.

The finger-tips and thumb of the right hand
are missing. Brown and dull green patina.

The left hand is clenched and may have held
a staff. The mass of hair is tightly rolled and
incised around the forehead. Despite some
crudity, the broad body, especially the chest,
suggests derivation from Argive bronzes in
the tradition of Polykleitos.

If not made in the western Peloponnesus,
this bronze was certainly produced in south-
east Italy.

E. Robinson, *Ann. Rep.* 1901, 36; *AA* 1902, 131;
AJA 6 (1902) 377.

Youth Taking an Oath
Circa 440 b.c. or later
h.: 0.095m.
Purchased by Contribution 01.7476
E. P. Warren Collection.

The left arm is broken off at the elbow and the
left leg at the ankle. Somewhat corroded.
Brownish patina.

This bronze is somewhat like the previous,
but the more hipshot pose and elongated pro-
portions suggest the Polykleitan tradition of
the Westmacott Athlete, or the proto-Lysippic
proportions of the standing Diskobolos at-
tributed to Naukydes of Argos.

The style seems to be eastern Pelopon-
nesian, provincial. There are conservative,
late transitional elements which suggest the
long, curved body is a personal invention of
the sculptor rather than a miniature manifes-
tation of the major arts. Hair and face, especial-
ly in profile, recall the Mount Holyoke youth
of 460 to 450 b.c., and that famous bronze
also offers inspiration for the excessive curve
of the back, the forward cast of the shoulders
(Buffalo, *Master Bronzes*, no. 86; Schefold-

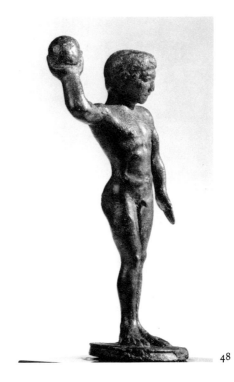

48

Cahn, *Meisterwerke*, no. 273; see also no.
268).

E. Robinson, *Ann. Rep.* 1901, 36; *AA* 1902, 131;
AJA 6 (1902) 377.

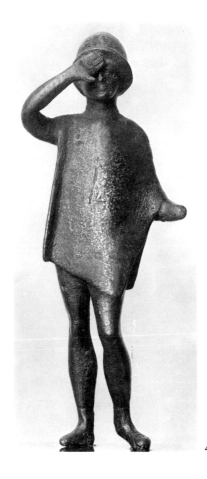

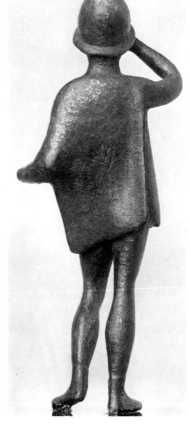

49

49

48

YOUTH PUTTING A WEIGHT
Circa 420 B.C.
H.: 0.097m.
Purchased by Contribution 01.7487
E. P. Warren Collection; Forman Collection.

Corroded. Dull dark green patina.

He holds the weight, like the Diskophoros from Croton (above, no. 43), in his raised right hand.

The style, especially of the face, is a miniature version of Argive masterpieces in the generation after Polykleitos.

E. Robinson, *Ann. Rep.* 1901, 36; *AA* 1902, 131; *AJA* 6 (1902) 377.

Smith, Forman Sale I, *Catalogue*, 13, lot 82, cites Hertz Sale, no. 576.

Exhibited: Cambridge (Mass.), Fogg Art Museum, *Greek Art and Life*, no. 11.

49

YOUTH
Circa 420 B.C.
H.: 0.153m. H. (with tangs): 0.155-.157m.
Seth K. Sweetser Fund 34.223
From Kastritsi, Achaia, near the road between Kalavryta and Patras.

The right arm has been accidently bent at the elbow, and the right palm has been turned outward. The back touches the forehead. Left

hand and part of forearm are missing. Green patina.

Two tangs project down from the feet, from the right heel and the toes of the left. He wears a pilos, chlamys, and boots.

The strong, yet refined proportions of the face, coupled with the Polykleitan standing-walking pose, suggest the influence of later Polykleitan statues, such as the New York-Berlin-Copenhagen (Lansdowne) Amazon or even the Diadumenos. Caskey felt the workmanship might be Arcadian. An older man of the previous generation, similarly clad, has been termed Boeotian; the slender, summarized but delicate proportions of the bronze in Boston are already there (Schefold-Cahn, *Meisterwerke*, 221, fig., 224, no. 259).

L. D. Caskey, *BMFA* 34 (1936) 53-55, 4 illus.; *idem*, *AJA* 40 (1936) 310, fig. 4.

Bloesch, *MusHelv* 16 (1959) 255.

Exhibited: Buffalo, *Master Bronzes*, no. 91, illus.; Andover, (Mass.), *Classical Art*.

Auction Sale XVI, June 30, 1956, 44f., no. 162, pl. 39). There is no difficulty in distinguishing the Etruscan examples, and the presence of a small, circular plinth, as here, suggests they served as the finials of candelabra or bronze shafts. Such pieces, however, may have been manufactured in the Peloponnesus or at Tarentum and in Campania. It seems safe, therefore, to identify this youth as Greek provincial, in contrast to his Etruscan counterparts who have harder faces, heavier muscles, and more flattened, linear drapery. The question is a constant aspect of Greek relations with Etruria.

E. Robinson, *Ann. Rep.* 1896, 28, no. 5 (as Herakles); *AA* 1897, 73.

Reinach, *Rép. stat.*, II, 2, 796, 3 (also as Herakles); E. Hill, *Magazine of Art* 33 (1940) 476f., fig. 15 (as Etruscan); Mitten-Doeringer, *Master Bronzes*, under no. 174.

50

YOUTH

Circa 460 B.C.

H.: 0.084m.

Perkins Collection 96.709

E. P. Warren Collection.

Brown patina with greenish corrosion.

He is standing on a small plinth, leaning cross-legged on a thin club, and wearing a chlamys. His right hand held something, perhaps a phiale. There is a fillet in the hair, and the locks falling over the forehead recall the Blond Boy from the Acropolis. A certain linear quality in the arrangement of the folds of drapery also suggests the late Archaic to early Transitional periods (circa 480 B.C.), but treatment of muscles seems advanced by at least a generation. So also does the line of the profile, seen in side view.

Youths of this class, divinities, athletes, or possibly shepherds, are usually Etruscan, and a workshop at Vulci seems to have produced a number of them (see Münzen und Medaillen,

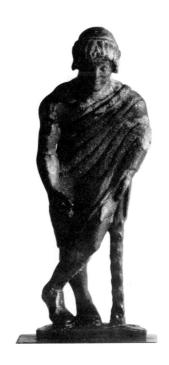

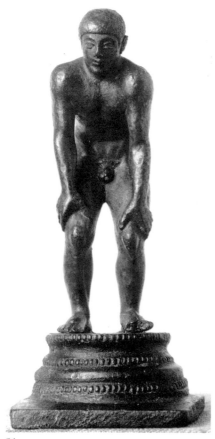

51

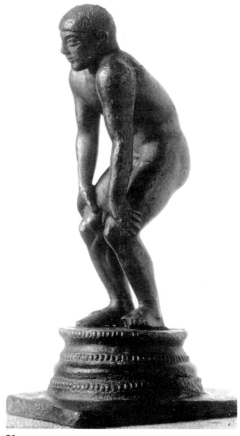

51

STOOPING YOUTH
Circa 450 B.C.
H.: 0.136m.
Perkins Collection 96.710
E. P. Warren Collection.
Said to come from Southern Italy.

Green patina. The base is modern. Some toes
of the left foot missing.

 A youth is stooping, placing his hands on
his knees. Traces on the back show that a
second youth, now lost, was seated on his
shoulders. They were evidently participants
in a ball game.

 Despite the provenience, the consensus is
that this bronze was made in the Pelopon-
nesus, probably in Argos.

 The youth has been dated about 460 B.C.
(Buffalo, *Master Bronzes*, no. 85), but the free
form of the body seems to place him up to a
generation later than the sculptors who
worked before the temple of Zeus at Olympia
was begun. He is almost early Polykleitan in
body but still an athlete of the end of the
severe style in hair, cast of the eyes, and sim-
ple, round proportions of his head. In ex-
pression he is the more elegant, slightly older
brother of the Warren standing youth prob-
ably also from the Peloponnesus (above,
no. 45).

E. Robinson, *Ann. Rep.* 1896, 28; *AA* 1897, 73; Beazley in Burdett, Goddard, *E. P. Warren*, 359.

Petersen, *RM* 6 (1891) 270ff., pl. 7; Reinach, *Rép. stat.*, II, 543, no. 6; Buschor, Hamann, *Die Skulpturen des Zeustempels zu Olympia*, 39; Langlotz, *Frühgriechische Bildhauerschulen*, 56, 62, pl. 29c ("Argos"); Picard, *Manuel*, II, 159f.; Blümel, *Sport der Hellenen*, pl. 92; Jantzen, *Bronzewerkstätten*, 55, no. 11; Gerke, *Griechische Plastik*, pl. 152, 1-3; Neugebauer, Berlin *Bronzes*, II, 11; Byvanck, *De Kunst der Oudheid*, III, 96, pl. 12, fig. 50; Schuchhardt, *Gnomon* 30 (1958) 483 (wohl argivisch).

Exhibited: Buffalo, *Master Bronzes*, no. 85, illus.; Detroit, *Small Bronzes of the Ancient World*, 10, no. 68, 37, illus.

52

SATYR

Circa 440 to 430 B.C.

H.: 0.113m.

H. L. Pierce Fund 98.669

E. P. Warren Collection; Tyszkiewicz Collection.

From Epidaurus.

The fingers of the right hand are missing.

He appears to have been dancing along, or perhaps pouring wine from a kantharos in his right hand. His body has been influenced by the young athletes of the Polykleitan school, but his face is still that of silens or satyrs on Greek vases of around 470 B.C.

A comparable, although somewhat cruder, satyr is in Kassel: Bieber, *Cassel*, pl. 40, no. 171 = Reinach, *Rép. stat.*, V, 478, no. 5. Lapiths in the west pediment of the temple of Zeus at Olympia and their counterparts among the conservative metopes of the Parthenon have similar round skulls with large foreheads, compressed faces, and mop-like beards.

E. Robinson, *Ann. Rep.* 1898, 30f.; *AA* 1899, 137; Chase, *Antiquities*, 86, fig. 97; 2nd edition, 122, 132, fig. 113; Vermeule, *CJ* 63 (1967) 52f., fig. 4.

Wernicke, *RM* 4 (1889) 170, 2 illus.; Neugebauer, Berlin *Bronzes*, II, 11; Mitten-Doeringer, *Master Bronzes*, under no. 94.

Exhibited: Cambridge (Mass.), Fogg Art Museum, *Greek Art and Life*, no. 13.

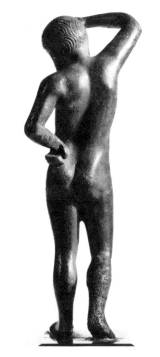

52

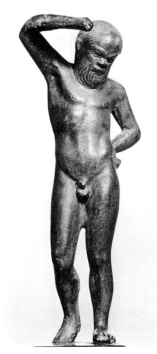

52

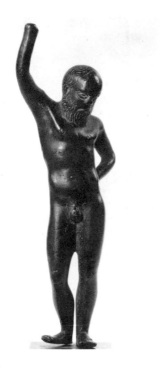

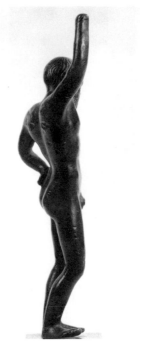

53

53

53

SILEN OR SATYR
440 to 430 B.C.
H. (max.): 0.135m. H. (to top of head):
0.115m.
Gift of Jerome M. Eisenberg 67.643
Said to come from Egypt.

Dents across the back at the shoulders. Casting defects on left elbow. Reddish brown patina.

He stands with weight on left leg, left hand on hip, and right arm (most of hand missing) raised to its fullest extent. The right leg has been bent too far forward, and the foot has been pushed upward as a result. The surface details of the body are represented by incision, and the alternations of weight and position of the limbs give the figure a lively rhythm.

This satyr or silen is similar to the previous statuette. The chief difference is that the first satyr's right arm has been or is bent forward in front of his head, suggesting he may have been pouring wine from a pitcher or crowning himself with a wreath, in the manner of the

Westmacott Athlete attributed to Polykleitos. Figures like these, in marble and in small bronzes, appear in the fifth and well into the fourth century B.C. Pose and proportions of these satyrs represent the link between Polykleitan sculpture and the decades in which Praxiteles grew up.

The position of this satyr's arm exhibits nothing to suggest that it has been bent out of shape since the figure was cast. This figure may have parodied another familiar athletic type of the fifth century B.C., the diskophoros, most of the hand and discus or ball having been broken away. In connection with a similar bronze satyr or silen of about 450 B.C., a kottabos has been suggested as attribute (Münzen und Medaillen, Auktion XXXIV, 6 May 1967, 9f., no. 11). The two statuettes shown here must be contemporary versions of a famous satyr of the late fifth to fourth centuries B.C., in the tradition of the Marsyas of Myron combined with the developments in the Argive school of Polykleitos and later.

Vermeule, *Ann. Rep. 1967*, 47; *idem, CJ 63 (1967)* 51ff., fig. 3.

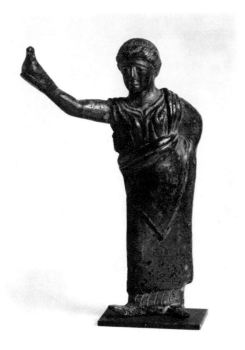

54

54

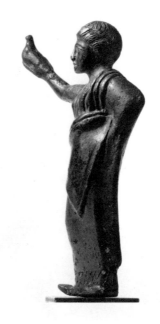

54

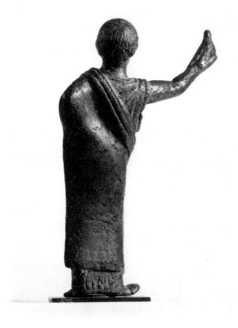

54

54

Girl with a Dove

Circa 430 B.C.

H.: 0.083m.

Purchased by Contribution 01.7497

E. P. Warren Collection.

Bought in Athens; said to be from Achaia.

Brown in color.

 She holds the dove on her outstretched right hand and places the left on the hip. She has a fillet in her rolled hair and wears a long chiton beneath an ample himation, with a V-shaped overfold in front.

 Compare the statuette in Berlin (no. 8599), from Thessaly: Reinach, *Rép. stat.*, IV, 199, no. 7 = *AA* 1904, 34; Lamb, *Greek and Roman Bronzes*, 155, pl. 55a.

 Her stylistic forerunner is the seemingly-Peloponnesian girl of about 450 B.C. at Bowdoin College (K. Herbert, *Ancient Art in Bowdoin College*, 119, no. 422, pl. 41).

E. Robinson, *Ann. Rep.* 1901, 36; *AA* 1902, 131; *AJA* 6 (1902) 377.

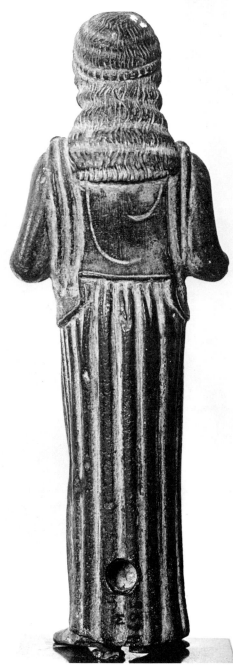

GIRL WITH OFFERING

450 B.C.

H.: 0.13m.

H. L. Pierce Fund 98.668

E. P. Warren Collection.

Said to have been found at Corinth.

Traces of gilding remain. A hole, for an attachment, is in the lower rear of the chiton. Green patina with brown (earth) encrustation.

She carries a tray laden with cakes and fruit in the fold of her Doric chiton.

Langlotz identified this charming figure with his school of Kleonai, while Lippold saw in her the motif of the Monosandalos, a youth holding a pig in similar fashion as an Eleusinian offering, combined with a head of the Argive Heraeum type. Neugebauer pointed to the alleged provenance as further support for the girl's Argive derivation.

E. Robinson, *Ann. Rep.* 1898, 30; *AA* 1899, 137; J. Addison, *The Boston Museum of Fine Arts,* 295; Beazley, in Burdett, Goddard, *E. P. Warren,* 359.

Schuchhardt, *AM* 52 (1927) 152; Langlotz, *Frühgriechische Bildhauerschulen,* 68, pl. 8; V. Poulsen, *Der Strenge Stil, ActaA* 8 (1937) 12; Neugebauer, *Die Antike* 11 (1935) 43f., fig. 3; Lippold, *Handbuch,* 170; Neugebauer, Berlin *Bronzes,* II, 37; Byvanck, *De Kunst der Oudheid,* III, 86, pl. 11, fig. 44; Hanfmann, *AJA* 66 (1962) 283, note 17; Pierce College, Athens, Greece, *A Year of Dedication,* 1964-65, **cover.**

Exhibited: Buffalo, *Master Bronzes,* no. 89, illus.; Detroit, *Small Bronzes of the Ancient World,* 10, no. 69.

56

PROTOME OF RIVER GOD

Circa 460 B.C.

H.: 0.046m. L.: 0.06m.

Gift of Dr. Herbert A. Cahn 59.552

From Syracuse.

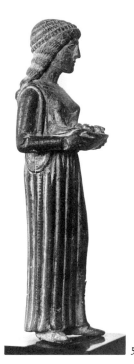

55

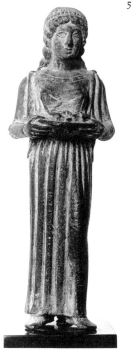

55

Corroded and cleaned. Greenish-black patina.

The protome takes the form of the head and neck of a man-headed bull. The face is bearded, and the mane hangs down either side below the horns; the neck is formed of the typical, loose skin of the bull, treated in broad folds or large wrinkles. The bronze is cast solid, and the rivet-hole at the break on the left and the curved underside suggest that this protome adorned the rim of a large vessel. The presence of a river-god on the rim of a large bronze louter or water basin would be most appropriate. The protome, otherwise, may have come from a rod-tripod, as part of the decoration on one of the shafts.

The most popular river-god represented in this fashion is Acheloös, the largest river in Greece, flowing south between Acarnania and Aetolia into the Ionian Sea at the entrance to the Gulf of Corinth. Acheloös, oldest of the 3000 river-god brothers and (according to some) the son of Oceanus and Tethys, was popular on Attic reliefs dedicated in the fifth and fourth centuries B.C. to Hermes and the nymphs. Closer to Syracuse, there is the river-god Gelas, who appears on contemporary coins of Gela as a man-headed bull swimming in his river. The city even had a statue of its patron represented in this semi-bovine guise. The subject in bronzes is, at any rate, unusual.

Vermeule, *Ann. Rep.* 1959, 26; *idem, CJ* 55 (1960) 196, fig. 4; *FastiA* 15 (1960) no. 671.

Monnaies et Médailles, Basle, Auction XIV, June 19, 1954, no. 28.

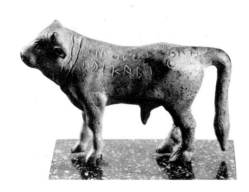

57

58

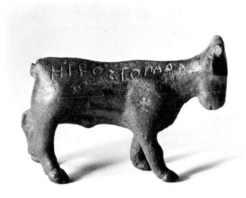

nos. 39, 39a) and G. Bruns, *Neue Deutsche Ausgrabungen im Mittelmeergebiet und im Vorderen Orient*, 242ff., fig. 5; De Ridder, Acropolis *Bronzes*, 187f., no. 515, fig. 162; Richter, Met. Mus. *Handbook*, 209, pl. 49d. On their technique see Roeder, *JdI* 48 (1933) 245-249.

E. Robinson, *Ann. Rep.* 1898, 29; *AJA* 3 (1899) 571; *AA* 1899, 137.

Froehner, Tyszkiewicz Sale, *Catalogue*, 51f., no. 142; Reinach, *Rép. stat.*, IV, 484, no. 5; Casson, *Descriptive Catalogue of the Warren Classical Collection of Bowdoin College*, under no. 106 (similar bull, "similar" inscription: HIEPOI KABEIPOI); *idem*, *AJA* 39 (1935) 512 (circa 450 B.C.); Neugebauer, Berlin *Bronzes*, II, 50; P. Wolters, G. Bruns, *Das Kabirenheiligtum bei Theben*, I, 39, no. 34.

58

VOTIVE BULL
Circa 450 B.C.
H.: 0.065m. L.: 0.087m.
Gift of Dr. Elie Borowski 67.743
From the Kabeirion, Thebes.

Tail and perhaps the ends of the horns missing. Surfaces worn down and corroded. Greenish, brown patina.

The inscription on the right side runs from the tail to the head: HIPOΣTOΠAΔAOIΣ. On the left side it runs from the shoulder to the tail: ONIIIIIO.

See, generally, P. Wolters, G. Bruns, *Das Kabirenheiligtum bei Theben*, I, 36ff., nos. 17ff.

Vermeule, *Ann. Rep.* 1967, 47.

57

VOTIVE BULL
Circa 490 B.C.
H.: 0.053m. L.: 0.08m.
H. L. Pierce Fund 98.663
E. P. Warren Collection; Tyszkiewicz Collection.
Seen by Lolling in the Art Market, Athens. From the Kabeirion, Thebes.

Green patina.
He is inscribed on one side:
OMOΛΩIXOΣ
ΠAIΔI KABIPΩ
"Homoloïchos [dedicated this] to the child of Kabeiros."

There are a number of such bulls, some from the excavations at the Kabeirion: see below (Wolters-Bruns, 36ff., especially 40,

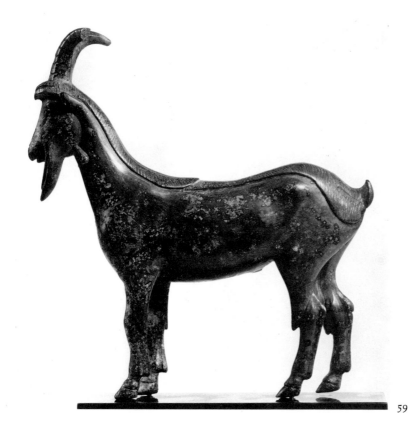

59

59

GOAT

Circa 460 to 450 B.C.

H.: 0.148m. L.: 0.139m.

H. L. Pierce Fund *99.491*

E. P. Warren Collection.

Bought in Rome; said to come from Milan;
found in the Val d'Aosta (Sieveking, *loc. cit.*).

The tip of the left horn is missing. Green
patina.

The statuette is cast hollow, with one rath-
er large hole in front of the hind legs.

This goat also has a twin in Geneva (Rich-
ter, *Sculpture*, 114, fig. 362; *EA*, no. 1867,
from Sierre or Evreux) and a parallel in Berlin,
from Dodona (*Berliner Museen* 50 [1929] 30).
Jantzen assigns their production to Tarentum.

For a list of goats from the rims of early
fifth century bronze kraters, see D. M. Robin-
son, *AJA* 59 (1955) 20, under no. 3.

E. Robinson, *Ann. Rep.* 1899, 38, no. 4 (possibly
Etruscan); *AA* 1900, 217; *AJA* 4 (1900) 510f.

Reinach, *Rép. stat.*, IV, 513, 4; Sieveking, *Bronzen
. . . Loeb*, 26; Richter, *Animals*, 69, pl. 41, fig. 127;
Jantzen, *Bronzewerkstätten*, 28; Blümel, *Tierplas-
tik*, pl. 62, no. 60; Hill, *Walters Bronzes*, 114,
under no. 260; Stuart Jones, *Conservatori*, 296, no.
37, pl. 118 (almost identical and found in Rome);
Amandry, *AM* 77 (1962) 51, note 102; Mitten-
Doeringer, *Master Bronzes*, under no. 101.

Exhibited: Buffalo, *Master Bronzes*, no. 88, illus.;
Detroit, *Small Bronzes of the Ancient World*, 10,
no. 71, 38, illus.

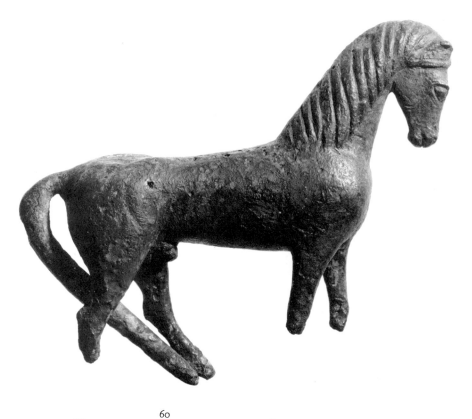

60

HORSE

Circa 480 B.C.
L.: 0.164m.
Purchased by Contribution 01.7518
E. P. Warren Collection.
Bought in Athens; from the Acropolis.

Feet missing; considerably corroded.

There are holes in the back, due to casting. He has an unusually long tail and mane on both sides.

A similar horse, slightly more summary and corroded, is in Walter Baker's collection, New York (D. von Bothmer, *Catalogue*, 8, no. 31). Compare also De Ridder, Louvre *Bronzes*, I, 29, no. 148, pl. 16; *idem*, Acropolis *Bronzes*, 277f., no. 752, fig. 260. Mr. Baker's horse has been most recently dated in the sixth century B.C., but both seem rather, on the basis of

numismatic comparisons, to belong to the early years of the fifth.

E. Robinson, *Ann. Rep.* 1901, 36; *AA* 1902, 132; *AJA* 6 (1902) 377.

D. von Bothmer, *Ancient Art from New York Private Collections*, 34, under no. 131.

61

APHRODITE
Fourth Century B.C., after 350 (circa 325 B.C.?)
H. (Aphrodite): 0.186m. H. (base): 0.053m.
H. L. Pierce Fund 04.8
E. P. Warren Collection.

Both thumbs missing.
Olive patina. Some corrosion.

She stands on her right foot, with left leg bent and left foot drawn back. The head is inclined, and the palms are open. The circular pedestal with ornate mouldings was made for a statuette somewhat larger than this and is late Hellenistic or Graeco-Roman in workmanship.

There are many similar Aphrodites, dating from the fourth century well into Roman times. It is often difficult to tell which are creations contemporary with the work of Praxiteles, Skopas or Lysippos, and which are later works of good quality. A statuette in the collection of Joseph V. Noble, from Egypt, shows a comparable Aphrodite, with hair derived from the Cnidia, and belongs in the late Hellenistic period. A certain heaviness of hips and legs might lead one to call it Roman (see D. von Bothmer, *Ancient Art from New York Private Collections*, 41, no. 158). Others in similar, soft and glossed-over volume and proportions seem to be definitely Roman in that they relate to Pasitelean and other Roman "neo-classic" productions: see N. Himmelmann-Wildschütz, *Marburger WPr* 1958, 1-8.

B. H. Hill, *Ann. Rep.* 1904, 58; *AJA* 9 (1905) 369f.; *AA* 1906, cols. 261-262.

Reinach, *Rép. stat.*, IV, 209, no. 4.

Exhibited: London, Burlington Fine Arts Club, *Ancient Greek Art*, 40, no. 13.

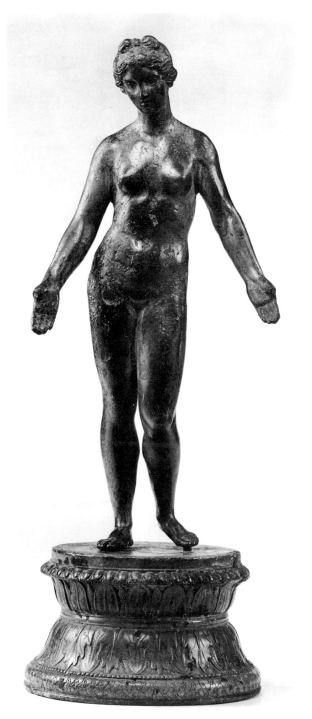

61

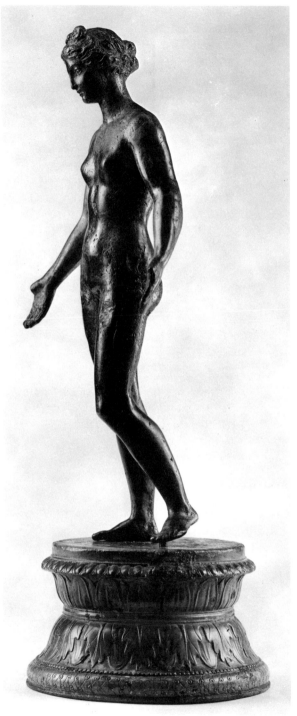

61

62

RIGHT FOREARM AND HAND OF A WOMAN
Fourth Century B.C.
L.: 0.20m.
James Fund and Special Contribution 10.165
E. P. Warren Collection.
Bought in Constantinople.

Dark patina.

Bent at the elbow and wrist, hand and arm are gracefully relaxed. The statue was half lifesize.

Pose and motion recall the Eirene of the Athenian group of Eirene and Ploutos, attributed to Kephisodotos (father or uncle of Praxiteles) about 375 B.C.

L. D. Caskey, *Ann. Rep.* 1910, 60; *AA* 1911, col. 474; *AJA* 15 (1911) 433.

62

62

63

SNAKE
Circa 400 B.C.
L.: 0.14m.
Gift of E. P. Warren 13.182
From Athens.

Green and brown patina; covered with earth.

The votive snake is shown as if extended to strike.

This snake is more finished and elegant than the example in a group of East Greek, sixth century B.C. bronzes, many in the British Museum (Haynes, *JHS* 72 [1952] 77, pl. 5, i). For the subject in general, see Greifenhagen, *AA* 1957, cols. 21 ff.; a similar snake, nearly three times as large, was found in the Antonine fill of the Asklepeion at Pergamon; the plaque attached has a dedication to Asklepios: E. Boehringer, *Neue Deutsche Ausgrabungen im Mittelmeergebiet und im vorderen Orient*, 163 ff., fig. 31. See also Reinach, *Rép. stat.*, II, 2, 777, no. 2 (cited as Caylus VI, 5, from Rome).

L. D. Caskey, *Ann. Rep.* 1913, 88; *AA* 1914, col. 493; *AJA* 18 (1914) 414.

63

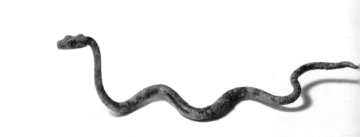

64

 Aphrodite
Hellenistic
H.: 0.175m.
Gift of E. P. Warren 95.75
From the Joseph Sale at Christie's, February
1894, labelled "Found at Corinth, 1876."

Mottled brown and green patina.
 This statuette reflects the fourth century
Aphrodite best known from the marble copy
in the Museo Capitolino (Bieber, *The Sculpture
of the Hellenistic Age,* 20; Felletti Maj, *ArchCl*
3 [1951] 33ff., 61ff., with list of the Dresden-
Capitoline replicas). The original may have
been created by Lysippos. For a comparable
bronze in the Louvre, see De Ridder, *Louvre
Bronzes,* I, 9, no. 14, pl. 3; Reinach, *Rép. stat.,*
IV, 219, no. 4 (cited as Sarti Sale, no. 35).

E. Robinson, *Ann. Rep.* 1895, 25; *AA* 1896, 97;
J. Addison, *The Boston Museum of Fine Arts,* 295.

64

64

APHRODITE

Hellenistic

H. (with plinth): 0.313m. H. (without plinth): 0.259m.

H. L. Pierce Fund 00.313

E. P. Warren Collection; Tyszkiewicz Collection.

Said to have been found at Beirut (although Froehner says, "envoyée de Grèce").

Left leg broken just above the ankle (nothing missing; repaired without restoration).
The arms have been reattached with wax.

She stands on a circular, moulded base and wears earrings consisting of gold spirals with pearl drops. There were double bracelets on her upper arms.

This Aphrodite is a simpler version of the Capitoline type (see previous), with hairdress recalling that of the Praxitelean Cnidia.

Small bronzes in the circle of the Praxitelean Aphrodite(s) are discussed with relation to the Cnidia by Ch. Picard, *Manuel*, III, 1, 613 ff. Those with gold earrings, necklaces and bracelets are not uncommon: see K. Schefold, P. Tschudin, "Eine Venus-Statuette aus Augst," *Ur Schweiz* 25 (1961) 21-30. The difference between this bronze as a Hellenistic work and a parallel Roman copy can be seen by comparing it to *Collection Durighello*, Paris, May 1911, 36, no. 334, pl. 15 (also on an antique base). P. Lévêque (*Les antiquités du Musée de Mariemont*, 91, under G 66) points out that such bronzes in the Hellenistic period were placed in tombs, under the head of the deceased.

E. Robinson, *Ann. Rep.* 1900, 30f.; *AA* 1901, 166; *AJA* 5 (1901) 360f.; *BMFA* 1 (1903) 15.

E. Loewy, *MonAnt* 1 (1892) col. 965f., pls. 1-2; Froehner, *La Collection Tyszkiewicz*, pls. 6, 7; Reinach, *Rép. stat.*, IV, 218, 7.

65

CENTAUR WITH ARMS TIED
Circa 150 B.C.
H. (max.): 0.042m. L. (max.): 0.050m.
Gift in Memory of Karl Lehmann 63.1039
Found in Asia Minor.

Forelegs, hind legs and tail broken off. Surface slightly pitted. Brown patina. Traces of an iron pin through middle of equine back, for mounting on a stand and for mounting the Eros on the back.

This is a spirited original reflecting the prototype (version) of the marble old and young centaurs carrying Erotes in the Louvre, the Vatican, and the Museo Capitolino (Bieber, *The Sculpture of the Hellenistic Age*, 140f., figs. 583f.). The old and young Capitoline centaurs are copies made circa A.D. 150 for the Villa Adriana by Aristeas and Papias of Aphrodisias, after originals of the period 170 to 140 B.C. (Stuart Jones, *Conservatori*, 274ff., nos. 2, 4, pl. 64). Related to the originals are the prancing (but evidently not bound) centaurs in high relief from the ceiling of the pronaos of the Hieron at Samothrace (K. Lehmann, *AJA* 61 [1957] 123ff., pl. 37; P. W. Lehmann, *The Pedimental Sculptures of the Hieron at Samothrace*, figs. 39-41), dated close to 170 B.C. The bound centaur, without Eros on his back, is also a symbol of the triumph of Dionysos or Herakles, as on the marble oscillum from Pompeii (Reinach, *Rép. rel.*, III, 68, no. 1; F. Matz, *Festschrift für Carl Weickert*, 50ff., fig. 8).

The old centaur in marble in the Louvre (and his less-complete companions) is a symbol of frustrated love in old age, being tortured and trying to lash back at the Eros with his tail. Here, in the bronze, there is a note of heroic pathos in the centaur's face, but he is more contemplative than the marble, rococo copy. This suggests closer relationship to an important original, and, in fact, with the pointed ears the head is something like the "Cheiron" in the Palazzo dei Conservatori (Stuart Jones, *Conservatori*, 128f., no. 3, pl. 47), which Mrs. Lehmann (*loc. cit.*, especially

23f.) sees as an original of the Pergamene school, not later than 150 to 125 B.C.

There are not many surviving Hellenistic centaurs in bronze, a similarly spirited example in lead being in the Louvre (De Ridder, *Bronzes*, II, 195, no. 3745, pl. 122) and a centaur with panther being in the Bibliothèque Nationale (Babelon-Blanchet, *Bronzes*, no. 515). A centaur preparing to hurl a rock (at a Lapith?), said to come from Olympia, has been dated about 450 B.C. (D. von Bothmer, *Ancient Art from New York Private Collections*, 36, no. 138, pl. 44; H. A. Cahn, *Antike Kunst* 3 [1960] 90, pl. 17). It seems difficult to accept the allegedly second century B.C. chalcedony centaur (also hurling a rock) from Alexandria, in Kansas City, as ancient (*Handbook*, 35, illus.).

Vermeule, *Ann. Rep.* 1963, 36; *idem*, *BMFA* 61 (1963) 111, illus.; *idem*, *CJ* 60 (1965) 295, fig. 8.

ArtQ 26 (1963) 483, 488, illus.

67

DIONYSOS
Late Hellenistic (or Graeco-Roman)
H.: 0.20m.

Francis Bartlett Collection 03.987
E. P. Warren Collection; Theodor Graf Collection.
From Lower Egypt.

The feet, left arm, right arm from above the elbow and support at the left are missing. Corroded.
Nude except for the vine-wreathed fillet in his hair and the ends of the fillet on his shoulders, he leans to the left.

The type is a late fourth century or Hellenistic modification of the Praxitelean type represented by the so-called Hermes at Olympia.

Compare the example in the Dionysiac group in the Louvre, from Trebizond: Charbonneaux, *Les bronzes grecs*, pl. 30; *idem*, *Greek Bronzes*, pl. 30. The more compact, Roman style of a statuette derived from another, early Praxitelean type is exemplified by the bronze found in Italy and once in the De Sanctis collection: L. Pollak, Sale, Rome, 26-28 March 1923, 14, no. 73, pl. 1; see also Licht, *Sittengeschichte Griechenlands*, I, 222.

B. H. Hill, *Ann. Rep.* 1903, 60; *AA* 1904, 194; *AJA* 8 (1904) 382; *BMFA* 2 (1904) 6.

Schreiber, *AA* 1890, 157f., no. 9; Reinach, *Rép. stat.*, II, 1, 118, 4.

66

66

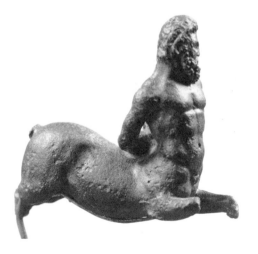

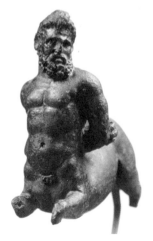

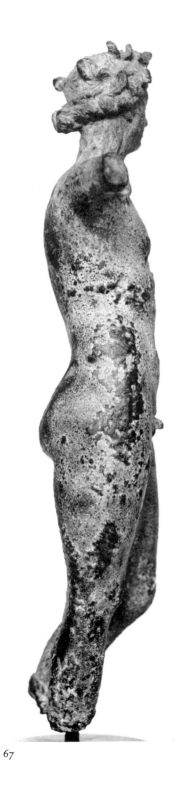

67

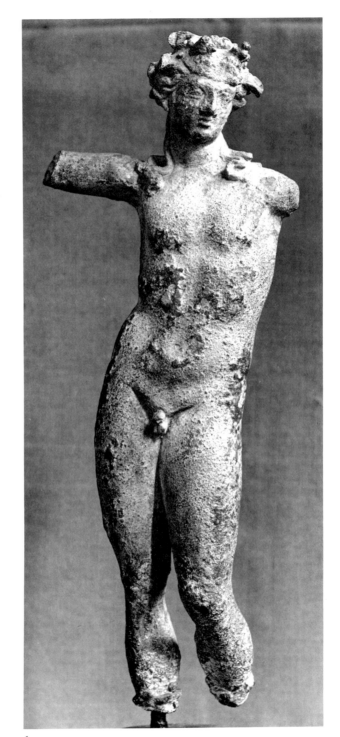

67

67

68

HEAD OF DIONYSOS
Late Hellenistic
H.: 0.13m.
Gift of Harvard University-Museum of Fine Arts Expedition December, 1921 24.957
From the tomb of Prince Arikankharēr at Meroë.

Encrusted and partially cleaned; much of the inlaid eyes, made of shell, survive.

Vine leaves are twined in his long locks; the whites of the eyes are inlaid.

This head, the hand, and the foot were found in a tomb of circa A.D. 15. Another head of the same type was found with it and is in Khartoum (*BMFA, loc. cit.,* illus.). A complete statue of similar type, lifesize and thought to come from northern Syria, was in the New York Market in 1963. It is probably a Hellenistic original, and all these statues go back to a creation in the circle of the Pouring (Dresden-Palermo) Satyr of Praxiteles (see

G. M. A. Richter, *Sculpture,* 266, figs. 682-684).

G. A. Reisner, *BMFA* 21 (1923) 16f., 4 illus.; W. S. Smith, *Ancient Egypt,* 1952, 163; 1960 edition, 185; D. Dunham, *The Royal Cemeteries of Kush,* Vol. IV, *Royal Tombs at Meroë and Barkal,* 127, no. 59, pls. 48, 49A; idem, *Archaeology* 6 (1953) 93, illus.; idem, *AJA* 50 (1946) pl. 31.

Sir Leonard Woolley, *Digging up the Past,* (Penguin-Pelican ed.) pl. 32.

69

HAND
Late Hellenistic
L.: 0.11m.
Gift of Harvard University-Museum of Fine Arts Expedition 24.897
From the tomb of Prince Arikankharēr at Meroë.

69

68 70

Green patina, partly cleaned away.

This is the right hand of the previous, or of the head in Khartoum. It was extended horizontally and grasped a rectangular object which is hollowed as vertical support for an attribute. Perhaps a thyrsos was joined in two pieces above and below.

Dunham, *The Royal Cemeteries of Kush*, Vol. IV, *Royal Tombs at Meroë and Barkal*, 127, no. 61, pl. 49 B.

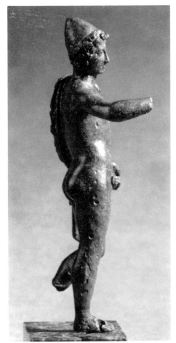

71

70

FOOT
Late Hellenistic
L.: 0.149m.
Gift of Harvard University-Museum of Fine Arts Expedition 24.896
From the tomb of Prince Arikankharēr at Meroë.

Green patina, partly cleaned away.

This sandaled left foot belongs with the two previous and/or with the head in Khartoum.

Dunham, *The Royal Cemeteries of Kush*, Vol. IV, *Royal Tombs at Meroë and Barkal*, 127, no. 60, pl. 49 C, and fig. 82.

71

71

DIOSKOUROS
Hellenistic, circa 200 B.C.
H.: 0.115m.
William E. Nickerson Fund No. 2 60.137
Said to come from Tarentum.

The right hand, left foot, and sword or spear held in the left hand are missing. Hole for mounting in right foot. Dark brown patina, with red and green areas.

He stands with his weight on the right leg (the pose of the Polykleitan Doryphoros) and is nude except for his pointed cap (pilos) and the cloak over his shoulder and left arm.

There are many parallels from the fourth century B.C. into the Roman period. Since these statuettes naturally came in pairs, greater prevalence of the pendant or reversed type

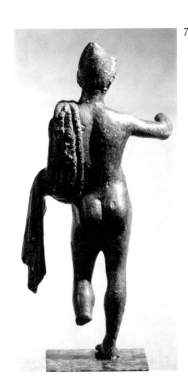

suggests *this* example portrays Pollux. Both statuettes are represented in Baltimore (Hill, Walters *Bronzes*, 26f., nos. 47, 48, pls. 10, 12), and a parallel from Paramythia in the British Museum is dated before 300 B.C. (Walters, British Museum *Bronzes*, 37, pl. 6, no. 277). Compare also the whole statue from Baii, in Rome (Cultrera, *BdA* 1907, fasc. 11, 3ff., illus.) and the colossus from Cyrene (Reinach, *Rép. stat.*, V, 43, no. 1).

Vermeule, *CJ* 56 (1960) 4f., fig. 4; *FastiA* 15 (1960) no. 665.

72

ARM FROM A STATUETTE OF A DIVINITY, HERO OR MAN REPRESENTED AS SUCH
Hellenistic, circa 200 B.C. or later
H. (max.): 0.115m.
John M. Rodocanachi Fund 62.978
From the Art Market in Athens.

The inside of the shoulder is cast hollow for soldering to the body. The arm and cloak are a single unit. Greenish patina, slightly crusty.

The hand held a spear or scepter-staff, or, less likely, a parazonium. The cloak is pinned with a brooch on the left shoulder and has a weight at the bottom.

For function and form, compare the previous, the statue of a Dioskouros.

Vermeule, *CJ* 60 (1965) 297, fig. 10.

72

73

73

EROS
Hellenistic
H.: 0.047m.
Gift of C. Granville Way 72.4440
Hay Collection.

The wings were broken off at the base of attachment and are missing. Crusty green patina.

He wears only a thick, plain fillet around his head. He is seated, playing the double-flute.

NIKE ON ORB
Circa 150 to 100 B.C.
H.: 0.16m.
Harriet Otis Cruft Fund 62.971
New York Art Market.

Green patina, with some pitting. Right arm
from above elbow missing; edges of wings
and drapery slightly damaged.

The extended right hand held a wreath, and
a small trophy or standard or palm was un-
doubtedly supported in the crook of the left
arm.

This statuette, with drapery reflecting a
somewhat mannered reaction to the Perga-
mene baroque, has connections with a proto-
type created to be held on the hand of Zeus.
Just such a Zeus Nikephoros is portrayed on
silver coins of Antiochus VIII "Grypos" of
Syria, 121 to 96 B.C., struck at Antioch.

There are many comparable bronzes, but
they are generally duller, more stilted exam-
ples of Graeco-Roman mass production (as
Marseille no. 773 cited as Reinach, *Rép. stat.*,
III, 258, no. 8); an example in Baltimore, of
the "end of the Hellenistic age," has some of
the same freedom (Hill, Walters *Bronzes*, 100,
no. 220, pl. 45). In 19 B.C. a Hellenistic Nike
similar to this statuette was brought to Rome
from Tarentum to become the image in the
chamber of the imperial senate. It appears
frequently on Augustan and later coins and
exercised considerable influence on Roman
decorative and minor arts. Skopas, whose con-
nections with Tarentum revolve around his
Herakles and who favored fluttery females in
action, may have had a hand in the ultimate
prototype disseminated throughout the Hel-
lenistic world (see K. A. Neugebauer, *Studien
über Skopas*, 15, pl. I, 3).

H. Hoffmann, *BMFA* 60 (1962) 126f., 2 illus.;
Vermeule, *CJ* 60 (1965) 293f., fig. 6; *FastiA* 17
(1962) no. 240.

74

74

72

PAN
Hellenistic
H.: 0.121m.
H. L. Pierce Fund 99.490
E. P. Warren Collection.
Bought in Athens.

Left arm and legs below the knees are missing.
Right arm and syrinx are somewhat corroded;
most of the crusty green patina has been re-
moved. The remaining patina is green and
very dark brown.

He stands, about to play the syrinx. The
style is not uncommon in late Hellenistic
terracottas from Smyrna. It descends from the
bronze satyr of the second century B.C., found
at Pergamon (therefore compare Neugebauer,
Antiken in Deutschem Privatbesitz, 24, no.
70, pl. 31). This bronze must be after a major
Hellenistic statue, as the example in Istanbul,
Archaeological Museum, from Nicomedia in
Bithynia (Mendel, *Cat.* II, 327f., no. 594;
Reinach, *Rép. stat.*, V, 23, no. 6).

For the fourth-century antecedents, see
Brommer, *Marburger Jahrbuch für Kunstwis-
senschaft* 15 (1949/50) 36ff.

E. Robinson, *Ann. Rep.* 1899, 37f.; *AA* 1900, 217;
AJA 4 (1900) 510.

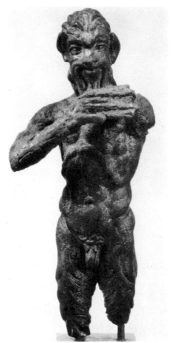

75

75

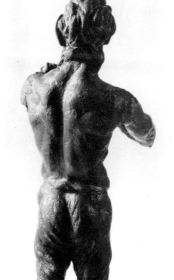

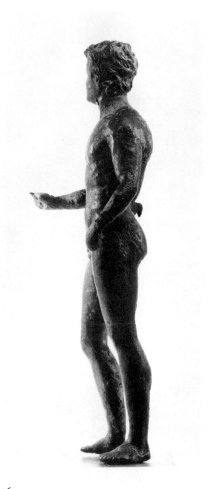

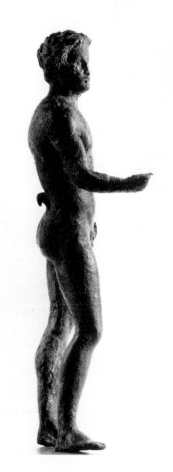

76

76

74

Young Satyr, Standing

Hellenistic

H.: 0.18m.

Perkins Collection 96.704

E. P. Warren Collection.

Bought in Rome; presumably from the Tiber.

Part of left hand and object held in it (pedum or thyrsos) are missing. The surface is corroded, with yellow ("Tiber"), black and grey patina. Horns and whiskers are silver. Metallic content is actually copper with silver and trace of lead. The piece was probably plated in places.

He has short horns, the usual pointed ears, and a small tail in the middle of his back.

Robinson likened him to an example from Herculaneum (Comparetti, de Petra, *La Villa Ercolanese*, pl. 16, 6). The body, with accent on the thrust of the left hip, is very like the pouring (Dresden-Palermo-Baltimore) satyr attributed to Praxiteles.

Compare, for style, a young Pan of the late Hellenistic (classicistic) period: Ars Antiqua Sale V, Lucerne, 7 November 1964, no. 53, pl. 14.

E. Robinson, *Ann. Rep.* 1896, 28f.; *AA* 1897, 73. Reinach, *Rép. stat.*, II, 781, 7; *idem*, 788, 8.

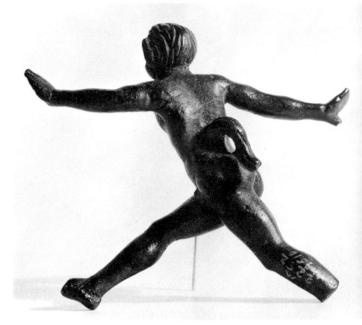

77

Young Satyr, Running

Hellenistic

H.: 0.068m.

Purchased by Contribution 01.7510

E. P. Warren Collection.

Bought in Athens.

The left foot, toes of the right foot and part of the right hand are missing. Dark brown patina.

He has a chubby body, a lively face, and a tail.

For Hellenistic bronze satyrs in vigorous poses, see Bieber, *The Sculpture of the Hellenistic Age*, figs. 447ff., 559ff.

E. Robinson, *Ann. Rep.* 1901, 36; *AA* 1902, 131; *AJA* 6 (1902) 377.

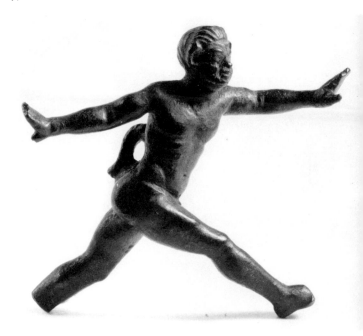

77

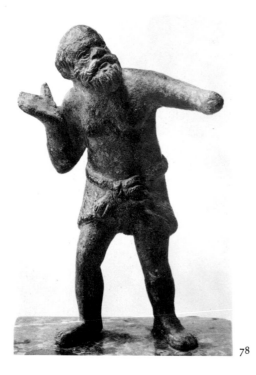

78

SILENUS
Hellenistic
H.: 0.125m.
Gift of J. J. Dixwell by Exchange 60.41

The left hand is missing.

He is standing in dramatic pose, with his feet apart and his right hand with open palm brought up to his shoulder. The missing left hand was extended. He is nude, except for a woolen cloth wrapped around his waist and knotted in front.

The pose suggests those of running actors and slaves, as the terracotta in Boston (01.7679; Bieber, *The History of the Greek and Roman Theater*, 156ff., fig. 213; 2nd edition, 81f., fig. 297).

Vermeule, *CJ* 56 (1960) 5f., fig. 5; *FastiA* 15 (1960) no. 665.

Exhibited: Cambridge (Mass.), Fogg Art Museum, *Master Bronzes*, no. 125.

78

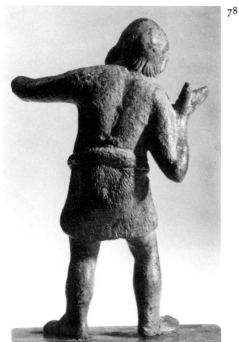

78

79

HELMETED HEAD OF ALEXANDER THE GREAT
Late Hellenistic
H.: 0.04m.
Gift of Harvard University-Museum of Fine Arts Expedition 24.878
From the tomb of King Ariteñyesbēkhe at Meroë.

Pitted; electrolytically cleaned.

The eyes of this head, from a statuette, are hollowed for filling in a different material. The helmet is crested.

Compare the bronze Alexander riding into battle, in an elephant-skin cap, from the Dattari collection and Alexandria, now in New York (Bieber, *The Sculpture of the Hellenistic Age*, fig. 298). Also, for style, the bronze (attachment) bust of an Amazon in New York (*BMMA* 1959, 58).

D. Dunham, *The Royal Cemeteries of Kush*, IV, *Royal Tombs at Meroë and Barkal*, 164, no. 22-1-4, pl. 49 G, and fig. 107.

BOY

Hellenistic

H.: 0.078m.

James Fund and Special Contribution 10.166
Bought from a London Collector (Sir Charles
Robinson?).

Dark patina, even and almost black.

He stands with his right foot advanced, his
body wrapped in a himation, his head sunk
on his breast. His hair is short in front and is
plaited behind in a sort of short pigtail.

There is a whole group of these boy orators
or child imitators of philosophers in pensive
poses. The concept of youthful heroization in
this fashion is both Hellenistic and Italic
(see G. M. A. Hanfmann, Princeton *Record* 2
[1943] 8). D. K. Hill suggests that Baltimore,
Walters no. 54.1134 (Walters *Bronzes*, 74,
no. 158) is possibly Castellani Sale, Paris 1884,
no. 441 (Reinach, *Rép. stat.*, II, 454, no. 7)
as well as Sambon Sale, Paris 1914, no. 64
(mis-quoted as no. 63) (see under Reinach,
Rép. stat., V, 181, no. 4).

The general pose used here is based on that
of the well-known Sophocles in the Lateran,
a Roman copy. That these Hellenistic statues
of boys relate to life-sized statues in marble
and bronze can be seen by comparing Lippold,
Vatican *Katalog*, III, 2, 155f., pl. 74, Galleria
dei Candelabri II, no. 4.

L. D. Caskey, *Ann. Rep.* 1910, 61; *AA* 1911, col.
474f.; *AJA* 15 (1911) 433; Chase, *Antiquities*,
116f., fig. 141; 2nd edition, 169, 182, fig. 163.

A. E. Klein, *Child Life in Greek Art*, 35, pl. 38, D;
probably Reinach, *Rép. stat.*, II, 811, no. 7 and pos-
sibly II, 454, no. 6 (Gréau Sale, 1885, no. 979).

79

79

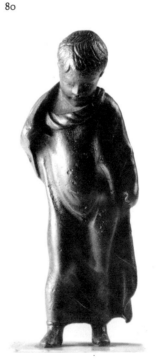

80

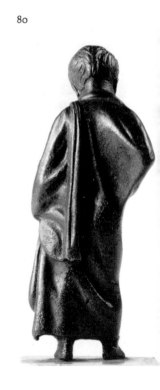

80

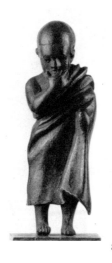 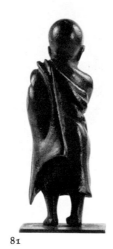

81 81

81

BOY
Hellenistic
H.: 0.054m.
James Fund and Special Contribution 10.169
E. P. Warren Collection.
Bought in Paris from a Greek dealer.

Green patina.

This very dolichocephalic lad stands hold-
ing his chin in his right hand; he is enveloped
in a himation which leaves his right arm and
shoulder bare. His hair is treated in a smooth
mass.

There are also other examples of these Hel-
lenistic caricatures in bronze, illustrations of
abnormal children which may or may not be
related to the theater. Compare Reinach,
Rép. stat., II, 484, nos. 8 (Oise) and 9 (Chalon-
sur-Saône); Bibliothèque Nationale: Babelon-
Blanchet, *Bronzes*, 430, no. 974; Froehner,
Collection Gréau, 1885, 209, no. 979.

L. D. Caskey, *Ann. Rep.* 1910, 61; *AA* 1911, col.
475; *AJA* 15 (1911) 433.

82

(NEGRO) BOY
Hellenistic
H.: 0.08m.

J. H. and E. A. Payne Fund 59.11
Found at Chalon-sur-Saône, 1763-1764, in an
oak chest containing eighteen master bronzes,
and acquired by the Comte de Caylus. Be-
queathed with five others to the Duc de Caylus
in 1765 and acquired from his descendant.

The right hand was pierced to hold an object,
now missing, undoubtedly a scroll or *rotulus*
manuscript. There is a pin in the middle of
the back; it is perhaps the remains of a collec-
tor's mounting in antiquity.

His head is bent somewhat forward, as if
nodding in the urgency of an important
speech. He wears an ample himation, wrapped
around his body and over his clenched left
fist. The surfaces are delicately finished, with
the fleecy hair, the face and the bent legs of
the subject being carefully delineated. The dra-
pery is very precisely modelled.

This statuette dignifies its subject. Usually
the Greeks represented non-Greek races as
social commentaries or in comic, even degrad-
ing poses. The negro boy presented here is a
product of the Hellenistic (Alexandrian?) love
of representing children as orators, a theme to
which touches of whimsy were often imparted.
Here, the noble little boy making his speech is
deadly serious, and the fact that he is of
African descent is testimony to the broadness
of the Greek world, especially the Graeco-
Egyptian world after Ptolemy II added Ethio-
pia on the upper Nile to Macedonian Greek
Egypt. He is some princely lad from upper
Egypt or beyond, sent to study among the
philosophers and teachers of rhetoric in
Alexandria.

There is a connection, not accidental, with
monumental art and the representation of
ancient men of intellect. Several other Hellen-
istic statuettes in bronze, marble and terra-
cotta preserve reflections of well-known
statues of Greek men of letters. The Socrates
in the British Museum, the Demosthenes in a
private collection in New York (Bieber, *The
Sculpture of the Hellenistic Age*, 2nd edition,
67, figs. 226ff.), and the possible Hermachos
of Mytilene in the Metropolitan Museum

(Richter, *Latomus* 36 [1959] 25f., fig. 37) are among the leading examples. In these bronzes showing children as orators, they are often posed like their counterparts representing famous men. This negro boy follows the pose of the Epicurean Hermachos in New York, if the identification is correct. At least this may be a standard pose for Epicureans, and the African boy may have been a student in one of the schools of that philosophy.

Vermeule, *Ann. Rep.* 1959, 27; MFA *Calendar of Events*, March 1960, 2 and illus.; Vermeule, *CJ* 55 (1960) 198ff., fig. 7; *FastiA* 15 (1960) nos. 208, 671; *FastiA* 17 (1962) no. 243.

F. M. Snowden, *Blacks in Antiquity, Ethiopians in the Greco-Roman Experience* (Cambridge [Mass.], 1970) 28, 89, fig. 64, 186, 194-195.

83

DWARF SEATED
Hellenistic
H.: 0.057m.
Gift of Mrs. Charles Gaston Smith's Group
34.42

The left arm is missing below the elbow. Green patina, corroded.

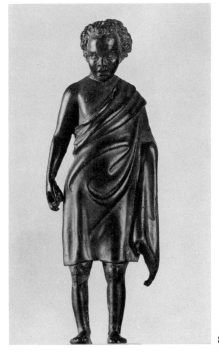

82

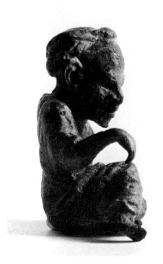

83

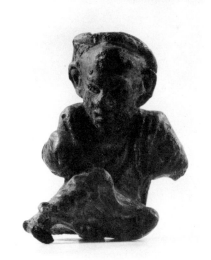

83

tomb-relief or a freestanding (decorative or fountain) figure. The original conception goes back, in the fourth century, to something such as the mourning boy on the Lysippic grave-relief from the Ilissos (Diepolder, *Attischen Grabreliefs*, pl. 48). The ultimate prototype may have been a Praxitelean sleeping Eros. A late Hellenistic alabaster statuette in London (1914. 10-20.1) has such an Eros as support for an Aphrodite removing her sandal.

In bronzes, compare the "Somnus" in the British Museum (Walters, British Museum *Bronzes*, 246, no. 1509); see also the bronze Eros: Reinach, *Rép. stat.*, II, 448, no. 6, with quiver and bow. There are many related Graeco-Roman statues in marble (Copenhagen, F. Poulsen, *Cat.*, no. 176; Amelung, Vatican *Cat.*, I, no. 287; Villa Albani, *EA*, no. 4561, also Florence, Corsini al Prato, no. 4085). The figure has a fruitful history on sarcophagi (e.g. Mustilli, *Museo Mussolini*, 98, nos. 232f., pl. 58).

84

He has inlaid eyes and is shown with a withered right hand. He wears chiton and small himation.

Hill, Walters *Bronzes*, 73, under no. 156.

Exhibited: Hartford, *The Medicine Man Medicine in Art*, 31, no. 149.

84

SLEEPING BOY
Hellenistic
H.: 0.029m.
Gift of C. Granville Way 72.4439
Hay Collection.
Presumably from Egypt.

Greenish patina; corroded.

He is seated on the ground, with knees raised, resting his head on the right knee.

The motif of the resting, sleeping, or mourning child, fisherboy, or Eros, etc., in this or in exactly reversed position enjoys a long history in Hellenistic and Roman art, as a

85

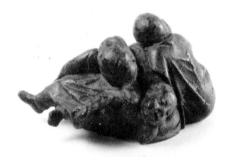

85

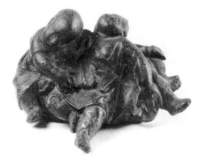

SLEEPING CHILDREN
Hellenistic
H.: 0.024m. Greatest dimension: 0.053m.
James Fund and Special Contribution 10.170
E. P. Warren Collection.
Bought in Sicily and probably found there.

Even green patina.

The three sleeping children, in short tunics,
are huddled closely together. Their hair is
slightly indicated.

A comparable marble group was once in the
Westmacott collection in London (Michaelis,
Ancient Marbles, 487, no. 4; Reinach, *Rép.
stat.*, I, 535, no. 2); another is in the Vatican
(Lippold, *Katalog*, III, 2, 150f., pl. 71).

L. D. Caskey, *Ann. Rep.* 1910, 61; *AA* 1911, col.
475; *AJA* 15 (1911) 433.
Klein, *Child Life in Greek Art,* 7, pl. 7, B.

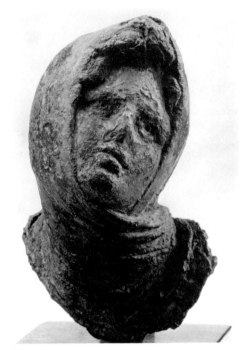

86

HEAD AND SHOULDERS OF AN ALEXANDRIAN
DANCING GIRL
Hellenistic
H.: 0.098m.
James Fund and Special Contribution 10.168
E. P. Warren Collection.
Bought from a Greek dealer.

Light green patina; somewhat corroded. The
pupils are drilled and were once presumably
inlaid.

The head is bent upward and to the left,
with himation wound around so as to leave
only the face exposed. The work is very deli-
cate.

The complete statue, recognized for what it
was by Dorothy Burr Thompson, can be visu-
alized from the bronze in Walter Baker's col-
lection in New York (D. von Bothmer, *Cata-
logue,* 9, no. 46, illus.; idem, *Ancient Art from
New York Private Collections*, 37f., no. 144,
pls. 44, 50, 51; idem, *Ancient Art in Ameri-
can Private Collections*, 32, no. 221).

L. D. Caskey, *Ann. Rep.* 1910, 60; *AA* 1911, col.
474; *AJA* 15 (1911) 433.

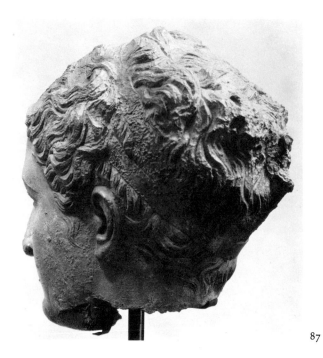

QUEEN ARSINOË II

Circa 300 B.C.

H.: 0.255m.

C. P. Perkins Collection 96.712

E. P. Warren Collection; Tyszkiewicz Collection.

Said to have been found at Memphis.

Green patina. This was probably a slightly defective, but finished, casting. There is a break in the hair, and the right side has been jammed in. The chin is repaired.

The eyes were inserted, and the lips were coated in another metal.

The wife of Lysimachus of Thrace and (later) of Ptolemy II Philadelphus (285 – 246 B.C.) is seen well before the age of twenty, at the outset of her career.

87

87

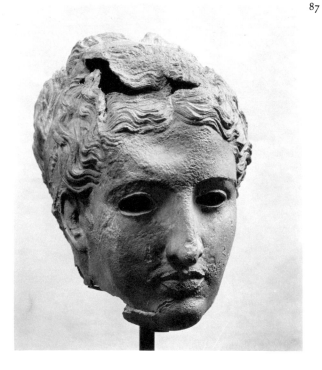

E. Robinson, *Ann. Rep. 1896*, 26f.; *AA 1897*, 73; *BMFA 1* (1903) 15; J. Addison, *The Boston Museum of Fine Arts*, 295-296; Chase, *Greek and Roman Sculpture in American Collections*, 128ff., fig. 160; *idem, Antiquities*, 110ff., fig. 135; 2nd edition, 166, 176, fig. 156; *idem, Greek Gods and Heroes*, 14, fig. 4; 1962 edition, 14ff., fig. 4; Caskey, *Catalogue*, 118ff., no. 56, 2 illus.; Vermeule, *Greek and Roman Portraits 470 B.C. – A.D. 500*, no. 14, illus.; *Handbook 1964*, 80f., illus.; *Museum of Fine Arts, Boston, Western Art* (Japanese edition, Tokyo, 1969) pl. 17, 153, no. 17; *Museum of Fine Arts Boston* (Newsweek/Great Museums of the World, New York, 1969) 92, illus.; W. Whitehill, *Museum of Fine Arts Boston, A Centennial History* (Cambridge [Mass.], 1970) 153, illus.

Froehner, *La Collection Tyszkiewicz*, pls. 43, 44; A. W. Lawrence, *JEA 11* (1925) 186, pl. 23; Lippold, *Handbuch*, 328; D. B. Thompson, *AJA 59* (1955) 205f.; Eydoux, *Les grandes dames de l'archéologie*, 163, fig. 183; Richter, *The Portraits of the Greeks*, 262; S. A. Immerwahr, *Ancient Portraits*, Ackland Art Center, University of North Carolina at Chapel Hill, 1970, under entry no. 2.

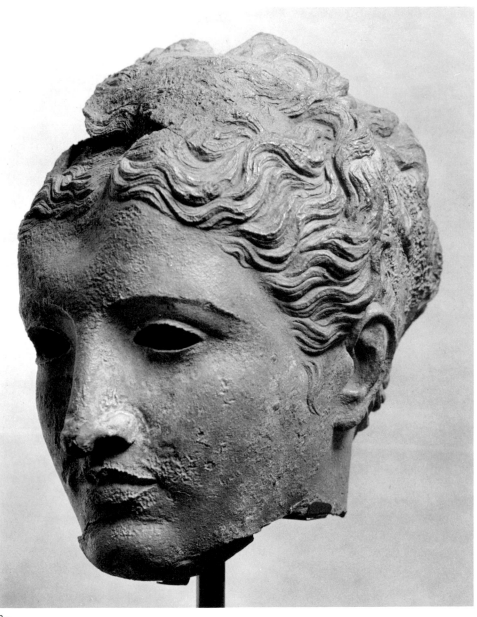

87

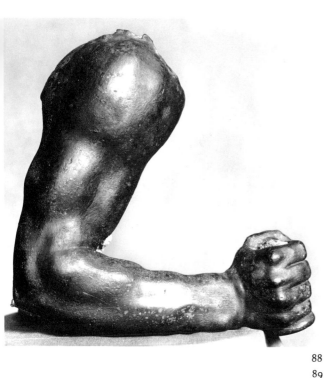

88

RIGHT ARM
Hellenistic
H.: 0.236m. L. (of forearm): 0.29m.
Purchased by Contribution 01.7517
E. P. Warren Collection.
Bought from Furtwängler.

Dark brown patina.
 This vigorous right arm is bent at the
elbow, the right hand being clenched (around
the shaft of a spear or staff?). The style is that
of the earlier sculptures in the school of
Pergamon.

E. Robinson, *Ann. Rep.* 1901, 36.

89

LEFT FOREARM AND HAND
Hellenistic
L.: 0.108m.
James Fund and Special Contribution 10.167
E. P. Warren Collection.
Bought in Rome.

Hollow-cast, green patina. The object (strigil?)
held in the hand is incomplete.
 This equally vigorous forearm has carefully
modelled muscles and veins, suggestive of the
later school of Pergamon. The Laocoon, for
instance, represents veins in similar detail.

L. D. Caskey, *Ann. Rep.* 1910, 60f.; *AA* 1911, col.
474; *AJA* 15 (1911) 433.

Johnson, *Lysippos*, 77, pl. 14a; Picard, *Manuel*,
IV, 2, 457, note.

88
89

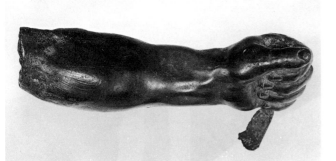

90

LEFT FOOT
Hellenistic
L.: 0.09m.
Francis Bartlett Collection 03.995
E. P. Warren Collection.
From Lykosoura.

Brown patina.

B. H. Hill, *Ann. Rep.* 1903, 60; *AA* 1904, 194; *AJA*
8 (1904) 382.

HEAD OF A DOG
Hellenistic
L.: 0.038m.
Gift of Mrs. Edward Jackson Holmes 52.189

Hollow cast; brown patina.

The hound's head is straining forward with the ears curled back, neck terminating in a collar. The head and neck were made as a fitting for a circular, tubular shaft.

Dog's heads such as this occur as furniture fittings or terminals: e.g. *Fouilles de Delphes* V, 126, no. 682, fig. 470 *bis*. For a comparable marble, see *EA*, no. 3912.

BMFA 50 (1952) 33 (list of eight bronzes given by Mrs. Holmes); H. Palmer, *Ann. Rep. 1952*, 19.

91

 90

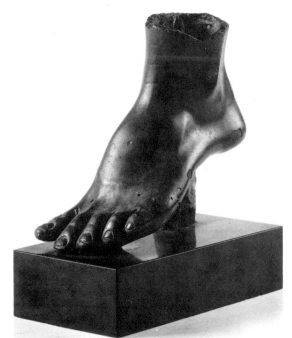

SOW AT BAY
Hellenistic
H. (max.): 0.10m. L.(max.): 0.19m.
William Francis Warden Fund 64.510
From Beirut Art Market.

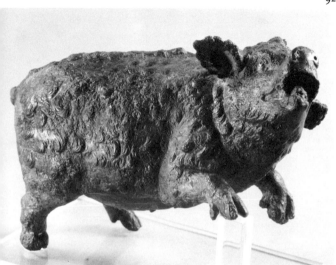

92

92

Green and brown patina. Encrusted.

The sow is about to crouch backwards, as if to spring. The mouth is open, and the tongue and upper teeth show. The eyes are inlaid in silver, and the fur or bristles are carefully cast and chasened.

This master bronze, with its spirited and careful treatment of subject, may have been part of a group, a hunter and the hunted, or a sow protecting her young.

Compare the Hellenistic decorative works and the reflections of the Laurentian sow: F. Poulsen, Ny Carlsberg Glyptotek, *Catalogue of Ancient Sculpture*, 352f., no. 494a; Richter, *Animals*, 25, 68, fig. 119. The marble boar, trotting along, in Madrid is a Roman copy of a work comparable in quality to the bronze from Syria (O. Keller, *Die antike Tierwelt* I, 388ff., 405, fig. 141; Reinach, *Rép. stat.*, IV, 503, no. 1). A bronze tigress in Copenhagen (Poulsen, *op. cit.*, 604, no. Br. 1) has stripes of fur inlaid in copper; the eyes are also set in with another metal.

The well-known group in Naples from Pompeii (no. 4899), a boar assaulted by two hounds, comes to mind as a possible indication of the type of group to which this sow belonged (see Chiurazzi, 144, no. 229; Reinach, *Rép. stat.*, III, 219, no. 10).

Rathbone, *Ann. Rep. 1964*, 15; Vermeule, *Ann. Rep. 1964*, 33, 34, illus.; MFA, *Calendar of Events*, March 1965, 1, illus.; Vermeule, *CJ* 61 (1966) 302f., 297, fig. 18.

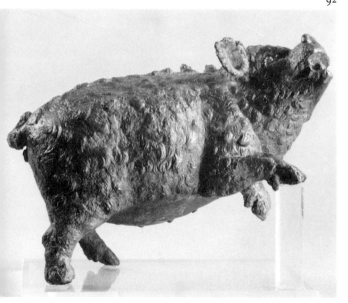

APOLLO

Graeco-Roman

H.: 0.30m.

H. L. Pierce Fund 98.674

E. P. Warren Collection; Tyszkiewicz Collection.

Found in Rome (Froehner says Italy).

Arms broken off just below the shoulders. They were made separately and joined. Cast solid. Tiber (brownish yellow) patina.

His hair is done in a knot on the top of the head, a style of wearing the hair known best from the Apollo Belvedere or the Apollo Giustiniani (see British Museum, A. H. Smith, *Catalogue of Sculpture*, III, 15f., no. 1547, pl. 3). The whole statuette is a good interpretation of an original of the third or last quarter of the fourth century B.C. It is in many respects a mirror reversal of the Apollo known as the Palazzo Vecchio type, dated by Lippold between 350 and 320 B.C. (*Handbuch*, 264, pl. 96, 2).

E. Robinson, *Ann. Rep.* 1898, 32; *AA* 1899, 137f.; *AJA* 3 (1899) 570; *BMFA* 1 (1903) 15; J. Addison, *The Boston Museum of Fine Arts*, 295, illus.

Froehner, *La Collection Tyszkiewicz*, 17f., pl. 20; Reinach, *Rép. stat.*, II, 100, no. 11; *ibid.*, IV, 52, no. 2.

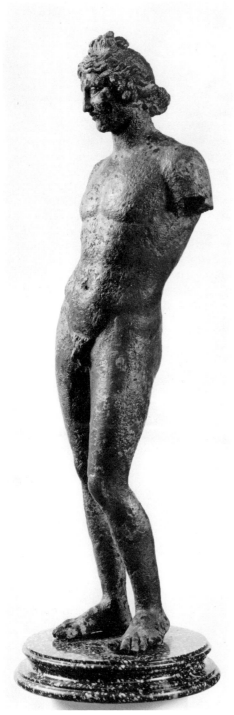

93

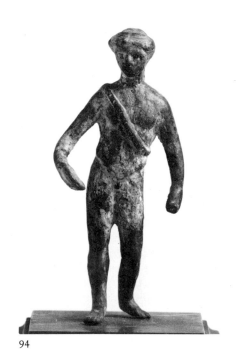

94

APOLLO
Graeco-Roman
H.: 0.066m.
Gift of E. P. Warren 96.664

Remains of part of bow in left hand. Crusty green patina.

He wears a quiver suspended from a strap and holds a phiale in the right hand. His hair is arranged in a long coil behind.

Although the work is rather crude, the prototype is clearly pre- or early Praxitelean in date. In hair style this Apollo is the male counterpart of the Artemis Colonna (see *AJA* 68 [1964] 330f., pl. 101).

Compare the statuette of Apollo in the Burlington Exhibition of 1903: *Ancient Greek Art*, 1904, 47, no. 40, pl. 51.

E. Robinson, *Ann. Rep.* 1896, 28; *AA* 1897, 73 (type of fourth century).

94

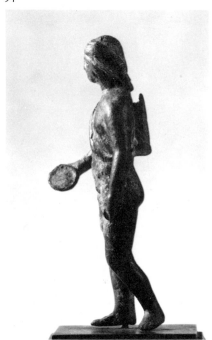

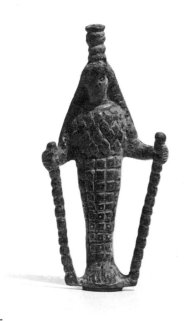

95

DIVINITY SIMILAR TO THE EPHESIAN ARTEMIS

Graeco-Roman, circa A.D. 100 to 300
H.: 0.073m.
Arthur Mason Knapp Fund 66.951
From Asia Minor.

Green patina, with earth encrustations.

She wears polos and veil. Her usual costume is otherwise reduced to a series of triangles in relief and similar rectangles. Both the schematic breasts and the reliefs of the body cover only the front half of the figure. The back is smooth, following the statue's contours.

In general this statuette is a miniature version of the Ephesian Artemis, outstretched hands supported at the wrists by the slender, sculpted pillars running to the base and flanked by a pair of stags. Elimination of the animals and placing of the supports in the hands of the goddess are natural variations on so small a scale. A Hellenistic terracotta from Smyrna in the Museum of Fine Arts (03.886a) omits these poles altogether, as do many marble versions of the huge image in various sizes, for some claim and coins confirm that the pillars of the original statue may have been long, twisted, complex fillets (H. Thiersch, *Artemis Ephesia*, Abhandlungen der Gesellschaft der Wissenschaften zu Göttigen, Berlin 1935, I; C. Seltman, *Num Chron* 12 [1952] 33 – 51).

Greek imperial coins demonstrate, however, that a statuette such as this may reproduce the cult image of a city other than Ephesus. Such images, copying the famous Artemis, were popular in a number of Anatolian cities that were prosperous in late Hellenistic and, particularly, imperial times. At least thirty such cities have been recorded, mostly in Lydia and Phrygia (B. V. Head, *Historia Numorum*, 941).

Vermeule, *Ann. Rep. 1966*, 54; *idem, CJ* 63 (1967) 56, fig. 8 (left), 58f.

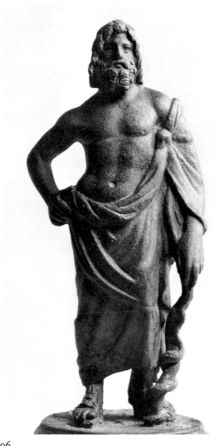

96

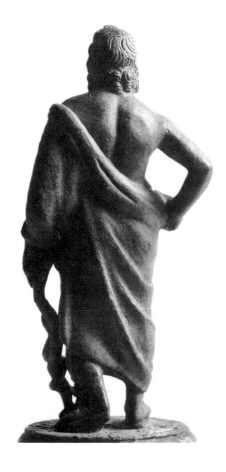

96

96

ASKLEPIOS
Graeco-Roman
H.: 0.127m.
Purchased by Contribution 01.7484
E. P. Warren Collection; A. Furtwängler
Collection.

Dark green patina. The base is modern.

Asklepios wears a full himation, falling
from his left shoulder in full folds around his
waist. The serpent-entwined staff is in his low-
ered left hand, and the right hand is on his
hip.

For this widely found type, derived from
statues at Cos and Epidaurus, see Bieber,
PAPS 101 (1957) 80-87; Reinach, *Rép. stat.*,
II, 31, no. 2.

For quality and style in this bronze, com-
pare van Gulik, Allard Pierson *Bronzes*, 14f.,
no. 23, pl. 7. The drapery retains the simple,
broad folds of the fourth-century figures,
rather than the fussiness of many Roman
copies in marble.

E. Robinson, *Ann. Rep.* 1901, 36; *AA* 1902, 131;
AJA 6 (1902) 377.

Exhibited: Hartford, *The Medicine Man Medicine
in Art*, 57, no. 348, pl. 2.

ASKLEPIOS
Graeco-Roman
H.: 0.103m.
Gift of Jerome M. Eisenberg 67.1025

Right hand, right foot, left foot, and staff are
missing. Green patina.

Asklepios stands with weight on his left
leg, leaning on the staff that was in his right
hand. His left hand is mostly concealed in the
overfolds of his ample himation at his left
side.

The work is precise yet vigorous. The type
is a variant of the Jameson Asklepios in
Cincinnati, with the triangular fold of the
himation across the pelvis reduced to a
series of deep V-shaped folds (Bieber, *PAPS*
101 [1957] 70-92, figs. 1-4). A number of
Roman marble copies define the type more pre-
cisely, showing that the fold over the abdo-
men was omitted either in major Graeco-
Roman versions or even in statues and reliefs
of the late fifth and fourth centuries B.C.
(see Bieber, 73ff., figs. 5-8).

Vermeule, *Ann. Rep. 1967*, 47.

J. M. Eisenberg, *Art of the Ancient World*, II
(New York, 1966), no. 32, illus.

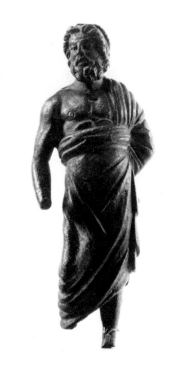

96A

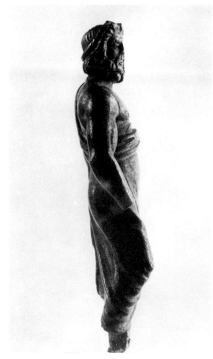

96A

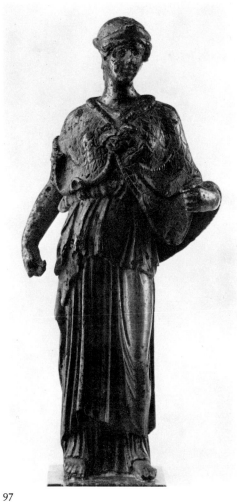

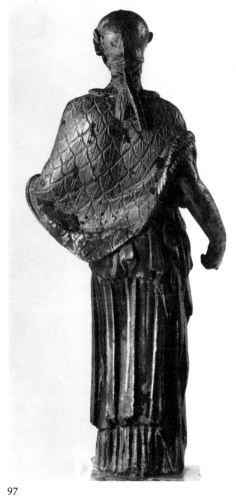

97

97

<u>97</u>

Athena
Graeco-Roman, circa A.D. 100 to 200
H.: 0.151m.
*Gift of Samuel Dennis Warren and
Everett Fund 87.7*
Collection of Herr Josef Zervas.
Found in 1871 near Ettringen, at a mountain
shrine to Minerva in the vicinity of Coblenz,
on the Rhine.

Spear missing from left hand; fulmen (?) was
held in the right.

This statuette, of "Pheidian" type with large aegis and Gorgoneion, is characterized by a tight-fitting Athenian helmet. The type, going back to the late fifth century B.C., is represented in a Roman marble statuette in Istanbul from Lepcis Magna (no. 532; Schede, *Meisterwerke der türkischen Museen zu Konstantinopel*, pl. 8) and a head in the collection of Joseph V. Noble, Maplewood, New Jersey (D. von Bothmer, *Ancient Art from New York Private Collections*, 29f., no. 117, pl. 39).

E. Robinson, *Ann. Rep.* 1887, 8-10; *AJA* 4 (1888) 124; *BMFA* 1 (1903) 15; *M.F.A. Handbook*, 1906, 40; 1908, 69; J. Addison, *The Boston Museum of Fine Arts*, 296; Burdett, Goddard, *E. P. Warren*, 133; Beazley in *op. cit.*, 331; Chase, *Antiquities*, 2nd edition, 225, 259, fig. 242; *idem*, *Greek Gods and Heroes*, 22, fig. 9; 1962 edition, 25f., fig. 10; W. Whitehill, *Museum of Fine Arts Boston, A Centennial History* (Cambridge [Mass.], 1970) 67, illus., 147.

Heydemann, *Jahrbücher des Vereins von Alterthumsfreunden im Rheinlande*, Bonn, 73 (1882) 51-52, pls. 1, 1a; Reinach, *Rép. stat.*, II, 274, no. 8; *idem, Apollo*, 1905, 52f., fig. 69; English edition, 1904, 52, fig. 71; Niemeyer, *Promachos*, 83, note 321 (the modern replica); Münzen und Medaillen, Auktion XXXIV, 6 May 1967, under no. 40.

Exhibited: Detroit, *Small Bronzes of the Ancient World*, 12, no. 96.

98

ATHENA

Graeco-Roman

H.: 0.092m.

Francis Bartlett Collection 03.990
E. P. Warren Collection; Sir Charles Robinson Collection.

Crest on helmet, spear (left hand) and object on right hand (owl? or phiale?) missing. Brown patina.

The Corinthian helmet is inlaid with silver.

In general concept, with arms reversed, the type is that of the Athena from Velletri, circa 450 to 420 B.C. (Lippold, *Handbuch*, 173, pl. 62, 3), the drapery taking more of the arrangement of the Athena Medici (see above, under no. 40). With variations, the figure is found in the mid-fourth century in the monumental bronze Athena from the Piraeus cache of 1959 (Vanderpool, *AJA* 64 [1960] 266, pls. 68f.; Holloway, *AJA* 67 [1963] 212). In small bronzes, the Athena in Mariemont (P. Lévêque, *Les Antiquités du Musée de Mariemont*, 89, G. 62, pl. 32), who holds a phiale, provides an excellent parallel; there are merely variations in the draping of the aegis. The Athena from the Piraeus, incidentally, as D. von Bothmer has suggested, also probably held a phiale.

B. H. Hill, *Ann. Rep.* 1903, 60; *AA* 1904, 194; *AJA* 8 (1904) 382; *BMFA* 2 (1904) 7.

Reinach, *Rép. stat.*, II, 283, no. 8.

98

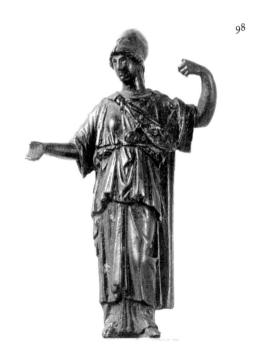

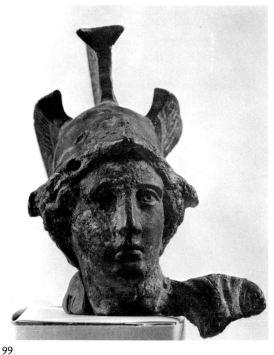

99

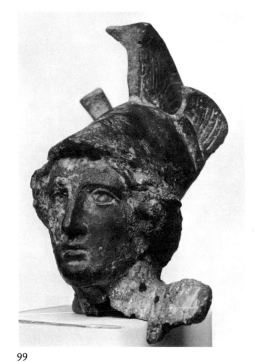

99

99

ATHENA
Graeco-Roman
H.: 0.102m.
C. P. Perkins Collection 96.662
E. P. Warren Collection.
Acquired in Rome.

Fragment of a statue; only the head with triple-crested helmet, neck and part of left shoulder with drapery survive. Heavy green patina, much of which has been removed.

 Like the previous, the type is characterized by the himation (or end of the aegis) wrapped around the neck and thrown over the left shoulder. The plumes of the crests are rendered by summary incisions, and the expression of the pupils might suggest a date in the second century A.D. or later.

E. Robinson, *Ann. Rep.* 1896, 28; *AA* 1897, 73.

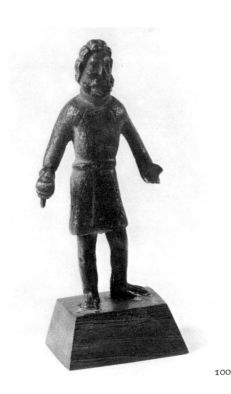

orthodox imperial pantheon in the Roman West. Gallo-Roman representations of Dispater, very numerous, vary in size and quality. Most, like this, are crude votives, but a few large statuettes rival good likenesses of Jupiter, indicating that wealthy Gauls turned to skilled Graeco-Roman artists for these (cf. Babelon-Blanchet, *Bronzes*, nos. 694-698; Walters, British Museum *Bronzes*, 142f., nos. 788-791, pl. 21). For a stylistically comparable piece, see *Annales . . . Besançon*, vol. 26, *Archéologie* 8, *Bronzes*, pl. 8.

Vermeule, *Ann. Rep.* 1959, 26f.; *idem, CJ* 56 (1960) 10f., fig. 13; *FastiA* 15 (1960) nos. 208, 665.

100

EROS
Graeco-Roman
H.: 0.042m.
Gift of C. Granville Way 72.4441
Hay Collection.

Heavily encrusted. Right arm from middle of forearm and left hand are missing.

He advances with left foot forward and arms outstretched, bent at the elbow. He could have held a bow and arrow, or a fillet.

For similar Erotes running, compare the examples in the Bibliothèque Nationale (Babelon-Blanchet, *Bronzes*, nos. 277-279).

100

DISPATER
Circa A.D. 100 to 300 (Gallo-Roman)
H.: 0.083m.
Gift of Mr. and Mrs. C. C. Vermeule III
59.692
From Paris.

Remains of a hammer or mallet in right hand; jar was held in left.

He wears a long-sleeved, belted tunic and trousers.

His costume is traditional to artisans from the Roman imperial period (especially in the Latin West) through the Middle Ages to the Renaissance. His face, hair and beard are crude transcriptions of the features identifying Roman Jupiter.

Dispater, widely worshipped in Roman Gaul, incorporated in his Celtic manifestation aspects of Jupiter, Pluto and Vulcan, powers designed to make him one of the most important native divinities existing alongside the

101

102

102

102

FLYING EROS
Graeco-Roman
H.: 0.048m.
Gift of the Estate of Mrs. Susan C. Warren
02.41

Part of left foot missing. Blackish patina with green corrosion.

His right arm is raised (and further bent since antiquity), and his left is extended.

Compare examples in Autun (Reinach, *Rép. stat.*, IV, 263, no. 1), Baltimore (Hill, *Walters Bronzes*, 31f., no. 57, pl. 16), and Amsterdam (van Gulik, *Allard Pierson Bronzes*, 19, no. 31, pl. 10). The Eros in the Karapanos Room of the National Museum, Athens (no. 519), is shooting a bow.

103

HARPOCRATES
Graeco-Roman
H.: 0.176m.
Gift of C. C. Vermeule III 59.30
Found in Western Asia Minor.

Encrusted; green patina.

Harpocrates is represented as a chubby child wearing an elaborate headdress topped by the uraeus characteristic of the Egyptian god Horus. His right hand points to his mouth, and he carries cornucopiae in the left.

Cults of the Egyptian divinities were widespread in Asia Minor in Hellenistic and Roman times, and this Harpocrates is of good quality compared with the mass-produced statuettes crowding every major museum in Europe and the Near East (compare Hill, *Walters Bronzes*, 36f. under nos. 68-75).

In Hellenistic times the baby god Eros or Cupid was developed into the concept of the Egyptian Harpocrates, the infant Horus, who was originally represented as sucking his finger and later as merely placing it close to his lips. This gesture, in its earlier form, was erroneously interpreted by the Romans as one of silence, and hence they gave to the child Horus (Har-pa-chrat in Egyptian) the name of Harpocrates whom they regarded as the god of silence. The popularity of the type stemmed not so much from the religious connections but, as is obvious here, from the late Hellenistic love of the child form.

Harpocrates appears in reliefs and on Alexandrine coins together with Isis and Sarapis, and the triad was worshipped not only in Alexandria but in Rome where all three had shrines in the Iseum and Sarapeum of the Campus Martius. The evidence of the statuary types with which the Harpocrates of this bronze appears suggests the ultimate prototype was a cult-statue set up in Alexandria in the third century B.C. (full discussion under London, Soane Museum, *Catalogue*, no. 429).

A similar bronze, the same size, is in the Chalkis Museum.

Vermeule, *CJ* 55 (1960) 200, fig. 8; *FastiA* 15 (1960) no. 671.

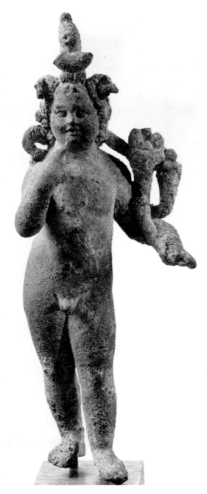

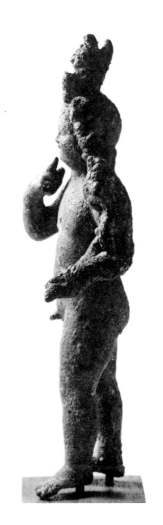

103

103

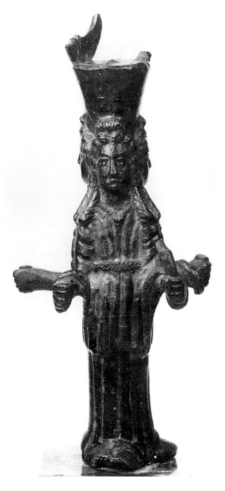

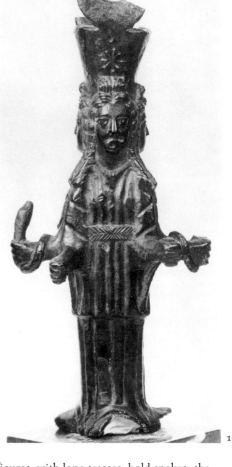

104

104

104

TRIPLE HEKATE
Graeco-Roman, A.D. 50 to 200
H. (max.): 0.176m.
Edwin E. Jack Fund 64.6
Fauvel Collection.
Said to have been found on the island of
Aegina.

Brown patina; two attributes above polos,
two snakeheads, and the two torches are miss-
ing. So also much of two of the feet.

She wears Doric chiton with long peplos-
like overfold, a wreath-like belt, a polos with
three stars, and crescent on top. Two of the

figures, with long tresses, hold snakes; the
third held two torches.

The Hellenistic topknot headdresses suggest
a later intermediary between some fifth-
century prototype and this bronze of the im-
perial period. T. Kraus (*Hekate*, Heidelberger
Kunstgeschichtliche Abhandlungen, vol. 5,
1960) illustrates nothing comparable, al-
though a marble example in Berlin from Rome
(pl. 20, 1) has a freer version of similar dra-
pery. Compare Stuart Jones, *Conservatori*,
pl. 114, which shows the variety of attributes
and headgear possible in one of these Graeco-
Roman bronzes. The bronze triple Hekate of
similar size and Graeco-Roman date in Sir

John Soane's Museum, London, is a much purer copy of a possible fifth century prototype (*Catalogue,* no. 432).

There is a similar Hekate in the Karapanos Room of the National Museum in Athens (no. 523) and several in the British Museum (Walters, British Museum *Bronzes,* 183, nos. 1011-1014). A related statuette is in Kassel: Bieber, *Cassel,* 59f., no. 148, pl. 42.

Vermeule, *CJ* 60 (1965) 295f., fig. 9.

O. von Stackelberg, *Die Graeber der Hellenen* (Berlin, 1837) 47, pl. 72 (= Reinach, *Rep. stat.,* II, 2, 323, no. 9).

Exhibited: Cambridge (Mass.), Fogg Art Museum, *Master Bronzes,* no. 291.

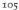

105

105

HEAD OF HELIOS, WITH STYLIZED RADIATE CROWN AND URAEUS

Second to Third Centuries A.D.

H. (max.): 0.075m.

Gift of Mr. and Mrs. C. C. Vermeule III

64.316

Acquired by the former owner (H. C. Morton, the author) in Jerusalem.

Light green patina. The neck is irregular, suggesting it was broken from a statuette.

The hair is wavy, in the tradition of Alexander the Great. The pupils are incised. The rays of the crown are like a cap of leaves.

Comparison with coins suggests the ultimate influence of the colossal statue of Helios at the entrance to the harbor of Rhodes (H. Maryon, *JHS* 76 [1956] 68ff.). The statuette, for the head comes from a fairly large bronze (about two feet high), must have been one of those soft, rubbery products characteristic of Graeco-Roman art along the Syrian coast in the second or third centuries A.D. A bronze from the Gréau collection shows the Helios one stage back toward the Hellenistic type and just before addition of the uraeus (Froehner, *Collection Gréau,* 196f., no. 946). A more classical example in the British Museum is Praxitelean in attitude: here the rays that become the stylized radiate crown are much more clearly defined as rays (Walters, British Museum *Bronzes,* 183, no. 1015, pl. 28). The concept of Helios with uraeus, in the Graeco-Roman art of Syria and Egypt, stems from representations of Apollo or Hermes with high headdress, dominated by a single feather. These are Polykleitan or neo-Polykleitan figures which may go back to some famous image of the fifth or fourth century B.C. (compare Schumacher, Karlsruhe *Bronzen,* 178, no. 934).

H. Hoffmann, *JARCE* 2 (1963) 121, pl. 27, fig. 15; Vermeule, *Ann. Rep.* 1964, 31.

106

106

106

HERAKLES
Graeco-Roman
H.: 1.01m.
C. P. Perkins Collection 95.76
E. P. Warren Collection.

Put together from fragments. Mane and head of lion-skin restored; also a piece in the upper part of the right thigh, and a small piece in the middle of the back. Dark patina with green encrustation.

He held a drinking cup in his extended right hand. This Herakles, surviving in over thirty copies, goes back to an original of the Pergamene school, a variant of the statues in which Herakles holds the infant Telephos, and ultimately to a creation of the fourth century B.C., also surviving in Graeco-Roman marble copies.

E. Robinson, *Ann. Rep.* 1896, 25f.; *AA* 1897, 73; Chase, *Antiquities*, 154f., fig. 203; 2nd edition, 225, 259, fig. 241; *idem, Greek and Roman Sculpture in American Collections*, 145ff., fig. 172.

Furtwängler in Roscher, *Lexikon* I, col. 2180; J. R. Wheeler, *AJA* 10 (1906) 377-384, pls. 14-15; Reinach, *Rép. stat.*, IV, 127, 8; Andrén, *OpusArch* 5 (1948) 17ff.; P. Staccioli, *ArchCl* 9 (1957) 41, no. 22 (of 28 statues in list); Congdon, *AJA* 67 (1963) 12; R. Tölle, *JdI* 81 (1966) 167.

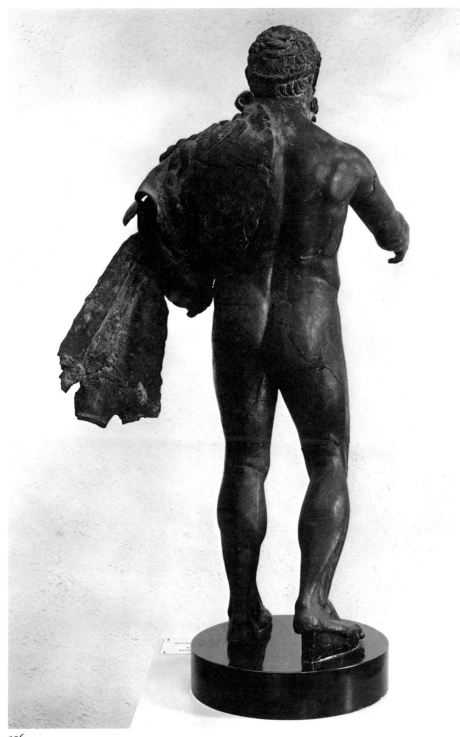

106

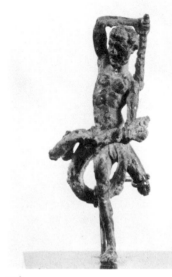

108

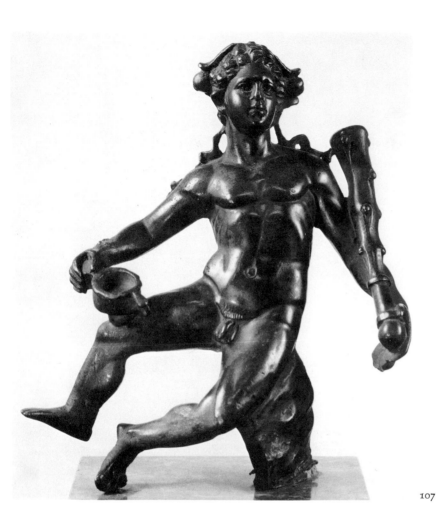

107

107

HERAKLES
Graeco-Roman
H.: 0.167m.
Gift of E. P. Warren 01.8375
Bought in London.

A large piece is cut out of the back. There is a
hole in the right knee. The patina is glossy
green-brown.

The hero reclines on a rockwork support.
He is wreathed and holds a club and skyphos.

For the reclining Herakles of this type in
small bronzes, see J. Sieveking, *Münchner*

Jahrbuch der bildenden Kunst, N. F. I, 1
(1924) 13f. Here the face and body go back
through a Hellenistic original to the Herakles
of Skopas, set up in the gymnasium at Sikyon.
This standing, poplar-crowned Herakles is
known from at least two complete Graeco-
Roman copies in marble and from the series
of busts of the Genzano type, often copied as
herms (see *JHS* 77 [1957] 292, especially
note 40).

E. Robinson, *Ann. Rep.* 1901, 36; *AA* 1902, 131;
AJA 6 (1902) 377.
Exhibited: Cambridge (Mass.), Fogg Art Museum,
Master Bronzes, no. 261.

108

HERAKLES AND THE "HYDRA"
Graeco-Roman
H.: 0.038m.
Gift of E. P. Warren Res. 08.328
Bought in Rome.

Crusty green and brown patina.

He is striking at his seven-headed phallos with his club.

The elongated, manneristic qualities of this figure suggest it or its prototype is an original of the end of the Hellenistic period, around 50 B.C. in the Greek East.

Amelung suggests the parody of myth may be connected with the Cynic philosophers. The "portrait" bears some resemblance to the emperor Commodus, but if a specific person is represented he is a man of the Hellenistic as much as the Antonine age.

Mis-drawn as Reinach, *Rép. stat.*, IV, 137, 6; Amelung, *JOAI* 12 (1909) 183-185, fig. 92; Amandry, *Bull . . . Strasbourg* 30 (1952) 300, no. 78 in list of Herakles – Hydra.

109

HERMES
Graeco-Roman
H.: 0.148m.
Francis Bartlett Collection 03.988
E. P. Warren Collection.
Bought in Paris; said to be from Auverque.

Missing: wings on head (holes remain behind the fillet), fingers of right hand, and kerykeion held in left. There are traces of gilding.

The type belongs ultimately to the fourth century and recalls, in somewhat clumsy, toned-down fashion, the Agias of Lysippos at Delphi (see Lippold, *Handbuch*, 286f., pl. 102, no. 3).

B. H. Hill, *Ann. Rep.* 1903, 60; *AA* 1904, 194; *AJA* 8 (1904) 382; *BMFA* 2 (1904) 6-7.

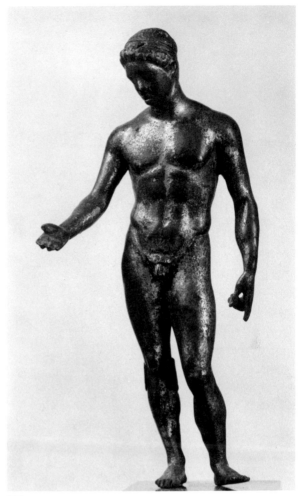

109

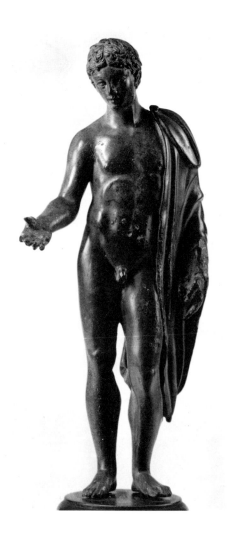

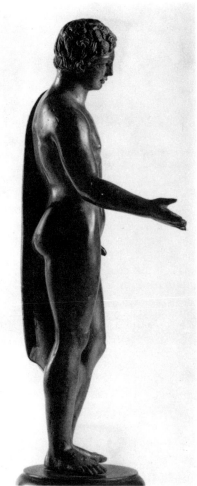

110

110

HERMES
Graeco-Roman
H.: 0.15m.
H. L. Pierce Fund 04.9
E. P. Warren Collection.

Fingertips of right hand broken off. Green patina.

The left hand held the kerykeion; a purse may have been in the extended right.

This Hermes goes back to a statue of the god made by Polykleitos or an associate circa 440 B.C. (see L. D. Caskey, *AJA* 15 [1911] 215f., pl. 6). A Graeco-Roman Hermes in the British Museum, with purse in his right hand, shows the Polykleitan style in its purest copyistic form (Lamb, *Greek and Roman Bronzes*, pl. 87; B. M. no. 825; Furtwängler, *Masterpieces of Greek Sculpture*, 232, fig. 93). There are a number of other related statuettes (e.g. Bibliothèque Nationale: Babelon-Blanchet, *Bronzes*, 141f., no. 315; ex Spink, London: *Greek and Roman Antiquities*, no. 41; Reinach, *Rép. stat.*, VI, 30, 1).

B. H. Hill, *Ann. Rep.* 1904, 58; *AJA* 9 (1905)
370; *AA* 1906, col. 262; C. Vermeule, *Polykleitos*
(Museum of Fine Arts, Boston, 1969) 17, 28, fig. 19.

Reinach, *Rép. stat.*, IV, 95, 6.

Exhibited: London, Burlington Fine Arts Club,
Ancient Greek Art, 45f., no. 35; Detroit, *Small
Bronzes of the Ancient World*, 12, no. 93.

111

HERMES-APOLLO
Graeco-Roman
H.: 0.072m.
Alfred Greenough Collection 08.535

Left hand held kerykeion; right hand is miss-
ing; the lower legs are also missing.

He wears a plume between the wings on the
head, and long fillets to the shoulders. There
is also a cloak around the shoulders.

The type is based on Polykleitan to early
Praxitelean models. According to Furtwängler,
the plume identifies Hermes with the Egyptian
Thoth (see under Hill, Walters *Bronzes*, 18,
no. 29, Baltimore), and bronze statuettes of
Hermes-Apollo with laurel crown, plume *and*
wings have been termed Alexandrian work
(Bibliothèque Nationale: Babelon-Blanchet,
Bronzes, 157, no. 357). One such bronze in
Tunis comes from Mahdia (*CRAI* 1913, 477
cited as Reinach, *Rép. stat.*, V, 64, no. 6).

111

111

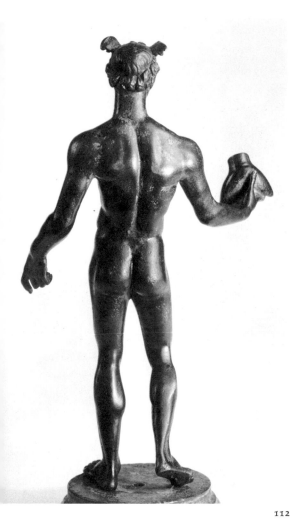

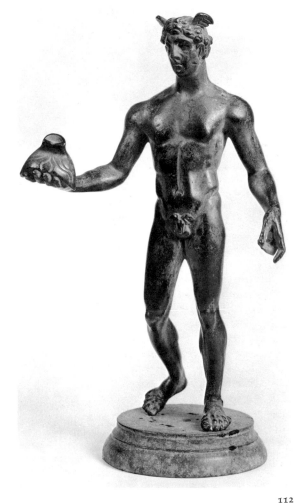

112

112

112

HERMES
Graeco-Roman
H.: 0.148m.
H. L. Pierce Fund 98.676
E. P. Warren Collection.
Acquired in Rome.

The left ankle is cracked. The base does not belong.

He holds a pouch in the extended right hand. The lowered left held the kerykeion. The eyes and nipples are silvered.

The somewhat crude but vigorous style also occurs in other Hermeses of various sizes; compare Bibliothèque Nationale, Babelon-Blanchet, *Bronzes*, nos. 317, 322 and 324; Menzel, *Die Römischen Bronzen aus Deutschland*, I, *Speyer*, 7, no. 10, pl. 10. One of the closest iconographic and stylistic parallels also comes from Germany, from Seligenstadt: Helbing Auction, Munich, 5 December 1929, 20, no. 42, pl. 9.

E. Robinson, *Ann. Rep.* 1898, 32f.; *AA* 1899, 138; Chase, *Antiquities*, 155f., fig. 205; 2nd edition, 225f., 260, fig. 244.

HYGIEIA

Graeco-Roman

H.: 0.084m.

Anonymous Gift 06.2372

Bought in Paris; said to be from Smyrna.

Hollow cast. Green patina.

She wears a sleeveless chiton and an elaborately draped himation. The right hand holds the serpent; there is an object of irregular shape in the left, perhaps the remains of a phiale (patera).

Although Hygieia of this type is found frequently on Roman (and occasionally on Greek) imperial coins, the subject is fairly rare in bronzes. Compare Bibliothèque Nationale: Babelon-Blanchet, *Bronzes*, 252f., no. 603, and Froehner, *Collection Gréau*, 206f., no. 970 (Reinach, *Rép. stat.*, II, 664, no. 3).

S. N. Deane, *Ann. Rep.* 1906, 59; *AA* 1907, col. 395.

Exhibited: Cambridge (Mass.), Fogg Art Museum, *Master Bronzes*, no. 136.

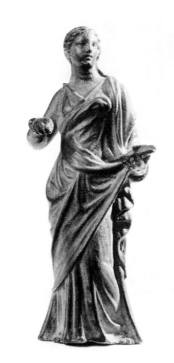

113

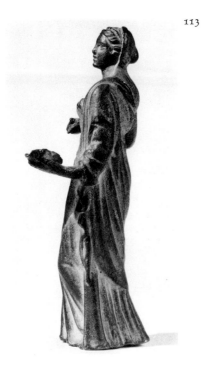

113

113

114

115

114

Isis

Graeco-Roman

H.: 0.13m.

Francis Bartlett Collection 04.1713
E. P. Warren Collection.

Only the handle of a sistrum held in the right
hand remains. The left hand held a vessel.
The headdress (uraeus) has been bent forward.
Green and brown patina.

 She is clad in a fringed mantle, fastened
with an "Isiac" knot; on the head there is the
solar disc with uraeus, between horns and
feathers.

 In a statuette of Isis in the Louvre, the left
hand holds fruits, and a situla hangs from
the left wrist (De Ridder, Louvre *Bronzes*, I,
107, no. 790, pl. 54). The raised right hand of
another Isis in the same collection holds a
second uraeus on top of a globe (*ibid.*, I, 73f.,
no. 499, pl. 37).

B. H. Hill, *Ann. Rep.* 1904, 63; *AJA* 9 (1905) 372;
AA 1906, col. 262; Chase, *Antiquities*, 155f.,
fig. 206; 2nd edition, 226, 260, fig. 245.

Mitten-Doeringer, *Master Bronzes*, under no. 270.

115

Isis

Roman, about A.D. 200 to 300

H.: 0.058m.

Gift of Richard R. Wagner 65.1179
From Istanbul.

Crusty green and brown patina.

 She wears a stylized crown in the form of a
uraeus and Hathor symbol and a chiton, over
which a tight himation has been wrapped.
She holds a sistrum in the raised right hand
and a spear-like paddle (?) vertically in the
left.

 Compare, generally, a Demeter from Egypt,
in the Louvre: De Ridder, Louvre *Bronzes*,
I, 59, no. 373, pl. 31.

Vermeule, *Ann. Rep.* 1965, 68.

ISIS-FORTUNA
Graeco-Roman, probably A.D. 100 to 300
H.: 0.13m.
John Michael Rodocanachi Fund 58.968

Lower part of colonette under left arm missing. Lower part of himation and feet encrusted. Traces of gilt on the headdress.

She wears a chiton and short himation; the headdress is similar to the previous; there is a rudder in the right hand, and the twin cornucopiae in the left are connected to the shoulder by a small support.

The colonette suggests derivation of the statuette from a major cult image in a temple in Rome or Egyptian Alexandria, centers of the worship of Isis. In ancient times the statuette no doubt adorned the private chapel of a Roman house or ended its career as a protective offering in an underground columbarium or burial chamber (see Hill, Walters *Bronzes*, 101, especially no. 221, for comparable examples in Baltimore).

One of these statuettes, from Salamanca, occurs on the lid of an elaborate "kantharos": see R. Thouvenot, *Catalogue des figurines et objects de bronze du Musée Archéologique de Madrid* I, 92, no. 462, pl. 20.

Vermeule, *Ann. Rep.* 1958, 32; *idem, CJ* 56 (1960) 8f., fig. 10; *FastiA* 15 (1960) no. 665.

NIKE
Graeco-Roman
H.: 0.038m.
Gift by Special Contribution 08.370
Purchased from Ferroni, Rome, through Richard Norton.

Green patina.

She is advancing, with wreath in upraised right hand and palm-branch in lowered left.

For the Hellenistic prototype, and the stylistic forerunners, see above discussion, under no. 74. Compare also De Ridder, Louvre *Bronzes*, I, 109, no. 806, pl. 55; Reinach, *Rép.*

stat., IV, 234ff., includes several parallels. Little figures such as this topped votive standards in military shrines and were part of sets of divinities in the Roman imperial cult. Similar Victoriae, seen frontally, are present as secondary details in a number of major Roman reliefs, on the Arch of Constantine, on the now-destroyed Arch of Divus Verus, both in Rome, and the Arch of the Severi at Lepcis Magna in Tripolitania (see Vermeule, *Aspects of Victoria on Roman Coins, Gems, and in Monumental Art,* 13f., nos. 1-4). Augustus Saint-Gaudens used a Nike or Victoria such as this as the model for his Liberty walking toward the viewer on the United States Twenty-Dollar Gold Double-Eagle of 1907 (R. S. Yeoman, *A Guide Book of United States Coins,* 19th Edition [1966] 187).

L. D. Caskey, *Ann. Rep.* 1908, 60; *AA* 1909, col. 428.

117

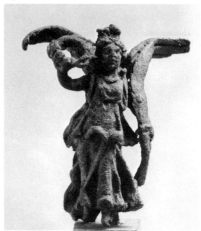

PANTHEISTIC DIVINITY ON COUCH

A.D. 150 to 250
L. (max.): 0.137m. W.: 0.082m. H.: 0.0102m.
Harriet Otis Cruft Fund 65.100
New York Art Market; from Alexandria (?).

Irregular green patina.

Wearing Phrygian cap, chiton, and ample himation, the goddess reclines on a heavy pillow and nurses a child. This is a pantheistic goddess of maternity (and other impulses), an unusual presentation of a Graeco-Oriental concept that derives, through representations of Isis nursing Horus (De Ridder, Louvre *Bronzes*, I, 102, no. 744, pl. 51; Reinach, *Rép. stat.*, II, 423, no. 5), from similar figures of Juno Lucina tending a child (Babelon-Blanchet, *Bronzes*, 26, no. 57).

The seven little goblets in the foreground have been said to symbolize the seven days of the week. Every other object surrounding the goddess, in her seemingly Mithraic or Bendis cap, can be related to some Graeco-Roman divinity, major or minor. There are the purse and caduceus of Hermes, the thunderbolt of Zeus, Dionysiac cymbals, Cybele's tambourine, Pan's pipes, and Tyche-Fortuna's or Justitia-Moneta's balances. The qualities of Egyptian Isis are suggested not only in the general iconography but in the Nilotic serpent and water beasts that attend the divinity. The couch, with its turned legs, is a standard Graeco-Roman (Alexandrine) piece of ceremonial furniture. The date is arrived at from the fact that such subjects (Sarapis-Harpocrates, Isis, Demeter) appear on Alexandrine imperial coins of Marcus Aurelius and Septimius Severus (Ph. Lederer, *Num Chron* 18 [1938] 75-78; *idem, Deutsche Münzblätter* 56 [1936] 201-211).

There are also Romano-Egyptian terracottas with divinities on lectisternia.

Vermeule, *Ann. Rep. 1965, 67; idem, CJ* 62 (1966) 108f., fig. 20.

Exhibited: Cambridge (Mass.), Fogg Art Museum, *Master Bronzes*, no. 274.

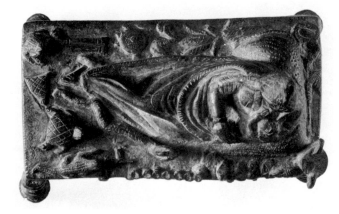

118

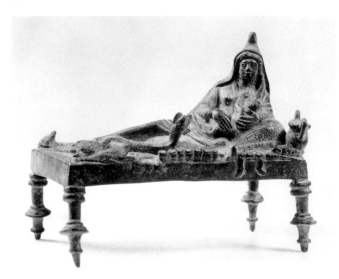

118

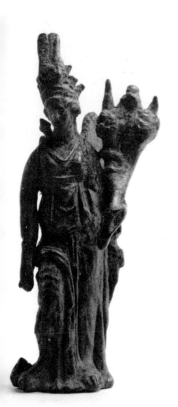 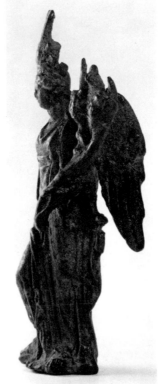

118A 118A

118A

PANTHEISTIC TYCHE
Graeco-Roman
H.: 0.114m.
Gift of George Zacos 67.1036
From Asia Minor.

Right wing and central section of rudder are missing. Grey-brown patina, with earth encrustation.

She stands with right foot drawn back, poised on the rough base. A mural crown is surmounted by the headdress of Isis (feathers, disc, and horns). On her back are the wings of Nike and the quiver of Artemis. Her lowered right hand held a rudder, of which the handle and paddle remain. Her left holds the double cornucopiae with a uraeus rising between the fruits. The base is filled with lead, as if the figure had been carried on a pole or placed in a stand.

The style of the statuette is excellent, reflecting a monumental prototype in bronze or marble, such as the colossal statue in the Istanbul Museum.

Vermeule, *Ann. Rep. 1967,* 47.

119

POSEIDON
Graeco-Roman
H.: 0.107m.
C. P. Perkins Collection 96.705
E. P. Warren Collection; Saulini Collection.
Found at Ancona in 1854.

Right hand, left hand and arm are missing. The base is modern. Green patina.

The full, over-rich hair and beard, and mild face seem to suggest this is Poseidon. The type in the Graeco-Roman period is difficult to identify as Poseidon, or his brother Zeus, especially when the attributes are missing. For a comparable Zeus, see Bibliothèque Nationale: Babelon-Blanchet, *Bronzes,* 1f., no. 3. A Poseidon of this type was created in the fourth century B.C. It has been attributed to Lysippos and survives in several Roman copies.

E. Robinson, *Ann. Rep.* 1896, 29, no. 13 (as Jupiter); *AA* 1897, 73; G. H. Chase, *Greek Gods and Heroes*, 30, fig. 21; 1962 edition, 38f., fig. 24; W. J. Young, *Technology Review*, April 1960, 26, illus.

Overbeck, *Griechische Kunstmythologie*, II, 287, pl. 3, 4; H. Brunn, *Bull. dell'Inst.* (1861) 85; idem, *Annali dell'Inst.* (1864) 386f.; *Mon. dell'Inst.* 8 (1864) pl. 12, 7; Reinach, *Rép. stat.*, II, 29, 5 and 779, 4.

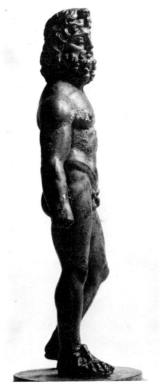

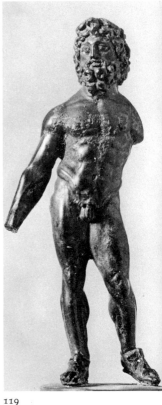

119

119

120

POSEIDON

Circa A.D. 150 to 250

H.: 0.05m.

Gift of Horace L. Mayer 63.2761

London Art Market.

Dark green patina, with encrustation. Ends of trident broken off.

He stands on a small, rectangular plinth and holds a long trident in the left hand and a dolphin in the extended right.

The crude style, with emphasis on heavy curls of hair and beard, suggests Gallo-Roman work after Lysippos. The ultimate model was a lifesized or larger bronze statue, attributed to Lysippos on the basis of the elongated, athletic limbs and best known from the marble Poseidon of Byblos in Istanbul (see Vermeule, *AJA* 63 [1959] 153 and refs.; Lippold, *EA*, nos. 4869f.).

Like so many other Roman cult or household shrine statuettes, this bronze is a pale reflection of its prototype, also in bronze; the statuette is perhaps not without interest, however, for preservation of the attributes. It is difficult to determine, beyond speculation, where the original bronze statue stood, for the type occurs on a number of Greek imperial coins. Most likely, the statue once was placed, with other deities by Lysippos, in Sikyon, Corinth, Isthmia, or Argos. By removing the statue to Rome, Mummius or Nero or another imperator may have made the type popular in the Latin West (see F. Imhoof-Blumer, P. Gardner, *JHS* 6 [1885] 60, pl. 50 [B], no. VI [Corinth]; 93, pl. 55 [L], no. VIII [Epidaurus]).

Vermeule, *Ann. Rep.* 1963, 35; idem, *CJ* 61 (1966) 307, 304, fig. 23.

120

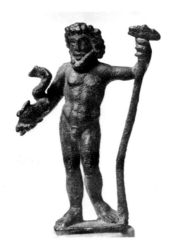

ZEUS
Graeco-Roman
H.: 0.085m.
Helen and Alice Colburn Fund 65.462
New York Art Market.

Left arm, left leg from just below the knee, and right foot are missing. The eyes have the remains of silver inlay. The rear half of the thunderbolt is preserved in the right hand. Brown patina with green spots.

The left hand was raised and held a scepter-staff. The thunderbolt serves as a support for the lowered right hand.

This statuette was probably made in the first or second centuries A.D. It is most likely a copy of a statue of the fourth century B.C., perhaps a bronze, which in turn was a copy of an earlier work. This ultimate prototype must have been of the generation of Pheidias or his pupils. In this respect the head invites comparison with that of the miniature Zeus,

in silver, that is a reminiscence of the Pheidian statue at Olympia (M. B. Comstock, *BMFA* 59 [1961] 110, illus.) or with the marble head from Mylasa (*Greek, Etruscan & Roman Art*, 118, 125, fig. 102). The softened limbs and curves of the body suggest Praxitelean influence and hence the more advanced date of the immediate prototype. The silver inlay in the eyes was a technique popular in Roman times to indicate the inlaid eyes of the Greek original.

Comparable bronzes include a figure wearing a heavy wreath, in the Bibliothèque Nationale (Babelon-Blanchet, *Bronzes*, 4, no. 7). The absence of the wreath here is more in keeping with a Pheidian prototype, and the shape of the head, arrangement of hair and beard are much more like the fifth century than the patently Hellenistic head of the statuette in Paris. For the relationship of the torso to early Hellenistic statuettes of divinities and athletes, compare a bronze in the Louvre from Thrace; it is a Herakles based on a statue by Skopas for the gymnasium at Sikyon (De Ridder, Louvre *Bronzes*, I, 72, no. 487, pl. 36). An intermediate stage in this development of the body, one closer to the fifth century B.C., is provided by the "Poseidon" in Berlin from Dodona; the heads are somewhat similar, although that of the bronze from Greece has been modernized (Lamb, *Greek and Roman Bronzes*, 172, pl. 63).

Vermeule, *Ann. Rep.* 1965, 67; *idem, BMFA 63* (1965) 210-211, illus.; *idem, CJ* 62 (1966) 105, fig. 13.

121 121

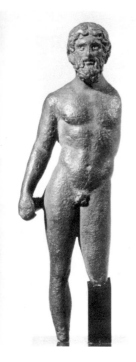
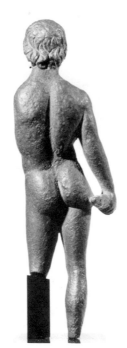

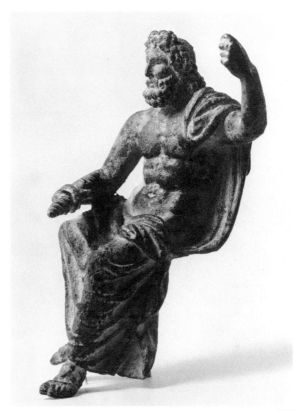

122

ZEUS

Graeco-Roman

H.: 0.095m.

H. L. Pierce Fund 98.678

E. P. Warren Collection.
Bought in Rome.

The eyes were inserted. The seat was a sepa-
rate piece and is now lost. Darkish brown
patina.

He wears the long himation and sandals.
The right hand holds a thunderbolt on the
lap; a scepter-staff was in the raised left.

This is a common type of Zeus, reflecting
one of the Republican or imperial statues of
Jupiter Capitolinus in the temple in Rome.
The image was remade after the fires of 85
B.C., A.D. 69, and A.D. 80, but only the two im-
perial statues seem to have the full himation
caught up over the shoulder in the fashion
seen here. Therefore, this bronze might belong
to the late first or second centuries A.D. (see
A. Zadoks Jitta, *JRS* 28 [1938] 50-55).

Compare, especially, *Nachlass Dr. Jacob
Hirsch*, Hess-Schab, Lucerne, 7 Dec. 1957, no.
58, pl. 28; Babelon-Blanchet, *Bronzes*, nos.
17f., (the first with its throne); Neugebauer,
Antike Bronzestatuetten, 113; and Ars An-
tiqua Sale, Lucerne, 2 May 1959, no. 70, pl. 37
(from Salonika). The type also occurs with
the arms reversed, indicating a different cult
prototype, e.g. Compiègne: Reinach, *Rép.
stat.*, V, 469, 5.

E. Robinson, *Ann. Rep.* 1898, 33; *AA* 1899, 138;
Chase, *Antiquities*, 2nd edition, 225, 259, fig. 243;
Handbook 1964, 84f., illus.

Cited under Richter, New York *Bronzes*, 111;
L. Lindsay, *The Christian Science Monitor*, Oct.
15, 1965, 2, illus.; V. Karageorghis, C. Vermeule,
Sculptures from Salamis, I, 32.

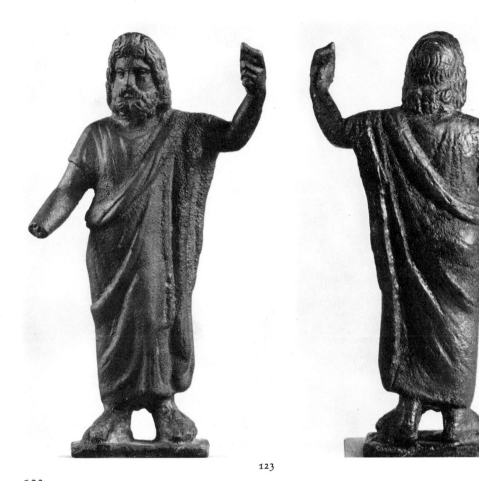

123

123

Zeus
Graeco-Roman
H.: 0.118m.
John Michael Rodocanachi Fund 59.298

Right hand and lower arm are missing, as is scepter formerly held in left hand. Red, green and brown patina.

He wears a chiton, with short sleeves, and an ample himation draped over the left shoulder and down the left side, front and back. He also wears sandals and stands on a plinth.

This figure illustrates the freedom with which the iconographic types of the major divinities were interchanged, combined and confused in Roman imperial times. The pose and presentation is certainly a logical one for Zeus; the head with its luxuriant hair and beard recalls Greek fourth-century work of Lysippos, Bryaxis and sculptors of the early Hellenistic period. When we look for similar bronzes, however, we find that the Roman artist who cast this piece borrowed the pose and details of costume from Graeco-Roman representations of Sarapis. He merely omitted the kalathos or modius, the basket-like grain measure on top of the god's head, and turned the figure back into a Zeus. He altered the attribute in the right hand, no doubt, from a patera to the fulmen (compare Reinach, *Rép. stat.*, V, 8, no. 5 = Perdrizet, *Collection Fouquet*, pl. 21; especially no. 6 = *Collection*

Borelli Bey, 33, no. 286, pl. 30; also II, 13, no. 1, where the chiton is omitted as is usual with Zeus rather than Sarapis, cited as von Rath Collection, sold at Sotheby's, 18 June 1891, lot 45, pl. 3).

The transformation of Sarapis-Hades back into Zeus completes a full circle, for the colossal statues of Sarapis seated and standing made for the sanctuaries of Ptolemaic Alexandria in the early third century B.C. had been inspired by comparable statues of Zeus in Asia Minor and in Greece proper.

This particular Zeus may be a copy of the cult statue of Zeus Salaminios, as on coins of the Cypriote Koinon under the Flavians (see *Sylloge Nummorum Graecorum, Cyprus* etc., Copenhagen, nos. 79-80; A. B. Cook, *Zeus,* III, 1, 649f.).

Vermeule, *CJ* 55 (1960), 201, fig. 9; *FastiA* 15 (1960) no. 671.

Exhibited: Cambridge (Mass.), Fogg Art Museum, *Master Bronzes,* no. 138.

124

CARIAN ZEUS
Graeco-Roman
H.: 0.105m.
Seth K. Sweetser Fund 67.730
From a British collection.

Light green patina with an earth encrustation. The ridges of drapery on the back have been cleaned with a wire brush.

The bearded god has his hair done up in a knot behind, like a Greek priest. His pectoral and apron are represented only in front; at the back, his chiton flows from the shoulders to well below the ankles and feet in five large folds with deep grooves in between. His sandaled feet protrude from beneath the chiton below the apron in front. The base is in the form of a small, round plinth, and the attributes, fitted separately in the hands, are now missing. The paraphernalia around the neck appears to consist of a rectangular pectoral on which is a necklace, the three pinecone-like medallions, and a pelta-shaped shield below

these. The skirt may be suspended from the shoulders by straps below the pectoral, for it is not held by a belt. The enrichment of the skirt is like a heavy netting of crossbars and medallions at the joints.

The whole work has a summary vigor that is provincial, or local Anatolian, rather than crude. Coins of Mylasa in Caria show the cult image of Zeus Labraundos with double axe in his right hand, a scepter-staff in the left. He wears a polos, and fillets hang from the arms which are purposefully represented as stretched sideways. He stands in a hexastyle Ionic temple. The date of these coins, Geta as Caesar, A.D. 198 to 209, with its testimonial of the statue's popularity could well be the period when this small bronze was produced. Excellent specimens of the coin even show the skirts and apron (A. Akarca, *Les monnaies grecques de Mylasa* [Paris, 1959] 33ff., pl. 11, nos. 90, 91). The image may have had a removable himation that was wrapped around the apron, for several reliefs show the image

124 124

thus adorned (A. Akarca, *op. cit.*, pl. 20, nos. 1-3; bronze from Albania, so-called priestess, but a bad restoration or misunderstood drawing of this type: Reinach, *Rép. stat.*, IV, 552, no. 3; relief from Mylasa: Reinach, *Rép. rel.*, II, 106, no. 3.). The alternative is that there were two images, perhaps the one with the himation belonging to the fourth century B.C. and the one with the apron being a creation of the imperial age. Another Zeus popular at Mylasa was Zeus Osogoa, but he held a trident in the raised right hand and an eagle on the outstretched left. He did not sport a polos. Zeus Labraundos, according to Strabo (XIV, 659), was created in wood, but head, hands, and garments were probably of other, more appropriate materials.

An over-lifesized marble head of Zeus in Boston, found at Mylasa, has long been acclaimed as a slightly-softened, fourth-century B.C. version of the Pheidian Zeus at Olympia (L. D. Caskey, *Catalogue of Greek and Roman Sculpture*, 59ff., no. 25). It is usually forgotten that this marble reflection of Pheidias' masterpiece in gold and ivory has holes for the attachment of a metal polos. The head thus was probably part of a fourth-century cult-image of Zeus Labraundos, and, given proper support, there is no reason why the the body could not have been fashioned in wood as Strabo stated, to conform to traditions of older Anatolian statues in temples.

Vermeule, *Ann. Rep. 1967*, 46; *idem, CJ* 63 (1967) 57, fig. 9, 59.

125

BUST OF SARAPIS
Graeco-Roman
H.: 0.18m.
Harriet Otis Cruft Fund 60.1450
From Alexandria (another bust from the same or similar mould came to the New York Art Market with this).

Even green patina.

The god wears an undecorated kalathos or modius on his head and a himation over the chiton or tunic covering his shoulders.

This bronze from a shrine or private chapel to the Isiac divinities (Sarapis, Isis and Harpocrates) was made late in the history of the pagan empire. From the restless yet stylized curls of the hair and beard this bust may be-

125

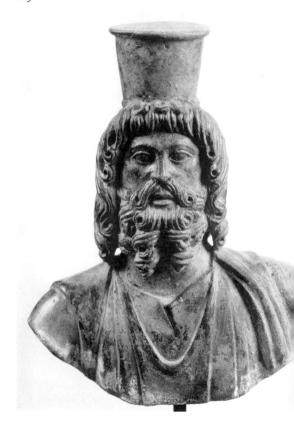

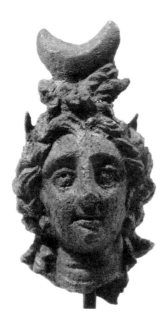

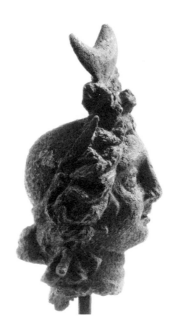

126

126

long to the fourth century A.D. At this time the worship of Sarapis continued as a strong force in Egypt, and the emperor Julian the Apostate (A.D. 361-363) placed likenesses of these Egyptian divinities and the Apis bull on his coins.

The bust is a simplified excerpt of the colossal statue, created in the dark materials befitting a god of the underworld, for the Sarapeum of Ptolemy II Philadelphus in Alexandria by Bryaxis the younger about 280 B.C. The statue was copied in all sizes and materials, and from its model, marble and bronze busts were produced, ranging in size from several feet down to a few inches. These are found all over the ancient world (see Bieber, *The Sculpture of the Hellenistic Age,* 83f.; Ch. Picard, *RA* 47 [1956] I, 65-77; for this bronze, compare Bibliothèque Nationale, Babelon-Blanchet, *Bronzes,* 14, no. 30; London, Soane Museum, *Catalogue,* no. 430). A bronze head similar to this but much earlier in the Roman period is in Baltimore, Walters Art Gallery (Hill, Walters *Bronzes,* 13, no. 21, pl. 9, and refs.). An alabaster bust of similar size and style is in the Treasury of Saint Mark at Venice. It must come from Egypt.

Vermeule, *CJ* 57 (1962) 150-151, fig. 7; *FastiA* 17 (1962) no. 243; Vermeule, *BMFA* 64 (1966) 31, fig. 18a.

H. Jucker, *Schweizer Münzblätter* 19 (1969) 79, fig. 3.

126

HEAD OF A COMBINED DIVINITY
Graeco-Roman, probably A.D. 100 to 300
H.: 0.068m.
Gift of Harvard University – Museum of Fine Arts Expedition 21.3099
From Gebel Barkal, the Great Temple.

Brown surfaces, evidently cleaned.

It is difficult to say whether the head is male (an Apollo with long locks) or female (Artemis). It wears the wreath of Apollo surmounted by the crescent of Artemis, in total appearance not unlike the horns of Hathor. A classical Egyptian syncretism of several divinities was doubtless intended. Compare the bust of Artemis Tauropolos or Io: Babelon-Blanchet, *Bronzes,* 15, no. 34; or the bust of Isis Pharia or Selene, on a plaque with Helios: *op. cit.,* 55f., no. 121.

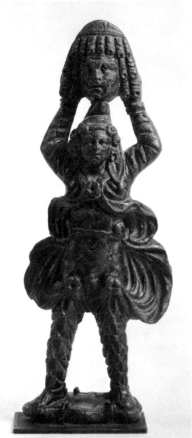

127

128

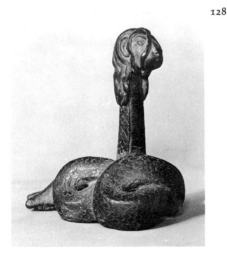

127

ATTIS
Graeco-Roman
H.: 0.13m.
Purchased by Contribution 01.7473
E. P. Warren Collection.
Bought in Munich.

The mask and body are hollow behind. Dark green patina.

He wears his typical Asiatic costume and Phrygian cap and holds a tragic mask over his head.

There are a number of these pseudo-theatrical appliqué bronzes surviving. Compare Bibliothèque Nationale: Babelon-Blanchet, *Bronzes*, 432, no. 980; De Ridder, *Louvre Bronzes*, I, 96, no. 694, pl. 48, and refs.; Agram: Reinach, *Rép. stat.*, V, 220, no. 7; and especially Marseilles, no. 781, cited as Reinach, *Rép. stat.*, III, 261, no. 7.

E. Robinson, *Ann. Rep.* 1901, 36; *AA* 1902, 131; *AJA* 6 (1902) 377.

T. B. L. Webster, *Monuments Illustrating Tragedy and Satyr-Play* (London, 1967) 107.

128

GLYKON
Graeco-Roman
H.: 0.06m.
Francis Bartlett Collection 03.986
E. P. Warren Collection.
Bought of Ready in London; said to have come from Athens.

Dark green patina.

The human-headed or human-faced serpent is coiled on itself, head erect and frontal.

A similar bronze exists in the material from the Agora in Athens (see D. B. Thompson, *Miniature Sculpture from the Athenian Agora*, no. 79), and a monumental marble of the Antonine period has been found at Tomi-Constanza on the Rumanian Black Sea *(FastiA 17 [1962] no. 3093, pl. 20; Saturday Review, 3. viii. 1963, p. 31, illus.; V. Canarache, et al., Tezaurul de Sculpturi de la Tomis*

[Bucharest, 1963] 109, no. 24, pls. 1, 55-57).
Glykon was a reincarnation of Asklepios, as
created by a magician of Asia Minor in the
second century A.D. He occurs in similar fash-
ion on coins of Ionopolis in Paphlagonia
under Lucius Verus (A.D. 161-169). It was
at Ionopolis (Abonuteichus) that the false
magician Alexander first exhibited Glykon
(see B. V. Head, *Historia Numorum*, 505;
and A. B. Cook, *Zeus*, II, 2, 1083ff.).

B. H. Hill, *Ann. Rep.* 1903, 60f.; *AA* 1904, 194;
AJA 8 (1904) 382; *BMFA* 2 (1904) 7.
Reinach, *Rép. stat.*, IV, 545, 2.

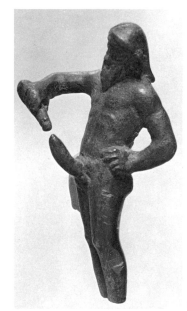

129

129

PRIAPOS
Graeco-Roman
H.: 0.07m.
Gift of E. P. Warren Res. 08.32m
Bought from a Greek.

Feet missing. Green patina.

His hair is done up in a coif; his left hand is
on his hip, and the right is pouring oil from
an alabastron on to his phallos.

Compare the two bronzes in Naples, in
similar pose (J. Marcadé, *Roma Amor*, 47,
illus.). Hair and beard are pseudo-archaic in
spirit, but the body betrays influences of Hel-
lenistic naturalism, or at least of Pergamene
muscular proportions. It is likely, therefore,
that the major prototype for statuettes of
Priapos such as this was created in the age of
Pasitelean eclecticism, that is about 50 B.C. The
ultimate inspiration must belong to the fourth
century, to the generations in which Praxiteles
created the "Sardanapalus" or bearded, draped
Dionysos and secondary Dionysiac figures
became popular in statuary and decorative
friezes.

130

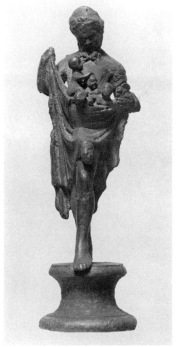

130

PRIAPOS
Graeco-Roman
H.: 0.08m. H. (with stand): 0.102m.
Gift of E. P. Warren Res. 08.32p
In 1897 in the collection of Sir Ch. Robinson,
London.

Thick green patina. Left hand mostly broken away.

He stands with his left foot forward; both hands hold up the skirts of his belted garment, in which are four tiny children.

This is a version of the orthodox late Hellenistic decorative figure of Priapos, of which the Boston Museum possesses a lifesized example in marble.

Compare also the bronze herm and statuette in the Warren collection at Bowdoin College: Casson, *Descriptive Catalogue*, nos. 115, 128, = K. Herbert, *Ancient Art in Bowdoin College*, 120f., nos. 430, 427; a bronze in Munich: H. Licht, *Sittengeschichte Griechenlands*, I, 230, illus.

Reinach, *Rép. stat.*, II, 2, 782, no. 5.

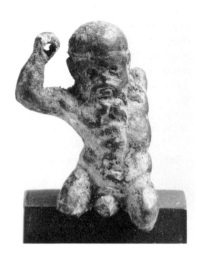

132

131

SEATED FIGURE
Graeco-Roman
H.: 0.044m.
Gift of E. P. Warren Res. 08.32 0
Greenish-black patina.

The upper half is a phallos, and the lower part is a male human. A small second phallos is attached at the back.

Grotesques such as this, paralleled by numerous curious representations on gems and in terracotta or even wood, were popular in Rome in the late Republic and early Empire. The taste for objects of this nature must have come from the Hellenistic cities of the east, from Smyrna, Antioch, and Alexandria.

131

132

PIGMY
Graeco-Roman
H.: 0.05m.
Gift of E. P. Warren 96.669
Bought in Florence.

The left arm (drawn back) and the legs below the middle of the thighs are missing. The eyes were inserted. The right arm held an object now lost.

He appears to have been half-kneeling or at least bending forward suddenly. He was perhaps spearing a crocodile (or fighting a crane), as in the well-known Pompeiian and other "Alexandrine" Nilotic scenes.

There are many comparable bronzes: see Bibliothèque Nationale: Babelon-Blanchet, *Bronzes*, nos. 377, 381; Bieber, *Cassel*, pl. 45, no. 239 = Reinach, *Rép. stat.*, V, 478, no. 4. The whole statuette can be visualized by the example, with loincloth, shown in the Burlington Exhibition, 1903, *Ancient Greek Art*, 1904, 53, no. 64, pl. 59; also a nude example in Munich: Licht, *Sittengeschichte Griechenlands*, III, vii; and the "Pan" in Copenhagen: *Bildertafeln des Etruskischen Museums*, pl. 109a.

E. Robinson, *Ann. Rep.* 1896, 29, no. 12 (Silenus); *AA* 1897, 73.

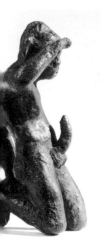
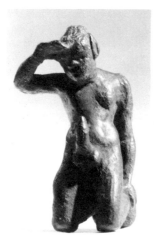

133 133

133

Satyr
Graeco-Roman (Hellenistic)
H.: 0.049m.
Gift of E. P. Warren Res. 08.32b
Bought in Smyrna.

Greenish black patina, with metallic and
earthy encrustation.

He is kneeling and ithyphallic, right hand
shading the eyes and the left on his ankle.

The somewhat grotesque face recalls those
of terracottas from Smyrna. For the gesture,
see I. Jucker, *Der Gestus des Aposkopein*,
figs. 36-40. The satyr is scanning the horizon
for a likely maenad or is awaiting the appear-
ance of Dionysos.

134

Athlete
Graeco-Roman
H.: 0.12m.
H. L. Pierce Fund 98.675
E. P. Warren Collection.
Bought in London from Ready, who had it
from a Smyrnite; said by the latter to come
from Cilicia.

The right hand and foot are missing. The sur-
face, especially of the face, is somewhat worn.
Greenish brown patina.

He may have held a discus or a phiale in
the lowered left hand. The style is faceless,
vaguely Lysippic with slight suggestions of a
Julio-Claudian portrait in the head. The body
is paralleled by that of an athlete, with
fourth-century head, in Cleveland: S. Lee,
Bulletin, Feb. 1959, 22, illus.; the statuette in
Cleveland can also be compared with the
Hermes, above no. 109.

E. Robinson, *Ann. Rep.* 1898, 32; *AA* 1899, 138.

135

Youth
Graeco-Roman
H.: 0.083m.
Gift of Miss H. L. Brown 77.251
Said to have been found at Pompeii.

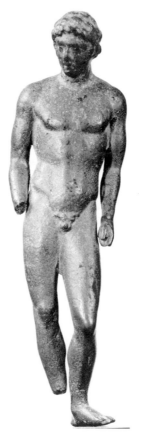

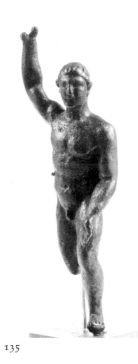

135

134

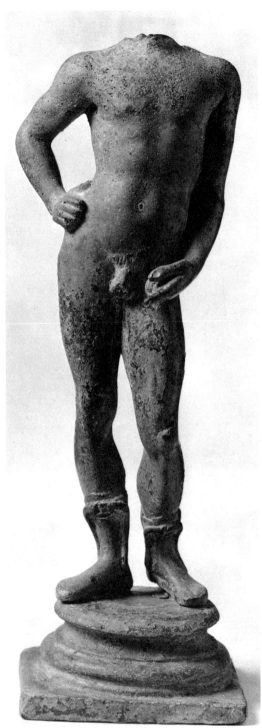

The right leg is missing from the knee. Dark green patina.

The right arm is raised perpendicularly, and the left is extended along the thigh. The gesture is peculiar, unless this athletic youth is to be thought of as holding up something in this hand. The hand is too high to have grasped a discus, but from the position of the fingers a spear or ball is not impossible. In style the athlete derives his inspiration from fourth-century works such as the Agias of Lysippos at Delphi.

136

YOUTH
Graeco-Roman
H.: 0.23m.
Gift of E. P. Warren 96.663
Bought in Rome.

The head is missing, and the object held in the left hand is broken. The base is ancient and belongs. The patina is green, smooth, and lustrous.

This booted youth in strongly hipshot pose could have been a young god of vegetation, holding a sickle in his left hand. Robinson likened him to the "Narcissus" in Naples (no. 5003; Ruesch, *Guida*, 118, no. 556, fig. 38; *Chiurazzi*, 61, no. 91). This famous statue is probably a Dionysos or an ideal presentation of a satyr, and it is possible the "youth" shown here was also Dionysos or one of his followers. In any case, this statuette comes from the same late Hellenistic, early imperial phase of decorative art that produced the bronze statuettes and small statues from Pompeii and Herculaneum.

E. Robinson, *Ann. Rep.* 1896, 28; *AA* 1897, 73.

Reinach, *Rép. stat.*, II, 787, 6.

136

YOUNG BOY

Graeco-Roman, 100 B.C. to A.D. 100

H.: 0.195m.

Gift of Edward Robinson by Exchange

60.530

New York Art Market; from a sale in Paris, 7 June 1922.

Some encrustation; green and brown patina.

He stands awkwardly with his big feet on a circular pedestal; he wears a poet's wreath on his head and a himation which envelopes his arms.

He seems to be about to make a speech or recite a bit of verse. This statuette probably comes from a tomb or household chapel; the linear, tubular style of the figure culminating in emphasis on the head and eyes is very much what is associated with Hellenistic art in Syria during the Roman period. This heroization of intellectual youth has been discussed in connection with the Hellenistic negro boy (see above, no. 82).

The Roman boy is intended to present a Greek or Roman youth in the provinces, who probably died in his school years and whose spirit was remembered by his family in connection with achievements in the classroom. The grandest commemorative monument of this nature is the grave relief in the Musei Capitolini of the boy Quintus Sulpicius Maximus, who bored his audience for hours with indifferent poetry and died of overstudy about A.D. 95 at the age of ten or so. He stands in the aedicula of his tombstone, rotulus open in his left hand and the right in a half-Napoleonic gesture of oratory. His poetry is carved in profusion on the surfaces of his tombstone (Stuart Jones, *Conservatori*, 149f., pl. 45, no. 36).

This bronze boy, however, is only a general symbol of the nobility of Graeco-Roman education, as no such literary identification accompanies him.

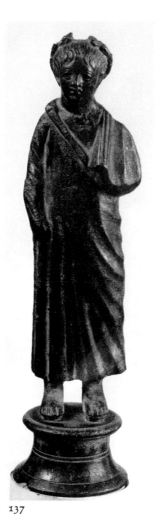
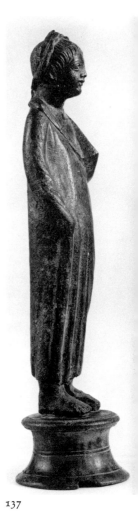

137 137

Vermeule, *CJ* 57 (1962) 148-149, fig. 4.

Reinach, *Rép. stat.*, V, 351, no. 2; D. Adlow, *The Christian Science Monitor*, 6 Sept. 1962, 7.

Exhibited: Cambridge (Mass.), Fogg Art Museum, *Master Bronzes*, no. 137.

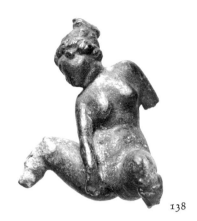

138

138

SQUATTING WOMAN
Graeco-Roman
H.: 0.031m.
Gift of E. P. Warren Res. 08.32f
Bought from a Greek dealer, 1902.

Left arm and lower legs missing. Green patina, somewhat crusty.

Her knees are wide apart, and her hand reaches between her thighs. She has a melon coiffure with a knot of hair at the back of her head, and is looking violently backward and down.

She may have been part of an erotic group. Her puffed-out cheeks and baby face, the proportions of her body (thinnish above and plump below), and her twisted pose all recall the comparable characteristics of the early Hellenistic nymph or maenad from the group known as the "Invitation to the Dance" (see D. M. Brinkerhoff, *AJA* 69 [1965] 29-36; Bieber, *The Sculpture of the Hellenistic Age*, 139, fig. 564).

139

COMIC ACTOR
Graeco-Roman
H. (with base): 0.108m.
H. L. Pierce Fund 98.677
E. P. Warren Collection.
Bought in Perugia.

Greenish patina, slightly crusty.

His right arm is raised in a gesture of declamation. He wears a small cloak on his left shoulder and a short, girdled tunic with long sleeves, tight trousers, sandals, and a slave mask. He stands on a circular, moulded base.

E. Robinson, *Ann. Rep.* 1898, 33; *AA* 1899, 138; *Handbook* 1964, 84f., illus.

Bieber, *History of the Greek and Roman Theater*, 315, fig. 418; 2nd edition, 161, fig. 580.

Exhibited: Princeton, *The Theater in Ancient Art*, no. 52 and illus.

139

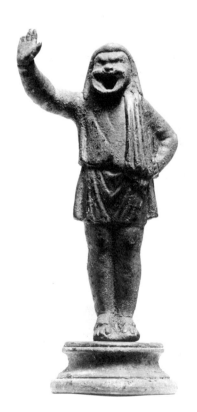

Comic Actor

Graeco-Roman

H.: 0.04m.

Gift by Special Contribution 08.371
Purchased from Ferroni, Rome, through
Richard Norton.

Once silvered, or containing a high admixture
of silver. Green encrustation.

He appears to be the slave who takes refuge
on an altar. He wears a slave mask, tunic
with girdle, and trousers. His hands hold a
funnel-shaped object. There are the remains of
a ring for suspension, on the top of his head.

The funnel-shaped object seems to be a
musical instrument, like a small hand drum
or tambourine with sounding board.

For style, compare a bronze in Cairo: *AA*
1903, 149, fig. 4.

L. D. Caskey, *Ann. Rep.* 1908, 60; *AA* 1909, col.
428.

Exhibited: Princeton, *The Theater in Ancient Art*,
no. 35 and illus.

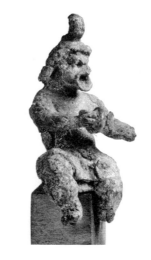

140

141

Bearded Man, Perhaps an Actor

Graeco-Roman

H.: 0.147m.

Gift of E. P. Warren Res. 08.32a
Bought from a French dealer.

The right foot is missing. Black and green
patina.

He stands with his left foot forward, his
right arm at his chest, and his left hand pulls
up the chlamys which is wrapped in deep
folds about his upper body. His features are
somewhat like those of a fourth-century or
early Hellenistic philosopher.

The oversized phallos either makes this
figure a grotesque or else it must be thought
of as a piece of theatrical equipment, akin to
the representations on Phlyax vases of the
fourth century B.C. (see A. D. Trendall, *Phlyax
Vases, passim,* especially pls. 1, d, 2).

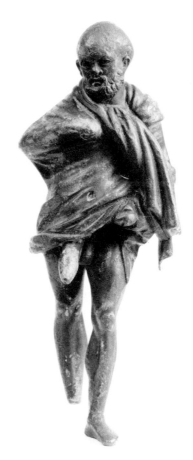

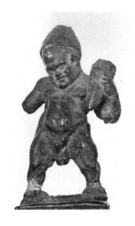

142

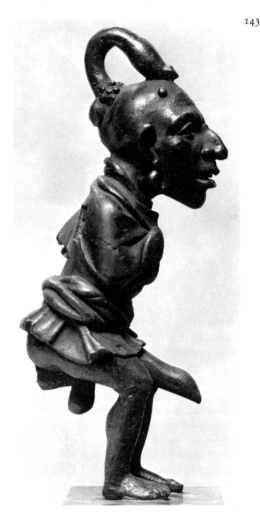

Phallos projecting rearward is broken off. Square (casting) hole (patch gone) in back; smaller one on left buttock. Black patina, with pitting.

He is stooped somewhat, arms clutching the chlamys at his chest. His features are oriental, and he has warts. He wears large earrings and a second phallos on his head.

Compare the phallic dwarf with chain, perhaps found in Spain: A. García y Bellido, *Esculturas Romanas de España y Portugal*, 450, no. 479, pl. 335.

Licht, *Sittengeschichte Griechenlands*, III, 72, illus. (as Berlin, Antiquarium).

143

142

DWARF

Graeco-Roman

H. (figure): 0.042m. H. (base): 0.018m.
James Fund and Special Contribution 10.171
E. P. Warren Collection.
Bought in Rome, 1901.

The right arm is missing from the elbow. The base is antique but seems not to belong. Greenish patina with slight corrosion in spots, and earth encrustation.

He stands with his legs apart. The left hand carries an undetermined object pressed against the left shoulder. He wears a conical cap. The base may be an altar.

Compare De Ridder, Louvre *Bronzes*, I, 98, no. 706, pl. 48 and refs.; dwarf dancing with shield: Münzen und Medaillen A. G., Auktion XVIII, November 1958, 13, no. 30, pl. 10; Ars Antiqua Sale, Lucerne, 14 May 1960, 40, under no. 96. See also the literature under van Gulik, Allard Pierson *Bronzes*, 9f., no. 15.

L. D. Caskey, *Ann. Rep.* 1910, 61; *AA* 1911, col. 475; *AJA* 15 (1911) 433.

143

DWARF

Graeco-Roman

H.: 0.151m.
Gift of E. P. Warren Res. 08.32d
Bought in Paris, 1901.

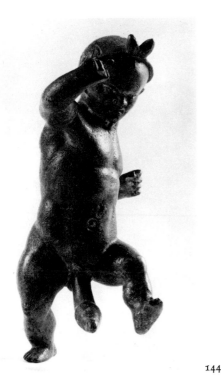

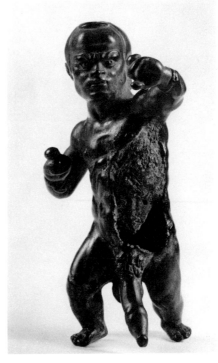

144

145

144

Dwarf Dancing

Graeco-Roman

H.: 0.11m. H. (with base): 0.132m.

Gift of E. P. Warren Res. 08.32j

A circular base probably did not belong, and
has been removed. Two fingers on right hand
broken away. Pitty green patina.

His right hand and left foot are raised.
Around his head is a narrow circlet, tied at
the back and with two large projections over
the forehead. He has a tiny, pointed beard.

Compare Bibliothèque Nationale: Babelon-
Blanchet, *Bronzes*, 218, no. 511.

145

Dwarf Boxing

Graeco-Roman

H.: 0.111m.

Gift of E. P. Warren Res. 08.32k

Bardini Sale, 1899.

The left side and top of his head are dam-
aged. There is a hole in the latter, as if it
served as an attachment or support (for a
candelabrum?); the lead filling and the fact
that he balances on his phallos contribute to
this suggestion. Even green patina.

He wears a cap and, on his hands, cesti.

Compare Ars Antiqua Sale, Lucerne, 14
May 1960, 40, under no. 95; W. Froehner,
Collection Gréau, 83, no. 383, sketch, p. 81.
The subject goes back to vase-painting of the
fifth century B.C.: e.g. E. N. Gardiner, *Ath-
letics of the Ancient World*, 84f., fig. 50. A
similar boxing dwarf in the Giamalakis Col-
lection, Heraklion (Crete) Museum, sports a
shield on his left arm. For a grotesque figure
made into a candelabrum or similar support,
compare Licht, *Sittengeschichte Griechen-
lands*, II, 228 (in Berlin).

Dwarfs of this general type, boxing and
otherwise, are collected by A. Adriani, *RM*
70 (1963) 80ff., pls. 32ff.; see also Perdrizet,
Collection Fouquet, 62, no. 99, pl. 24.

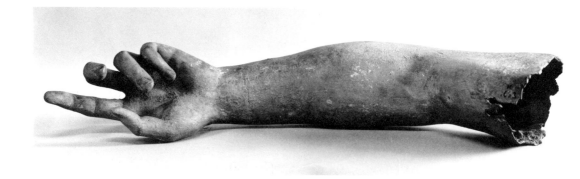

146

DWARF
Graeco-Roman
H.: 0.06m.
Gift of E. P. Warren Res. 08.32e
Bought in Italy, 1907.

Surface badly corroded.

He wears a rolled fillet with a floral device above his forehead and appears to be battling with his monstrous seven-headed phallos.

For grotesque dwarfs, compare Menzel, *Die Römischen Bronzen aus Deutschland*, I, *Speyer*, 19f., no. 26, pl. 31. This figure is a dwarfish parody of the Herakles whose elongated phallos turns into the seven-headed Hydra (see above, no. 108).

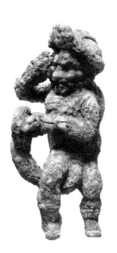

146

147

ARM AND HAND
Graeco-Roman
L.: 0.755m. L.(of hand): 0.28m.
Gift of E. P. Warren 96.667
Said to be from Hieron near Trebizond.

Bright green crusty patina.

This left hand was raised and appears to have held a spear. The long, muscular yet elegant proportions suggest a statue of a ruler in heroic pose, a derivation from the statue of Alexander with the Lance. The pose can be visualized from the so-called Hellenistic ruler in the Museo Nazionale Romano (P. L. Williams, *AJA* 49 [1945] 330ff., esp. fig. 11). The reversed pendant exists in the statue of a Roman emperor, probably the young Caracalla, from Pisidia or Pamphylia, in the Museum of Fine Arts, Houston, Texas (J. J. Sweeney, *Space and Fantasy, A Selection*, no. 2, illus.; *The Connoisseur*, November 1963, 202ff., illus.). For this statue and others from the same find, see C. Vermeule, *Roman Imperial Art in Greece and Asia Minor* (Cambridge [Mass.] 1968) 300, 401, 548.

E. Robinson, *Ann. Rep.* 1896, 27f.; *AA* 1897, 73.

148

FOREARM, FROM A STATUETTE
Graeco-Roman
L.: 0.041m.
Gift of H. P. Kidder 81.137
Purchased by W. J. Stillman; from Crete?

Worn and rough, with light brown encrustation.
 The left hand is closed, and the fist is clenched.

148

149

HAND, FEMALE
Graeco-Roman
L.: 0.195m.
Purchased by Contribution 01.7495
E. P. Warren Collection.
Bought in Rome.

Broken off at the wrist. Repaired, with square patches, across the fingers in antiquity. Partly corroded, and worn. It has been under water.
 The arm may have been extended, with the palm partly open and facing upwards.

E. Robinson, *Ann. Rep. 1901*, 36.

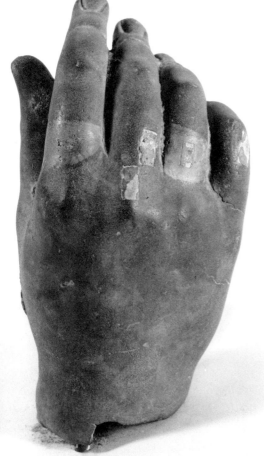

149

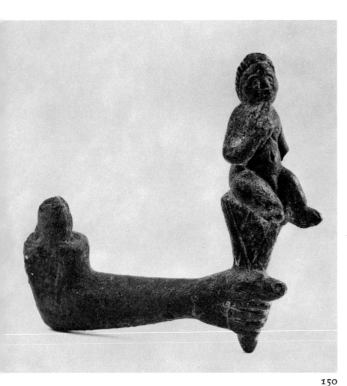

150

no. 2. There is a complete, Egyptianizing statue of Isis with the left arm thus (preserved) and the right arm, also made separately (missing) in the Allard Pierson Museum, in Amsterdam (van Gulik, *Allard Pierson Bronzes* I, 46f., no. 59, pl. 14). In Romano-Egyptian household shrines, the counterpart of this type of Isis was the statue of Horus, in the costume of a Roman legionary and holding an Egyptian hawk on his extended left hand (see Reinach, *Rép. stat.*, IV, 256, no. 4 citing *Expédition Sieglin* I, 149).

150

LEFT ARM AND HAND OF A ROMANO-EGYPTIAN STATUETTE OF ISIS, HOLDING A LOTUS PLANT ON WHICH HARPOCRATES SITS
Graeco-Roman
H. (max.): 0.073m. L. (max.): 0.075m.
Source unknown 68.39

Pitty, greenish-black Egyptian patina.

The upper arm seems to have fitted (via a tenon) into a draped statue. Harpocrates is nude, with his right index finger raised toward his mouth. The work is schematic, being partly incised. It should be dated circa 50 B.C. to A.D. 100 or perhaps later.

Another left arm and Harpocrates in the Louvre, also with rectangular tenon below the shoulder, comes from Cyprus and is slightly smaller: De Ridder, Louvre *Bronzes*, I, 68, no. 448, pl. 35; Reinach, *Rép. stat.*, V, 230,

151

VOTIVE FINGER
Roman Republican
L.: 0.095m.
Purchased by Contribution 01.7491
E. P. Warren Collection.
Bought in Rome.

Pale green patina. Much corroded.

The finger ends in a tang for mounting or insertion. The inscription reads:
MARCVRIO
FONT DONO DED
"Font(eius?) gave (this) as an offering to Mercury."

It is unusual to have an anatomical votive to Mercury, presumably a thank-offering for relief from an affliction.

E. Robinson, *Ann. Rep. 1901*, 36.

Exhibited: University of Wisconsin Memorial Library, *Rome An Exhibition of Facts and Ideas*, 33, no. 56, 34, illus.

151

152

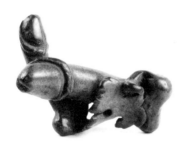

153

154

152

RIGHT FOOT OF A STATUE
Graeco-Roman
L.: 0.234m. H.: 0.141m.
Purchased by Contribution 01.7509
E. P. Warren Collection.
Bought in Florence.

The back of the foot and the inside of the instep are missing. Green patina.

The sandal has a very elaborate arrangement of straps and laces. The foot seems to be male, and sandals such as these can belong to himation-clad men or gods, or emperors and officials in cuirasses (see V. Karageorghis, C. Vermeule, *Sculptures from Salamis*, I, 40, under no. 46). The bronze Hadrian in Istanbul from near Adana wears less elaborate sandals with his tunic and himation (P. Devambez, *Grands bronzes du Musée de Stamboul*, 103-111, pls. 31ff.). Most marble cuirassed statues also wear footgear that gives more protection and omits the scrolled enrichment on top and sides (see *Berytus* 13 [1959] pls. 4, 8, 10, 11, etc.).

E. Robinson, *Ann. Rep.* 1901, 36.

153

PHALLOS
Greek
H.: 0.04m.
Gift of E. P. Warren 13.110

Green patina, with hard deposit on front and back (the latter may be partly formed of the material used to stick it on wood, or metal or stone).

This probably comes from a small herm, perhaps one carved in marble or even wood.

Compare the examples collected by A. Greifenhagen, *AA* 1964, cols. 628 – 638.

154

CROSSED PHALLOI
Graeco-Roman
L.: 0.045m.
Gift of E. P. Warren Res. 08.32l

Fine, smooth green patina.

One is large, and the other is small. A vineleaf is attached to the larger.

Compare the bronze amulet in the form of a phallos: Licht, *Sittengeschichte Griechenlands*, II, 74, illus.

155

A VOTARY, PROBABLY A PRIEST OF DIANA
Circa 50 B.C.
H.: 0.201m.
J. H. and E. A. Payne Fund 59.10

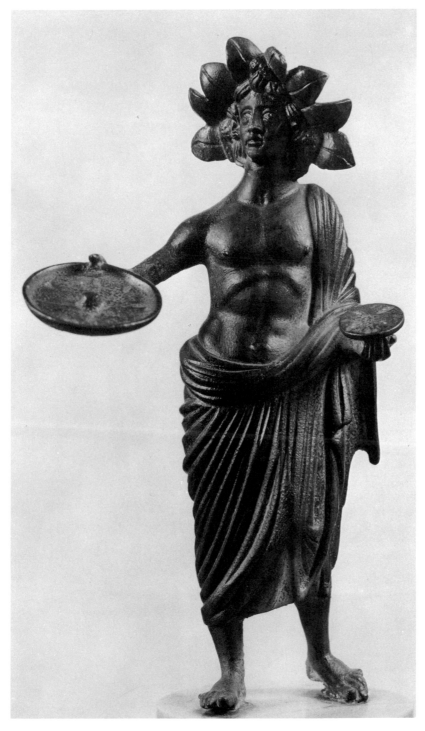

155

From the New York and London Art Markets;
from the shrine of Diana at Nemi, "said to
have been found in the pleasure galley of
Caligula."

Even dark brown patina.

He is moving forward with right foot; the
extended right hand holds a patera, and there
is a small, flat object (an incense jar?) in the
left hand. A toga is draped around the lower
body and over the left shoulder. He wears a
large floral headdress.

The subject is central Italian of the period
when late Etruscan, Hellenistic, and Roman
art were fusing into one, in the service of
native cults (circa 50 B.C. to A.D. 50). As a
type, this votary turns up in almost identical
form at dozens of Italic and late Etruscan
sites from Praeneste to Etruria (see *Vente
Lehmann*, Paris 1925, pl. 13, no. 118; Rein-
ach, *Rép. stat.*, VI, 123, no. 2; also Hill, Wal-
ters *Bronzes*, 63f., no. 127, pl. 30). This
bronze represents the best in Italian Hellen-
istic art before Italy and the Latin West were
inundated with craftsmen and art forms from
Greece or the Hellenistic East.

Vermeule and D. von Bothmer, *AJA* 60 (1956) 339;
Vermeule, *CJ* 55 (1960) 201f., fig. 10; *FastiA* 15
(1960) no. 671.

Reinach, *Rép. stat.*, IV, 307, nos. 5 and/or 6;
Reinach, *RA* 14 (1909) 177; Lamb, *Greek and Ro-
man Bronzes*, 219; S. Haynes, *RM* 67 (1960) 34ff.,
39, no. 10, pl. 17, 1 (cited on plate as London,
British Museum) (with extensive parallels);
Northwick Park Collection, Antiquities, June,
1965, nos. 506f., pl. 71.

156

APOLLO (?)
Late Roman Republic
H.: 0.077m.
Purchased by Contribution 88.615
Purchased of R. Lanciani; from the sanctuary
of Diana at Nemi.

Smooth light-green patina, with hard (cal-
cium) earth deposit on much of the surface.

There is a thick mass of hair around the
face. The extended right hand holds a patera,

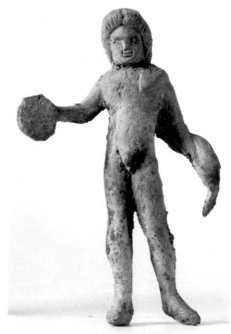

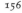
156

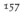
157

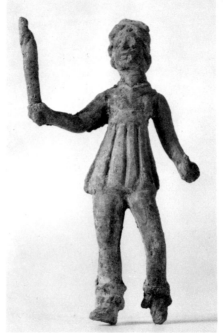

and the left holds the end of the cloak which goes around the neck, over both shoulders. The head is modelled on the fourth-century Helios-Alexander type sometimes attributed to Leochares and popular in the Hellenistic period, in originals and copies.

For a group of votives and other bronzes from the Nemi shrine, a collection comparable to those discussed here, see O. Rossbach, in *Verhandlungen der 40. Versammlung Deutscher Philologen und Schulmänner in Görlitz*, pl. 2.

157

DIANA
As previous.
H.: 0.085m.
Purchased by Contribution 88.613
Purchased of R. Lanciani; from the sanctuary of Diana at Nemi.

Fragment of bow in left hand and remains of quiver on back. Green patina with hard earth encrustation.

The extended right hand holds a torch. Her hair is done in the Hellenistic fashion over the forehead, and she may have worn a diadem. Otherwise, she wears a high-girt hunting chiton and boots.

Compare R. Thouvenot, *Catalogue des figurines et objects de bronze du Musée Archéologique de Madrid* I, 46, no. 212, pl. 14.

158

DIANA (?)
As previous, or earlier.
H.: 0.084m.
Gift of Francis L. Higginson 15.860
Found at Lake Nemi by F. L. Higginson.

Brown, green patina and surface corrosion, somewhat cleaned.

She wears a short, girt chiton and high boots. The object in her extended right hand appears to be a broken-off torch. A bow (?) was in her left hand. She too appears to have worn a diadem.

L. D. Caskey, *Ann. Rep.* 1915, 96.

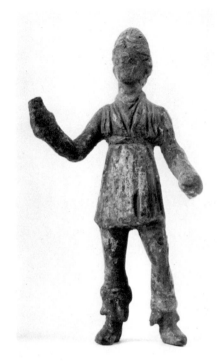

158

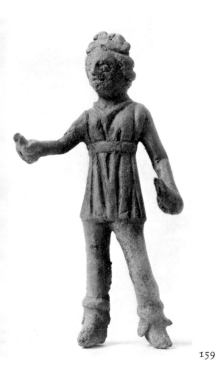

159

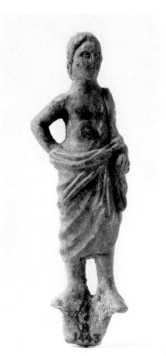

160

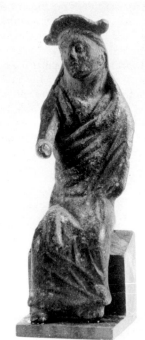

161

159

DIANA

As previous.

H.: 0.09m.

Purchased by Contribution 88.614

Purchased of R. Lanciani; from the sanctuary of Diana at Nemi.

The long torch-like object in the right hand has been broken off. The left hand holds a fragment of a bow. Clean light green bronze, with hard earth deposit on top.

She wears a chiton girt with a broad band and boots. Her hair is arranged in a luxuriant topknot above the forehead and is brought around back to fall down on the spine in a knot or small bun.

160

MAN

As previous.

H.: 0.096m.

Purchased by Contribution 88.616

Purchased of R. Lanciani; from the sanctuary of Diana at Nemi.

Smooth dull green patina, with earthy encrustation.

The hair of this votary is bound with a fillet. He wears a long himation over the left shoulder and the lower part of the figure. There is a rough tang under the feet.

The pose is a crude version of some monumental Hellenistic statue in the style and tradition of the Zeus from Pergamon or the Poseidon of Melos. Statues from Cos show such divine types transferred to the representation of mortals.

161

SEATED WOMAN

As previous, or earlier.

H.: 0.09m.

Gift of Francis L. Higginson 15.859

Found at Lake Nemi by F. L. Higginson.

Brown patina with crusty green corrosion.

She wears a himation, drawn up over the back of her head, and a high diadem. Her right hand (broken off) was extended. The head is turned slightly upwards and to the right.

L. D. Caskey, *Ann. Rep.* 1915, 96.

162

DOG

As previous.

H.: 0.076m.

Purchased by Contribution 88.618

Purchased of R. Lanciani; from the sanctuary of Diana at Nemi.

The feet and lower half of the left foreleg are missing. Dull surface, light green and grey with hard encrustation.

His head is tilted upwards, baying or sniffing, and he wears no collar. The head is strongly, naturally modelled.

Compare Reinach, *Rép. stat.*, IV, 524, no. 4 (Avignon) and 525, no. 2 (Cairo = Edgar, Cairo *Bronzes*, 24, no. 27726, pl. 6).

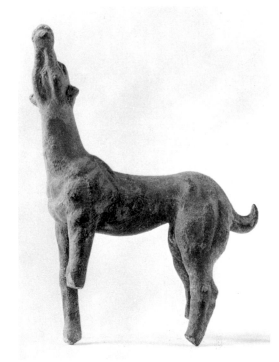

162

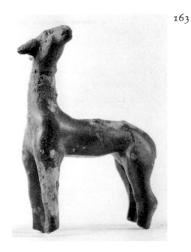

163

163

DOG

As previous.

H.: 0.051m.

Purchased by Contribution 88.619

Purchased of R. Lanciani; from the sanctuary of Diana at Nemi.

All the feet are missing. Fine dark green patina, with light areas and hard, earthy encrustation, especially at the base of the neck.

A collar is indicated by incision. The dog is looking up and backwards. He could have been standing beside a larger figure of Diana.

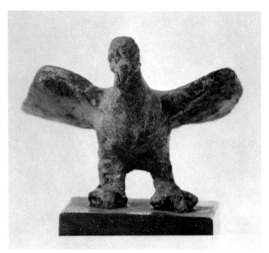

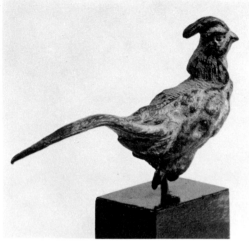

164

165

164

EAGLE

As previous.

H.: 0.062m. W.: 0.059m.

Purchased by Contribution 88.621

Purchased of R. Lanciani; from the sanctuary of Diana at Nemi.

Dull gray-green coating, with hard, earthy deposit.

The wings are outstretched. The shape of the head and the pose are almost like a Mediaeval ampulla or pulpit ornament.

Compare the small eagle in Cairo: Edgar, Cairo *Bronzes*, 86, no. 27986, pl. 6; Reinach, *Rép. stat.*, IV, 534, no. 1.

165

ROOSTER

Graeco-Roman, probably 50 B.C. to A.D. 100

L. (max.): 0.066m.

Gift of Richard R. Wagner 65.1181

From Istanbul.

Feet missing. Brown and green patina.

He has a cock's comb and a long tail. The chasing of the surfaces is very carefully handled.

Compare the marble rooster, M.F.A. no. 03.759 (Caskey, *Catalogue*, 175, no. 98), which is heavily restored; also the bronze examples, somewhat simpler than this in all respects, in the Bibliothèque Nationale (Babelon-Blanchet, *Bronzes*, 495, no. 1263) and the Metropolitan Museum (Richter, *Animals*, 84, fig. 215). The grandest rooster is the lifesized example in the Louvre (De Ridder, Louvre *Bronzes*, I, 134, no. 1092, pl. 64).

Vermeule, *Ann. Rep.* 1965, 68; *idem, CJ* 62 (1966) 107, fig. 17.

Young Bird
Roman, probably about A.D. 100 to 200
L. (max.): 0.04m.
Gift of Richard R. Wagner 65.1182
From Istanbul.

Green patina.

The wings are spread, and the head is turned upwards.

The bird is not a dove and, seemingly, not an eagle; the workmanship is quite good, and the expression is successfully naturalistic.

Vermeule, *Ann. Rep.* 1965, 68; *idem, CJ* 62 (1966) 108, fig. 18.

166

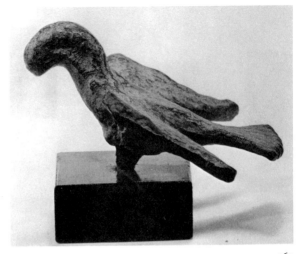

167

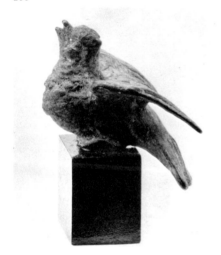

Eagle with Wings Spread
Late Roman or Byzantine, about A.D. 400 or later
L. (max.): 0.077m.
Gift of Richard R. Wagner 65.1183
From Istanbul.

Dark green patina with earth encrustation.

The wings are spread. Underneath the stomach there is an iron peg that probably fitted into a lid or pole.

Compare an example in the Louvre, mounted on an elaborate base (De Ridder, *Louvre Bronzes*, I, 123, no. 989, pl. 60); also a stone eagle of the fifth or sixth centuries in Berlin from Cairo (O. Wulff, *Altchristliche und Mittelalterliche Byzantinische und Italienische Bildwerke*, III, 1, 26, no. 48) and a bronze crowning piece, probably of a candelabrum, of the sixth or seventh centuries A.D., from Smyrna (Wulff, *op. cit.*, 163, no. 722, pl. 33).

Vermeule, *Ann. Rep.* 1965, 68; *idem, CJ* 62 (1966) 108, fig. 19.

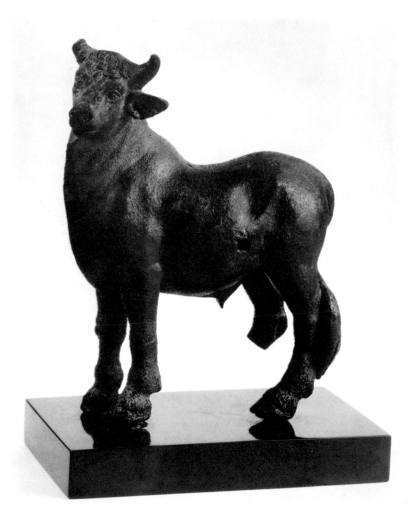

168

BULL

Graeco-Roman

H.: 0.15m.

Perkins Collection 96.707

E. P. Warren Collection.

Said to be from Rhodes.

The tip of the right horn and the right ear are missing. The surface has been cleaned. Brownish black patina.

The bull is standing with head erect.

Such statuettes have been termed votives in connection with the rites of the Roman state religion; see Ars Antiqua Sale, Lucerne, 14 May 1960, 43, no. 108.

E. Robinson, *Ann. Rep.* 1896, 29; *AA* 1897, 73.

Reinach, *Rép. stat.*, II, 824, 2.

Exhibited: Cambridge (Mass.), Fogg Art Museum, *Greek Art and Life*, no. 23.

169

BULL

Graeco-Roman

L.: 0.09m. H.: 0.076m.

H. L. Pierce Fund 98.680

E. P. Warren Collection.

From Savona.

There is a hole for attachment between the horns. Irregular green and brown patina.

The hole between the horns suggests attachment of a sun-disc and that this might have been an Apis bull. The type is found in a number of similar bronzes (e.g. Hill, Walters *Bronzes*, 112, no. 253, pl. 51 and references, including this) and in lead in an example from the Agora at Athens (B374).

E. Robinson, *Ann. Rep.* 1898, 33; *AA* 1899, 138.

Vittorio Pozzi, *La Strenna Savonese per l'anno 1894*; Reinach, *Rép. stat.*, IV, 485, 6 cites *Bonn Jahrb.*, 114, 200.

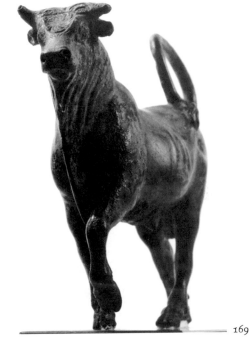

169

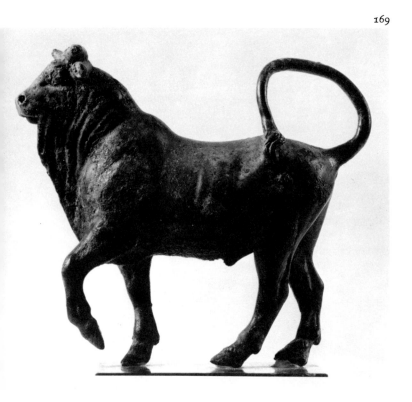
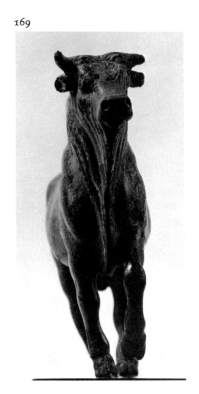

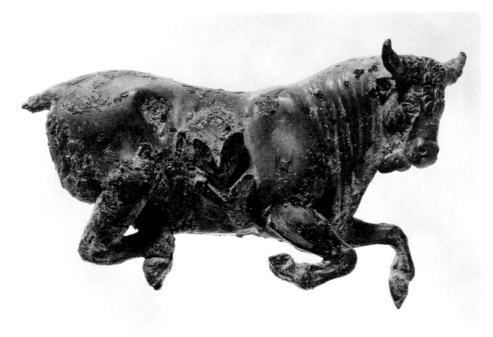

170

170

BULL, A HIGH RELIEF
Graeco-Roman
L.: 0.139m.
Purchased by Contribution 01.7498
E. P. Warren Collection.
Bought in Florence.

The tail has been broken off. Brown patina.
Badly corroded.

This comprises the right side of the bull's
body, originally attached to some object. The
head is turned to the right, and the tongue
lolls out to the right side. A flower with leaves
springs up the middle of the stomach, half-
way up the right side.

A bovine in high relief appears on a brazier
in Naples (no. 73005), from Pompeii.

E. Robinson, *Ann. Rep. 1901*, 36; *AA 1902*, 132;
AJA 6 (1902) 377.

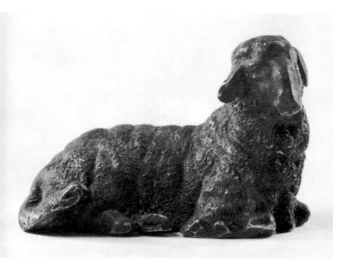

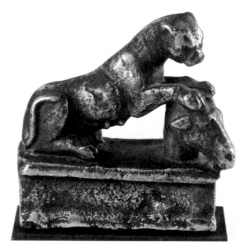

170A

171

170A

RECLINING EWE
Graeco-Roman
L.: 0.057m.
Gift of Richard R. Wagner 67.1033
From Asia Minor.

Light and dark green patina.

The presentation is naturalistic, with dotted incisions and series of wrinkles for fleece and folds of skin.

Compare the sheep on the Parthenon frieze and the ram in Palermo (Richter, *Animals*, figs. 142f.). Earlier versions of the pose were figures on the rims of vessels or the sides of handles. The reclining ram in Palermo is the grand Hellenistic prototype for this bronze. A famous lekythos by the Brygos Painter, in the Wadsworth Atheneum at Hartford (Conn.), shows the early fifth century graphic origins of fleece, folds, and profile (G. M. A. Richter, *Charites*, 140-143, pl. 19).

Vermeule, *Ann. Rep. 1967*, 47.

171

LIONESS
Graeco-Roman
L.: 0.055m. H.: 0.052m.
Purchased by Contribution 01.8476
E. P. Warren Collection.

The color is brassy. The bottom of the pedestal is hollow, and a large tang fills the middle, extending below the lower moulding.

This appears to be a decoration for attachment to an object. A crouching (Abyssinian) lioness, with forepaws raised, is resting on the head of an ass. This is set on a rectangular, moulded pedestal.

Compare (in marble), the example in the Vatican: Amelung, Vatican *Cat.*, II, 371f., no. 190, pl. 40; Reinach, *Rép. stat.*, IV, 474, no. 2.

E. Robinson, *Ann. Rep. 1901*, 36; *AA 1902*, 132; *AJA* 6 (1902) 377.

BEAR WITH A STICK IN HER MOUTH
Graeco-Roman
H.: 0.09m.
Samuel Putnam Avery Fund 67.627
Perhaps from Egypt.

Even green patina. A hole in the upper back suggests a harness or loop was attached in another metal.

She is raised on her hind legs and bending forward, a stick between her teeth. Perhaps this masterpiece of animal observation and craftsmanship was suspended, as an ornament on a candelabrum of Hellenistic type. Treatment of the fur, tufts and patches, has afforded the artist a great latitude for expression. Although often classified "Alexandrian," such spirited, naturalistic bronzes could have been and doubtless were made in centers from Smyrna to Antioch, in addition to Egyptian Alexandria.

Aside from the contemplative bear also illustrated here, comparisons for this animal are general. Performing bears, usually standing on their hind legs, are not uncommon in the repertory of Graeco-Roman bronzes. A she-bear in Aix-la-Chapelle is seated on her haunches, forepaws firmly on the ground

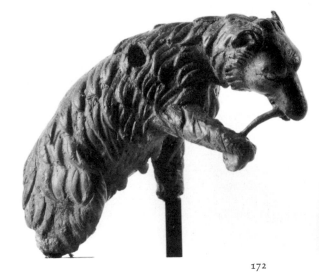

172

(Reinach, *Rép. stat.*, VI, 154, no. 1; IV, 478, no. 6: Lyon, 481, nos. 2, 4: Vente Gréau).

Vermeule, *Ann. Rep.* 1967, 46; *idem, CJ* 63 (1967) 63, fig. 15.

ArtQ 30 (1967) 266, 271, illus.

172A

STANDING STAG
Graeco-Roman
L. (max.): 0.065m.
Gift of Richard R. Wagner 67.1034
From Asia Minor.

Horns were made separately and are now missing. The hooves are broken away, and the left rear leg is bent against the other. Green and brown patina.

See Richter, *Animals*, figs. 147-151. This is a version in miniature, with more Graeco-Roman naturalism, of a famous classical stag, known from several ancient and later replicas. See J. Chittenden, C. Seltman, *Greek Art,* Burlington House, London, 1946, 39, no. 177; compare also Mitten-Doeringer, *Master Bronzes*, 102, no. 100; and especially Babelon-Blanchet, *Bronzes*, 486, no. 1197. For deer and their development in Greek, Hellenistic art see H. Hoffmann, *AJA* 64 (1960) 277f.

Vermeule, *Ann. Rep.* 1967, 47.

172A

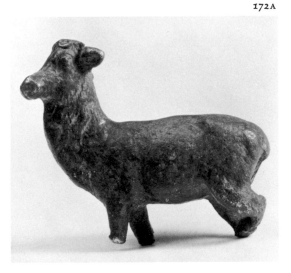

GRIFFIN OF NEMESIS
Graeco-Roman
H. (max.): 0.06m.
Gift of Jerome M. Eisenberg 67.645
From Egypt.

The tip of the left wing and a small segment of the plinth have been restored. Even, light green patina.

A griffin is seated, with his raised right paw and foreleg placed on a wheel with four spokes. The figure is set on an oval plinth.

The famous mythological animal in precisely this pose is an attribute and symbol of the goddess Nemesis. Aside from occurring on sundry Graeco-Roman gems, the beast with its wheel is found alongside the goddess in a marble statue from Salamis on Cyprus or alone in a faience figure in the Brooklyn Museum, from Egypt, and a marble in Israel (V. Karageorghis, C. Vermeule, *Sculptures from Salamis*, I, 12ff., no. 4; E. Riefstahl, *The Brooklyn Museum Bulletin* 17 [1956] 1-7 and bibl.; J. Leibovitch, *Israel Exploration Journal* 8 [1958] 141-148). The subject in bronze is rare. One published in the Fouquet Collection has lost the wheel and most of its wings. The example from the Alphonse Kann collection also lacks the wheel but is of very fine workmanship, and a splendid large bronze griffin in similar condition was excavated in Austria (Reinach, *Rép. stat.*, V, 401, no. 7; VI, 146, no. 2; Perdrizet, *Collection Fouquet*, pl. 18; *The Alphonse Kann Collection*, I, New York, American Art Association, 1927, no. 88, illus.). The elusive wheel, were it large enough to be shown in detail, would be enriched with the signs of the Zodiac and is thus a symbol of cosmic revolution and evolution similar to wheels in other aspects of Graeco-Roman iconography.

Vermeule, *Ann. Rep. 1967*, 47; idem, *CJ* 63 (1967) 62, fig. 14.

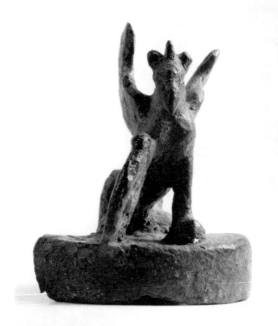

173

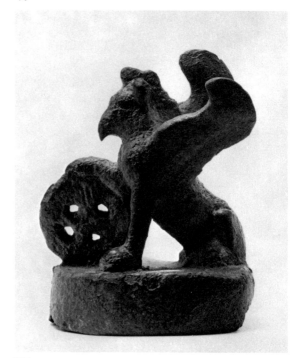

173

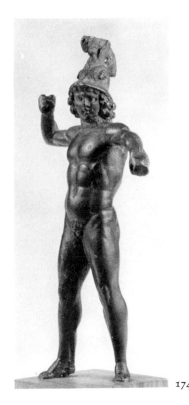

174

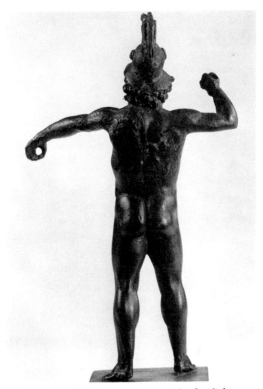

174

174

A Hero, perhaps Alexander the Great

A.D. 200 to 300

H. (max.): 0.117m.

William E. Nickerson Fund, No. 2 64.702
New York Art Market.

Green patina; helmet and back corroded.

He was holding a sword or spear in his raised right hand and a short sword or, perhaps more likely, a shield in his extended left hand. He wears a crested Macedonian helmet with rams' heads on the sides.

His youthful face with curly hair is that of Alexander the Great. Otherwise, he is perhaps Theseus with two swords, his own sword and that of his father which was discovered under the rock, or that of his friend Peirithoos on their adventure in the Underworld (see *BMFA* 61 [1963] 7f., figs. 3, 3a; M. Robertson, *JWarb* 15 [1952] 99f.). In this case, however, we would expect him to be wearing a swordbelt, scabbard, and the sandals also left for him by his father.

The prototype of the complete statuette was a more forceful, animated, less academic version of a Lysippic work than the Hadrianic Alexander from Cyrene (E. Rosenbaum, *A Catalogue of Cyrenaican Portrait Sculpture*, 55ff., no. 44, pl. 32, 1, 3). The style of the statuette is similar to the bronze statuette probably of Alexander the Great in the Bibliothèque Nationale, Paris, from Reims and dated in the Flavian period. He wears the same helmet, but the lance and sheathed sword of this enthroned figure are restorations (M. Bieber, *PAPS* 93 [1949] 424, fig. 72; Reinach, *Rép. stat.*, II, 2, 567, no. 9; Babelon-Blanchet, *Bronzes*, 357ff., no. 824; cf. also, 356f., no. 822).

Vermeule, *Ann. Rep.* 1964, 33; MFA, *Calendar of Events*, March 1965, 1; Vermeule, *CJ* 61 (1966) 305ff., 302, fig. 22.

Exhibited: Cambridge (Mass.), Fogg Art Museum, *Master Bronzes*, no. 281.

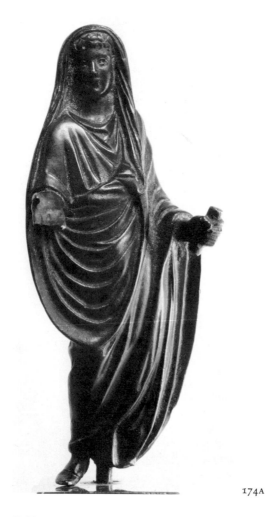

174A

174A

174A

SMALL STATUE OF A ROMAN IN A TOGA
Graeco-Roman
H.: 0.163m.
Gift of Dr. and Mrs. Freddy Homburger
67.1185

Right arm and hand cast separately, left hand
with scroll also. Left foot and all but small
finger on right hand missing or damaged.
Crack in casting across the back from left
shoulder to right side. Seam or split along-
side the heavy vertical fall of the toga down
the left side of the back. Dark, deep olive

patina. Hard white clay or plaster core re-
mains within.

The statue is characterized by a thin profile
in head and upper body. This, coupled with a
face that reflects Augustan or Julio-Claudian
classicism, indicates the statue was made,
probably as a public or personal votive offer-
ing, in some central Italian workshop, such as
that which produced the latest, largest votive
bronzes from Nemi (see under no. 155). The
face has some resemblance to portraits of
the second emperor, Tiberius, who ruled from
A.D. 14 to 37 but who was prominent in im-
perial affairs for at least a generation pre-

viously (compare Vermeule, *Greek and Roman Portraits*, no. 40).

The right hand could have held a patera. The rotulus in the extended left hand is an attribute common to marble statues, when this part is preserved rather than merely restored in Renaissance or later times. For further statuettes of togate emperors, priests, or notables sacrificing, see under Mitten-Doeringer, *Master Bronzes*, 253, no. 243, an example in the Royal Ontario Museum, Toronto. See also D. K. Hill, "The Togate Genius in Bronze," *AJA* 72 (1968) 166, a classification of the entire series.

Vermeule, *Ann. Rep.* 1967, 47, 48, illus.

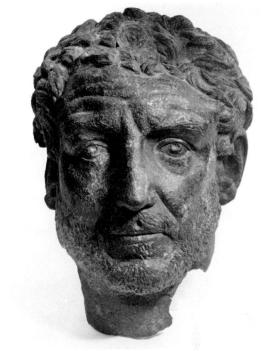

175

175

HEAD OF A ROMAN
Early Third Century A.D.
H.: 0.31m.
C. P. Perkins Collection 96.703
E. P. Warren Collection.
Said to have been found in the Tiber (Ponte Sisto).

Broken from a statue, the right side of the head (above the ear) has been pushed in. Dark greenish black patina.

In this work of great quality, the man has a strong, conservative yet sensitive face. Using other fragments, Dehn attempted a reconstruction of the complete statue as a standing, half-draped figure in sandals.

E. Robinson, *Ann. Rep.* 1896, 27; *AA* 1897, 73 (perhaps Antoninus Pius); *BMFA* 1 (1903) 15; Chase, *Antiquities*, 2nd edition, 221, 250, fig. 228; Caskey, *Catalogue*, 223f., no. 132, illus.; Vermeule, *Greek and Roman Portraits*, no. 61, illus.

Reinach, *Rép. stat.*, V, 317, no. 7; G. Dehn, *RM* 26 (1911) 253f., fig. 10 a-b; Kluge, Lehmann-Hartleben, *Grossbronzen der Römischen Kaiserzeit*, II, 44f., fig. 2; Strong, *Art in Ancient Rome*, II, 193.

Exhibited: Cambridge (Mass.), Fogg Art Museum, *Master Bronzes*, no. 235.

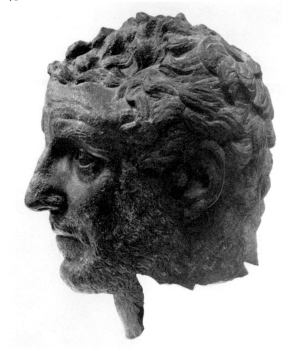

175

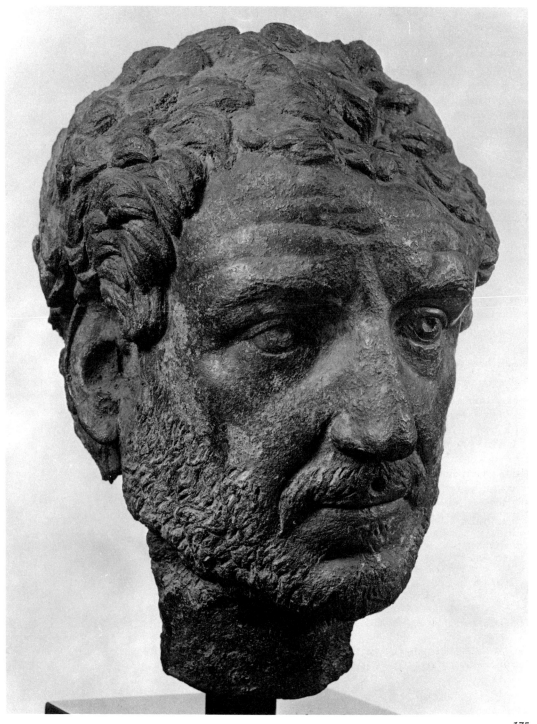

BACK OF A STATUE OF A HIMATION-
CLAD MAN
Roman, probably Second Century A.D.
H.: 1.52m.
Purchased by Contribution 01.7524
E. P. Warren Collection.
Bought in London; found at Casanuovo, near
Reggio.

Green patina.

More than half the back and most of the
right side of this lifesized standing figure are
preserved. He is presumably an emperor, a
man of intellect, or a magistrate. The bronze
statue of Hadrian in Istanbul from the Adana
area gives an idea of what the complete
statue must have looked like (Wegner,
Hadrian, 99; Istanbul, *Guide Illustré*, no.
5311). So also *EA*, no. 624, a torso in marble.

Robinson noted that the statue was "ap-
parently standing in an attitude like that of
the Aeschines in Naples" and termed it
Greek, probably of the fourth century.

At the scientific conferences in connection
with the 1967 – 1968 exhibition of *Master
Bronzes*, it was suggested that the figure was
attached to a background as a high relief, on
account of the way the edges were bent back.
This may be merely an accident of preserva-
tion. Roman buildings did have metal pedi-
ments, the best example being the Pantheon
in Rome.

E. Robinson, *Ann. Rep.* 1901, 36; *AA* 1902, 131;
AJA 6 (1902) 377; Vermeule, *Berytus* 15 (1964)
96.

Exhibited: Cambridge (Mass.), Fogg Art Museum,
Master Bronzes, no. 237.

176

176A

RIGHT LEG OF AN OVERLIFESIZED
MALE STATUE
Roman, Imperial period
H. (max.): 0.86m.
*Gift of Jerome M. Eisenberg and
Alan Ravenal 68.732*
From Cremna in Pisidia.

The foot was broken away above the ankle
and the leg wrenched from the body near
the torso. Light green patina. There are re-
mains of rectangular patches and serrated
inlays throughout. A seam from casting runs
down the center of the outside front.

This fragment was found with a large
group of imperial statues, Antonines and
Severans, set up in a temple late in the second
and early in the third century (Vermeule,
*Roman Imperial Art in Greece and Asia
Minor* [Cambridge, Mass., 1968] 401, 548).
The slightly larger scale of this statue in rela-
tion to most of the others in the find sug-
gests it might have belonged to an image of
Zeus, patron god of Cremna, set with his
eagle in the midst of the emperors and their
relations. One of the two heroic nude
statues of Septimius Severus in the group,
one set up about A.D. 200, is exactly the same
size, and this leg, therefore, could belong to
a similar imperial image, Antoninus Pius,
Lucius Verus, or the mature Caracalla.

Vermeule, *Ann. Rep.* 1968, 33; *idem, AJA* 72
(1968) 174.

177

STATUETTE OF THE EMPEROR CONSTANTINUS
MAGNUS (A.D. 306-337)
Roman, circa A.D. 306
H.: 0.186m.
*Gift of Mr. and Mrs. Benjamin Rowland, Jr.
62.1204*
From Gaul.

Right arm and left hand broken off. Green
patina.

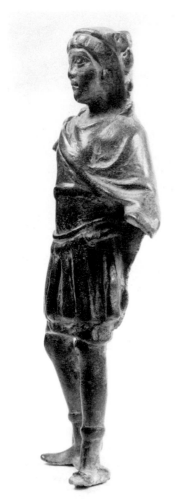

177

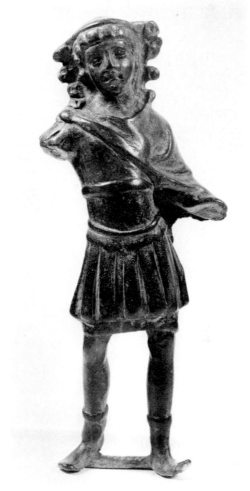

177

He is represented in the guise of an officer in the legions. He wears an animal's skin (pinned as a cloak on one shoulder) above the imperial diadem, a simple cuirass with cingulum, tunic below, and boots. There is a tang between the feet.

Vermeule, *Ann. Rep.* 1962, 32; *idem, Berytus* 15 (1964) 109, no. 320A, pl. 22, figs. 12, 12A.

Exhibited: Cambridge (Mass.), Fogg Art Museum, *Master Bronzes*, no. 282.

Etruscan and Italian

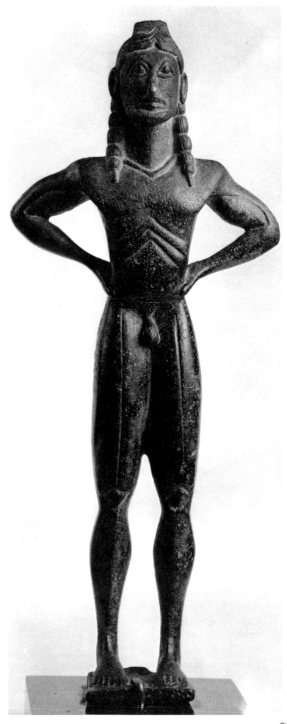

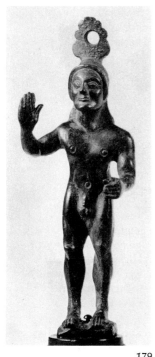

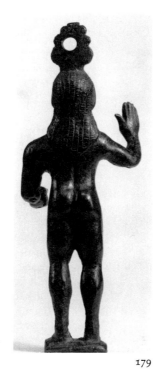

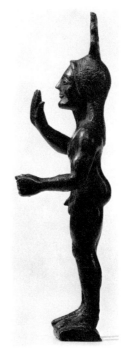

179 179 179

178

"APOLLO"

Archaic, circa 500 B.C.

H.: 0.213m.

H. L. Pierce Fund *98.653*

E. P. Warren Collection.

Bought in Naples.

Even, greenish patina.

He stands with hands on hips, feet planted firmly on a small plinth. Anatomical details are rendered in simple, summary fashion. A long, cylindrical projection from the back of the head shows that the figure was attached to something. There are traces of other attachments at the top of the head and the back of the base.

This charmingly provincial, probably Campanian transcription of a Greek kouros could have been the handle of a situla.

E. Robinson, *Ann. Rep.* 1898, 25; *AA* 1899, 136; *AJA* 3 (1899) 570f.; Chase, *Antiquities*, 2nd edition, 195, 210, fig. 200.

Langlotz, *Antike Plastik* (Amelung), 1928, 115, note 3 (Campanian); Neugebauer, Berlin *Bronzes*, I, 107; Rumpf, *Griechische und Römische Kunst*, 16; Jantzen, *Bronzewerkstätten*, 3, 69, no. 1, pl. 1, 1; P. J. Riis, *From the Collections Ny Carlsberg* 2 (1939) 153, fig. 18; *idem, Etruscan Art*, 41f., pl. 16, fig. 24; *idem, ActaA* 30 (1959) 44.

Exhibited: Worcester Art Museum, *Masterpieces of Etruscan Art*, 27-29, no. 13, 120, fig. 13.

179

"APOLLO"

Archaic

H.: 0.10m.

H. L. Pierce Fund *98.654*

E. P. Warren Collection.

Bought in London.

The left hand held a staff, now missing. Thick green and dark brown patina.

This was probably the handle of a vase or cista or situla. From the head rises a palmette ornament. The figure stands on a small, rec-

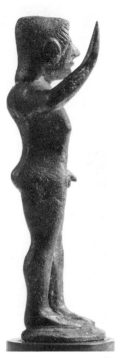
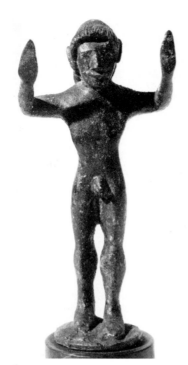

180 180

tangular plinth, with a rivet-hole in the center. The hair is long, and falls in a solid mass (details incised) on the back.

E. Robinson, *Ann. Rep.* 1898, 25; *AA* 1899, 136; Chase, *Antiquities*, 132, fig. 166; 2nd edition, 193, 205, fig. 191.

180

"Apollo" or an Orant
Archaic
H.: 0.085m.
H. L. Pierce Fund 98.655
E. P. Warren Collection.

Green patina, slightly crusty.

This figure probably comes from the top of a cista. The left foot is slightly advanced. Both hands are raised, with palms outward. The hair falls to the top of the shoulder. The inner lines of the ears and the eyes are incised.

A somewhat more refined figure in similar style, in the Walters Art Gallery, is dated 520 to 500 B.C.: Hill, Walters *Bronzes*, 80, no. 173, pl. 36; Queens College, Paul Klapper Library, *Man in the Ancient World*, 21, no. 129, 49, illus. Miss Hill feels this bronze is Greek, possibly Attic. For the pose of the Boston bronze, compare Sambon-Canessa Sale, Paris, 18-20 March 1901, no. 208, pl. 6. The Boston man with his hands up appears to have been made at Capua and belongs in the same workshop as the galloping horsemen on cistae (Ortiz).

E. Robinson, *Ann. Rep.* 1898, 26; *AA* 1899, 136.

Centaur

Archaic

H.: 0.083m. L. (plinth): 0.067m.

Gift of Harold W. Parsons 09.291

Probably formerly in the Tyszkiewicz Collection (Helbig, *Bull. dell'Inst.*, 1871, 68).

Remains of iron pin which ran through body and plinth. Green patina.

The features are rather rudely executed. The forelegs are human. Hair falls down on the shoulders, and the hands are held out in front.

Baur indicates that this statuette is a slightly cruder version of two examples in Berlin (his nos. 294, 295). This centaur must have been made about 520 B.C

L. D. Caskey, *Ann. Rep.* 1909, 56; *AA* 1910, col. 518; *AJA* 14 (1910) 390; *The Trojan War in Greek Art*, fig. 8a.

P. Baur, *Centaurs in Ancient Art*, 117f., fig. 30, no. 296; De Ridder, Louvre *Bronzes*, II, 104, under no. 2627; *AA* 1928, col. 686; Reinach, *Rép. stat.*, V, 401, no. 1.

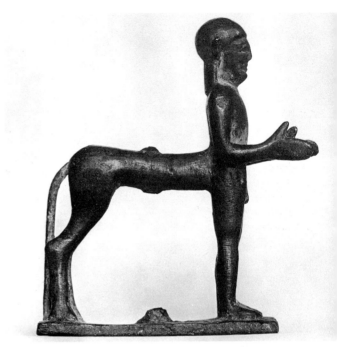

181

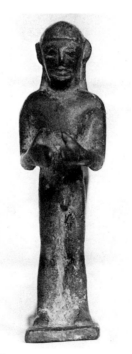

181

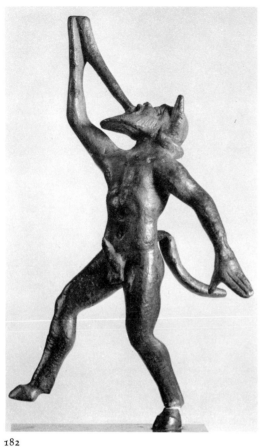

182

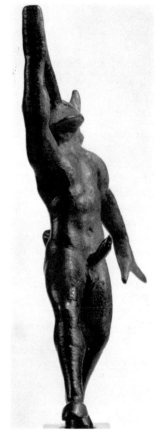

182

182

Silenus
Archaic, perhaps about 500 to 480 B.C.
H.: 0.13m.
Gift of E. P. Warren 13.112

One (left) hoof is restored. Green patina.
 He has horse's hoofs and is ithyphallic. He
is blowing a horn held in his raised right
hand.
 A replica, perhaps a forgery after this
bronze, has been noted by H. Hoffmann in
Brindisi (he cited G. Marzano, *Il Museo pro-
vinciale Francesco Ribezzo di Brindisi, Guida,*
1961, pl. XIV). Compare also the bronze in

Munich: *AA* 1910, cols. 49f., fig. 4; Reinach,
Rép. stat., IV, 551, no. 3; Petit Palais, *Col-
lection Dutuit:* pl. 150, no. 170, cited as Rein-
ach, *Rép. stat.*, III, 16, no. 7; Copenhagen,
Thorvaldsen Museum: I, 158, no. 8, and
Micali, *Monum* XLI, 7, cited as Reinach, *Rép.
stat.*, II, 48, no. 3.

L. D. Caskey, *Ann. Rep.* 1913, 88; *AA* 1914, col.
494.

E. Hill, *Magazine of Art* 33 (1940) 474f., fig. 8;
Mitten-Doeringer, *Master Bronzes*, under no. 80.

Exhibited: Worcester Art Museum, *Masterpieces
of Etruscan Art*, 53, no. 40, 130, fig. 40.

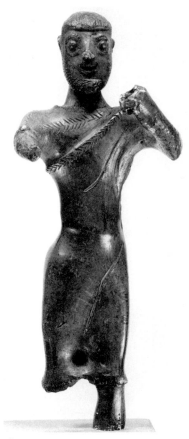

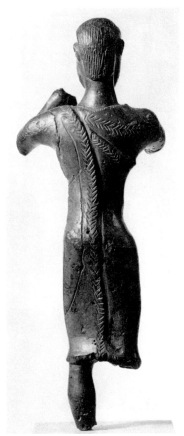

183

183

183

Draped Man
Archaic, circa 510 to 480 B.C.
H.: 0.14m.
Gift of Mrs. Edward Jackson Holmes 52.187

Right arm, right leg, left below (from) knee missing. Green patina, with corrosion.

The right arm was brought forward, and the raised left hand is pierced vertically to hold a scepter or thunderbolt. The bulging eyes with prominent lashes are set off by the short hair, mustache and short beard. Both tunic and toga are decorated with chevron designs on the borders. All details are incised.

The artist has turned a good Archaic Greek model into something very simple and schematized. A parallel in Berlin suggests that, if not a ruler or priest, this figure is Zeus Keraunios (E. H. Richardson, *MAAR* 21 [1953] 85, fig. 1). The fact that this Zeus, if it is he, is clothed likens him to the multitude of Cypriote votive statues of gods, rulers or priests surviving from the fifth century B.C. Something brought by the Etruscan ruling classes from the Near East led them to prefer their figures clad in long garments rather than represented in the athletic nude. This statue raises his left rather than his right hand, and this fact might make him a mortal rather than the Father of the Gods, who prefers to hurl his thunderbolts with his right hand.

H. Palmer, *Ann. Rep.* 1952, 19; Vermeule, *CJ* 55 (1960) 196f., fig. 5; *FastiA* 15 (1960) no. 671.

184

184

184

ZEUS (OR HOMER)
Etruscan, circa 440 B.C.
H. (without tangs): 0.103m. H. (with tangs
and part of ancient base): 0.12m.
Seth K. Sweetser Fund 65.565
Swiss Art Market.

Right hand and forearm missing, also object
held in left hand. Patina is light brown and
green, encrusted. Part of original lead base
still attached to curved tangs at feet.

He wears a long garment (himation?) about
his waist and most of his legs. It is wrapped
around the left shoulder and left arm, falling
down the back behind the former. He also
wears a fillet in his hair. A sharply-cut face
with almond-shaped eyes, straight nose, and
a long upper lip characterize the statuette.

The figure is a slightly older, more Etruscan
version of a type best known from a bronze
in Munich, that has been classed as Cam-
panian (P. J. Riis, *From the Collections of the
Ny Carlsberg Glyptothek* 2, 162ff., fig. 24).
The face of the statuette in Munich is less
individual, more clearly related to Zeus in the
transitional phase of Greek sculpture. Here,
although identification as Zeus seems more
likely, it is tempting to speculate whether or
not the Etruscan artist has tried to copy the
fifth-century type of the blind Homer with
closed eyes, a bronze statue that may have
stood at Olympia (compare K. Schefold, *Die
Bildnisse der antiken Dichter Redner und
Denker*, 62f., 203).

MFA, *Calendar of Events*, November 1965, 2,
illus.; Vermeule, *Ann. Rep. 1965*, 67; idem,
CJ 62 (1966) 104f., fig. 12.

Münzen und Medaillen, Auktion XXII, 13 May
1961, 40f., no. 76, pl. 23.

185

HERAKLES

Italo-Etruscan, circa 200 B.C.

H.: 0.085m.

Gift of Mr. Samuel Cabot 61.940

Left hand missing. Dark green patina.

He is brandishing his club in the raised right hand, and attachments indicate that an object such as a sword or spear was held in the outstretched left hand. The Nemean Lion's skin is worn on the hero's head, forepaws being knotted around the neck and hind-paws and tail wrapped over the left arm.

In its combination of Etruscan naturalism with the canons of Lysippos and the art of the early Hellenistic period, this bronze provides an excellent illustration of northern Italian art in the era of Roman rise to power. Bronzes such as these continued to be cast in Italy and Gaul down toward the end of the Roman Republic. They provide a form of continuity in the Hellenistic art of the Italian peninsula.

This statuette is a very good example of the Italic Herakles; many later versions of this figure are very crude, without the modelling and the incised detail (of the lion's skin) seen here (compare Hill, Walters *Bronzes*, 44f., no. 90, pl. 23 and references, a piece dated circa 400 B.C.).

Vermeule, *Ann. Rep.* 1961, 44; *idem, CJ* 57 (1962) 147f., fig. 3; *FastiA* 17 (1962) nos. 238, 243.

186

WARRIOR OR HERO, PROBABLY HERAKLES

Archaic

H.: 0.087m.

Gift of Mrs. Katharine Gale Gere 08.328

Traces of greenish patina.

He could be a very stylized Herakles, with rudimentary lion's skin on his left arm and club in his raised right hand.

Caskey, *Ann. Rep.* 1908, 60; *AA* 1909, col. 428; Chase, *Antiquities*, 132f., fig. 167; 2nd edition, 193, 205, fig. 192.

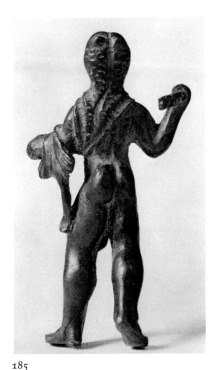 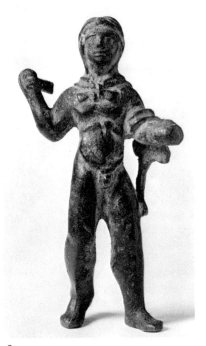 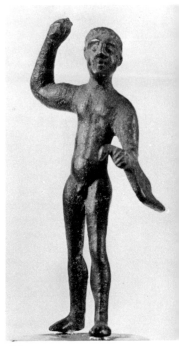

185 185 186

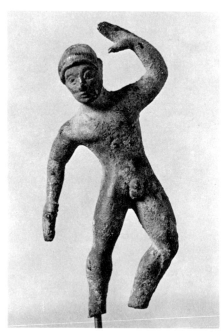

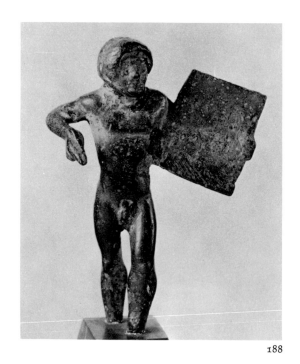

187

188

187

DISKOBOLOS
Circa 480 B.C.
H.: 0.067m.
Purchased by Contribution 01.7492
E. P. Warren Collection.
Bought in Rome.

Both feet are missing. The patina is dark blue.

The hair is arranged in a roll at the back of the head.

So far as motion goes, this figure is possibly a later development of Schumacher, Karlsruhe *Bronzen*, 175, no. 929, from Kleitor in Arcadia. Neugebauer *(Antiken in Deutschem Privatbesitz,* 21f., under no. 55) notes the same type of bronzes from Greece, South Italy, and Etruria. Style and workmanship distinguish the categories. One of the closest parallels is in Schloss Fasanerie (Adolphseck): Brommer, *Antike Kleinkunst,* 6ff., fig. 13; compare also a youth, probably holding up a discus, from the Spencer-Churchill collection: *Northwick Park Collection, Antiquities,* no. 446, pl. 50.

E. Robinson, *Ann. Rep. 1901,* 36; *AA 1902,* 131; *AJA 6* (1902) 377.
von Massow, *AM 51* (1926) 45, fig. 3.

188

MAN WITH TABLET
Circa 490 B.C.
H.: 0.063m.
Purchased by Contribution 01.7527
E. P. Warren Collection; Forman Collection.

Both feet are missing. The face is badly corroded.

The hair is represented by a series of engraved circles. He holds the large tablet in the crook of his left arm; an uncertain object (not a stylus?) was in the right hand.

The former, like the whole statuette, was probably intended to be and represent an offering at a sanctuary.

E. Robinson, *Ann. Rep. 1901,* 36; *AA 1902,* 131; *AJA 6* (1902) 377.
Forman Sale II, Lot 553.

Youth Reclining
Circa 480 B.C.
H.: 0.032m. L.: 0.056m.
Gift by Special Contribution 08.372
Purchased from Ferroni, Rome, through
Richard Norton.

Patina green and blue, crusty in spots.
 He is nude and rests his left elbow on a
cushion. He was originally fastened by a
large pin through the left thigh. His palms
are open and extended.
 From the edge of a cauldron (?): compare
Schumacher, Karlsruhe *Bronzen*, 88, no. 475;
Stuart Jones, *Conservatori*, 295, no. 34
(found in Rome), pl. 118.

L. D. Caskey, *Ann. Rep.* 1908, 60.

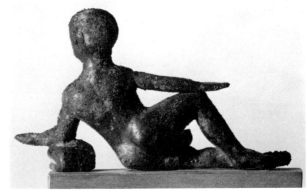

189

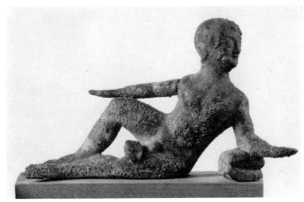

189

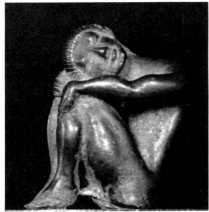

190

Seated Nude Youth
Early Fifth Century B.C.
H.: 0.038m.
James Fund and Special Contribution 10.164
E. P. Warren Collection.

Surfaces are worn and have marks from use
as a handle of a lid. Deep greenish brown
patina, with light green corrosion in spots.
 He is a grotesque. His knees are drawn up,
and one hand rests on each. He is asleep, his
head resting on his right knee.

L. D. Caskey, *Ann. Rep.* 1910, 60; *AA* 1911, col.
474; *AJA* 15 (1911) 433.
Forman Sale II, no. 575.

191 191

166

WARRIOR

Fifth Century B.C.

H.: 0.15m.

Gift of Mrs. Edward Jackson Holmes 52.186

The left arm, right hand and the spear held in the right hand are missing. The legs are broken off above the knees. Olive green patina with spots of light green corrosion.

The slender figure is striding forward, right arm raised. The features are crudely modelled. The helmet has a very large, decorated crest and upturned cheekpieces. The cuirass is incised, and a short skirt shows beneath.

There are many Central Italian or Etruscan bronzes of this type, one being at the Fogg Museum in Cambridge. Compare Walter Baker collection: D. von Bothmer, *Catalogue*, 7, no. 7, illus.; E. Hill, *JWalt* 7-8 (1944-45) 112ff.; *UPMB* 4, No. 6 (1933) 168ff., pl. 10; Babelon-Blanchet, *Bronzes*, 83f., no. 185 (Zurich, Kunsthaus, *Kunst und Leben der Etrusker*, no. 290, pl. 51); Bendinelli, *MonAnt* 26 (1920) cols. 224ff.; Rhode Island School of Design: Brinkerhoff, *Archaeology* 11 (1958) 156, illus.

While their pose is late Archaic, many belong in the fifth century B.C., and often their faces are modernized in a provincial version of High Classicism. An example of relevant style in Princeton is dated between 475 and 450 B.C. (F. F. Jones, *Ancient Art in the Art Museum, Princeton University*, 32f.).

H. Palmer, *Ann. Rep.* 1952, 19; M. F. A., *Engagement Calendar* 1958, March, illus.

YOUTH

Fourth Century B.C.

H.: 0.107m.

Gift of Mr. and Mrs. William de Forest Thomson 18.508

The right leg is broken off above the ankle and the left above the knee. Brown patina, the right arm and all below the waist also covered with green encrustation.

He stands with his left hand extended and his right hand on the hip, looking to the left.

The style depends vaguely on the leaning boy victors of Polykleitos ("Narcissus"). In Etruscan bronzes, compare the left hand figure on the lid of the Praenestine cista at Vassar (Ryberg, *AJA* 47 [1943] 217ff., fig. 2). If the object in the left hand were a club, the youth could have been Herakles. The pose is also derivative of the Polykleitan Herakles and its successors in the fourth century B.C.

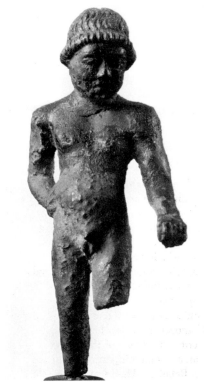

192

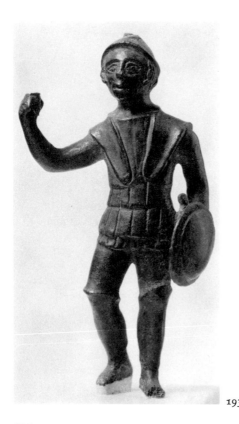

193

cuirass, with its two rows of large tabs or
pteryges, with the large, triangular shoulder
straps and with the tunic visible beneath the
lower row of tabs, is that diffused throughout
the early Hellenistic world by the soldiers
of Alexander the Great. The largest, grandest
bronze of the group with which this ex-
ample belongs is the so-called Mars from
Todi, in the Vatican. Here one cannot be sure
whether a divinity (Mars) or merely a mortal
(warrior) is intended.

A statuette of a warrior in Baltimore shows
the same rather crude features of the face,
with large, triangular eyes, a squashy nose
and heavy lips on a broad face (Hill, Walters
Bronzes, 55f., no. 113, pl. 26; see also Biblio-
thèque Nationale: Babelon-Blanchet,
Bronzes, 396, no. 906). One of the closest
comparable figures is a group of two war-
riors from the top of a candelabrum, once in
a private collection (Sarti) in Italy (F. Messer-
schmidt, *RM* 43 [1928] 147ff., especially
152ff., fig. 3).

Vermeule, *Ann. Rep.* 1958, 31; *idem, CJ* 55 (1960)
197f., fig. 6; *FastiA* 15 (1960) no. 671.

193

WARRIOR
Third Century B.C.
H.: 0.11m.
Gift of Horace L. Mayer 58.1281
Acquired in Florence.

The spear held in the right hand is missing.
Dark green patina with some spots of cor-
rosion in light green.

He is from the lid of a cista or the top of a
decorative candelabrum. The warrior wears
a round helmet which has lost its crest, a
leather cuirass with large shoulder straps and
greaves from above the knees to the ankles.
He held the spear vertically in the raised
right hand, and a short sword and small
round shield appear in his left hand.

This statuette is a product of the period
when Etruscan art is merging into that of the
rising Roman Republic. The form of the

194

HORSEMAN
Villanovan
L.: 0.04m.
Gift of E. P. Warren 13.139
From Italy.

The legs of the horse are missing, and so is
the rider's right hand. Greenish patina with
earth deposit.

The rider, whose legs are not rendered, is
seated on the crupper of the horse, his hands
lifted sideways, palm open. His head is
round, and his face is crude. The horse's
mouth is open and his tongue protrudes.

Similar figures occur with the rear legs of
the quadruped forming the catch or spring of
a fibula. The pin hooked on to the forelegs
(compare Helbing Sale, Munich, 22 February
1910, no. 365: two illus.).

L. D. Caskey, *Ann. Rep.* 1913, 88; *AA* 1914,
col. 494.

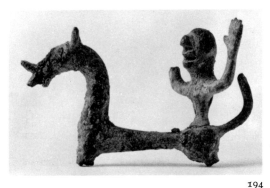

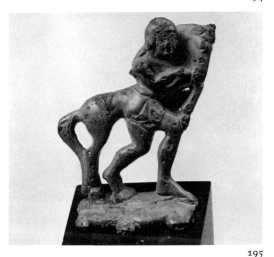

194

195

YOUTH SEIZING HORSE
Archaic
H.: 0.05m.
H. L. Pierce Fund 98.660
E. P. Warren Collection.
Bought in Rome.

Green patina.

The base of this ornament takes the form of two scrolls, juxtaposed.

Compare a bronze in the Bibliothèque Nationale: Babelon-Blanchet, *Bronzes*, 391f., no. 895, and another from Capua: Reinach, *Rép. stat.*, II, 534, no. 2. Robinson suggested that this was an ornament from a helmet, and the ornaments on a helmet in Copenhagen seem to support this: Copenhagen, *Bilder-*

tafeln des Etruskischen Museums, pls. 97ff., especially 99b. An example in the Villa Giulia Museum shows the same design moving from right to left and thus could have come from the left side of the same helmet: Giglioli, *L'Arte etrusca*, pl. 104, no. 2.

E. Robinson, *Ann. Rep.* 1898, 28; *AA* 1899, 137.

196

THREE FIGURES IN OPEN RELIEF
Late Archaic
H.: 0.047m.
Gift of E. P. Warren 01.8376

Brown patina. The two at the left are badly corroded, in light green.

This may be the ornament of a helmet or a tripod. A figure with a club in the left hand and a garment over the right arm walks away from a bearded figure at the left; there is a beardless figure at the right. Both outside figures grasp the one in the center by the arms. All appear to wear chitons. Lyre-form egg and palmette pattern below.

The scene may be an abstraction of the contest between Herakles and Apollo for the Delphic Tripod. Zeus would be at the left.

Two objects in the Louvre are similar in size and style; both feature Herakles in scenes of combat, once with Hera and once with a warrior: see De Ridder, Louvre *Bronzes*, II, 42, nos. 1681f., pl. 75.

E. Robinson, *Ann. Rep.* 1901, 36; *AA* 1902, 132; *AJA* 6 (1902) 377.

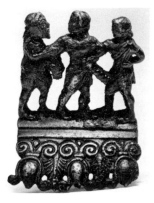

196

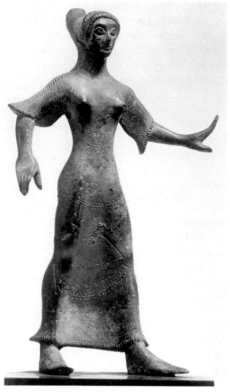
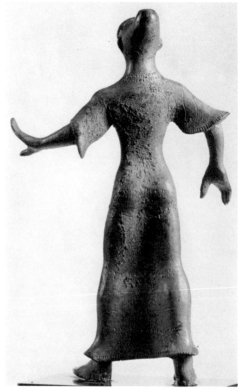

197 197

DANCER

Late Archaic, circa 500 B.C.

H.: 0.133m.

Purchased by Contribution 01.7482

E. P. Warren Collection.

Bought in Rome.

Toe of the right foot has been filed off. Surface somewhat corroded; brownish patina on head, with olive green on body.

Wearing tutulus and long chiton with embroidery around neckline and on shoulders prominently indicated by incised lines, she walks elegantly along in her pointed slippers. The edges of her sleeves and the lower part, including the hem of her himation, are also represented by incised lines or parallel hatchings.

This statuette comes from the same workshop and the same tomb as a kouros in the collection of Norbert Schimmel, New York, from the Simkhovitch collection (H. Hoffmann, *Norbert Schimmel Collection*, no. 40).

E. Robinson, *Ann. Rep.* 1901, 36; *AA* 1902, 131; *AJA* 6 (1902) 377; Chase, *Antiquities*, 132, fig. 165; 2nd edition, 193, 205, fig. 190; *Museum of Fine Arts Boston, Western Art* (Japanese edition, Tokyo, 1969) pl. 11, 152, no. 11.

E. Hill, *Magazine of Art* 33 (1940) 470f., figs. 1a, 1b; W. Schiering, *AA* 1966, 374f., fig. 10; Mitten-Doeringer, *Master Bronzes*, under no. 57.

Exhibited: Buffalo, *Master Bronzes*, no. 76, illus.; Detroit, *Small Bronzes of the Ancient World*, 8, no. 39, 23, illus.; Zurich, Kunsthaus, *Kunst und Leben der Etrusker*, no. 171.

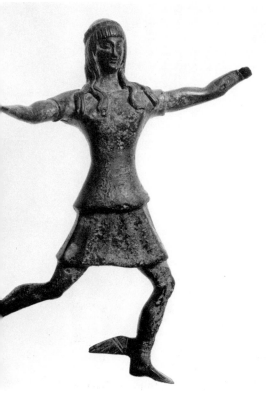
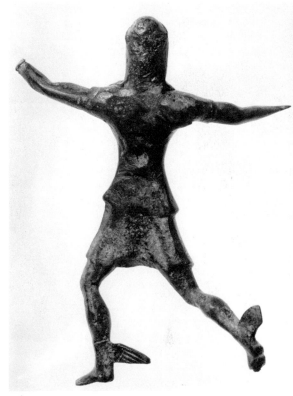

198 198

198

RUNNING GIRL ("LASA")
Early Fifth Century B.C. Campanian (?)
H.: 0.13m.
H. L. Pierce Fund 98.662
E. P. Warren Collection.
From Italy (sent from Reggio).

Right hand broken off and repaired; the left
mended at the wrist and mostly missing.
Darkish green patina.

She wears a chiton and close-fitting shirt
with short sleeves. Her hair is in long, wavy
locks on each side of her neck and on her
shoulders. The figure was attached at the
back to something else, and the feet show
traces of an attachment. Her semi-divine at-

mosphere is stressed by the presence of wings
attached to her footgear.

If not made in one of the southernmost
cities of Etruria, or in Latium, this Etruscan
concept of a running spirit or soul was pro-
duced in a Campanian Greek workshop for
consumption in the Etruscan market. If the
"Lasa" were found in or near Reggio, then the
statuette must have wandered by any variety
of means into the wrong export market or in-
to a collection of heirlooms.

E. Robinson, *Ann. Rep. 1898*, 29; *AA 1899*, 137;
Handbook 1964, 66f., illus.

D. Adlow, *The Christian Science Monitor*, 19 Feb.
1960, 12, illus.

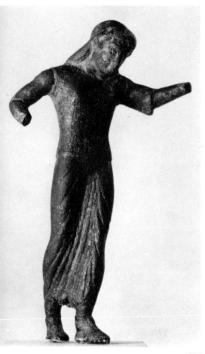

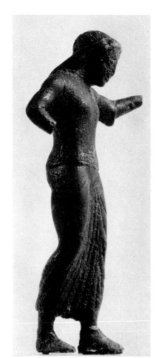

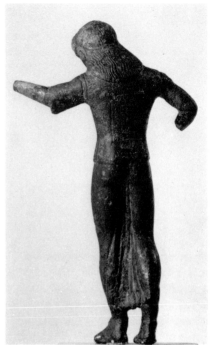

199 199 199

199

Dancing Maenad
Circa 480 B.C. Campanian
H.: 0.086m.
H. L. Pierce Fund 98.661
E. P. Warren Collection.
From South Italy.

Both hands are broken away. Brown patina,
with greenish corrosion on the hair.

She wears a chiton with incised meander
border on her jacket, shoes, and fillet in her
hair. The last falls in a solid mass on her back.

Compare Giglioli, *L'Arte etrusca*, pl. 209,
no. 1 (right-hand figure); an example at
Mariemont, a walking girl of unknown
provenance, was made in the same atelier, at
the same time (Renard, *Les antiquités du
Musée de Mariemont*, 121, no. I, 2, pl. 45).
See also the top of a candelabrum in the Vati-
can: F. Magi, *La raccolta Benedetto Guglielmi
nel Museo Gregoriano Etrusco*, II, 171ff.,
no. 2, pl. 51; and the girl in the conventional
walking-dancing pose, from the Spencer-
Churchill collection: *Northwick Park Collec-
tion, Antiquities*, 110, no. 447, pl. 50.

E. Robinson, *Ann. Rep.* 1898, 28f.; *AA* 1899, 137.

E. Hill (Richardson), *Magazine of Art* 33 (1940)
477ff., fig. 19 (with list in note 19 of other com-
parable bronzes).

200

Herakles
Fifth Century or later
H.: 0.075m.
*Gift of Mr. and Mrs. William de Forest
Thomson 18.506*
A label on the bottom of the pedestal suggests
the bronze came from an old French collec-
tion (Cannes?).

His right hand is missing. Green patina with
considerable wear.

He holds the lion's skin over his extended
left arm and probably held the club in his

raised right hand. He has large eyes and ears, drill holes for nipples and navel.

For similar inferior-quality fighting Herakleses and their literature, see van Gulik, Allard Pierson *Bronzes*, 19f., nos. 32ff., pl. 4. In connection with the Central Italian derivation of these figures, an amazing photograph in *AA* 1941 (col. 630, fig. 123) shows about thirty-three of these bronze statuettes from a find in Caramanico (province of Pescara), preserved in the Museo Provinziale, Chieti. A. Andrén *(OpusArch 5* [1948] 16f., nos. 27f.) notes the difficulty of assigning more than a general date to these classes of figures on other than qualitative and possibly stylistic grounds.

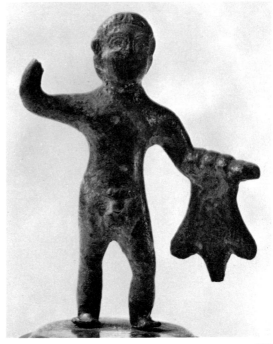

200

201

YOUTH
Early Fifth Century B.C. or later
H.: 0.08m.
Gift of Mr. and Mrs. William de Forest Thomson 18.497

The right foot and arm are missing. Green patina.

This nude youth is advancing, with left arm extended. The hair is combed forward, and the penis is roughly indicated. There is a tang under the left foot. The figure can also do for a very stylized Herakles, club in his raised right hand.

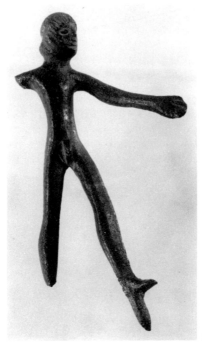

201

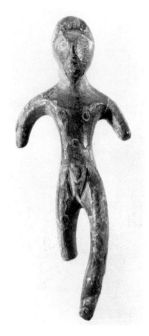

202

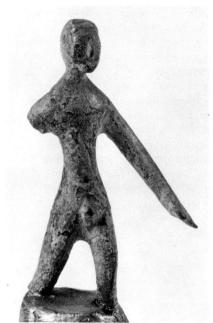

203

202

MAN STANDING
Archaic or later
H.: 0.065m.
*Gift of Mr. and Mrs. William de Forest
Thomson 18.498*

Both arms broken at or just above the elbows
and the right leg below the knee. Left foot
also missing. Green patina.

He is nude, and his left leg is extended. His
hair is combed forward. Eyes, nipples, and
navel are shown by large circles.

203

MAN ADVANCING
Archaic or later
H.: 0.063m.
*Gift of Mr. and Mrs. William de Forest
Thomson 18.499*

Right arm and legs below knees missing.
Green and black patina, with corroded sur-
face.

He is nude, and his left arm is extended,
palm open and downwards.

204

YOUTH (HERAKLES?)
Archaic or later
H.: 0.087m.
Gift of Mr. and Mrs. William de Forest Thomson 18.500

Left arm missing below elbow; both feet missing also. Crusty green patina with earth deposit.

He has remains of an object (a club?) in the raised right hand. A necklace-like incised decoration (remains of a lion's skin?) is about his chest and shoulders. Nipples are represented by incision.

205

MAN
Archaic or later
H.: 0.046m.
Gift of Mr. and Mrs. William de Forest Thomson 18.505

Right arm (and left hand?) missing. Greenish, gray patina, with corrosion and earth deposit.

He is nude, and his left arm is extended. Nipples and navel are represented by incision.

206

WARRIOR
Archaic or later
H.: 0.07m.
Gift of Mr. and Mrs. William de Forest Thomson 18.502

Both arms broken off above elbow and right leg at the knee. Green patina.

He is nude, save for a crested helmet, and advances to the right. Eyebrows are incised, and penis is suggested in relief. This figure is a very simplified version of the standard Italic or Etruscan striding warrior of the late archaic and classical periods (see above, under no. 191, a more developed and detailed example).

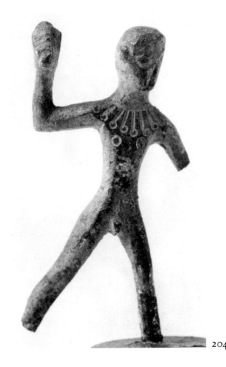

204

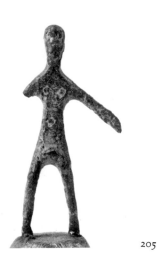

205

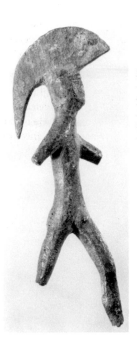

206

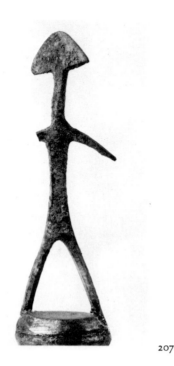

207

207

WARRIOR
Archaic or later
H.: 0.068m.
*Gift of Mr. and Mrs. William de Forest
Thomson 18.504*

Right arm (and left hand?) missing. Light
green and rusty patina.

He is nude, save for a crested helmet, and
advances to the right.

208

YOUTH
Archaic or later, probably Hellenistic period
H.: 0.05m.
*Gift of Mr. and Mrs. William de Forest
Thomson 18.507*

Green patina, with encrustation. The back is
hollowed out, as if the figure had been de-
signed as an appliqué.

He stands with legs apart and hands on
hips.

209

DRAPED WOMAN
Archaic or later
H.: 0.065m.
*Gift of Mr. and Mrs. William de Forest
Thomson 18.503*

Green and black patina, with encrustation.
Right hand missing (?).

She stands in the "kore" pose, holding up
her drapery in her left hand. She wears a
high hat and long garment.

Compare De Ridder, Louvre *Bronzes*, I, 40,
no. 225, and 41, no. 232, pl. 23; (London)
Soane Museum, *Catalogue*, no. 422. A bronze
in Copenhagen shows the Archaic Italic
prototype: *Bildertafeln des Etruskischen Mu-
seums*, pl. 92, c. Like the Etruscan and Italic
figures of Herakles brandishing his club, or
the helmeted warriors waving their spears,
these "korai" have a long tradition of styliza-
tion from good Etruscan models of the archa-
ic period. For further examples in the archaic
and the fifth-century tradition, see H. Hoff-
mann, *Norbert Schimmel Collection*, nos. 42,
41, the former said to come from near
Populonia.

Vermeule, *TAPS* 56 (1966) 41 (under fol. 59:
no. 8613).

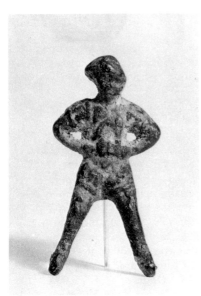

208

DRAPED WOMAN
Fifth Century B.C.
H.: 0.11m.
*Gift of Mr. and Mrs. William de Forest
Thomson 18.495*

Even dark-green patina. Left foot missing.
 She wears cap and/or hair in a large, rolled
braid and a long garment, to her ankles. Eyes
are incised, and lips are represented in plastic
fashion.
 Compare the Umbrian woman in the Bib-
liothèque Nationale, dated about 450 B.C.:
E. Richardson, *The Etruscans*, pl. 27b.

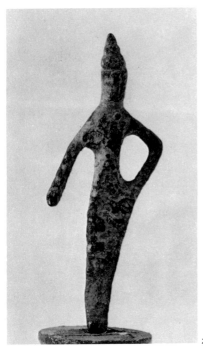

209

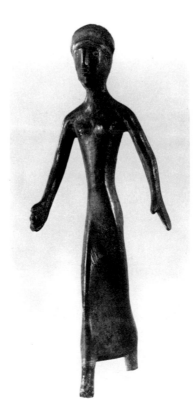

210

212 213

Crusty, green patina.

She holds a patera in her extended right
hand and wears a large, flowery hat, chiton,
and tight himation. The tang at the lower left
side suggests she may have been attached to
another figure.

There is a large group of these statues of
"Hera" or a votary: compare De Ridder,
Louvre *Bronzes*, I, 51, no. 316, pl. 28; of
"priestesses": compare Hill, Walters *Bronzes*,
102f., nos. 227-233; Kassel: Bieber, *Cassel*,
pl. 45, no. 224 = Reinach, *Rép. stat.*, V, 509,
no. 8; and especially from Geneva: Reinach,
Rép. stat., V, 372, no. 5; also New York:
Richter, *Ancient Italy*, 23, fig. 111; Lebel,
Annales . . . Besançon, vol. 26, *Archéologie*
8, *Bronzes*, pl. 46. Like the statuettes dis-
cussed previously, they show all stages of
qualitative and three-dimensional develop-
ment from Italic to Roman Republican to
early imperial times.

211

DRAPED YOUTH
Fourth Century B.C. or later
H.: 0.085m.
*Gift of Mr. and Mrs. William de Forest
Thomson 18.496*

Green patina, with some corrosion.

His longish hair is bound by a fillet. He
wears long chiton and a tightly-wrapped
himation.

Rhythm, proportions, and costume recall to
a certain extent the "Arringatore" in minia-
ture: Giglioli, *L'Arte etrusca*, pl. 369. Small
figures of this nature are the forerunners of
the standing youths in Greek dress or in
proto-Roman togas that have such a promi-
nent place in the repertory of Italic work in
bronze toward the end of the Roman Republic
and in the first century of the Empire.

212

DRAPED WOMAN
Fourth Century B.C. or later
H.: 0.061m.
*Gift of Mr. and Mrs. William de Forest
Thomson 18.501*

211

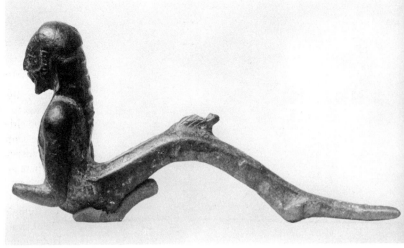

214 214

213

DRAPED WOMAN VOTARY
Fourth Century B.C. or later
H.: 0.038m.
Gift of the Misses Aimée and Rosamond
Lamb 68.41

Rough greenish black patina.

She wears a large diadem or hat and a long
himation wrapped tightly around her body.
Her hands are held outwards, palms open; the
left is turned slightly upwards, in the tradi-
tional Italo-Roman gesture of prayer. Head
and arms are tubular, but the body is thin,
almost a flat sheet. The fold of the garment is
shown merely as a diagonal groove from the
left shoulder to the right side. A tang projects
from below her feet, for attachment.

Again, the work is cursory but not without
a certain primitive, provincial appeal. The
date is certainly no earlier than the outset of
the Hellenistic period, and it could be as late
as the first century A.D.

214

TRITON
Late Sixth Century B.C.
H.: 0.041m. L.: 0.084m.
Purchased by Contribution 01.7508
E. P. Warren Collection.
Bought in Paris.

Right arm broken off at the elbow, left hand
at the wrist, also one tail fin. Green patina.

He is bearded, with human portion upright
and fish body undulating behind. He was sup-
ported on a base by an attachment at the
bottom.

Such figures occur on Etruscan black-figure
vases, as on the neck of a hydria in Boston
(01.8062; A. K. Fairbanks, *Greek and Etrus-
can Vases*, 200, no. 573, pl. 75).

E. Robinson, *Ann. Rep.* 1901, 36; *AA* 1902, 131;
AJA 6 (1902) 377.

K. Shepard, *The Fish-Tailed Monster*, 31, fig. 42.

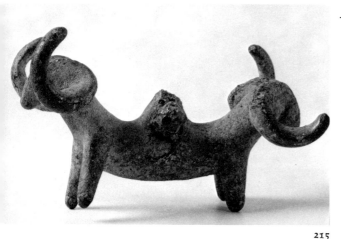

215

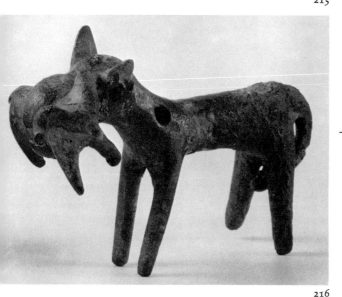

216

215

DOUBLE-HEADED RAM
Seventh Century B.C.
L.: 0.066m.
Gift of Mrs. Edward Jackson Holmes 52.185

Earthy, light green patina.

Two rams' heads with large horns are attached either end of the body. There is a loop in the center of the body, with remains of an iron suspension ring.

There are many of these bronzes, and they have been found at Olympia and Delphi (compare Orlandini, *ArchCl* 8 [1956] 2, pl. 1, 3; *Olympia* IV, pl. 25, no. 477; *Fouilles de Delphes* V, 56, no. 179, fig. 176). Herbert Hoffmann has mentioned two examples in Hamburg, Museum für Kunst und Gewerbe. See also De Ridder, Louvre *Bronzes*, I, 37, no. 199, pl. 21, and bibliography; Neugebauer, *Antiken in Deutschem Privatbesitz*, 21, no. 51 ("Ostitalische") and bibliography.

216

ANIMAL GROUP
Archaic
L.: 0.061m.
Gift of Mrs. James P. Tolman 22.710
Buffum Collection.

Pierced above the shoulders; tail bent in. Greenish patina, corroded.

A quadruped stands, holding a little ram in her (?) long, griffin-like mouth.

Compare Schefold-Cahn, *Meisterwerke*, 131, no. 61 (termed late eighth century, Peloponnesian; wolf or hound, with cub or "whelp").

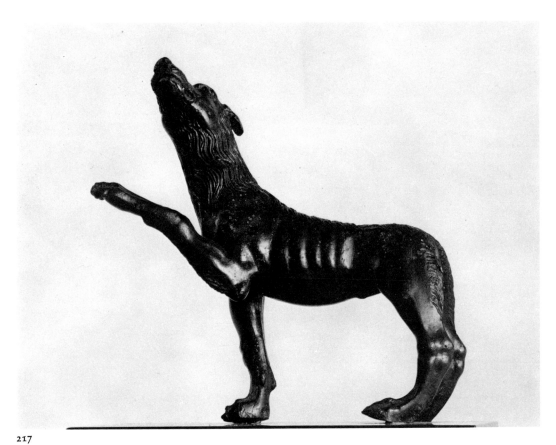

217

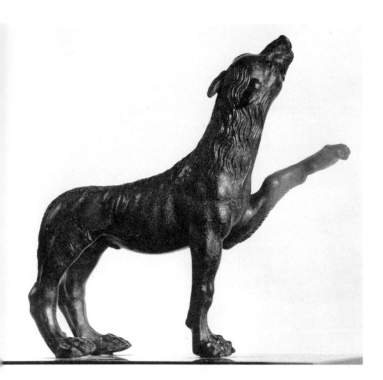
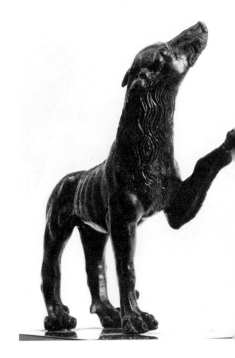

217 217

217

Dog
Fourth Century B.C. or later
H.: 0.108m.
Perkins Collection 96.713
E. P. Warren Collection; Fanello Fanelli Collection at Sartiano.
From near Chiusi.

The tail and the iris of the left eye are missing. Dark green patina, with slight pitting.

His left forepaw and head are raised.

The animal is executed in the naturalistic Etruscan tradition of the Lupa Romana or the Chimaera from Arezzo. The iris of the right eye is inlaid in another material, now covered by green patina. The tail could have been made of the same substance, perhaps silver.

Compare the "wolf" from Cortona, in Florence, with an Etruscan inscription: Reinach, *Rép. stat.*, VI, 153, no. 5.

Although this large, lupine canine appears to be raising his left paw as if trained to beg for something, the combination of tensed leg muscles and flat underside of the paw suggests the animal was resting his weight lightly on an object. It seems unlikely that this object was another animal. It could have been a handle or some other functional object, even the side of a vessel. A pair of such beasts could have guarded the looped handle on the rim of a large tray, basin, louter, or deeper receptacle.

E. Robinson, *Ann. Rep. 1896*, 29; *AA 1897*, 73.

Exhibited: Worcester Art Museum, *Masterpieces of Etruscan Art*, 92-93, no. 83, 177, fig. 83.

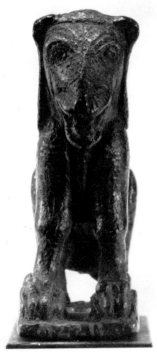

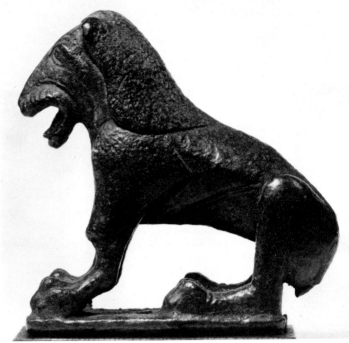

218 218

218

LION

Archaic, circa 520 B.C.

H.: 0.076m.

Purchased by Contribution 01.7469

E. P. Warren Collection; formerly belonged to
La Ferlita.

Bought in Palermo; found near Giarratana,
Sicily.

The tail is broken off and missing. Brown-
green patina.

The mane is unchiselled, and the muscula-
tion is schematic. The plinth has a square
projection beneath, where it is pierced by a
large round hole. For a stylistically compar-
able group of lions, from the edges of a four-
wheeled tray, see Schumacher, Karlsruhe
Bronzen, 65f., no. 380 (from Bolsena),
no. 381.

E. Robinson, *Ann. Rep. 1901*, 36; *AA* 1902, 132;
AJA 6 (1902) 377; Chase, *Antiquities*, 2nd edition,
194, 207, fig. 196.

dell'Agli, *Ricerche storiche su Giarratana*, pl. 2;
Brown, *The Etruscan Lion*, 12 (as "queer and
problematical").

Exhibited: Buffalo, *Master Bronzes*, no. 4, illus.;
Detroit, *Small Bronzes of the Ancient World*,
5, no. 5.

CICADA
Archaic Greek or Italian
L.: 0.050m.
Purchased by Contribution 01.7470
E. P. Warren Collection.
Bought at Taranto; found at or near there.

The left "feeler" is broken off. Corroded underneath (cleaned in 1954). Dull green patina.

The wings are closed along the body. At present the front legs are bent double, the others flat along the sides. The body is hollow.

Compare the cicada perched on an Attic white-slip phiale by Sotades (MFA 98.886), circa 440 B.C.: Richter, *Animals*, 86, fig. 225. See also the cicadas in crystal from Aquileia (Reinach, *Rép. stat.*, V, 467, 5) and ivory from Locri (467, 6); in terracotta they appear to be found in Attica as early as the sixth century B.C.: Schefold-Cahn, *Meisterwerke*, 183, 186, under no. 199; Lullies, ΘΕΩΡΙΑ, 146f., especially note 32.

A bronze creature in the Allard Pierson Museum is termed a locust; he has a ridged tail: van Gulik, Allard Pierson *Bronzes*, 62, no. 91, pl. 20.

E. Robinson, *Ann. Rep.* 1901, 36; *AA* 1902, 132; *AJA* 6 (1902) 377.

219

219

Works in the Manner of the Antique

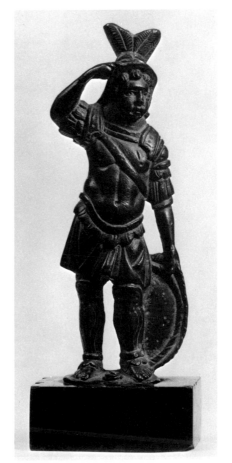

220

LEGIONARY
Seventeenth or Eighteenth Centuries
H.: 0.12m.
Gift of Mr. and Mrs. J. J. Klejman, New York
64.2197
From England.

Green patina.

 A legionary in plumed helmet, cuirass, greaves, and baldric stands, right hand on the edge of his helmet and left resting on a shield at his left leg. The back is hollow, as if the whole piece had been an appliqué.

 Compare the fourth-century statue of a legionary from York: Vermeule, *Berytus* 13 (1959) 73, no. 320; Reinach, *Rép. stat.*, V, 268, no. 3.

Vermeule, *Ann. Rep. 1964,* 31.

220

JEWELRY

Cypriote

221

BRACELET
Probably Fifth Century or later
DIAM.: 0.054m.
Purchased by Subscription 72.367
General di Cesnola Collection.
From Cyprus.

Varied encrustation.
 The ends are formed into the heads of snakes.

222

BRACELET
Late Cypriote
DIAM.: 0.07m.
Purchased by Subscription 72.369
General di Cesnola Collection.
From Cyprus.

Roughly encrusted.
 The ends are open, and the circle is irregular. The section is round.
 Compare Catling, *Cypriot Bronzework*, fig. 22, no. 7.

223

BRACELET
Late Cypriote
DIAM.: 0.076m.
Purchased by Subscription 72.370
General di Cesnola Collection.
From Cyprus.

Parts are encrusted.
 This is a circle with two coils, slightly overlapping at the ends. The section is round.
 Compare Catling, *Cypriot Bronzework*, fig. 22, nos. 6, 12, etc.

224

BRACELET
Late Cypriote
DIAM.: 0.089m.
Purchased by Subscription 72.371
General di Cesnola Collection.
From Cyprus.

Parts are encrusted.
 The circle is irregular, and there is an overlap of 0.055m. The section is thick and round.
 Such Geometric bracelets are occasionally decorated with birds: compare Hesperia Art, *Bulletin* XXIV, no. A1.

222

223

226

225

Bracelet
Late Cypriote
DIAM.: 0.111m.
Purchased by Subscription *72.373*
General di Cesnola Collection.
From Cyprus.

Brilliant green encrustation.
 The circle is irregular, and there is an overlap of 0.007m. The section is thick and round.

226

Bracelet
Late Cypriote
DIAM.: 0.051m.
Purchased by Subscription *72.368*
General di Cesnola Collection.
From Cyprus.

Thickly encrusted with green.
 The ends lap slightly, and the section is round.
 Compare Catling, *Cypriot Bronzework,* fig. 22, no. 9.

227

Spiral Ring
Middle or, more likely, Late Cypriote
DIAM. (max.): 0.038m.
Purchased by Subscription *72.4896*
General di Cesnola Collection.
From Cyprus.

Dark green patina, and encrusted. One end is broken off.
 This ring, perhaps for the hair, is comprised of one and one-half coils. In section it is flat and thin.

228

SPIRAL RING

Middle or, more likely, Late Cypriote

DIAM.: 0.044m.

Purchased by Subscription 72.4897

General di Cesnola Collection.

From Cyprus.

Dark green patina, and encrusted. The ends
are broken off.

This is too large for a finger ring; perhaps
it is a child's bracelet. The coils overlap rather
than forming a real spiral. In section, it is flat
and thin.

227

229

SPIRAL RING

Middle or, more likely, Late Cypriote

DIAM.: 0.029m.

Purchased by Subscription 72.362

General di Cesnola Collection.

From Cyprus.

Dull greenish brown encrustation.

There are nearly three complete coils. These
objects were probably set around the curls
of a woman's hair.

Compare Catling, *Cypriot Bronzework,*
fig. 22, no. 12 (Late Cypriot personal objects).

228

230

SPIRAL RING

Late Cypriote

DIAM.: 0.029m.

Purchased by Subscription 72.364

General di Cesnola Collection.

From Cyprus.

Dull, brown-green patina.

The ends of this coil are open and lapping.
There are over two coils, with a thick, round
section.

Compare Catling, *Cypriot Bronzework,*
fig. 22, nos. 13, 14.

229

230

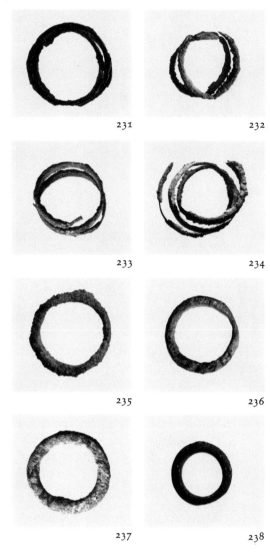

231

232

233

234

235

236

237

238

Compare Catling, *Cypriot Bronzework,* fig. 22, no. 13, etc. (all round).

232

SPIRAL RING
Late Cypriote
DIAM.: 0.024m.
Purchased by Subscription 72.4890
General di Cesnola Collection.
From Cyprus.

Dull green patina, heavily encrusted. Broken at one end and bent.
　There are nearly two complete coils; in section it is flat and thin.

233

SPIRAL RING
Late Cypriote
DIAM.: 0.023m.
Purchased by Subscription 72.4891
General di Cesnola Collection.
From Cyprus.

Green patina, much encrusted. One end is broken off.
　There are two and one-quarter coils. It is similar to the previous.

234

SPIRAL RING
Late Cypriote
DIAM.: 0.024m.
Purchased by Subscription 72.4892
General di Cesnola Collection.
From Cyprus.

Green patina, encrusted. One end is broken off.
　There are two and three-quarter coils. It is similar to the previous.

231

SPIRAL RING
Late Cypriote
DIAM. (max.): 0.022m.
Purchased by Subscription 72.4878
General di Cesnola Collection.
From Cyprus.

Greenish patina, crusty.
　Two coils; ends open and lapping. Flat, rather thin (not circular) wire.

235

SPIRAL RING
Late Cypriote
DIAM.: 0.025m.
Purchased by Subscription 72.363
General di Cesnola Collection.
From Cyprus.

Encrusted.

There are nearly two complete coils; the section is small and round. The ring could have been either for the hair or finger.

Compare Catling, *Cypriot Bronzework*, fig. 22, nos. 13, 14.

236

RING
Date undetermined
DIAM.: 0.024m.
Purchased by Subscription 72.4893
General di Cesnola Collection.
From Cyprus.

Dull green patina.

This is a plain round ring, thinner in one portion.

237

RING
Date undetermined
DIAM.: 0.026m.
Purchased by Subscription 72.4894
General di Cesnola Collection.
From Cyprus.

Green patina.

This is undecorated, slightly heavier in section than the previous.

238

RING
Date undetermined
DIAM.: 0.019m.
Purchased by Subscription 72.361

General di Cesnola Collection.
From Cyprus.

Crusty green patina.

There is a ridge in the middle and dull incision.

Also in the museum collection but not fully described in the catalogue are eleven small, undecorated rings of this type, two of which are suspended from another flattened one; three were overlapping circlets. Fragments of two others are included.

239

EARRING (?)
Late Cypriote
DIAM.: 0.035m.
Purchased by Subscription 72.365
General di Cesnola Collection.
From Cyprus.

Light green encrustation.

This is thick at the bottom and tapers to open ends.

Compare Catling, *Cypriot Bronzework*, fig. 22, no. 19; British Museum, *Greek and Roman Life*, 125, fig. 133 (sixth century, from Ephesus).

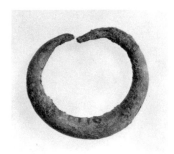

239

240

EARRING (?)
Late Cypriote
DIAM. (max.): 0.034m.
Purchased by Subscription 72.366
General di Cesnola Collection.
From Cyprus.

Light green encrustation.
As previous, thick at the bottom, tapering to open ends which are broken off.

241

EARRING (?)
Late Cypriote
DIAM.: 0.022m.
Purchased by Subscription 72.4895
General di Cesnola Collection.
From Cyprus.

Heavily encrusted, and dark green patina. One (or both) ends are broken off.
This is more U-shaped than the previous, but otherwise similar.
Also in the museum collection but not described are three earrings, one fragmentary (Apparatus); they are similar to the preceding.

242

HAIR PIN
Early or Middle Cypriote
L.: 0.095m.
Purchased by Subscription 72.395
General di Cesnola Collection.
From Cyprus.

A section is broken away.
The ends are thickened into elongated drops.
Compare Catling, *Cypriot Bronzework*, fig. 5, no. 12.

243

NEEDLE OR KNOT-HEADED PIN
Early to Middle Cypriote
L.: 0.105m.
Purchased by Subscription 72.398
General di Cesnola Collection.
From Cyprus.

Encrusted, whitish green.
There is a ring at one end.
Compare British Museum, *Greek and Roman Life*, 137f., figs. 154f.; Catling, *Cypriot Bronzework*, fig. 6, no. 7.

244

PIN
Early to Middle Cypriote
L.: 0.048m.
Purchased by Subscription 72.384
General di Cesnola Collection.
From Cyprus.

Green encrustation.
This is a circular section, thicker at one end than the other. It appears to be the central section and most of the lower end of a toggle pin.
Compare Catling, *Cypriot Bronzework*, fig. 5, nos. 19-22.

245

PIN
Early to Middle Cypriote
L.: 0.07m.
Purchased by Subscription 72.393
General di Cesnola Collection.
From Cyprus.

Varied encrustation.
There is a small projection at right angles at one end. The main section is cylindrical.
Compare Catling, *Cypriot Bronzework*, fig. 6, no. 1.

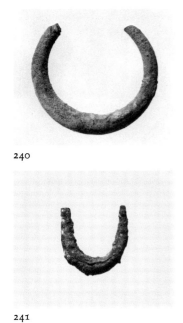

240

241

242

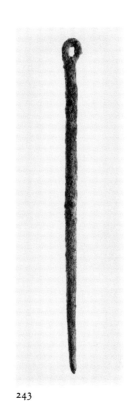

243

244

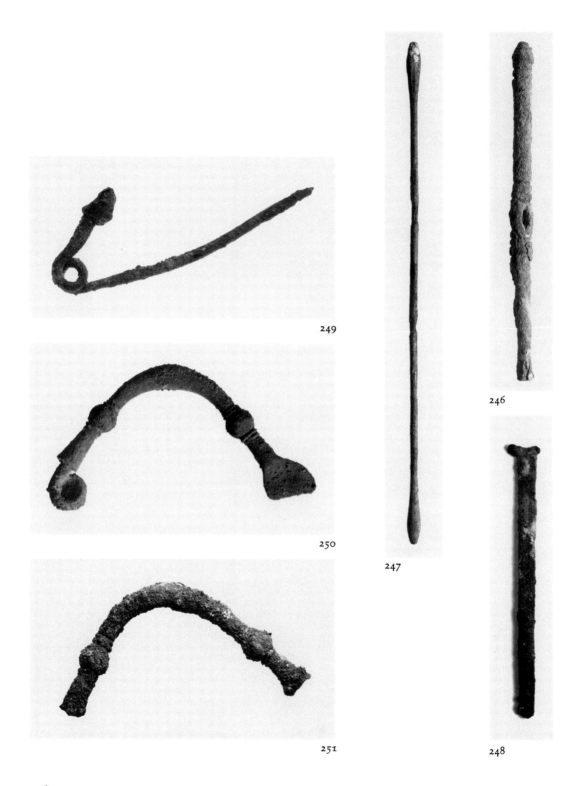

249

246

247

250

248

251

246

PIN
Early to Middle Cypriote
L.: 0.111m.
Purchased by Subscription 72.399
General di Cesnola Collection.
From Cyprus.

One end is broken away. Eaten by green cor-
rosion.
 This cylindrical section is split at the mid-
dle and has ring ornaments at four points.
 Compare Catling, *Cypriot Bronzework,*
fig. 6, no. 4 (with more pronounced head and
an eye in the center; therefore, a toggle pin).

247

HAIR PIN
Geometric or later
L.: 0.143m.
Purchased by Subscription 72.394
General di Cesnola Collection.
From Cyprus.

Crusty green patina.
 The central section is cylindrical, with two
thin parts in the very middle.
 Catling's Bronze Age parallels differ con-
siderably.

248

NEEDLE OR PIN
Cypriote, Geometric (?)
L. (max., present condition): 0.068m.
Purchased by Subscription 72.4875
General di Cesnola Collection.
From Cyprus.

There is an eye-hook (mostly broken) at one
end; the other end is broken off also. Slight
ridge (?) at break.
 There seem to be no Bronze Age examples
with eye-hooks: see Catling, *Cypriot Bronze-
work, passim.*

249

FIBULA
Late Cypriote
L.: 0.077m.
Purchased by Subscription 72.4876
General di Cesnola Collection.
From Cyprus.

Much of the clasp is missing. Green encrusta-
tion.
 Compare Catling, *Cypriot Bronzework,*
fig. 22, nos. 37, 38.

250

FIBULA
Late Cypriote
L.: 0.079m.
Purchased by Subscription 72.413
General di Cesnola Collection.
From Cyprus.

Spots of bright green in the patina.
 The ornamentation on each side consists of
a ball and bands.
 Compare Catling, *Cypriot Bronzework,*
fig. 22, no. 34.

251

FIBULA
Late Cypriote
L.: 0.073m.
Purchased by Subscription 72.415
General di Cesnola Collection.
From Cyprus.

Both ends are broken. Green encrustation.
 The balls and bands are similar to those of
the previous.
 Compare Catling, *Cypriot Bronzework,*
fig. 22, no. 36.

FIBULA
Late Cypriote
L.: 0.029m.
Purchased by Subscription 72.374
General di Cesnola Collection.
From Cyprus.

Light brown encrustation.

There is a semicircle of seven lobes with a ring at one end. This continuously-beaded fibula is similar to Hall, *Vrokastro*, pl. 20 B (with four lobes or beads). Other fibulae of this type are known from Myres' excavation at Amathus (not illustrated) as noted by J. M. Birmingham (letter, Feb. 19, 1962).

Compare also U. Jantzen, "Phrygische Fibeln," *Festschrift für Friedrich Matz*, pl. 8, 3-4 (Olympia).

252

Greek and
Graeco-Roman

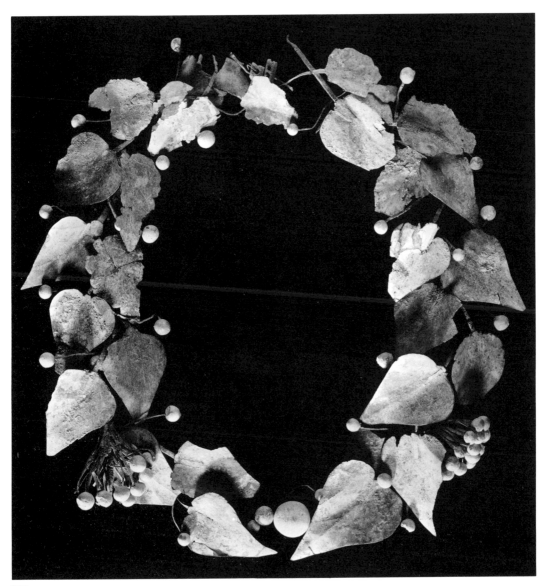

253

253

FRAGMENTS OF WREATH
Greek
L. (of largest leaf): 0.051m.
Gift of H. P. Kidder 81.333
Purchased by W. J. Stillman; from Crete ?

The various pieces have not been reassembled.

The ensemble comprises ivy leaves, stems, and berries which are shown in bunches or singly. The leaves are gilded. The berries are of clay. There are twenty-seven leaves and other fragments of leaves; two full clusters of berries; many single berries; and one large, single button.

254

254

254

EARRING
Greek, Fourth Century B.C.
L.: 0.04m. W.: 0.016m.
Gift of E. P. Warren 90.185

Much corroded. Green patina.

The form is that of an inverted pyramid with a square base, having several rows of small bosses and an acorn-shaped finial. Above, there is a head of a monster with open mouth.

Compare, in gold, British Museum, *Catalogue of Jewellery*, 180ff., fig. 58 (coin of Locris, fourth century), nos. 1666f., 1672f., etc.

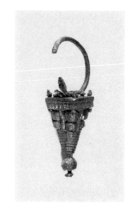

255

255

255

EARRING
Greek, Fourth Century B.C.
L.: 0.037m. W.: 0.01m.
Gift of E. P. Warren 90.238

Green patina; encrusted.

The earring consists of an inverted pyramid with square base and six little bosses; below there are two rows of balls and a cone of rope-moulding, ending in a crested ball.

256

257 258

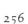 256

BRACELETS OR HAIR ORNAMENTS
Greek
DIAM.: 0.047m.
Gift of E. P. Warren 96.676, 96.677
Bought in Thebes; from Boeotia.

Crusty green patina.
 The inside is flat, and a ridge runs along the outside center. The decoration consists of incised zigzag lines, like a snake's skin.

E. Robinson, *Ann. Rep.* 1896, 31; *AA* 1897, 73, no. 28.

Olynthus X, 74, note 41.

257

SPIRAL, AS PREVIOUS
Greek
DIAM.: 0.02m.
Gift of T. A. Fox 94.44
From Argive Heraeum.

Very corroded.

E. Robinson, *Ann. Rep.* 1894, 16 (and following entry).

258

SPIRAL
Greek
DIAM.: 0.02m.
Gift of T. A. Fox 94.45
From Argive Heraeum.

Corroded.

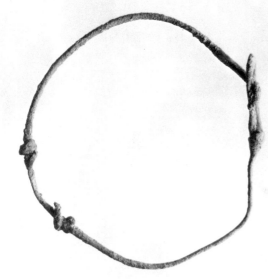

259

260

259

BRACELET
Greek (?)
DIAM.: 0.075m. – 0.080m.
Gift of the Archaeological Institute of America 84.564
From Assos.

Green patina.
 A thin, flattish wire comprises two segments; these are twisted together; there is a hook and loop closure.

260

BRACELET
Greek (?)
DIAM.: 0.075m.
Gift of the Archaeological Institute of America 84.566
From Assos.

Green patina. The bracelet is broken and damaged.
 A flattened wire was left nearly circular and also twisted in a loose knot at one point.

261

RING (?)
Date undetermined
DIAM.: 0.035m.
Gift of the Archaeological Institute of America 84.569
From the Necropolis at Assos.

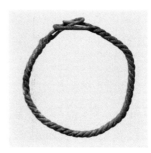

261

Dark green patina.

This is made of twisted wire; each end forms a loop. It closes by a free wire of one end piercing the loop of the other.

The size indicates a bracelet for a child.

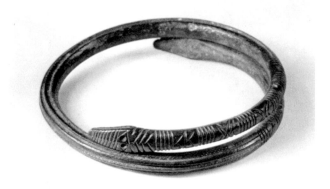
262

262

BRACELET
Graeco-Roman
DIAM.: 0.055m.
Gift of the Estate of Alfred Greenough
85.248

Dark green patina.

Circular spiral of one and a half turns; ribbed and moulded. There is a serpent's head at each end; engraved with cross-bars and crosses.

263

FIBULA
Greek, Geometric Period
L.: 0.096m.
Gift of E. P. Warren 96.675
Bought in Thebes.

Green patina, with light green corrosion in spots and tiny chips on the edge of the plate.

The square catch-plate is decorated with waterfowl within a zigzag border on one side. On the other side there is a larger star (rosette ?) in the center and four smaller stars around. The bow of the pin has engraved lines.

Compare Blinkenberg, *Fibules,* 172f., VIII 6a (3), fig. 205; Hamburg: *AA* 1928, col. 445f., no. 131, figs. 157f.

E. Robinson, *Ann. Rep. 1896,* 31; *AA* 1897, 73.

263

263

264

FIBULA
Greek, Geometric Period
L.: 0.187m.
H. L. Pierce Fund 98.643
E. P. Warren Collection.
Bought in Athens; said to come from Thebes.

Green patina; the plate has been cleaned.
Slightly corroded.
 Square plate with incised decoration:
 A. Horse walking to left, with loose rein;
 above, bird to left; below, bird flying
 to left and two stars.
 B. Lion walking to right, with prey in
 mouth; above, star, small flying bird
 and fish (?); below, two stars.

E. Robinson, *Ann. Rep.* 1898, 23; *AA* 1899, 136;
B. Segall, *BMFA* 41 (1943) 74ff., fig. 8; Chase,
Antiquities, 16, fig. 14; 2nd edition, 28, 32,
fig. 25.

Blinkenberg, *Fibules*, 179, e, Type VIII, 8, e;
Hampe, *Frühe Griechische Sagenbilder*, 19, 23, 40,
note 1, no. 64, pl. 10; Rolley, *Monumenta Graeca
et Romana*, V, fasc. 1, 19f., no. 180, pl. 61.

265

FIBULA
Greek, Geometric Period
L.: 0.16m.
H. L. Pierce Fund 98.644
E. P. Warren Collection.
From Greece.

Light green patina. The plate has been broken
near the bow-shaped back and the catch for
the pin.
 A square clasp-shield is decorated on both
sides with a waterfowl, surrounded by zigzag
border.

E. Robinson, *Ann. Rep.* 1898, 23; *AA* 1899, 136.

Bates, *AJA* 15 (1911) 1, fig. 1; Blinkenberg,
Fibules, 173, Type VIII, 6, d; R. Hampe, *Frühe
Griechische Sagenbilder*, 23, no. 65, 98-99.

264

FIBULA
Geometric Period, 800 to 700 B.C.
L. (max.): 0.15m. H. (max.): 0.09m.
William E. Nickerson Fund, No. 2 64.302
From Athens.

Dark green patina; the plate is broken and
repaired.

On the back: central ridge and four groups
of three relief bands. On the catch-plate,
within zigzag line border: A: Three birds
above a galley going to the right. Two fish to
right below. B: Horse (?) to left, with a bird
perched on his back.

Compare Hampe, *Frühe Griechische Sagen-
bilder*, pl. 7 (ship: London); 27, fig. 8, no. 36
(fish: Athens); for the horse and bird: MFA
98.643; also Walters, British Museum
Bronzes, 9, no. 119, fig. 4 (from Thebes), no.
121; H. Hoffmann, in *Norbert Schimmel Col-
lection*, no. 7.

Vermeule, *Ann. Rep.* 1964, 32; *idem, CJ* 61 (1966)
290f., fig. 2.

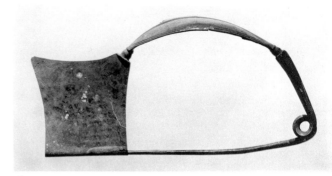

265

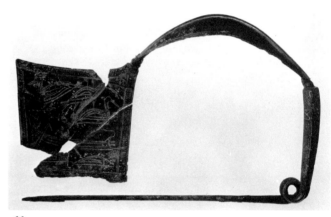

266

267

F I B U L A
Greek, Geometric Period
L.: 0.072m.
H. L. Pierce Fund 98.645
E. P. Warren Collection.
Bought from Rhousopoulos, as from Attica,
1877.

Dark green patina.

Two spirals and a pin are made of one
wire. There is a double twist between them.

For size, unusually small for these fibulae,
compare De Ridder, Louvre *Bronzes*, II,
64f., no. 1871, pl. 89. Greek, Greek island and
Italian find-spots for these fibulae are col-
lected under no. 1867. See also J. Alexander,
AJA 69 (1965) 8ff., ills. 2f., Type Ib (no
studs in the centers of the spirals), dated
1050 to 450 B.C.

E. Robinson, *Ann. Rep.* 1898, 23; *AA* 1899, 136.

Blinkenberg, *Fibules*, 256, Type XIV, 2, d; *Olyn-
thus* X, 97, note 122.

268

F I B U L A
Greek, Geometric Period
L.: 0.186m.
H. L. Pierce Fund 98.646
E. P. Warren Collection.
Bought in Naples.

Slightly crusty green patina with areas of
iron rust and earth.

There are two large spirals made of one
wire, with a double twist between them. The
pin, of "safety-pin" shape, has the back
riveted to the center of each spiral.

Compare Metropolitan Museum: *Early
Greek Art*, fig. 5B (0.15m.) These are found in
the ninth or eighth-century tombs at Vergina
in Macedonia, together with spiral bracelets
and so-called shield bosses (see *Ergon* 1959,
53ff., figs. 53, 55).

Those with iron studs through the centers
of the spirals, however, have been found in
southern Italy but not in Greece; see J. Alex-
ander, *AJA* 69 (1965) 9ff., ills. 2ff., dated
850 to 650 B.C.

E. Robinson, *Ann. Rep.* 1898, 23; *AA* 1899, 136.

Blinkenberg, *Fibules*, 256, Type XIV, 2, d; *Olyn-
thus* X, 97, note 122.

269

F I B U L A
Greek, perhaps Hellenistic
H.: 0.058m. W.: 0.047m.
Gift of E. P. Warren 95.176

Light and dark green patina. The pin on the
back is corroded shut, in its clasp.

In the center of a trapezoid of concave
volutes, with nuts at the corners (the one at
the bottom larger and open), a female
member.

270

F I B U L A
Roman
L.: 0.051m.

267

268

269

270

Gift of the Archaeological Institute of
America 84.79
From Assos.

Lump at one end corroded.
 There are a few engraved parallel "fish
bone" lines on the back.

271

PIN
Geometric
L.: 0.395m.
H. L. Pierce Fund 98.647
E. P. Warren Collection.
Bought in Athens; probably from Boeotia.

Green patina, slight surface corrosion.
 The upper part is decorated with zigzags,
lightly incised.
 Pins similar to this and the following were
found in the grave of a girl, circa 1000 B.C.,
under the North end of the Stoa of Attalos in
Athens.

E. Robinson, *Ann. Rep.* 1898, 23; *AA* 1899, 136.
Jacobsthal, *Pins*, 4, 5, 90, fig. 14a.

271

272

273

272

PIN

Geometric

L.: 0.23m.

H. L. Pierce Fund 98.648

E. P. Warren Collection.

Bought in Athens; probably found in Boeotia.

Green patina, slight surface corrosion.

E. Robinson, *Ann. Rep.* 1898, 23; *AA* 1899, 136.
Jacobsthal, *Pins*, 4, 5, 90, fig. 14b.

273

PIN

Archaic, mid-Sixth Century B.C.

L.: 0.18m.

Gift of E. P. Warren 96.674

Crusty green patina.

The head is in the form of a square block, on either side of which is a jumping frog in relief. There is a small ornament on top.

E. Robinson, *Ann. Rep.* 1896, 31; *AA* 1897, 73.
Jacobsthal, *Pins*, 57, figs. 255, 256.

274

PIN

Archaic

L.: 0.26m.

H. L. Pierce Fund 98.649

E. P. Warren Collection.

Bought in Naples

Green patina.

This was perhaps used in the hair. The point is bent into a small hook, and the opposite end is split to form flat spirals. There are linear incised decorations on one side of the pin.

This type is possibly German or Scandinavian in origin. Examples have been found in Italy (Montelius, I, pls. 7, no. 5 and 16, no. 20) and as far afield as the Lake Van area (Kuftesi, *Archeologicheskie Raskopi v. Trialeti*, 117, fig. 70). De Ridder relates the

elaborate example in the Louvre (Louvre *Bronzes*, II, 88, no. 2381, pl. 91) to those from early tombs on Syros (Tsountas, *Arch-Eph* 1899, col. 101, pl. 10).

E. Robinson, *Ann. Rep.* 1898, 23f.; *AA* 1899, 136.

Olynthus X, 97, note 122; Jacobsthal, *Pins*, 127, fig. 369.

274

275

Pendant Amulet

Circa 600 B.C.

L.: 0.055m.

Gift of Miss Rosamond Lamb in the name of Miss Rose Lamb 28.26

Dark green patina.

Head of a bull with a ring for suspension at the top; the back is hollowed, and there is a bar across the hollow. The hair and eyes are treated in a formalized manner. An indentation in the nose may be a casting mark.

Compare Schumacher, Karlsruhe *Bronzen*, 160, no. 827 (Etruscan); Richter, New York *Bronzes*, 466, nos. 1865f. (Etruscan, much rougher in detail); also, the class of cauldron ornaments, from Lindos, Olympia and elsewhere, dated first half of the seventh century: H. Hoffmann, *Jahrbuch der Hamburger Kunstsammlungen* 6 (1961) 234f., illus.; *idem, AA* 1960, col. 104ff., no. 28, figs. 43f.

Thence these bull's heads can be traced to Phrygian cauldrons and on to those of Urartu: Gordion cauldron: E. Akurgal, *Die Kunst Anatoliens von Homer bis Alexander*, 102, pl. 3 B.

L. D. Caskey, *BMFA* 26 (1928) 36.

275

276

AMULET
Archaic Period (?)
H. (including ring): 0.03m.
L. (max.): 0.038m.
Gift of E. P. Warren 68.42

Lightish green patina.
There is a male member below the loop, another phallos extending leftwards, and an indeterminate design at the right.

277

AMULET
Graeco-Roman
L. (max.): 0.039m.
Gift of E. P. Warren 68.43

Black patina with encrustation.
A winged phallos is suspended from a loop. Another phallos extends below, and a similar, small member protrudes rearward.

278

DOG COLLAR
Graeco-Roman
DIAM.: 0.115m.
Gift of E. P. Warren 13.121

Dark green patina.
This comprises a ring with hook-and-eye fastening and, on it, a small ring for attaching a chain.
The famous suffocated dog from Pompeii (Wisconsin Exhibition, fig. p. 30) wears just such a collar, although it has been suggested that such objects were strigil-holders. For an example of the latter, see A. Oliver, Jr., *BMMA*, 1965, 182ff., figs. 8, 12 (Roman silver hoard).

L. D. Caskey, *Ann. Rep.* 1913, 89; *AA* 1914, col. 494; *AJA* 18 (1914) 414.

Exhibited: University of Wisconsin Memorial Library, *Rome An Exhibition of Facts and Ideas*, 29, no. 46.

276

277

278

279

281

279

Ring or Miniature Votive Wreath
Greek
DIAM.: 0.033m.
Gift of T. A. Fox 94.48
From Argive Heraeum.

There are two major cracks, and several nicks. Crusty green patina.
 This is decorated with diagonal incised lines.

E. Robinson, *Ann. Rep.* 1894, 16 (this and three following).

280

Ring
Greek
DIAM. (of whole): 0.021m.
Gift of T. A. Fox 94.49
From Argive Heraeum.

Green patina, crusty.
 In two parts.

281

Ring
Greek
DIAM.: 0.03m.
Gift of T. A. Fox 94.43
From Argive Heraeum.

Crusty green patina.
 This ring is in the form of a simple circle.

282

RING
Greek
DIAM.: 0.025m.
Gift of T. A. Fox 94.46
From Argive Heraeum.

Crusty green patina.
 As previous.

283

RING
Greek
L. (of bezel): 0.025m.
Gift of Edward S. Morse 21.2302
From Asia Minor.

Traces of green patina in and on the cleaned, brassy surfaces.

On the bezel a man stands holding a bow in the outstretched right hand and an un-identified object, perhaps a shield, in the lowered left. He is nude.

The design, perhaps as early as the fourth century B.C., is a crude, Anatolian imitation of some Polykleitan or related prototype.

284

RING
Greek
DIAM.: 0.025m.
Gift of T. A. Fox 94.47
From Argive Heraeum.

Crusty green patina.

This is decorated with points around the outside. The form is again that of a simple circle.

E. Robinson, *Ann. Rep.* 1894, 16.

285

RING
Date undetermined
DIAM.: 0.019m.
Gift of H. P. Kidder 81.136

From Crete.

Much corroded and encrusted with green.

The bezel has a winged lion (?), or a ketos with lion's forepart, engraved in intaglio.

286

RING
Greek
DIAM.: 0.023m.
Gift of E. P. Warren 13.141
From Suessula.

The stamped design is off-center to the lower right. The (body of the) ring has been broken at two places and repaired (by W. J. Young). Crusty green patina, with spots of whitish corrosion.

Stamped in relief on the bezel there is a woman seated on a stool in a mournful atti-tude. A snake (?) appears in the field.

The woman's pose is that of the "Penel-ope" of the Vatican, but details of this slight-ly sentimental version of a late Transitional design, the fluidity of the body or the depth and foreshortening for instance, suggest a date in the fourth century B.C.

L. D. Caskey, *Ann. Rep.* 1913, 88; *AA* 1914, col. 493f.

287

RING
Greek
L.: 0.019m.
Gift of E. P. Warren 23.601
Bought in Sicily.

Dark, almost black patina. The surface is corroded.

The bezel is engraved with an Eros whose body is that of a dog. He is seated.

Beazley, *The Lewes House Collection of Ancient Gems,* 54, no. 59.

282

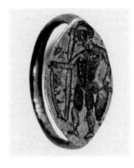

283

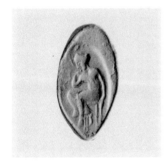

284

285

286

287

288

289

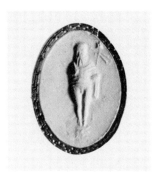

290

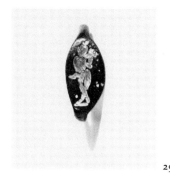

291

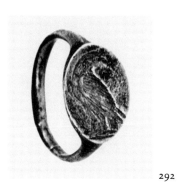

292

292

288

RING
Hellenistic
L.: 0.019m.
Purchased by Contribution 01.7531
E. P. Warren Collection.

Most of the ring broken away. Dark green patina.

On the bezel in intaglio, Herakles walks to the left, carrying his lion's skin on the left shoulder and his club in his left hand. In the extended right he holds a skyphos.

The figure is strongly baroque in modeling and pose, recalling a composition of the Pergamene School after 200 B.C.

E. Robinson, *Ann. Rep.* 1901, 36.

J. R. Wheeler, *AJA* 10 (1906) 380f., fig. 1.

289

RING
Hellenistic
L.: 0.019m.
Purchased by Contribution 01.7533
E. P. Warren Collection.
Bought in Athens.

Most of the ring is broken away.

On the bezel in intaglio, Eros kneels and sets up a trophy, which seems to consist of a conical helmet, a long shield, and a tunic all on a tree trunk.

E. Robinson, *Ann. Rep.* 1901, 36.

290

RING
Hellenistic
L.: 0.02m.
Purchased by Contribution 01.7532
E. P. Warren Collection.
Bought in Athens.

Most of the ring broken away. Dark green patina with some light green surface encrustation.

On the bezel in intaglio, Silenus stands full front with the upper part of his figure draped. He holds a thyrsos in his left hand, and his feet seem to be placed on a rockwork altar.

E. Robinson, *Ann. Rep.* 1901, 36.

291

RING
Graeco-Roman
L. (of bezel): 0.013m.
Gift of Mr. and Mrs. William de Forest Thomson 18.517

Part of the loop is broken away. Dark green patina with some corrosion.

The plain hoop leads to a pointed oval bezel with engraved design: a satyr stands to front with feet crossed and holds a child. The child may have wings and therefore be the young Eros rather than the infant Dionysos.

If this is the young Eros, he appears to be whispering words about love to the satyr, a Hellenistic rococo allegory of the persuasive powers of love.

292

RING
Graeco-Roman
L.: 0.019m.
Francis Bartlett Donation (1912) 27.748
E. P. Warren Collection.
Bought in Greece.

Traces and areas of green patina in and on the surface, which is mostly brassy.

On the bezel in intaglio, an eagle stands on a ground area, looking back; beside him, a palm branch.

Although clearly a Graeco-Roman design, the eagle has a monumentality and precision of carving which recall the birds on Greek coins in the fourth century B.C. Compare, for instance, the staters of Elis, about 350 B.C. (M. Comstock, C. Vermeule, *Greek Coins, 1950 to 1963*, no. 105) or similar coins of

Abydos in the Troad, about 390 B.C. (*ibid.*, no. 155).

293

RING
Greek (?)
DIAM.: 0.019m.
Gift of the Archaeological Institute of America 84.80
From Assos.

293

Green patina, somewhat crusty.
 There is a thin, ovoid bezel, which is plain.

294

RING BEZEL
Greek (?)
DIAM.: 0.024m. – 0.020m.
Gift of the Archaeological Institute of America 84.567
From Assos.

294

Green patina, heavily encrusted.
 There is an oval bezel, which apparently was plain. The loop of the ring is mostly broken away.

Etruscan, Italian and Roman

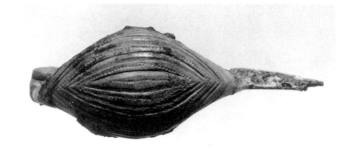

295

295

Fibula
Prehistoric
L.: 0.073m.
Purchased by Contribution 88.610
Purchased of R. Lanciani; from tomb on the
Esquiline Hill.

The long jointed pin has rusted on the guard.
Green encrustation.

 The body is boat-shaped and hollow under-
neath. Concentric beaded rings ornament the
outer surface.

295

296

296

RING
Prehistoric
DIAM.: 0.148m.
Purchased by Contribution 88.611
Purchased of R. Lanciani; from tomb on the
Esquiline.

Mottled pea green encrustation.
Each side of this thin, circular ring is
convex and ornamented with an incised zig-
zag.

297

RING
Prehistoric
DIAM.: 0.111m.
Purchased by Contribution 88.612
Purchased of R. Lanciani; from tomb on the
Esquiline.

Light green encrustation.
Each side is slightly convex and is orna-
mented with incised zigzags.

297

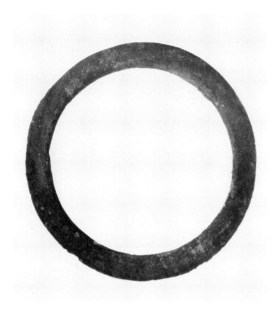

298

298

CIRCULAR HOOP
Archaic
DIAM. (outside): 0.126m. DIAM. (inside):
0.101m.
Gift of Mrs. James P. Tolman 22.730
Buffum Collection.
From Praeneste (Palestrina).

Crusty green patina.
 Both sides are ornamented with incised designs of continuous triangles.

299

CIRCULAR HOOP
Archaic
DIAM. (outside): 0.19m. DIAM. (inside):
0.15m.
Gift of Mrs. James P. Tolman 22.731
Buffum Collection.
From Praeneste.

Green patina.
 Both sides are ornamented with incised designs of continuous triangles of triple outline.

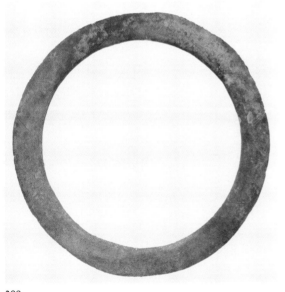

299

300

301

302

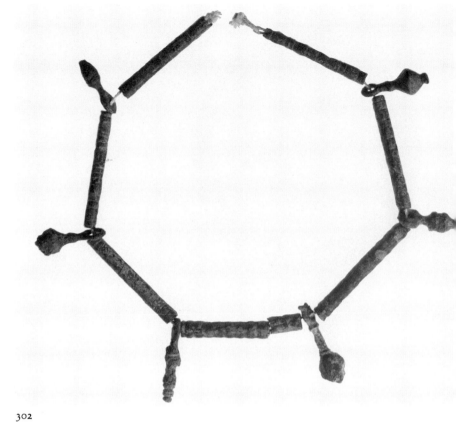

300

SPIRAL RING
Archaic (Etruscan)
DIAM.: 0.036m.
Gift of Mrs. James P. Tolman 22.725
Buffum Collection.
From Praeneste.

Green patina.
 There are four turns; the spirals are un-ornamented. The ring was designed for the hair.
 Compare Richter, New York *Bronzes*, 342f., nos. 1150f.; they have been found as early as the seventh century B.C. on both Greek and Etruscan sites.

301

SPIRAL RING
Archaic (Etruscan)
DIAM.: 0.038m.
Gift of Mrs. James P. Tolman 22.723
Buffum Collection.
From Praeneste.

Green patina.
 There are three turns. As previous.

302

NECKLACE
Archaic (Italic)
L.: 0.385m.
Gift of Miss C. Wissmann 02.296
Buffum Collection.
From Palestrina.

Crusty green patina.
 There are seven long, heavy, corrugated beads, with six variously shaped pendants between.

E. Robinson, *Ann. Rep.* 1902, 66f. (on the Buffum collection); *AA* 1903, 156 (same).

303

NECKLET
Archaic (Italic)
DIAM.: 0.155m.
Gift of Miss C. Wissmann 02.293
Buffum Collection.
From Palestrina.

Crusty green patina. Much corroded.
 A slightly twisted bronze wire is in circular form, with hooks at the ends; a heavy, round pendant hangs on it. The pendant, cast in two pieces and perhaps filled with something, has concentric ridges and a boss in the center on either side.

303

304

305

NECKLET ?
Archaic (Italic)
DIAM.: 0.135m.
Gift of Miss C. Wissmann 02.295
Buffum Collection.
From Palestrina.

Corroded and mended (in antiquity). Green and blue patina.

A plain, heavy ring has cone-shaped ends which curve back. The small size suggests this was either intended for a baby or had some other undetermined use.

306

NECKLET
Archaic (Italic)
DIAM.: 0.09m.
Gift of Miss C. Wissmann 02.297
Buffum Collection.
From Palestrina.

Green patina, crusty in places.

A plain wire has hooks at the ends.

304

NECKLET
Archaic (Italic)
DIAM.: 0.14m.
Gift of Miss C. Wissmann 02.294
Buffum Collection.
From Palestrina.

Crusty green patina.

As previous.

307

WREATH
Fifth Century B.C. or later (Italic)
L.: 0.40m.
Gift of Miss C. Wissmann 02.306
Buffum Collection.

The wreath has been broken in the center. The clusters of berries and leaves are much broken. The wreath is partially gilded.

Small clusters of laurel leaves and berries meet in a conical ornament in the center and terminate in loops at the ends.

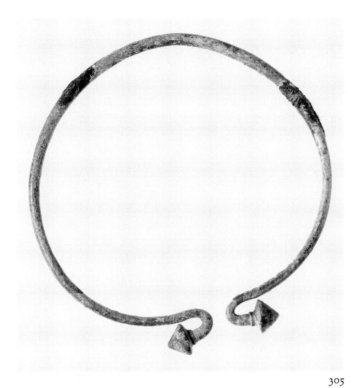

305

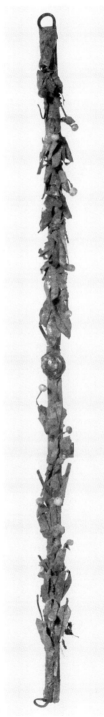

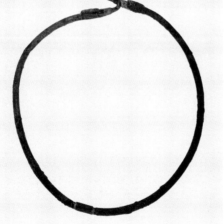

306

307

308

309

310

311

308

ARMLET
Archaic (Italic)
DIAM.: 0.10m.
Gift of Miss C. Wissmann 02.298
Buffum Collection.

Crusty green patina.
 It is hollow, with the ends overlapping.
The decoration comprises hatched triangles
on both sides of a group of parallel lines.

309

BRACELET
Archaic
DIAM.: 0.06m.
Gift of Miss C. Wissmann 02.299
Buffum Collection.
From Palestrina.

Slight green patina.
 A single wire, slightly flattened on the in-
side, becomes thicker and wider at the ends,
which almost meet.

310

BRACELET
Archaic (Italic)
DIAM.: 0.06m.
Gift of Miss C. Wissmann 02.300
Buffum Collection.
From Palestrina.

Much corroded. One end missing.
 This small wire has the ends turned back.

311

BRACELET
Archaic (Italic)
DIAM.: 0.06m.
Gift of Miss C. Wissmann 02.301
Buffum Collection.
From Palestrina.

Crusty green and dark brown patina.
 The flattened wire broadens out in two
places and is hooked at the ends. There are
four rings strung on it.

312

BRACELET
Archaic (Etruscan or Italic)
DIAM.: 0.092m.
Gift of Mrs. James P. Tolman 22.720
Buffum Collection.
From Praeneste.

Corroded; green patina.
 The circular loop has overlapping ends
occupying almost half the circumference.
Undecorated.

312

313

BRACELET
Archaic (Etruscan or Italic)
DIAM.: 0.086m.
Gift of Mrs. James P. Tolman 22.721
Buffum Collection.
From Praeneste.

Green patina.
 The circular hoop has overlapping ends
and is ridged to imitate twisted wire.

314

BRACELET
Archaic (Etruscan or Italic)
DIAM.: 0.089m.
Gift of Mrs. James P. Tolman 22.722
Buffum Collection.
From Praeneste.

Corroded; green patina.
 The circular hoop has overlapping,
knobbed ends.

315

BRACELET
Etruscan
DIAM.: 0.08m.
Gift of Mrs. James P. Tolman 22.724
Buffum Collection.

Green patina.
 This is a single band of twisted wire,
slightly flattened on the inside. The ends
overlap somewhat.

316

BRACELET, FOR A CHILD
Archaic (Etruscan or Italic)
DIAM.: 0.05m.
Gift of Mrs. James P. Tolman 22.726
Buffum Collection.
From Praeneste.

313

314

Green patina.

The circular hoop is ornamented with incised lines extending diagonally across the surface.

317

RING
Archaic or later (Italic)
DIAM.: 0.02m.
Gift of Miss C. Wissmann 02.302
Buffum Collection.
From Palestrina.

Corroded.

The plain wire is flat on the inside and curved on the outside.

318

FIBULA
Archaic (Etruscan)
L.: 0.09m.
H. L. Pierce Fund 98.685
E. P. Warren Collection.
Bought in Naples.

Crusty green patina.

From each side of the arched back there project six cone-shaped ornaments.

Compare Schumacher, Karlsruhe *Bronzen*, pl. 1, no. 17.

E. Robinson, *Ann. Rep.* 1898, 34; *AA* 1899, 138, no. 43.

315

316

317

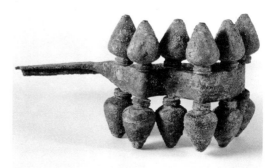

318

319

319

320

319

FIBULA
Geometric
L.: 0.82m.
John Michael Rodocanachi Fund 59.9
Found at Strasbourg.

The catch-plate is partly missing. The pin is broken off and may not belong.

Leech-shaped, with heavy bow closed underneath. The body is decorated with cross bands of carefully incised, hatched designs, four each of triangles and key pattern.

Compare Sundwall, *Die Älteren Italischen Fibeln*, 179, 220.

320

FIBULA
Archaic (Italic)
L.: 0.095m.
Gift of Miss C. Wissmann 02.304
Buffum Collection.
From Palestrina.

Mended; the bronze corroded.

On the back is strung a crescent-shaped ornament made up of five sections of amber (one is missing) over two of which are laid thin strips of gold, ornamented with incised, hatched triangles.

For other examples from Praeneste, see D. E. Strong, *Catalogue of the Carved Amber in the Department of Greek and Roman Antiquities*, British Museum (London, 1966), 54ff., pls. XI-XII.

321

FIBULA
Archaic (Italic)
L.: 0.09m.
Gift of Miss C. Wissmann 02.305
Buffum Collection.
From Palestrina.

Corroded.

On the back is strung a crescent-shaped

ornament made up of pieces of amber; two
are overlaid with stripes of gold, divided in
panels, with diagonal hatching.

322

FIBULA
Archaic (Italic)
Gift of Miss C. Wissmann 02.307
Buffum Collection.
From Palestrina.

321

Corroded and in fragments.
 The bronze has been strung with amber.

323

FIBULA
Archaic (Italic)
L.: 0.035m.
Gift of Miss C. Wissmann 02.308
Buffum Collection.
From Palestrina.

322

Corroded and fragmentary.
 This fibula also has been strung with
amber.

324

FIBULA
Archaic (Italic)
Gift of Miss C. Wissmann 02.309
Buffum Collection.
From Palestrina.

Corroded.

323

325

FIBULA
Archaic (Italic)
Gift of Miss C. Wissmann 02.310
Buffum Collection.
From Palestrina.

Corroded.
 This fibula has a large, high-backed bow.

326

326

FIBULA
Archaic (Italic)
L.: 0.096m.
Gift of Miss C. Wissmann 02.311
Buffum Collection.
From Palestrina.

Corroded; the pin broken.
 This fibula has a long shaft, with separate
"handle" near the pin end.

327

FIBULA
Archaic (Italic)
Gift of Miss C. Wissmann 02.312
Buffum Collection.
From Palestrina.

Corroded.
 Similar to 02.310 (no. 325).

328

FIBULA
Archaic (Italic)
L.: 0.10m.
Gift of Miss C. Wissmann 02.313
Buffum Collection.
From Palestrina.

Dark green patina; corroded.
 The back is flat and undecorated on this
(generally) bow-shaped fibula.

328

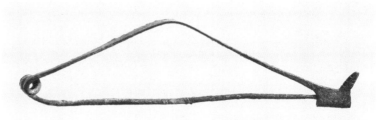

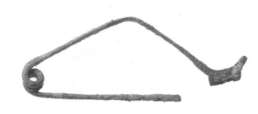

329

329

FIBULA
Archaic (Italic)
L.: 0.08m.
Gift of Miss C. Wissmann 02.314
Buffum Collection.
From Palestrina.

The pin is broken.
 As previous.
 Included also in the museum collection but
not catalogued in detail are a number of
fragmentary fibulae from the Buffum Collec-
tion. They were probably all strung with
amber. Three are fairly intact, with rings of
amber still encircling the bows; the remain-
ing are less complete (Apparatus).

330

330

FIBULA
Archaic (Italic)
L.: 0.063m. w.: 0.035m.
Gift of Miss C. Wissmann 02.315
Buffum Collection.
From Palestrina.

Crusty green patina.
 This bow fibula has eight rings strung on
a pin.

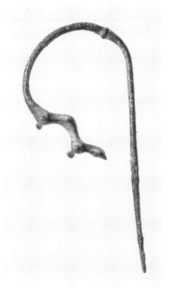

331

331

PIN
Archaic (Italic)
L.: 0.073m.
Gift of Miss C. Wissmann 02.316
Buffum Collection.
From Palestrina.

Green and dark brown patina.
 The top of this long pin is curved over,
like a shepherd's crook.

FIBULA

Seventh Century B.C. (Early Italic)

L.: 0.087m.

Gift of the Estate of Alfred Greenough

Res. 08.38

The shank of the pin is missing.

This fibula has a serpentine-type bow, with a pair of bosses and a grooved, hollow cross-piece.

Compare Sundwall, *Die Älteren Italischen Fibeln*, 240; *AA* 1928, col. 446f., fig. 159: Hamburg.

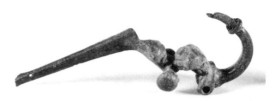

332

333

FIBULA

Circa 700 B.C. (Italic)

0.12m. square

Gift of E. P. Warren 13.126

From Suessula.

Green patina with brownish (cleaned) surfaces. Cleaned in Aug., 1955.

Four large spirals form a square; over this is a large, four-pointed star, on the center of which is a bird.

For fibulae of like type, from Suessula, compare Montelius, I, pl. 21, no. 288 = *NSc* 1878, pl. 6, 5 = Hadaczek, *JOAI* 6 (1903) 113f., fig. 57; Furtwängler, *Olympia* IV, pl. 21, no. 360; Sundwall, *Die Älteren Italischen Fibeln*, 176. For the bird, compare Hesperia Art, *Bulletin* XIX, no. 122. See also, generally, J. Alexander, *AJA* 69 (1965) 15ff., ills. 9f., developed in Sicily and also from Italy; dated in the eighth century B.C.

L. D. Caskey, *Ann. Rep.* 1913, 88; *AA* 1914, col. 494; *AJA* 18 (1914) 414.

Olynthus X, 97, note 122.

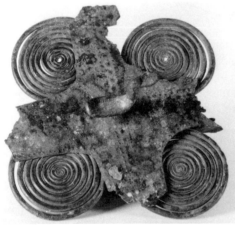

333

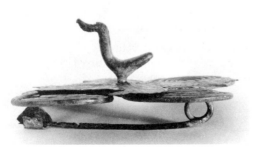

333

334

FIBULA

Circa 700 B.C. (Italic)

0.035m. square

Gift of E. P. Warren 13.127

From Suessula.

Crusty, light green patina.

Four spirals form a square; over this there is a four-pointed star. As the dimensions indicate, this is a miniature version of the previous.

Compare Montelius, I, pl. 21; Schumacher, Karlsruhe *Bronzen*, 3, no. 11, pl. I, 2.

L. D. Caskey, *Ann. Rep.* 1913, 88; *AA* 1914, col. 494; *AJA* 18 (1914) 414.

Olynthus X, 97, note 122.

335

SPECTACLE FIBULA
Geometric (Greek, or possibly Italic)
L.: 0.183m.
Gift of Mrs. Edward Jackson Holmes
52.184

Green patina. Tip of the pin is missing.

Two large spirals are joined by a double loop, formed of single wire, round in section. On the back, a "safety-pin" is riveted to the center of each spiral.

Compare Schumacher, Karlsruhe *Bronzen*, 3, no. 12, pl. I, 3; *Olympia* IV, pl. 21, no. 359. The inner spiral, pin and catch are somewhat simpler than the fibula of similar size from Naples or the smaller pin from Attica (above, nos. 268, 267).

H. Palmer, *Ann. Rep.* 1952, 19.

334

335

336

SERPENTINE FIBULA
Eighth Century B.C. (Italic)
L.: 0.149m.
Gift of Mrs. Edward Jackson Holmes
52.183

Light green patina, slightly mottled. Intact.

An elaborate "safety-pin" is made from a single piece of bronze; there is a double loop in the bow, and the section between the loops is twisted. The catch comprises a double fold of metal flattened at the end into a large, round plate with a broad, spiral cutting.

Compare Sundwall, *Die Älteren Italischen Fibeln,* 153, and, for the catch-plate: Hesperia Art, *Bulletin* XXVI, no. A 4.

H. Palmer, *Ann. Rep.* 1952, 19.

337

FIBULA
Archaic (Etruscan or Italic)
L.: 0.135m.
Gift of E. P. Warren 13.128
From Suessula.

Dark green patina.

A straight and a curved piece of bronze are joined by a pivot, beyond which the ends project in the form of pincers.

L. D. Caskey, *Ann. Rep.* 1913, 88; *AA* 1914, col. 494; *AJA* 18 (1914) 414.

Olynthus X, 113, note 177.

338

BOW OF FIBULA
Early Iron Age (Italic)
L.: 0.083m.
Gift of Mrs. James P. Tolman 22.711
Buffum Collection.
From Praeneste.

Green patina.

This is of the hollow, boat-shaped type. The upper surface is decorated with an incised pattern of concentric circles and cross-hatching. The head is formed of a spiral with two turns.

339

ARC OF FIBULA
Early Iron Age (Italic)
L.: 0.08m.
Gift of Mrs. James P. Tolman 22.712
Buffum Collection.
From Praeneste.

Green patina.

Hollow and boat-shaped. The upper surface is decorated with incised, rectilinear design.

340

ARC OF FIBULA
Early Iron Age (Italic)
L.: 0.077m.
Gift of Mrs. James P. Tolman 22.713

Buffum Collection.

From Praeneste.

Green patina.

 This fibula is hollow and boat-shaped. The upper surface is decorated with incised designs, chiefly concentric circles in four rows.

337

341

FIBULA

Early Iron Age (Italic)

L.: 0.095m.

Gift of Mrs. James P. Tolman 22.714

Buffum Collection.

From Praeneste.

The upper surface is corroded.

 The bow is also hollow and boat-shaped. The upper surface is decorated with incised designs of concentric circles and hatching. The head is formed of a spiral with two turns.

338

339

341

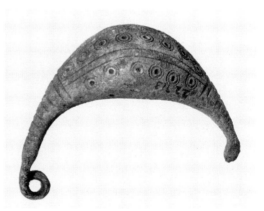

340

342

FIBULA
Early Iron Age (Italic)
L.: 0.084m.
Gift of Mrs. James P. Tolman 22.715
Buffum Collection.
From Praeneste.

Green patina.
 As previous.
 The upper surface is decorated with an incised design of hatching; the head is formed of a spiral with two turns.

343

343

FIBULA
Early Iron Age (Italic)
L.: 0.093m.
Gift of Mrs. James P. Tolman 22.716
Buffum Collection.
From Praeneste.

The upper surface is corroded.
 The bow is hollow and boat-shaped, with a long sheathlike foot. Decoration on the upper surface comprises incised design of concentric circles and hatching. The head is formed of a spiral with two turns.

344

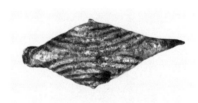

345

345

344

FIBULA
Early Iron Age (Italic)
L.: 0.085m.
Gift of Mrs. James P. Tolman 22.717
Buffum Collection.
From Praeneste.

Crusty green patina.
 The bow is solid and boat-shaped. The long sheath is undecorated.

From Suessula.

Gray surface.

From the center of a horizontal strip of bronze rises a conical strip ending in a ring. On either side of this there is a triangle, *à jour*. The horizontal piece is pierced with five holes from which depend five rude human figures.

Compare the pectoral with similar pendants, also from Suessula: *NSc* 1878, pl. 6, 1.

346

L. D. Caskey, *Ann. Rep.* 1913, 88; *AA* 1914, col. 494; *AJA* 18 (1914) 414.

345

FIBULA
Early Iron Age (Italic)
L.: 0.042m.
Gift of Mrs. James P. Tolman 22.718
Buffum Collection.
From Praeneste.

Green patina.

The bow is hollow and boat-shaped. The upper surface is decorated with a ridged pattern of concentric arcs terminating on each side with a small knob at the center of the innermost circle.

346

FIBULA
Early Iron Age (Italic)
L.: 0.042m.
Gift of Mrs. James P. Tolman 22.719
Buffum Collection.
From Praeneste.

Green patina.

The bow is solid; the upper surface is decorated with incised lines, and the head is formed of a spiral with two turns.

347

347

PECTORAL
Archaic (Italic)
L. (of horizontal strip): 0.074m.
Gift of E. P. Warren 13.129

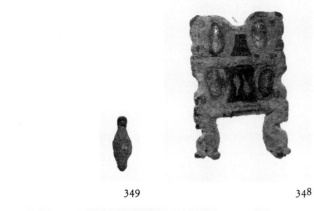

348

PLAQUE

Archaic (Italic)

H.: 0.05m. W.: 0.035m.

Gift of Miss C. Wissmann 02.317

Buffum Collection.

From Palestrina.

Corroded.

This rectangular plaque is set with four small pieces of amber and two of engraved carnelian. One of the latter has two leaves on it; the other shows an inscription: TAƧAI. The plaque has two short legs on one side, in the form of dolphins, a pin below the right one. On the back are four rings, perhaps for pushing a pin through.

349

ORNAMENT

Roman (?)

W.: 0.129m.

Gift of E. P. Warren Res. 08.32u

Green patina, with areas of corrosion, in light green.

A narrow plate is pierced at the top edge with four holes, in one of which a heavy chain is preserved. At the lower edge are attached twelve rods, terminating in charms, probably female members.

There are also three additional charms, from another such ornament.

349 348

349

MIRRORS

Greek

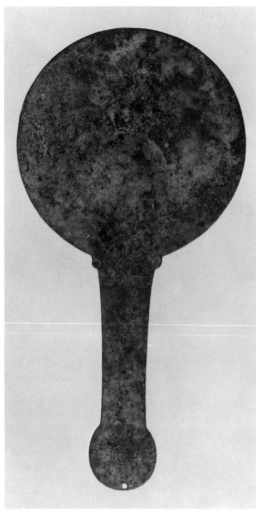

350

MIRROR
600 to 500 B.C.
L.: 0.219m.
*Gift of Mr. and Mrs. William de Forest
Thomson 19.315*
From Athens.

Green patina, with earthy encrustation on
the reverse.

Disc, with handle in one piece. Palmette
and ovolo strip incised on handle just
below disc, and circular ovolo incised at end
of handle. The end of the handle has a
hole for suspension.

351

HANDLE
Circa 580 B.C.
L.: 0.205m.
H. L. Pierce Fund 98.651
E. P. Warren Collection.
Bought in Athens; probably from Boeotia.

Broken off at the base of disc. Dark, olive
green patina with areas and small spots of
light green corrosion.

Between tiny circular ornaments and on a
zigzag groundline, Artemis stands to right
with head turned back; she holds a bow and
wears polos-crown, quiver and long chiton.
Incised ovolo in circle below.

For this class of "Peloponnesian" mirror,
see Lamb, *Greek and Roman Bronzes*, 125f.;
Waldstein, *Argive Heraeum*, II, nos.
1565ff., especially nos. 1566, 1581.

An example in the Allard Pierson Museum
has been considered a probable forgery,
perhaps because of the peculiar style common
to the incised designs in this class of mirrors:
van Gulik, *Allard Pierson Bronzes*, 104ff.,
no. 157, pl. 36; see also Jantzen, *Bronze-
werkstätten*, 67 (with list).

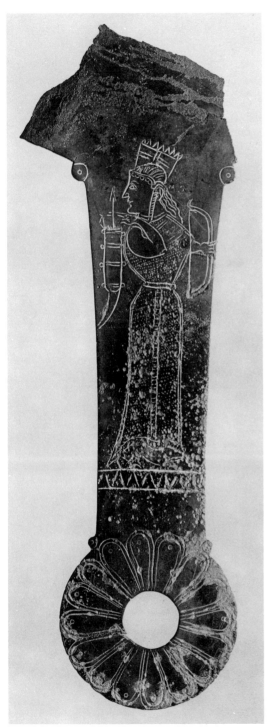

E. Robinson, *Ann. Rep.* 1898, 24; *AA* 1899, 136.

G. Bruns, *Die Jägerin Artemis* (Diss., Borna-Leipzig, 1929) pl. I, 3; Jantzen, *Bronzewerkstätten,* 67, no. 18; Mitten-Doeringer, *Master Bronzes,* under no. 74.

351

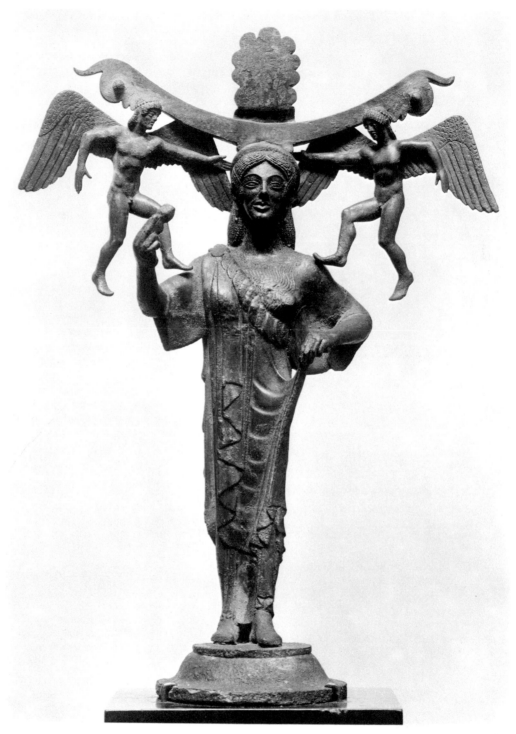

352

MIRROR STAND. APHRODITE AND EROTES
Circa 500 B.C.
H.: 0.256m. H. (of Aphrodite): 0.19m.
H. L. Pierce Fund 04.7
E. P. Warren Collection; Forman Collection.

Dark green patina with light green encrustation on the surface.

Aphrodite stands on a round base, wearing boots, an Ionic chiton and a peplos, which she holds up with the left hand. A flower is extended in the right hand. Between her shoulders and the mirror's frame are winged Erotes, also wearing boots. The back of the mirror's immediate support takes the form of a palmette, similar to the tops of grave stelai.

This mirror stand has been placed beside an example in Leningrad (Langlotz, *loc. cit.*), which is less advanced in style. Payne related it to the stool-mirror from Thebes in the Louvre and other bronzes (Beazley).

B. H. Hill, *Ann. Rep.* 1904, 57f.; *AJA* 9 (1905) 369; *AA* 1906, col. 261; Burdett, Goddard, *E. P. Warren*, pl., 218; G. H. Chase, *Greek Gods and Heroes*, 39f., fig. 37; 1962 edition, 53ff., fig. 40.

Smith, Forman Sale I, *Catalogue*, 10, no. 66, pl. 3; Reinach, *Rép. stat.*, III, 101, no. 2; IV, 196, no. 1; Buschor, Hamann, *Die Sculpturen des Zeustempels zu Olympia*, 38; Chase, *Greek and Roman Sculpture in American Collections*, 21f., fig. 24; E. Franck, *Griechische Standspiegel*, 12f., 38ff., 111, 116f., 125, no. 21; *idem*, *AA* 1923-24, col. 374; Langlotz, *Frühgriechische Bildhauerschulen*, 99, no. 5, pl. 54b (Aegina); Ashmole, *Greek Sculpture in Sicily and South Italy*, 14, note 3; Beazley, *Proc Irish Acad* 45 (1939) 39; Charbonneaux, *Les bronzes grecs*, 77f.; *idem*, *Greek Bronzes*, 99 (as from Aegina); Congdon, *Greek Caryatid Mirrors*, 38ff., 76, 136, 138, 147ff., 220ff., 237; *idem*, *AJA* 71 (1967) 150ff.

Exhibited: Detroit, *Small Bronzes of the Ancient World*, 10, no. 63, 35, illus.

MIRROR STAND
500 to 480 B.C.
H.: 0.224m.
Purchased by Contribution 01.7483
E. P. Warren Collection.
Bought from a Greek dealer in London, probably from Paris.

Dark green patina, with some light green and cleaned corrosion.

The support takes the form of a female in an Ionic chiton with overfold; she holds the edge of her garment in the left hand and a flower in the raised right. A fillet or diadem around the crown is enriched with three floral rosettes separated by rectangular "braids" which may imitate small gold plaques. The diadem forms a transition to the attachment for the mirror springing out of the top of the head.

This stand is a slightly later example from the same milieu that produced the previous, and these stands, like those that follow, were undoubtedly made at Sikyon or, equally likely, Corinth. They form the perfect synthesis between the metalwork of the Peloponnesus and the marble sculpture of Athens in the generations before the second Persian War.

E. Robinson, *Ann. Rep.* 1901, 36; *AA* 1902, 131; *AJA* 6 (1902) 377; Beazley in Burdett, Goddard, *E. P. Warren*, 358f.

E. Franck, *Griechische Standspiegel*, not mentioned; M. Gjødesen, *AJA* 67 (1963) 334; Congdon, *Greek Caryatid Mirrors*, 43f., 79f., 138, 149f., 240, pl. 14.

353 353

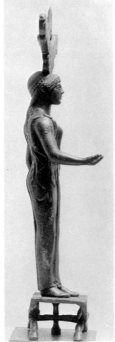

354 354

354

MIRROR STAND
Circa 480 B.C.
H.: 0.265m.
Purchased by Contribution 01.7499
E. P. Warren Collection; Forman Collection.

Dark green and olive, with light green patina on the front. Bright green patina on the reverse. Stool reattached. Caskey wrote that he "found clear traces that the feet were originally placed as they are now. . . . the traces of the feet made by different weathering of the surface of the stool under the feet and just around them look ancient. . .".

A woman, clad in an Ionic chiton with overfold, extends her right hand and holds the edge of her garment with the left. The low footstool has hoofs for feet. The attachment for the mirror consists of two tendrils ending in volutes.

Langlotz classified this mirror stand next to examples in British and French collections. He placed it in his lists of sculptures from Sikyon. Payne took this bronze to be Corinthian.

E. Robinson, *Ann. Rep.* 1901, 36; *AA* 1902, 131; *AJA* 6 (1902) 377; *Handbook* 1964, 58f., illus.; Beazley in Burdett, Goddard, *E. P. Warren*, 358.

Smith, Forman Sale I, *Catalogue*, 10, no. 67, pl. 3; Reinach, *Rép. stat.*, III, 101, no. 4; E. Franck, *Griechische Standspiegel*, 10, 30f., 124, no. 16; Richter, *Ancient Furniture*, fig. 110; Langlotz, *Frühgriechische Bildhauerschulen*, 30, 33, pl. 16, a; Webster, *AntJ* 16 (1936), 145ff.; Payne in Poulsen, *Der Strenge Stil*, ActaA 8 (1937) 19; Beazley, *Proc Irish Acad* 45 (1939) 36ff., pl. 11-12; Richter, *Sculpture*, 90, fig. 255; Lippold, *Handbuch*, 105, note 8; Congdon, *Greek Caryatid Mirrors*, 50ff., 77ff., 128, 130f., 134, 149f., 243f., pl. 10; idem, *AJA* 70 (1966) 163, note 29; Rolley, *Monumenta Graeca et Romana*, V, fasc. 1, 5f., no. 53, pl. 17; T. H. Robsjohn-Gibbings, C. W. Pullin, *Furniture of Classical Greece* (New York, 1963) 70, illus.; Richter, *The Furniture of the Greeks Etruscans and Romans* (London, 1966) 43-44, fig. 253 (caption switched with fig. 252).

Exhibited: Buffalo, *Master Bronzes*, no. 84, illus.

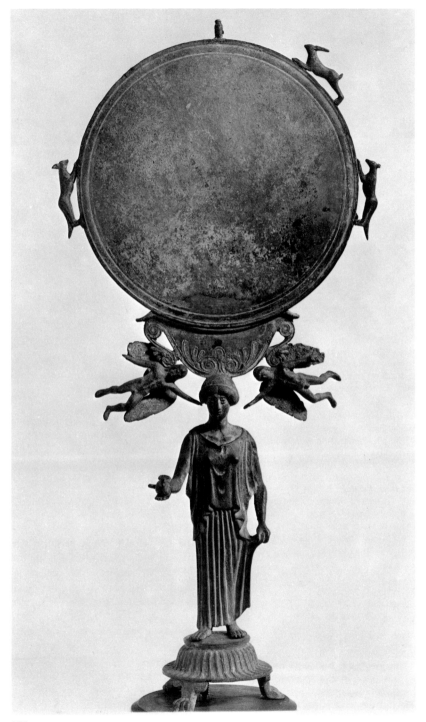

355

MIRROR AND STAND
Circa 460 B.C.
H.: 0.45m. H. (figure): 0.16m.
H. L. Pierce Fund 98.667
E. P. Warren Collection.

One dog on the rim is missing. Light green
patina, with earth encrustation.

Aphrodite stands on a circular, fluted base
with legs in the form of lion's paws. She
wears Ionic chiton with overfold, holds the
edge of the garment in her left hand and a
dove on the extended right. Between her
head and the disc, the attachment is flanked
by winged Erotes. On the edge of the disc
there appears a hare pursued by two dogs.

Langlotz listed this ensemble under
Kleonai, and the workshop certainly must
have been in the Sikyon-Corinth-Argos
triangle, if not in one of these major centers.

E. Robinson, *Ann. Rep.* 1898, 30; *AA* 1899, 137;
AJA 3 (1899) 570; *BMFA* 1 (1903) 15; B. H. Hill,
BMFA 3 (1905) 46, illus.; *AJA* 10 (1906) 199;
J. Addison, *The Boston Museum of Fine Arts*,
296; Hambidge, Caskey, *The Diagonal* 1 (1920)
55f., illus.; Chase, *Antiquities*, 72f., fig. 80; 2nd
edition, 94, 115, fig. 96.

Fowler, *Greek Archaeology*, 328, illus.; E. Franck,
Griechische Standspiegel, 10, 14, 54f., 131, no.
44; Langlotz, *Frühgriechische Bildhauerschulen*,
68, no. 5; Reinach, *Rép. stat.*, IV, 196, no. 5;
Sieveking, *Antike Metalgeräte*, 9, pl. 20; V.
Poulsen, *Der Strenge Stil, ActaA* 8 (1937) 21, no.
14; Beazley, *Proc Irish Acad* 45 (1939) 31, note 1;
R. L. Koehl, *et al.*, *Athens in the Fifth Century
B.C.*, fig. 16; Congdon, *Greek Caryatid Mirrors*,
55, 81f., 151f., 176, note 36, 220ff., 257 (Congdon
cites *Copenhagen Fra Nat. chems Arc.* [1937]
49f.); *idem, AJA* 71 (1967) 150ff.

355

MIRROR AND HANDLE
Circa 450 B.C.
L.: 0.378m. DIAM.: 0.18m.
C. P. Perkins Collection 96.716
E. P. Warren Collection.
From Athens.

Rough dark and light green patina, with

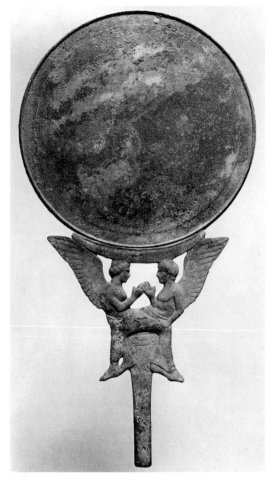

356

areas of blue.

The handle takes the form of a winged
youth and a winged maiden playing "morra."
For the subject, compare the scene on a South
Italian krater in Munich: A. Greifenhagen,
Griechische Eroten, 50f., fig. 38. Jantzen lists
this ensemble in his chapter on Locri and
identifies the pair as Eros (on the right) and
Psyche.

E. Robinson, *Ann. Rep.* 1896, 30; *AA* 1897, 73
(Eros and Psyche); J. Addison, *The Boston
Museum of Fine Arts*, 297.

Jantzen, *Bronzewerkstätten*, 22, no. 59, pl. 6, 28.

MIRROR HANDLE, UPPER PART
Fifth Century B.C., early
H.: 0.114m.
Purchased by Contribution 01.7523
E. P. Warren Collection.
Bought in Rome.

Much corroded. Green patina. The tang for
insertion in the handle proper (wood or bone)
is smooth.

A Siren with wings outspread stands amid
supporting volutes. The back of the handle,
where it joined the mirror, is in the form of a
palmette. The late archaic face of the Siren
is moulded in a good Sikyonian or Corinthian
style. Form and workmanship suggest this
handle comes from a South Italian Greek
workshop, perhaps Tarentum.

E. Robinson, *Ann. Rep.* 1901, 36.

358

HANDLE, FRAGMENT, FROM A MIRROR
Fifth Century B.C., circa 425 to 400 B.C.
H.: 0.063m. W.: 0.084m.
H. L. Pierce Fund 99.468
E. P. Warren Collection.
Bought in Greece.

The feathers are incised. The lower part is
missing. Green patina.

357

358

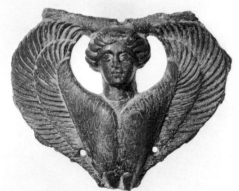

A Siren with wings spread, feathers on the
body incised. Holes for attachment at top, on
left and on right. The top bar is curved and
grooved for attachment.

Compare De Ridder, Acropolis *Bronzes*,
137f., no. 449, fig. 116. It bears stylistic re-
semblance to the base of the back handle of a
hydria, as the earlier fifth century example
in New York, from Aegina (?): D. von Both-
mer, *BMMA* 1955, 196, illus.

E. Robinson, *Ann. Rep.* 1899, 45; *AA* 1900, 218.

E. Diehl, *Die Hydria*, 38; Mitten-Doeringer,
Master Bronzes, under no. 105.

MIRROR

Circa 480 B.C.

H. (max.): 0.328m. DIAM. (of disc): 0.179m.

Gift of Mr. and Mrs. Norbert Schimmel

62.1189

Formerly in the possession of A. Arslanian,
Hamburg.

Somewhat smoothed by wear. Brown-black
patina.

At the end of the handle, a seated lion; at
the joint with the disc, a crouching boar.

Mirrors of this type are collected in detail
by W. Skudnowa, *Skythische Spiegel aus
der archaischen Nekropole von Olbia* (in
Russian). Compare especially figs. 10, 11. See
also *AA* 1913, col. 202, fig. 47, and Minns,
Scythians and Greeks, 65f., 178.

Vermeule, *Ann. Rep.* 1962, 32; MFA, *Calendar of
Events*, May 1963, 2, illus.; H. Hoffmann, *AJA*
69 (1965) 65f., pl. 20, figs. 1, 2; Vermeule,
CJ 60 (1965) 292f., fig. 5.

359

360

MIRROR AND COVER
Circa 400 B.C.
DIAM.: 0.118m.
H. L. Pierce Fund 99.492a, b
E. P. Warren Collection.
Bought in Athens.

Light green patina and encrusted earth.
 (a) Mirror, which is the box itself. The edge and under surface are decorated with concentric circles.
 (b) Cover, with a rope pattern encircling the top, within which are groups of concentric circles.

E. Robinson, *Ann. Rep.* 1899, 48; *AA* 1900, 218; *AJA* 4 (1900) 511.

361

MIRROR CASE AND COVER
Circa 380 B.C.
DIAM. (case): 0.105m. DIAM. (cover): 0.16m.
H. L. Pierce Fund 98.671
E. P. Warren Collection; Tyszkiewicz Collection.
Said to have been found at Corinth.

Green patina, with cleaned areas and areas of encrustation.
 On the cover, in relief, a winged Eros, seated to the left, rides a dolphin to the right, over waves. Eros holds a dove in his right hand, and there is a cloak draped over his right arm. The empty look of the face combined with the posture and the unnatural agitation of the drapery all adds up to a somewhat provincial treatment of style popular in Attic vase-painting at the end of the fifth century and in the sculpture associated with Timotheos at Epidaurus about 370 B.C.

360 361

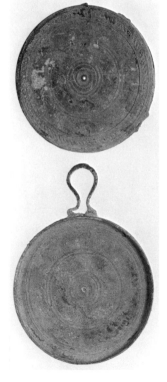
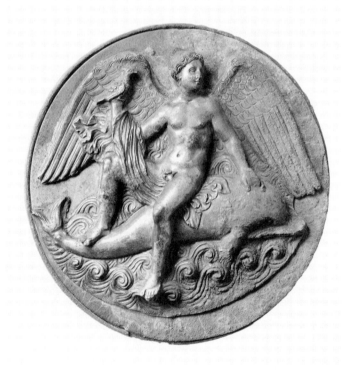

E. Robinson, *Ann. Rep.* 1898, 31; *AA* 1899, 137;
MFA, *Engagement Calendar* 1958, April.

Froehner, *Collection Tyszkiewicz*, 4, pl. 5;
Schefold, *Untersuchungen zu den Kertscher
Vasen*, 98, note 74; Züchner, *Klappspiegel*, 27f.,
no. 27.

362

Mirror and Case

Circa 375 B.C.

DIAM. (case): 0.17m. DIAM. (cover): 0.175m.

H. L. Pierce Fund 98.673

E. P. Warren Collection.

Probably from Elis.

The mirror has been corroded by blue and
green patina. The cover is repaired and slight-
ly restored. A ring-handle once attached to
the rosette is missing.

 On the cover, Dionysos in battle with a
giant, who is falling against his shield in a
rocky landscape. Dionysos reaches toward
the giant's hair with his left hand and was
probably hurling a thunderbolt with the right.
Below the group, a rosette, to which a ring-
handle was once attached.

E. Robinson, *Ann. Rep.* 1898, 32; *AA* 1899, 137.

Wuilleumier, *Le Trésor de Tarente*, 121f.;
Züchner, *Klappspiegel*, 50, no. 68, pl. 10, 33, 198,
200 (Corinthian, ca. 375 B.C.); D. B. Thompson,
Hesperia Suppl. VIII (1949) 369, pl. 50, fig. 3;
Vian, *Répertoire des Gigantomachies*, no. 424,
pl. 52; P. Bernard, Fr. Salviat, *BCH* 83 (1959)
288ff., esp. 323, fig. 26; P. Bernard, J. Marcadé,
BCH 85 (1961) 459, fig. 7.

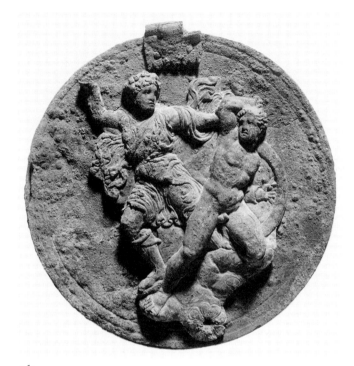

362

363

MIRROR AND CASE
Circa 375 B.C.
DIAM.: 0.183m.
Purchased by Contribution 01.7516a, b
E. P. Warren Collection.
"Bought in London from a Greek dealer"
(Warren); bought from Furtwängler?

The mirror has green and purple patina.

On the cover, Dionysos seizes a young
giant by the hair. The giant, who tries to
break the grip with his left hand and grasp
the god's chin with the right, falls into a
landscape with small stones. Below the
giant's right leg is a small, circular shield, to
which a ring-handle was once attached.

Stylistically, these two cases with scenes
of Dionysos combating a giant form docu-
ments of transition between the art of the
Dexilios stele in Athens (394 B.C.) and the
fourth-century forces that, on a monumental
scale, will form the sculptural School of
Pergamon in the early Hellenistic period.

E. Robinson, *Ann. Rep.* 1901, 36; *AA* 1902, 131;
AJA 6 (1902) 377.

Züchner, *Klappspiegel*, 51, no. 70, fig. 23, 198;
R. Lullies, *Die Antike* 20 (1944) 85f., 83, fig. 6;
D. B. Thompson, *Hesperia* Suppl. VIII (1949),

364

369; Vian, *Répertoire des Gigantomachies*, no.
425, pl. 52; P. Bernard, Fr. Salviat, *BCH* 83
(1959) 323, note 1; P. Bernard, J. Marcadé, *BCH*
85 (1961) 459, fig. 6.

364

MIRROR CASE
375 to 350 B.C.
DIAM.: 0.168m.
C. P. Perkins Collection 96.714
E. P. Warren Collection.
Said to be from Palaeopolis in Elis.

Part of relief on cover broken away. Green
patina. Rough corrosion on some parts.

On the cover, centaur and nymph. He
wears a panther-skin cloak and is pulling her
along with his left hand on her wrist and his
right arm around her waist. Below the group,
a ring-handle. In style, the two figures recall
the sculptural influence of the frieze on the
temple of Apollo at Bassae. The centaur be-

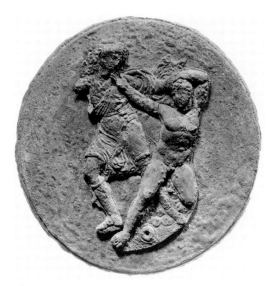

363

gins to show the proto-Pergamene qualities manifest in these mirror cases of the second quarter of the fourth century B.C.

E. Robinson, *Ann. Rep.* 1896, 29f.; *AA* 1897, 73; *BMFA* 1 (1903) 15; B. H. Hill, *BMFA* 3 (1905) 47, illus.; *AJA* 10 (1906) 199; B. H. Hill, *The Burlington Magazine* 8 (1905-06) 368f., illus.; J. Addison, *The Boston Museum of Fine Arts*, 296.

Züchner, *Klappspiegel*, 65, no. 93; 200, 186, fig. 100.

365

MIRROR AND CASE

Circa 350 B.C.

DIAM.: 0.163m.

Purchased by Contribution 01.7513a, b

E. P. Warren Collection.

Bought in Athens.

365

The mirror has a light glossy green patina. The case is a smooth dark green. It has lost the heads of both figures, both arms of the female figure, and the right arm, left shoulder, and upper arm of the male figure; also the upper part of the tree at the right.

On the cover, below remains of incised floral designs at the top, a female (Ariadne?) clad in high-girt chiton and himation is seated on one end of a large rock. On the other end is seated a nude man (Dionysos?). She was holding up drapery in her right hand and placing the left seemingly on or near his shoulder. The rock is covered by a fringed cloth, and the lower half of a large tree is visible at the right. Elegant repose and balance of proportions characterize these two figures, which seem to be in the calmer Skopaic or early Lysippic traditions of the fourth century B.C.

E. Robinson, *Ann. Rep.* 1901, 36; *AA* 1902, 131; *AJA* 6 (1902) 377; *BMFA* 1 (1903) 15; B. H. Hill, *The Burlington Magazine* 8 (1905-06) 368f., illus.

Züchner, *AA* (1935) 369; idem, *Klappspiegel*, 33f., no. 38, pl. 19; Segall, *Winckelmanns-programm* 119/120, 32f.

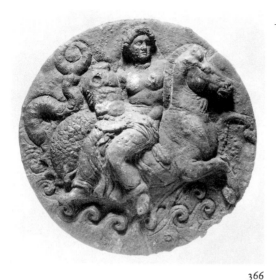

366

366

MIRROR, CASE AND COVER

Circa 350 B.C.

DIAM. (case): 0.19m. DIAM. (cover): 0.185m.

H. L. Pierce Fund 98.672

E. P. Warren Collection.

Said to come from Corinth.

The mirror and case are welded together by corrosion. The cover and its relief have been repaired and slightly restored. The figures of the interior design were silvered.

On the outside of the cover, Thetis, half-draped, rides to the right on a hippocamp, with scaly tail. She is holding a muscled cuirass with circular and long pteryges. Stylized waves appear below. On the inside of the cover, incised, an adolescent Eros with wings rides to the left on a dolphin; he wears a bracelet on each wrist. Stylized waves surround the scene. The mirror itself is a disc of burnished bronze, a portion of the surface being still lustrous. Thetis and the hippocamp are presented in a late, slightly rough version of the Timothean sculptural style, as documented at Epidaurus. The Eros and his dolphin were incised by a goldsmith.

E. Robinson, *Ann. Rep.* 1898, 31f.; *AA* 1899, 137; J. Addison, *The Boston Museum of Fine Arts*, 297; Chase, *Antiquities*, 101f., fig. 116; 2nd edition, 142, 153, figs. 133a, b.

Olynthus X, 170; Züchner, *Klappspiegel*, 89, no. 147, 172, 166, figs. 79, 80.

MIRROR AND COVER
Circa 350 B.C.
DIAM.: 0.15m.
Gift of E. W. Forbes 05.59a, b

The mirror has blue and pale green patina. The cover relief lacks fragments of the heads, bodies, and weapons. It has a pale green patina.

On the cover, there is a relief which was made for some other purpose. The scene comprised two chlamys-clad youths attacking a running boar. The youth on the left was lunging with a spear and holding a short sword; he on the right, wearing boots, was chopping with a broadsword. A cap of petasos type lies at the left, and another of pilos form is visible at the right. Holes at regular intervals (for stitching to a garment?) are visible in the ground below. On the mirror, there is incised concentric beading.

This scene may be an excerpt from Meleager's hunt of the Calydonian boar. Although the subject was being projected by the atelier of Skopas in the pediment of the temple of Athena at Tegea at this time, the style of these figures is Attic in the tradition of the big grave stele in the Villa Torlonia-Albani in Rome. This style and composition were to reappear in the second century A.D. in Attic sarcophagi, such as the example in the garden of the museum at Eleusis.

B. H. Hill, *Ann. Rep.* 1905, 47f.; *BMFA* 3 (1905) 47; *AJA* 10 (1906) 364; B. H. Hill, *The Burlington Magazine* 8 (1905-06) 368f., illus. p. 369, 1; *AA* 1906, col. 263f.; Chase, *Greek Gods and Heroes*, 53f., fig. 54; 1962 edition, 70f., fig. 57.

Züchner, *Klappspiegel*, 60f., no. 84, 59, fig. 29; Daltrop, *Die Kalydonische Jagd in der Antike* (Hamburg and Berlin, 1966) 22, 33, pl. 17.

366

367

MIRROR CASE
Circa 325 B.C.
DIAM.: 0.139m.
Purchased by Contribution 01.7514a, b
E. P. Warren Collection.
Bought in Athens; once in Corinth.

The relief on the cover lacks parts of the
heads of the two figures, as well as other
small portions. A piece from the edge of the
case is missing. Patina in part pale green.

On the cover, Aphrodite, clad in chiton and
ample himation, is seated to the left on a
rock. Eros, clad in a small chlamys, flies down
from the left to embrace her. At Aphrodite's
feet, a goose, and just below, the ring-handle.

Engraved inside the cover, winged Hy-
menaeus wears a wreath and a long chlamys;
he moves from left to right, carrying a torch
and a loutrophoros.

As a work of art this mirror case, especial-
ly the group of Aphrodite and Eros, is a
mannered continuation of the Epidaurus
style so manifest on a higher level in the
mirror cases made earlier in the century.

E. Robinson, *Ann. Rep.* 1901, 36; *AA* 1902, 131;
AJA 6 (1902) 377.

F. Endell, *Antike Spiegel*, pl. 39.

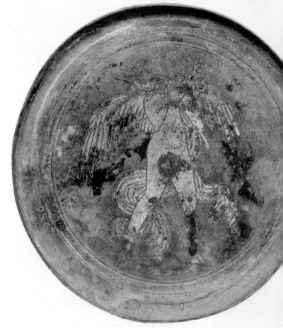

368

368

369

369

MIRROR AND COVER
Circa 325 B.C.
DIAM.: 0.175m.
Gift of E. P. Warren Res. 08.32c
From Corinth.

Crusty green patina, with the edges of the re-
lief on the cover (cast separately) corroded.

On the cover, within raised concentric
rings, symplegma on a couch with two large
pillows. Above, Eros flies to the right, holding
a fillet in his outstretched hands.

Engraved inside the cover, symplegma on
the edge of a similar couch. A pair of slippers
is on the footstool in the foreground.

On the underside of the mirror, raised con-
centric rings. The scene on the cover is a
splendid mixture of quality and rubbery
plasticity in design. The head of the youth is
Polykleitan in proportions, while the female
is more typical of the late fourth century
in terracotta as well as metalwork. Eros is a
detail that could come from the realm of the
jeweler's craft. He goes back to the secondary
Erotes of the fifth century B.C.

Six, *JdI* 20 (1905) 165ff., figs. 5-7; Züchner,
Klappspiegel, 66, no. 95; Marcadé, *Eros Kalos*,
pl. 130.

Interior: Furtwängler, *FR* II, 42, note 3 (as from
Megara), 43, note 4; Pfuhl, *MuZ* II, 732, para-
graph 798; Licht, *Sittengeschichte Griechenlands*,
III, 197, fig.; Marcadé, *op. cit.*, pl. 123.

369

MIRROR AND CASE
Circa 325 B.C.
DIAM. (bottom of case): 0.203m.
Purchased by Contribution 01.7494
E. P. Warren Collection.
Bought in England from a Greek dealer.

Portions of all the figures on the case are
missing. The handle has been reshaped with
a bar across the bottom. Dark green patina.

On the cover, Aphrodite stands and a satyr
sits on his panther-skin, on either side of a
tree; from the left a small Eros flies toward
Aphrodite, who is feeding a goose at her
right side. There is a separate handle, re-
shaped and with a bar across the bottom.

Closest to Züchner, *Klappspiegel*, 89f., no.
150, fig. 104 (New York): Form C1. Aphro-
dite resembles a terracotta figurine of the late
fourth century. The satyr combines a head
of Aristotle or an old man on a late Attic

371

grave stele with a Lysippic body. The design-
er's attempt to include landscape and model
the figures almost in the round ruins the
composition.

E. Robinson, *Ann. Rep.* 1901, 36; *AA* 1902, 131;
AJA 6 (1902) 377.

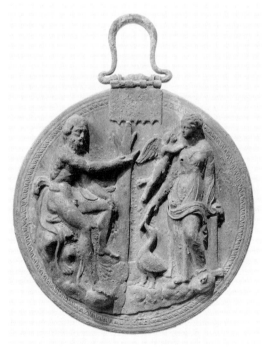

370

371

MIRROR AND CASE
Circa 350 B.C.
DIAM. (case): 0.16m.
Purchased by Contribution 01.7496a, b
E. P. Warren Collection.
Bought in Athens; from Corinth.

Part of the knot of hair has been lost. Rich
green patina. Somewhat corroded.

On the cover, there is a large female head
in relief, profile to left; her hair is done in
a knot behind, and drapery is arranged
around her shoulders. This version of the
melon hair style parallels the monumental

sakkos behind, and drapery covers the shoulders.

B. H. Hill, *Ann. Rep.* 1903, 61; *AA* 1904, 194; *AJA* 8 (1904) 382; *BMFA* 2 (1904) 15; Vermeule, *PAPS* 109 (1965) 366, fig. 9.

Züchner, *Klappspiegel*, 83f., no. 138, pl. 32.

373

MIRROR CASE
Fourth Century B.C., circa 325
DIAM. (mirror): 0.137m. H. (head): 0.055m.
Source unknown 01.7309
Perhaps from E. P. Warren Collection.

The mirror is complete but has been cracked. The cover is fragmentary.

On the cover, a female head is shown in three-quarter view, in high relief to the right.

Compare Züchner, *Klappspiegel*, 74f., no. 108, fig. 38 (Brussels). Hair and face are based on the Cnidian Aphrodite of Praxiteles.

E. Robinson, *Ann. Rep.* 1901, 36; *AA* 1902, 131; Vermeule, *PAPS* 109 (1965) 366f., fig. 10.

372

draped statues of Lysippos or the so-called Corinna of Silanion.

E. Robinson, *Ann. Rep.* 1901, 36; *AA* 1902, 131; *AJA* 6 (1902) 377.

Exhibited: Detroit, *Small Bronzes of the Ancient World*, 11, no. 74.

372

MIRROR AND CASE
Circa 350 B.C.
DIAM. (case): 0.162m.
Francis Bartlett Collection 03.992a, b
E. P. Warren Collection.
Bought in London; said to come from Asia Minor or the islands off its coast.

A bit of the lead with which the relief was attached remains; the original color and brilliant polish of the bronze are in part preserved. There is a hole just above the knot at the back of the sakkos. Crusty green patina.

On the cover, a large female head in relief, profile to the left; the hair is done up in a

373

374

374

Disc

Fourth Century B.C. (?)

DIAM.: 0.257m.

Purchased by Subscription 72.391

General di Cesnola Collection.

From Cyprus.

Thick light green encrustation.
The disc rises a little at the center.

375

Mirror

Fourth Century B.C. or later

L.: 0.105m. W.: 0.09m.

Purchased by Contribution 01.7493

E. P. Warren Collection.

Bought in Rome.

Polished on one side; other left rough. Front edges bevelled. Badly corroded near one edge. Very dark green patina.

Thin plate, nearly square and polished on one side. Back left rough and edges on the front are bevelled.

Compare Richter, New York *Bronzes*, 290, no. 840, dated in the Roman period (from Cyprus).

E. Robinson, *Ann. Rep. 1901*, 36; *AA* 1902, 131.

375

Etruscan, Italic and Roman

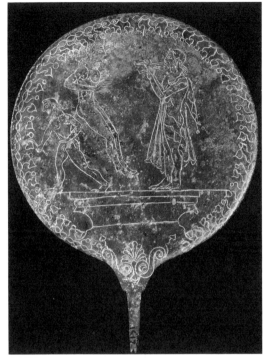

376

MIRROR
Fifth Century B.C.
L.: 0.21m. DIAM.: 0.155m.
C. P. Perkins Collection 95.73
E. P. Warren Collection.
Bought in Rome.

Light green patina and corrosion with areas
of cleaned surface in brown.

On the back, a group of three youths. The
one at the right plays the double flute; he in
the middle is just finishing a jump; and the
third, holding a strigil, walks away from the
others. Palmette below and thick cluster of
ivy leaves all around.

E. Robinson, *Ann. Rep.* 1895, 24; *AA* 1896, 97.
Gerhard, *Etruskische Spiegel*, V, pl. 144; Mayer-

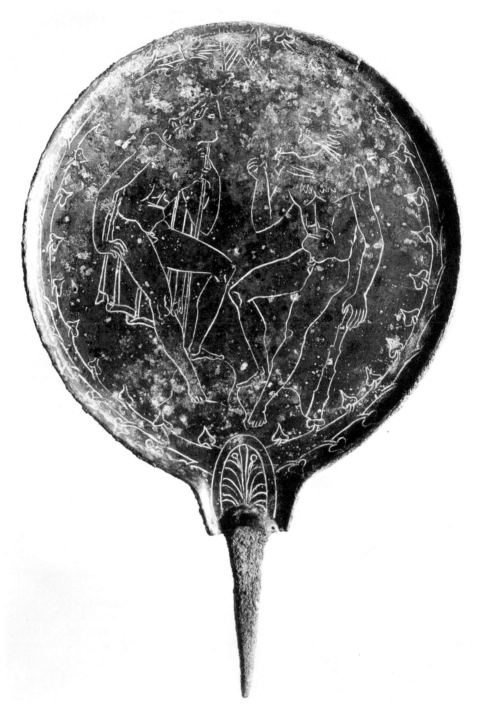

Prokop, *RM Ergänzungsheft* 13, 35, S44, pl.
39, 1-2.

377

MIRROR
Fourth Century B.C.
L.: 0.242m. DIAM.: 0.16m.
Gift of E. P. Warren 92.2740

Dark olive green and brown patina. Much
light green corrosion.
 On the back, two youthful heroes. He on
the left (Apollo) is seated with cloak; on the
right, Herakles is seen with his club and
lion's skin. All in vine-wreath with leaves.

E. Robinson, *Ann. Rep.* 1892, 18.

L. G. Eldridge, *AJA* 21 (1917) 384f., fig. 6; M. Del
Chiaro, *AJA* 59 (1955) 278ff., 282ff., no. 34.

378

MIRROR
Third Century B.C.
DIAM.: 0.183m.
H. L. Pierce Fund 98.686
E. P. Warren Collection.

Dark, olive green patina with light green
areas of corrosion.
 On the back, a half-draped winged female
and a seated youth, also half-draped, in lively
conversation with a youth standing in the
center, spear in his left hand and cloak over
his left arm. Palmette below and heavy
wreath of stylized grain.

E. Robinson, *Ann. Rep.* 1898, 34; *AA* 1899, 138.

L. G. Eldridge, *AJA* 21 (1917) 369-373, fig. 2;
F. Endell, *Antike Spiegel*, pl. 28.

379

MIRROR
Third Century B.C.
L.: 0.24m. DIAM.: 0.17m.
C. P. Perkins Collection 96.715
E. P. Warren Collection; Fanello Fanelli Col-
lection at Sartiano.

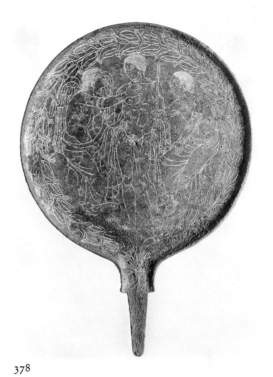

378

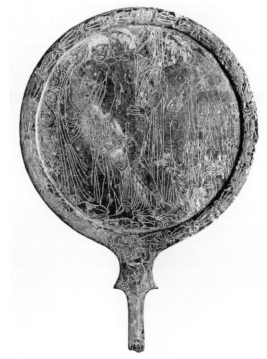

379

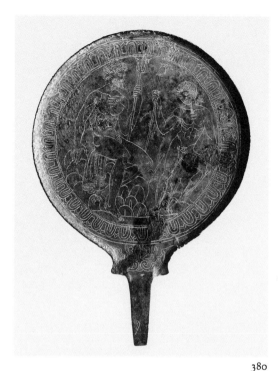

380

Muddy greenish patina.

On the back, a partly draped woman with high sandals and a diadem is attended by a youth who holds his cloak in the right hand and throws the left end about the female. A winged, diademed, partly draped Lasa stands at the right. Fishes below suggest this scene is taking place on a beach and is the birth of Aphrodite. An acanthus scroll fills the tondo at the left, and there is a small scroll at the lower right. At the base of the lotus-bud wreath, a standing Eros.

E. Robinson, *Ann. Rep. 1896*, 30; *AA 1897*, 73.

L. G. Eldridge, *AJA 21* (1917) 377-381, fig. 4; F. Endell, *Antike Spiegel*, pl. 27.

380

MIRROR
Third Century B.C.
DIAM.: 0.156m.
H. L. Pierce Fund 99.493
E. P. Warren Collection.

Green patina.

On the back, Poseidon at the left, seated on his cloak, thrown over rocks. He is filleted and holds his trident in the left hand. At the right, a youth (Glaukos) stands with flower-topped scepter in the right hand. There are flowers growing around his right leg. Tongue and chevron pattern around, and palmette below.

E. Robinson, *Ann. Rep. 1899*, 48; *AA 1900*, 218; *AJA 4* (1900) 511.

L. G. Eldridge, *AJA 21* (1917) 365-369, fig. 1; F. Endell, *Antike Spiegel*, pl. 6.

381

MIRROR
Early Fourth Century B.C.
DIAM.: 0.152m.
H. L. Pierce Fund 99.494
E. P. Warren Collection.
Bought in Rome.

Patina green and lustrous.

381

On the back, Athena, in crested helmet, aegis and peplos, is standing with spear vertically in her left hand. At the right, Telamonian Ajax kneels in cloak and scabbard. He is about to plunge a sword into his stomach. Wreath of olive about and lyre-form volutes below.

E. Robinson, *Ann. Rep.* 1899, 48f.; *AA* 1900, 218; *AJA* 4 (1900) 511; B. H. Hill, *BMFA* 3 (1905) 47, illus.; *AJA* 10 (1906) 199; Fairbanks, *Greek Gods and Heroes*, 73f., fig. 68; Chase, *Greek Gods and Heroes*, 71f., fig. 78; 1962 edition, 94f., fig. 82; *The Trojan War in Greek Art*, fig. 35B.

von Mach, *Harvard Studies in Classical Philology* 11 (1900) 93ff., illus.; Eldridge, *AJA* 21 (1917) 365, note 2; Beazley, *Etruscan Vase-Painting*, 139f.; idem, *JHS* 69 (1949) 8, pl. 7a; Dohrn, *RM* 73/74 (1966/67) 20, pl. 3, 1; T. B. L. Webster, *Monuments Illustrating Tragedy and Satyr Play*, London, 1967, 145.

Exhibited: Hartford, *The Medicine Man Medicine in Art*, 28, no. 127.

382

MIRROR
Fourth Century B.C.
DIAM.: 0.153m.
H. L. Pierce Fund 99.495
E. P. Warren Collection.
Bought in Rome.

Brown patina.

On the back, a nude youth runs to the right and reins back a prancing horse. Wreath of ivy about.

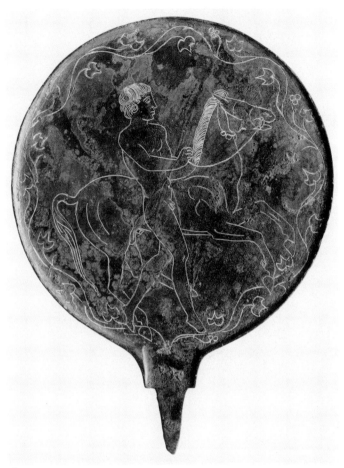

382

E. Robinson, *Ann. Rep.* 1899, 49; *AA* 1900, 218; *AJA* 4 (1900) 511; *Handbook* 1964, 76f., illus.; Chase, *Antiquities*, 134f., fig. 170; 2nd edition, 195, 209, fig. 198 (and cover of hardbound edition).

Eldridge, *AJA* 21 (1917) 373ff., fig. 3; F. Endell, *Antike Spiegel*, pl. 37.

Exhibited: Detroit, *Small Bronzes of the Ancient World*, 9, no. 50, 27, illus.

MIRROR

Third Century B.C.

DIAM.: 0.15m.

Purchased by Contribution 01.7525

E. P. Warren Collection.

The handle is missing, and there is a hole at the edge near the satyr's head. Dark green patina.

A satyr dances to the right, beside a bell krater; a thyrsos with fillets appears at the left. Two ivy or vine plants enframe the composition. Palmette and fillet tied in a circle below.

E. Robinson, *Ann. Rep. 1901*, 36; *AA 1902*, 131f.; *AJA 6* (1902) 377.

L. G. Eldridge, *AJA 21* (1917) 381ff., fig. 5; F. Endell, *Antike Spiegel*, pl. 30.

383

384

383

MIRROR

Fourth Century B.C.

DIAM.: 0.148m.

Purchased by Contribution 01.7467

E. P. Warren Collection.

From Bourguignon.

The handle is missing. Pale green patina.

On the back, within a cable border, Herakles (with sword and cloak) strides to the right and drags fallen Geras by the hair.

E. Robinson, *Ann. Rep. 1901*, 36; *AA 1902*, 131f.; *AJA 6* (1902) 377; Chase, *Antiquities*, 134f., fig. 171; 2nd edition, 195, 209, fig. 199.

Gerhard, *Etruskische Spiegel*, V, pl. 126; F. Endell, *Antike Spiegel*, pl. 16.

Exhibited: Worcester Art Museum, *Masterpieces of Etruscan Art*, 15, 83-84, no. 74, 174, fig. 74.

385

MIRROR

Fifth Century B.C.

DIAM.: 0.151m.

Francis Bartlett Collection 03.991

E. P. Warren Collection.

Bought in Paris.

Dark brown patina.

On the back, two satyrs with sickles, the one on the left wearing a nebris, gather grapes from the vine-wreath encircling the design. In the center, a maenad supports a basket of grapes on her shoulder.

B. H. Hill, *Ann. Rep.* 1903, 61; *AA* 1904, 194; *BMFA* 2 (1904) 15.

Gerhard, *Etruskische Spiegel*, IV, 45, pl. 313; F. Endell, *Antike Spiegel*, pl. 12.

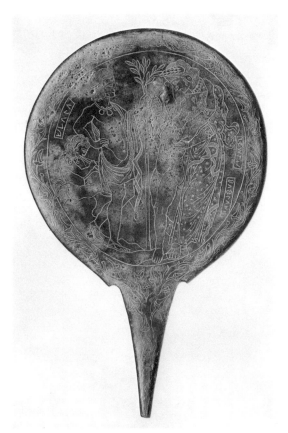

386

385

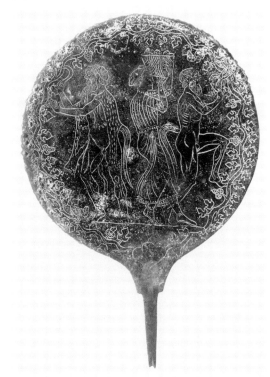

386

MIRROR

400 B.C. (?)

DIAM.: 0.137m.

Bequest of Charles H. Parker 08.253

Alfred Greenough Collection.

Dark, olive green patina with some areas of light green corrosion and brown (cleaned) surface.

On the back, Apollo stands to the right, holding a laurel-topped staff. A small satyr, seated on a rock at the left, is playing double flutes. At the right, Dionysos leans back from his thyrsos to embrace a wreathed, richly clad Semele who leans over

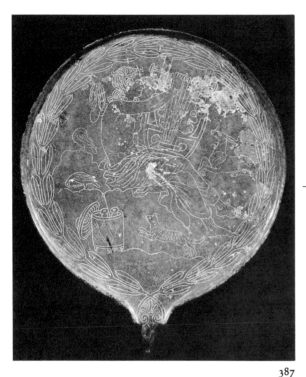

387

him. Apollo, Dionysos and the satyr wear necklaces with bullae suspended from the bands. A thin line and a wreath of leaves and berries encircle the composition.

Compare Gerhard, *Etruskische Spiegel*, I, pl. 83; Giglioli, *L'Arte etrusca*, pl. 296, 1 (drawing), 2 (photo); in Berlin.

L. D. Caskey, *Ann. Rep.* 1908, 60; *AA* 1909, col. 428.

387

MIRROR
Fourth Century B.C.
DIAM.: 0.146m.
Francis Bartlett Fund 13.207
E. P. Warren Collection; Tyszkiewicz Collection.

Light green patina, with slight corrosion on the edges.

On the back, Orpheus sits to the right, on a rocky landscape; he is playing the lyre, surrounded by a panther, a deer and two ravens. In the field, behind Orpheus, there is a laurel wreath, and on the ground at the left appears a cista containing two alabastra. There are palmettes at the beginning of the handle, on both faces.

Although Froehner followed Gerhard in terming the lyrist Apollo, the composition is the forerunner of Orpheus scenes in Hellenistic and Graeco-Roman painting, mosaics, and sculpture (see Vermeule, *European Art and the Classical Past*, 130f., fig. 110).

L. D. Caskey, *Ann. Rep.* 1913, 87f.; *AA* 1914, col. 493; *AJA* 18 (1914) 414; *Handbook* 1915, 115; Chase, *Greek Gods and Heroes*, 1962 edition, 34f., fig. 20.

Froehner, *Collection Tyszkiewicz*, pl. 4; Gerhard, *Etruskische Spiegel*, V, 211, pl. 160; Matthies, *Die Praenestinischen Spiegel*; F. Endell, *Antike Spiegel*, pl. 14; E. Richardson, *The Etruscans*, 138f., 284, pl. 41.

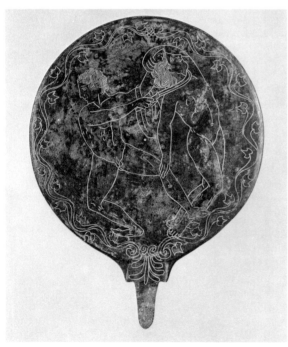

388

388

MIRROR

Fourth Century B.C.

H. (max.): 0.178m.

Gift of Horace L. Mayer 61.1257

Spink and Son, London.

Green and reddish patina.

On the back, within ivy-leaf wreath, bound by a palmette at the bottom, Perseus averts his gaze to the left as he cuts off Medusa's head. He holds a sack on his left arm.

Medusa is represented in sympathetic fashion as a young Greek girl. In overall design this scene is a masterpiece of relation between action, anatomy, and effective use of linear profiles. The foreshortening and sense of depth in the legs of the figures reflect developments in Greek painting in the generation after Pheidias. It is difficult to date this mirror, but the artist must have worked in the first quarter of the fourth century B.C. (compare Schauenburg, *Perseus in der Kunst des Altertums*, pl. 31, another mirror; a later Etruscan bronze statuette: H. Hoffmann, *Kunst des Altertums in Hamburg*, 14f., no. 43).

Vermeule, *Ann. Rep.* 1961, 43, 46, illus.; *idem, CJ* 58 (1962) 4f., fig. 5; *FastiA* 17 (1962) nos. 238, 244.

ILN, 11 June 1960, 1029, illus.

389

MIRROR

Fourth Century B.C.

H. (max.): 0.19m.

Gift of Horace L. Mayer 61.1258

The handle has been broken off near the end. Light green areas of corrosion and brown (cleaned) surface.

On the back, a diademed youth sits to the right in an acanthus calyx. A fully clad female advances from the right and grasps him by the left hand, while drawing his himation, held over his head, with the right hand.

The design is crowded and fussy. This is

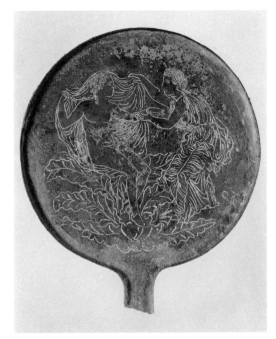

389

390

391

392

partly because of the involved drapery and acanthus leaves. The drawing of the faces lacks elegance.

The scene offers no ready interpretation. An Etruscan version of some Greek myth is certainly intended: Adonis and Aphrodite, or Selene and Endymion. The second suggestion stems from the fact that the woman is so chastely garbed. Were she Aphrodite visiting Adonis, we might expect to find the goddess unclad, although a rapid survey of other Etruscan mirrors will reveal that this is not always so. Scenes such as this are often aided by inscriptions. Adonis (Atunis) is well attested in Etruscan art, on bronze mirrors and, presumably, in a funerary terracotta showing him dying on a couch: M. Pallottino, M. Hürlimann, *Art of the Etruscans*, nos. 91, 116; Gerhard, *Etruskische Spiegel*, v, pls. 111, 114-116. Aphrodite (Turan) is fully clothed. See also the scenes of Achilles and Thetis: Gerhard, pl. 232; Thalna and Anchises: pl. 326; and even Apollo and Artemis: pl. 294.

Endymion is a questionable commodity in Etruscan art; see below, under the pair of handles from a stamnos: no. 512.

Vermeule, *Ann. Rep.* 1961, 43f.; *idem, CJ* 58 (1962) 5f., fig. 6; *FastiA* 17 (1962) nos. 238, 244.

390

MIRROR
Third Century B.C.
L.: 0.195m.
Gift of Mr. and Mrs. William de Forest Thomson 19.314

Light green patina, cleaned on figured side.

On the back, Peleus, in helmet and chlamys, grasps Thetis, who wears a short tunic and is winged. Double border, waterleaf and vine within, palmette at bottom.

Inscribed: ΘΕΟΙΣ
ΛΕΓΕ

MIRROR

Hellenistic Period

L.: 0.19m. DIAM.: 0.14m.

C. P. Perkins Collection 95.72

E. P. Warren Collection.

Said to be from Cosenza.

Light olive green patina with areas of lighter green corrosion.

On the back, ivy-leaf, dolphin, wave and ogee moulding patterns are arranged in concentric rings inward to a filleted head (of Helios) surrounded by tongues of flame.

E. Robinson, *Ann. Rep.* 1895, 24; *AA* 1896, 97.

Gerhard, *Etruskische Spiegel*, V, 210, no. 158a; K. Schauenburg, *Helios*, 12f., pl. 1 (termed second century B.C.); C. Clairmont, *Gnomon* 29 (1957) 224, note 1 (perhaps second half of the fourth century B.C.); M. J. Milne, *AJA* 61 (1957) 313; Schauenburg, *Antike Kunst* 5 (1962) 60, note 97; Mayer-Prokop, *RM Ergänzungsheft* 13, 13, S3, pl. 3, 1.

393

MIRROR

Hellenistic Period

DIAM.: 0.155m.

Francis Bartlett Fund 13.2886

From Chiusi (this and the five following).*

Crusty green patina.

Flat disc, with projection for a separate handle.

AJA 18 (1914) 414 (this and the four following).

* They were found with a large travertine cinerary urn (MFA 13.2860).

MIRROR

Hellenistic Period

DIAM.: 0.135m.

Francis Bartlett Fund 13.2887

Green patina, with heavy encrustation.

A flat disc, without handle or decoration.

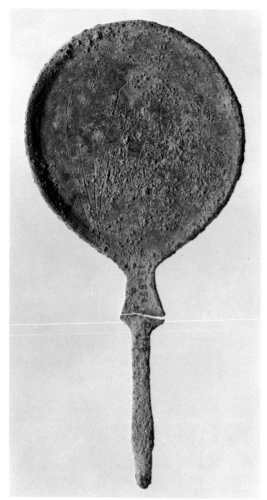

Mirror

Fourth Century B.C. to Hellenistic Period

L.: 0.21m.

Francis Bartlett Fund 13.2888

Heavily corroded. The handle is missing. A piece has been broken off the mirror at the edge. Crusty green patina.

Before a temple with three Aeolic columns stand Hephaistos (Vulcan), Aphrodite, Athena, and Persephone (?). A winged creature, resembling a demon, fills much of the exergue below. Analogies indicate it was probably standing.

Compare for style and general arrangement of the figures before a similar temple, Gerhard, II, pl. 228.

394

394

394

Mirror

Hellenistic Period

H. (without handle): 0.12m.

Francis Bartlett Fund 13.2890a, b

The handle has been broken, but preserved. Green patina, heavily encrusted.

A winged creature, seemingly a Lasa, with large wings and a Phrygian cap walks from right to left. On the back, a thin dentil is engraved around the rim and on the adjoining part of the handle.

Compare Gerhard, I, pl. 33.

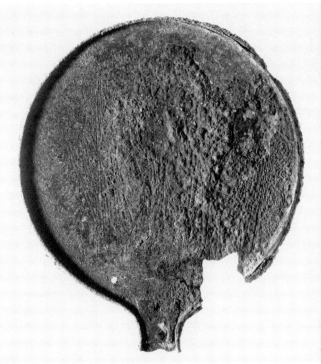

395 395

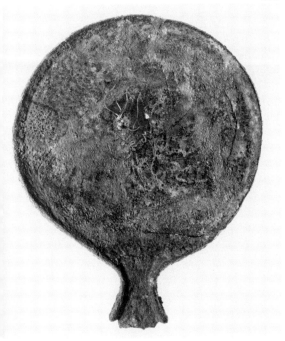

396

MIRROR
Hellenistic Period
L. (with handle): 0.146m.
Francis Bartlett Fund 13.2889

Heavily corroded. The handle preserved but
broken off. Crusty green patina.

On the back, within a raised rim, an almost
indistinguishable engraved design.

A youth, seemingly with wings and a
Phrygian cap, stands to the left in relaxed,
hipshot pose. A Lasa is doubtless intended.

Compare Gerhard, I, pl. 31.

396

MIRROR
Hellenistic Period
L.: 0.16m.
Francis Bartlett Fund 13.2891

Heavily corroded. The handle has been broken. Crusty green patina.
 The disc is plain.

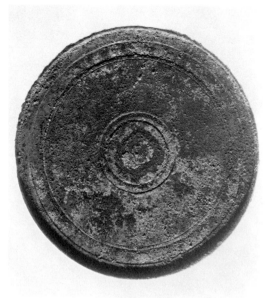

398

MIRROR
Graeco-Roman
DIAM.: 0.011m.
Gift of the Archaeological Institute of America 84.572
From the Necropolis at Assos.

Green patina.
 This is a circular disc; the rim is slightly turned up on one side. The "inside" is decorated with two pairs of concentric circles, incised.

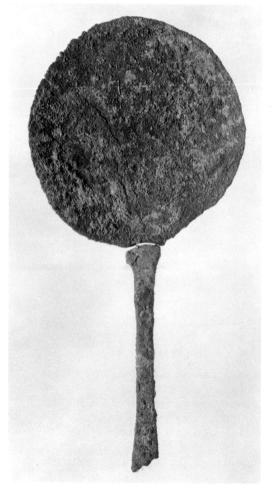

397

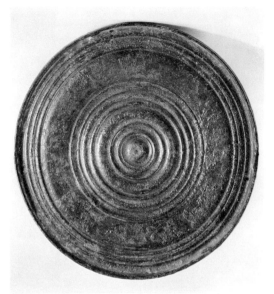

399

400

399

MIRROR
Graeco-Roman
DIAM.: 0.098m.
Gift of the Archaeological Institute of America 84.571
From the Necropolis at Assos.

Green patina.
 This comprises a flat disc, perfectly plain on both sides.

400

MIRROR
Roman Period
DIAM.: 0.12m.
Gift of Miss Catharine M. Peacock 48.1093a, b
Said to have been excavated in London during the 19th century.

Deep, olive green patina with some encrustation and small areas of lighter green.
 Mirror: Band of moulding on the (edge of the) disc; on the reverse side, engraved concentric circles.
 Cover: Concentric mouldings on the inside; exterior undecorated.

G. H. Chase, *Ann. Rep.* 1948, 26; *BMFA* 47 (1949) 12.

VESSELS

Including Lamps, Boxes, Various Handles and Attachments

401

Greek

401

BOWL
Early Bronze Age, circa 2400 B.C.
H.: 0.15m. DIAM. (at rim): 0.14m.
Gift of Richard R. Wagner 66.182

Green patina; some encrustation. Partly cleaned and repaired.

This deep round vessel has three lug handles of thin bronze rolled into double hollow cylinders, for suspension. It is decorated with a large zigzag pattern in deep incision.

This type originates in northwest Anatolia and serves as good evidence of the early connections within the Aegean area. Such vessels are found at sites up and down the Aegean coast from the Troad to the Halicarnassus peninsula. They are usually of clay. Few examples in bronze have survived because of the thinness of the fabric.

Vermeule, *Ann. Rep.* 1966, 55; *idem, CJ* 62 (1966) 98, fig. 1.

402

SIREN FROM THE RIM OF A LEBES
Mid Seventh Century B.C.
H.: 0.142m. L.: 0.25m.
H. L. Pierce Fund 99.458
E. P. Warren Collection.
Said to have been found at Olympia.

Patina green-blue and crusty; the back has a calcareous deposit.

The Siren's wings and tail are spread. The arms lie along the upper sides of the wings. The ring in the middle of the back is solid. Underneath: Λ and incised K.

These handles, best known from Olympia (*Olympia* IV, pl. 44, no. 783; on a cauldron, pl. 49b) and found also at Delphi (*Fouilles de Delphes* V, 80-82, pls. XIIf.), are famous for their Anatolian evidences of connections with metalwork from the Kingdom of Urartu

(Lake Van in Armenia) in the Orientalizing period (see Istanbul, *Guide Illustré*, no. 41, from Van). For their relationship, see Hermann, *Olympische Forschungen* VI (1966). The Boston example has been recognized as having a mate among those at Olympia, seemingly a confirmation of the provenience (see Ohly, *AM 66* (1941) 27, note 3; Hermann also cites Kunze, *Reinecke-Festschrift*, 100).

402

402

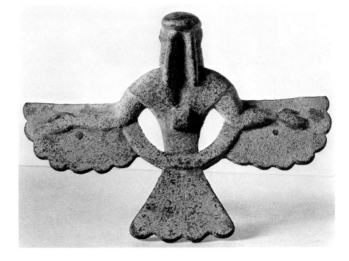

E. Robinson, *Ann. Rep.* 1899, 42; *AA* 1900, 217;
G. H. Chase, *BMFA* 48 (1950) 36f., fig. 7.

Kunze, *AM* 55 (1930) 158, pl. 47; *idem, Kretische Bronzereliefs*, 268, no. 15, 279; Hampe, *Frühe Griechische Sagenbilder*, 33, fig. 16; Hampe, *Jantzen, Olympiabericht*, 1 (1937) 73, note 2; D. M. Robinson, *AJA* 46 (1942) 187; Jantzen, *AM* 73 (1958) 36, note 8; J. Ducat, *BCH* 88 (1964) 601; Hermann, *Olympische Forschungen* VI (1966) 92, no. A23, 95ff., pl. 33; G. Kaulen, *Daidalika* (Munich, 1967) 199 B 8.

Exhibited: Cambridge (Mass.), Fogg Art Museum, *Greek Art and Life*, no. 3; Dayton, *Flight Fantasy, Faith, Fact*, 12, no. 67.

403

HANDLE OF A TRIPOD (?)
Seventh Century B.C., Orientalizing Period
H.: 0.038m.
Gift of C. Granville Way 72.4452
Hay Collection.

The tip of the left horn is missing. Brown patina, with earth encrustation in places.

A bull's head, with a circular tip on the right horn and large ears. The slender neck forms the attachment.

Compare the cauldron attachments: Bielefeld, *Wissenschaftl. Zeitschrift . . .Greifswald*, 4-5 (1955-56) 250ff., pl. 2, figs. 4-6, which are thought to be Asiatic (Urartu?); prototypes and parallels are discussed. Bronzes from Sparta illustrate the Greek development: Lamb, *Greek and Roman Bronzes*, pl. 23a. Since the Hay-Way Collection was formed exclusively in Egypt and from Cyprus, that island is the likely provenance of this attachment.

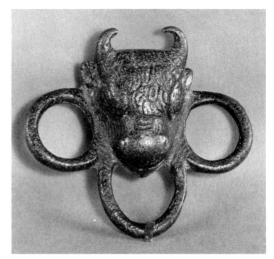

404

404

HANDLES
Hellenistic
H.: 0.072m. w.: 0.08m.
Gift of Richard R. Wagner 65.1340, 66.933
From Istanbul.

Dark green patina.

The handles are from a chest or vessel, perhaps a cauldron, in the form of bulls' heads with three rings from the face. The bulls' heads are hollow; the rings, solid. This is an Anatolian Hellenistic survival of a Phrygian and Urartu (Lake Van) motif.

Compare De Ridder, Louvre *Bronzes*, II, 28, no. 1530, pl. 72 ("harness attachment").

Vermeule, *Ann. Rep.* 1965, 68 (65.1340); *ibid.*, 1966, 55 (66.933); *idem, CJ* 62 (1966) 110, fig. 23 (65.1340 and the following).

D. G. Mitten, Fogg Art Museum, *Acquisitions 1965*, 138ff., fig. 2 (65.1340 and the following).

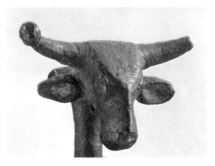

403

HANDLE

Hellenistic or Graeco-Roman

H.: 0.08m. W.: 0.07m.

Gift of Richard R. Wagner 65.1341

From Istanbul.

Green patina.

A handle of a chest or vessel, perhaps a cauldron, in the form of a bull's head with three rings from the face. The head is hollow, the rings solid. The design is highly stylized. The rings are flat and broad, each with an inset or incised circle at its lowest part.

A similar attachment, seen in 1966 in the New York Art Market, has a Maltese-cross plate on a swivel attachment in place of the lowest ring. On this is incised ΖΩΤΙΚΟΝ ΒΕΣΣΟΥΛΑ, suggesting a Phrygian name of the Roman imperial period. The bull's head protome of this type also survives in the heads of reclining bulls on the curved shoulder of the base of a twelfth-century lampstand in bronze from Ghazni in Afghanistan (B. Rowland, Jr., *Ancient Art from Afghanistan, Treasures of the Kabul Museum*, 139, no. 107, 137, illus.).

405 B

405 C

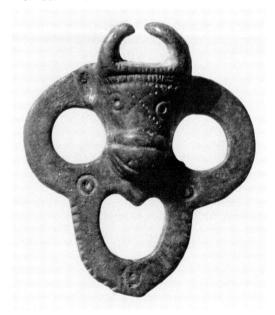

405

Two additional examples in Boston (68.733, 68.734), from the same sources, show how widely these handles vary in quality of casting, type of incised detail, size, and depth of relief. Appearance of so many similar attachments within a few years suggests discovery of a votive deposit, probably in Phrygia.

Vermeule, *Ann. Rep.* 1965, 68; idem, *Ann. Rep.* 1968, 33 (68.733, 68.734).

406

406

HEAD OF GRIFFIN
Circa 650 B.C.
H.: 0.113m.
Purchased by Contribution 01.7471
E. P. Warren Collection; Forman Collection.

Traces of incised scales all over the head, which is badly cracked. Pieces are missing from the top of the knob, nose, tip of the tongue, and right ear. Dingy green patina.

This is a cast piece, preserved to the base of the baggy pouch. An offset termination, like a ring, separates the head proper from the neck. The latter was hammered.

Benson writes (*loc. cit.*): "The upper skull of the creature is set off from a rather long beak in the form of a distinct roll so that the eyes seem to look sideways at the world from either end of a cylinder. The beak is not very widely opened and the tongue seems rather long. The knob is relatively slender and dainty but swells as it ascends. Thus the stem is smallest, the mushroom overlaps it considerably, and the termination swells and flares above this but probably did not extend much beyond its present length. The ears are long, sharp and crisply rendered, and the pouch compactly frames the jaws. . . . we have to do with a specimen of the so-called "Monumental Group", as it was designated by Jantzen; this may be added to his list as the ninth known example. It reflects a rather cool and analytical artistic will which has failed to achieve the most passionate unity of its contemporary fellows. However, in its strong articulation of the skull it points ahead to later protomes (e.g. Jantzen, *Griechische Greifenkessel*, nos. 88, 91a, 116a, etc.); it may well therefore be the latest member of the Monumental Group (as well as the smallest). Still, its effect is powerful."

E. Robinson, *Ann. Rep.* 1901, 36; *AA* 1902, 132; *AJA* 6 (1902) 377.

Forman Sale II; Benson, *Antike Kunst* 3 (1960) 60, pl. 2, 1, 2.

407

407

PARTS OF A CAULDRON: THREE GRIFFIN-
HEADS AND SECTION OF RIM
Seventh Century B.C.
H. (A): 0.178m. (B): 0.183m. (C): 0.154m.
L. (D): 0.37m.
William F. Warden Fund 50.144 a-d
Rome Art Market.

The three heads have incised scale pattern
with greenish patina. Griffin C has tips of
ears and tongue broken off; the neck was
broken and has been joined to the head. The
cauldron fragment (D) is heavily encrusted.
 Remarkable for the cleanness of their

finishing and casting, these griffin protomai
belong to Jantzen's Sixth Group and were
produced on Samos or the adjacent Ionian
coast in the late seventh century B.C.
 For the type of cauldron, see also Hampe,
Die Antike 15 (1939) 36, pl. 20-21.

G. H. Chase, *Ann. Rep.* 1950, 23; *idem, BMFA*
48 (1950) 33ff., figs. 1, 2; *idem, Antiquities,* 19ff.,
fig. 21; 2nd edition, 36, 41, fig. 32; *FastiA* 5
(1950) 1205, 1296.

Jantzen, *Griechische Greifenkessel*, 21, nos. 101-
03, pl. 37; Münzen und Medaillen, Auktion XVI,
30 June 1956, 9, under no. 19 (Samian, late
seventh century B.C.); Benson, *Antike Kunst* 3
(1960) 70; D. G. Mitten, *Fogg Acquisitions Re-
port* 1964, 11; Mitten-Doeringer, *Master Bronzes,*
under no. 66.

HEAD OF GRIFFIN

Circa 600 B.C.

H.: 0.133m.

Purchased by Contribution 01.7472

E. P. Warren Collection; Forman Collection.

Hollow-cast with hole through the head, connecting the eye-sockets. Slightly corroded; dark green patina.

The protome is completely preserved, including the flanged base and its three holes, two of which still have their bronze pins.

Benson places this with the so-called Tarquinia type of Jantzen's Sixth Group of Cast Protomes and deduces that the piece must have been manufactured on the island of Samos: see also Jantzen, *AM* 73 (1958) 41ff.

E. Robinson, *Ann. Rep.* 1901, 36; *AA* 1902, 132; *AJA* 6 (1902) 377.

Forman Sale II, *Catalogue*, no. 598; Benson, *Antike Kunst* 3 (1960) 60, pl. 2, 4-5.

408 408

409

WINGED GORGON, PROBABLY FROM A DINOS

Circa 550 B.C.

H.: 0.075m. L.: 0.053m.

H. L. Pierce Fund 98.656

E. P. Warren Collection.

From Gela.

Green patina, once encrusted but now cleaned.

The figure wears a fringed chiton and is running on an elongated Ionic capital. Both hands hold a small object pressed tightly against the body. While flat and evidently a piece of decoration, the figure is not a relief, being finished as carefully on the back as on the front, except the base, where it was attached to another object.

E. Robinson, *Ann. Rep.* 1898, 26; *AA* 1899, 136.

Jantzen, *Bronzewerkstätten*, 70, no. 27, pl. 32, 134; *FastiA* 9 (1954) no. 650.

Exhibited: Dayton, *Flight Fantasy, Faith, Fact*, 4, no. 22, pl. 3.

409

HANDLE OF A HYDRIA OR PITCHER
Circa 540 B.C.
H.: 0.128m.
Purchased by Contribution, through
C. E. Norton 85.515
Found near Sparta.

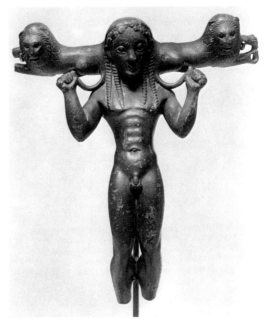

410

Both feet are missing, as are the paws of one
of the lions. Dark, olive green patina with
slight areas of corrosion in light green.

A nude youth grasps the tails of two lions,
at either side of his head. He has four long
braids falling in groups of two on his
shoulders and chest.

This handle was evidently produced in a
Laconian workshop, as it has been related to a
fragmentary handle from the Sparta excava-
tions (Hill, no. 11; compare also Walters,
British Museum *Bronzes*, 84, no. 580; Schu-
macher, Karlsruhe *Bronzen*, pl. 17; and *BCH*
79 [1955] 58, fig. 9). The date may be a
decade or two later: Schefold-Cahn, *Meister-
werke*, 176f., no. 174.

Reinach, *Rép. stat.*, II, 90, no. 2; H. N. Fowler,
Bonner Studien, 176ff.; L. Politis, *ArchEph* 1936,
166, pl. 4; *GBA* 19 (1938) 204, 200, fig. 12;
M. Gjødesen, *ActaA* 15 (1944) 150; D. K. Hill, *AJA*
62 (1958) 194, no. 10 (wrong inv. no.); E. Diehl,
Die Hydria, 215, B 67 (group of the hydria from
Randazzo).

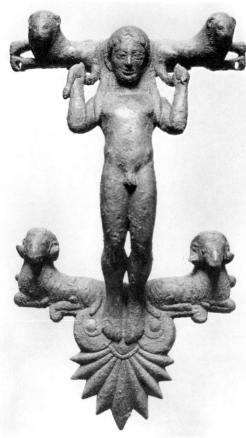

411

411

Handle of a Hydria or Pitcher
Circa 525 to 500 B.C.
H.: 0.206m.
H. L. Pierce Fund 99.460
E. P. Warren Collection.
Bought in Patras; probably from Palaeopolis.

The tail of one lion broken off at the youth's hand. Thick crusty green patina.

The kouros grasps the tails of two lions flanking his head. His feet are placed together on an inverted palmette with a ram on either side.

Politis suggested an Ionic workshop. This and the previous were attached by rivets through or between the forepaws of the lions to the lip of the vase.

E. Robinson, *Ann. Rep.* 1899, 43; *AA* 1900, 217f.

L. Politis, *ArchEph* 1936, 166, 172, fig. 23; Vallet, Villard, *BCH* 79 (1955) 60; D. K. Hill, *AJA* 62 (1958) 194, no. 9; E. Diehl, *Die Hydria*, 215, B 66 (group of the hydria from Randazzo); Rolley, *BCH* 87 (1963) 475.

412

Handle of a Hydria
Circa 540 B.C.
L. (max.): 0.185m.
Frederick Brown Fund 61.380
From Florina in Macedonia.

Details of the body and volute bases are incised. The faces were worn in antiquity. Dark green "Dodona" patina.

From palmette and volute bases two kouroi kneel back to back so that their headdresses join. Their hands are at their sides, palms out along their bodies.

Closest counterparts are a fragmentary handle found on the Acropolis in Athens (De Ridder, Acropolis *Bronzes*, 56f., no. 168, figs. 31-32) and the handles of a hydria from Locri, long in the National Museum at Naples (no. 73144; Lamb, *Greek and Roman Bronzes*, pl. 73). The Acropolis kouroi do not have the small palmettes on either side be-

tween the heads. They do have the same type of headdress and slightly cruder eyes. Although broken at the knees, they appear to have been standing rather than kneeling. Their bodies are moulded from a curved strip of rectangular metal or a bar which serves as backing. The handles of the Naples hydria also rely on metal backing behind the kouroi.

The best stylistic counterparts for this side-handle are the top or back handles of bronze vessels, that of a hydria in the Volos Museum, from Trikkala, providing a slenderer, more delicate, more Ionian parallel in vertical handles (N. M. Verdelis, *ArchEph* [1953-54] Part 1, 189ff.; see also D. K. Hill, *AJA* 62 [1958] 193-201). This side-handle has the solidity of a western mainland product, and it was most likely produced in the workshops which sprang up around Dodona or at a northern Peloponnesian center such as Sikyon.

Vermeule, *CJ* 57 (1962) 146f., fig. 2; *FastiA* 17 (1962) no. 243.

E. Diehl, *Die Hydria*, 26, note 71.

412

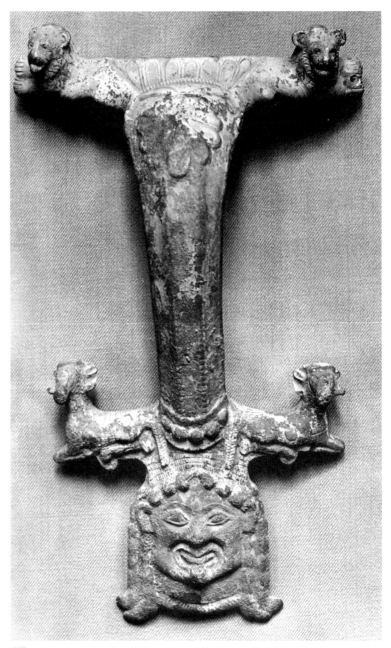

413

413

HANDLE OF A HYDRIA
Sixth Century B.C.
H.: 0.208m.
Purchased by Contribution 01.7474
E. P. Warren Collection.
Bought in Athens.

The lower part is corroded. Pale dull green
patina.

At the top, two lions, leading through in-
cisions and depressed tongue-patterns to an
inverted palmette; at the lower end, two rams
with two tongue fillets and crown of pearls
between. Below, Medusa mask.

E. Robinson, *Ann. Rep.* 1901, 36; *AA* 1925, col.
198f., fig. 11 (1).

Vallet, *Rhégion et Zancle*, 229, note 2; Münzen
und Medaillen, Auktion XXVI, 5 October 1963, 9,
under no. 13 (cites this and the following); E.
Diehl, *Die Hydria*, 214, B 38 (Gorgoneion group).

414

HANDLE OF A HYDRIA
Sixth Century B.C.
H.: 0.204m.
H. L. Pierce Fund 99.462
E. P. Warren Collection.
Bought in Paris.

The green crusty patina has been mostly re-
moved.

As previous, no tongue patterns; rope
fillets above and below.

E. Robinson, *Ann. Rep.* 1899, 43; *AA* 1900, 218;
Chase, *Greek Gods and Heroes*, 49, fig. 47; 1962
edition, 62f., fig. 49.

Neugebauer, *RM* 38-39 (1923-24) 386; *AA* 1925,
col. 198f., fig. 11, r.; L. Politis, *ArchEph* 1936,
161f., fig. 14; *BCH* 79 (1955) 53, fig. 3; Vallet,
Rhégion et Zancle, 230, note 2; Münzen und
Medaillen, Auktion XXII, 13 May 1961, 34, under
no. 59; E. Diehl, *Die Hydria*, 214, B 39 (Gorgo-
neion group); T. G. Karagiorga, *Deltion* 19 (1964)
A, 118, note 16.

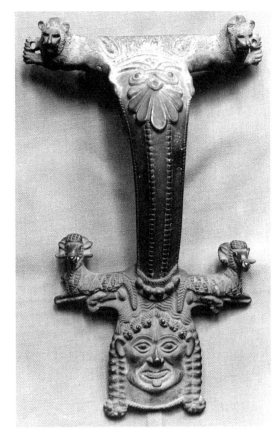

414

415

HANDLES FROM A HYDRIA
Late Sixth Century B.C.
L. (a, b): 0.229m. H. (c): 0.243m.
H. L. Pierce Fund *99.463 a-c*
E. P. Warren Collection.
Probably from Palaeopolis.

Even green patina.

Vertical handle: volutes in relief at top, five pearl-beads beyond holes for attachment left and right, stem with leaves to middle of handle, all terminating at the bottom in open-work design, resembling conventional ivy leaf.

Horizontal handles: terminations at the bases in same kind of ivy leaf.

A similar set of handles is in the Walters Art Gallery, Baltimore (see Helbing Sale, Munich, 28-30 October 1913, lot 565, pl. 23), and the original setting can be visualized from a hydria in the Danish National Museum, found near or at Corinth (*ActaA* 30 [1959] 34ff., fig. 25).

E. Robinson, *Ann. Rep.* 1899, 44; *AA* 1900, 218.

Rolley, *BCH* 87 (1963) 462; E. Diehl, *Die Hydria*, 44f., 222, B 212 (Patras group).

416

HANDLE

Sixth Century B.C.

H.: 0.197m.

H. L. Pierce Fund 99.461

E. P. Warren Collection.

Bought in Corinth; probably from Palaeopolis in Elis.

Light green, smooth patina, with extensive traces of earth all about.

At the top, tongues incised between two couchant lions, back to back; at the bottom, below rope fillets with beads between, an inverted palmette surmounted by spirals.

This is more developed than *Olympia* IV, no. 895, pl. 54; compare also *Fouilles de Delphes* V, 87f., no. 396, fig. 294. A side-handle in the Pernice collection at Greifswald, from Hermione, shows all the same details of the shaft and base (at *both* ends on the side-handle): E. Boehringer, *et. al., Greifswalder Antiken*, 104, no. 458, pl. 57.

E. Robinson, *Ann. Rep. 1899*, 43; *AA* 1900, 218.

E. Diehl, *Die Hydria*, 215, B 51 (Aigion group).

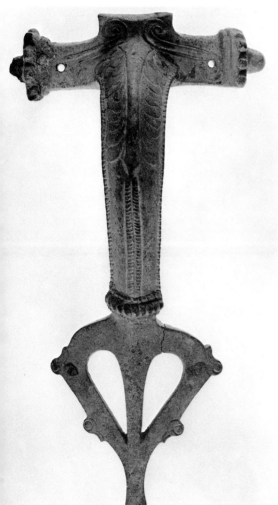

RAM, PROBABLY FROM HANDLE OF A HYDRIA
Sixth Century B.C.
L.: 0.062m.
Gift of Mrs. Edward Jackson Holmes 52.188

Dark green patina.

The legs are folded underneath. The head
is in the round and the body in hollow re-
lief. Details are incised on the body. There is
a hole for attachment on the right side of
the neck, another on the haunch.

This fragment appears to belong to a work-
shop at Capua.

H. Palmer, *Ann. Rep. 1952, 19.*

HANDLE, FROM SIDE OF HYDRIA
Sixth Century B.C.
L.: 0.175m.
H. L. Pierce Fund 99.465
E. P. Warren Collection.
Received from Corinth.

Green patina, mostly removed. Two of the
bronze pins for attachment remain.

In relief, heads of water-birds with long
bills spring from the palmettes at either base.

E. Robinson, *Ann. Rep.* 1899, 44; *AA* 1900, 218.

E. Diehl, *Die Hydria*, 214, B 35 (Sala Consilina
group).

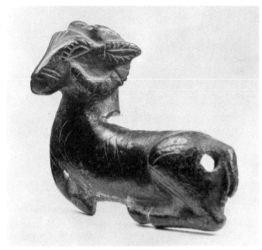

417

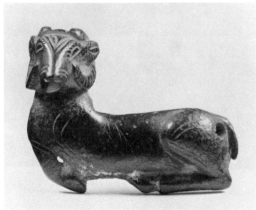

417

418

HANDLE OF A HYDRIA

Circa 450 B.C. or later

H.: 0.21m.

H. L. Pierce Fund 99.467

E. P. Warren Collection.

Bought in Athens; said to come from Elis.

Green crusty patina.

The base takes the form of a Siren with spread wings, feet together on a palmette from which volutes rise to left and right. The handle is fluted, and there is an ovolo pattern at the join to the vase itself.

Compare Hartford, Wadsworth Atheneum, Morgan collection: Reinach, *Rép. stat.*, V, 539, no. 1; Münzen und Medaillen, Auktion XXII, 13 May 1961, 34, no. 59; and D. von Bothmer, *BMMA* 1955, 197, illus., the last a slightly earlier version of the Boston handle.

E. Robinson, *Ann. Rep.* 1899, 45; *AA* 1900, 218.

E. Diehl, *Die Hydria*, 220, 249, B 151, pl. 16, 2.

419

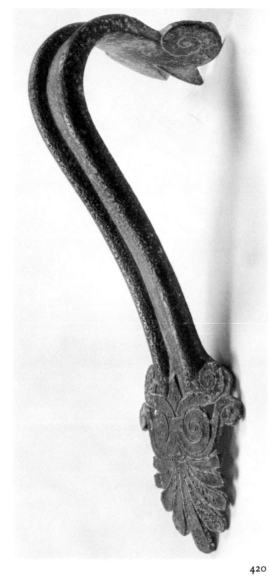

HANDLE AND FOOT OF AN AMPHORA

Circa 510 B.C. East Greek

L. (handle): 0.17m. Max. diam. of foot: 0.135m.

Gift of Herbert Hoffmann 62.1105a, b
Said to have been found at Miletus.

Green patina; cleaned.

At the top, the handle terminates in a double-scroll with dart between; at the bottom, double lyre-form volutes top an inverted palmette. The body has a double, rolled-fillet ridge or moulding. The foot is profiled as follows: fillet, cyma reversa, and rolled fillet.

For the shape, see De Ridder, Louvre *Bronzes*, II, 105, no. 2632, pl. 95; no. 2638, pl. 96, shows the join to the underside of the lip.

For the pattern of the handle, see the anthemion from Thera: *Ergon* 1961, 206ff., fig. 222; for the ornament in bronzes, compare Richter, New York *Bronzes*, 246, no. 710, dated fifth century B.C. and from Cyprus; De Ridder, Acropolis *Bronzes*, 44, no. 125. A later development of the amphora handle is the early fifth-century side handle of a hydria in New York, said to have been found on Aegina: D. von Bothmer, *BMMA* 1955, 196, illus.; see also the side-handles of a late sixth-century hydria in New York from the Chalcidice, where much of the same dryness, almost incised quality of the palmette is preserved: *BMMA* 1955, 195, top illus. The particular form of the palmette and volutes at the bottom of this amphora handle has been classed as Milesian-Rhodian, a grouping that accords well with the provenience: see Jacobsthal, *JdI* 44 (1929) 208ff., figs. 14f.

Vermeule, *Ann. Rep.* 1962, 32; idem, *CJ* 60 (1965) 291f., fig. 4.

420

420

HANDLE OF A LONG-BEAKED JUG
Circa 550 B.C.
L. (max.): 0.14m.
Gift of Mrs. Cornelius C. Vermeule Jr.
62.188
Said to come from Athens Art Market.

Dodona patina (deep, dark green).

Head of a Siren; palmette at base of handle.
Discs either side of her tresses; thumb-rest
on top, behind her head. Places for attach-
ment behind discs.

The bird-like face of the woman puts this
handle at the beginning (that is circa 550 B.C)
of the Archaic, long-beaked bronze jugs
and/or handles assembled by D. K. Hill (*AJA*
66 [1962] 57ff.), a total of seventeen. The
second example in the list is Athens, Cara-
panos no. 194b, from Dodona, and the third
is also in Boston; the following.

For general form, compare the example in
Jannina, from Metsovo; here the whole jug is
preserved, a squat globular affair (N. M.
Verdelis, *BCH* 73 [1949] 19f., fig. 1).

Vermeule, *Ann. Rep.* 1962, 32; MFA, *Calendar of
Events*, June 1962, 3; *FastiA* 17 (1962) no. 242;
Vermeule, *CJ* 60 (1965) 290f., fig. 3.

421

421

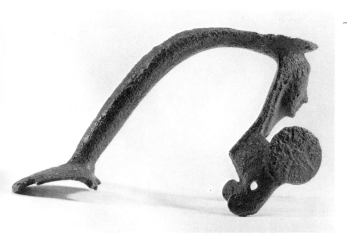

HANDLE OF A BEAKED OINOCHOE ("SCHNABELKANNE")

Circa 525 B.C.

H.: 0.10m.

Classical Department Special Fund 60.233
Gerd Rosen, Auktion XXXI, Berlin, 24-29
Nov. 1958, 236f., no. 1929, illus.

Electrolytically cleaned; uneven, pitted brown surface.

Rising from a base in the general shape of a palmette, a simple, curved handle, with thumb-rest on top. Below, head of a Siren with long tresses, flanked by discs incised with rosettes. Places for attachment behind discs.

Bielefeld termed this handle Laconian work (cf. Langlotz, *Frühgriechische Bildhauerschulen*, 86ff.) and compared it with the slightly later female figure on the lid of the Vix krater (R. Joffroy, *Le trésor de Vix*, 16ff.; *MonPiot* 48 [1954] pls. 16ff.). On the Laconian qualities of the krater: A. Rumpf, *B Ant Beschav* 29 (1954) 8ff., versus Vallet, Villard, *BCH* 79 (1955) 50ff., 73ff., who sought the origins of the work in Greek Southern Italy. Compare also the jug from a tomb near Tsotylion in Macedonia (P. Lemerle, *BCH* 59 [1935] 281f., fig. 37).

Vermeule, *CJ* 56 (1960) 2ff., fig. 3 and further refs.

E. Bielefeld, *Wissenschaftl. Zeitschrift . . . Greifswald*, 4-5 (1955-56) 254, no. 8, pl. 6, figs. 16-18; *FastiA* 15 (1960) no. 665; D. K. Hill, *AJA* 66 (1962) 57f., pl. 15, fig. 1; R. Blatter, *AA* 1966, 49, note 10.

422

423

422 OINOCHOE

Circa 450 B.C.

H. (to top of handle): 0.28m. DIAM.: 0.14m.

H. L. Pierce Fund 99.481
E. P. Warren Collection.

Found at Spongano, near Vaste, South Italy, together with oinochoe (no. 436) and volute krater (no. 441).

423

Bright green and crusty patina over part of the vase.

The lower end of the handle merges into the forepart of a winged Siren who stands on a palmette flanked by volutes. On the handle, a stem leading to a waterleaf at the top, and at the front of the handle, facing the mouth, half-figure bust of a woman in a chiton. Discs at terminations of the handle. The body has tongues in relief above a light ogee moulding within a fillet.

The workshop of this oinochoe, characterized by its charming handle, has been located variously as South Italian, perhaps Tarentine (Neugebauer), or Corinthian (Payne). D. M. Robinson related this to an oinochoe from the Argolid in the Louvre (De Ridder, Louvre *Bronzes*, II, 114f., no. 2756, pl. 99; Neugebauer, *loc cit.*, 346, fig. 1).

There is a modern silver replica of this vase in the Walters Art Gallery, Baltimore.

E. Robinson, *Ann. Rep.* 1899, 39; *AA* 1900, 217; *AJA* 4 (1900) 511; MFA *Handbook*, 1907, 75; *ibid.*, 1911, 84; *ibid.*, 1937, 40.

Neugebauer, *RM* 38-39 (1923-24) 346f., fig. 2; Lamb, *Greek and Roman Bronzes*, 163; Payne, *Necrocorinthia*, 215f., note 1, pl. 45, 5; D. M. Robinson, *AJA* 46 (1942) 185, figs. 19-21.

Exhibited: Cambridge (Mass.), Fogg Art Museum, *Greek Art and Life*, no. 14.

424

HANDLE OF HYDRIA

Circa 450 B.C.

H.: 0.26m.

H. L. Pierce Fund 99.469

E. P. Warren Collection.

Bought at Corinth; said to come from Palaeopolis (Kleitor in Arcadia).

The patina varies from pale green to blue-green.

At the top, facing the front of the vase: upper half of a woman in a Doric chiton. Her arms seem to terminate in the two discs at the widest part. Palmette and volutes in relief on the base.

Compare Richter, *Antike Plastik*, (Ame-

423

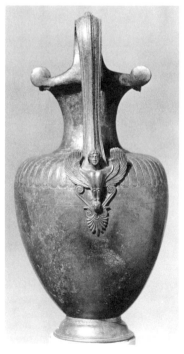

423

lung) 183ff.; D. von Bothmer, *BMMA* 1955, 195, bottom illus., dated circa 460 B.C. and inscribed as a prize from one of the contests at the Argive Heraeum. Robinson related the handle to that of a hydria from Aigion, in Achaia, now in his collection at the Fogg Museum (*Ancient Art in American Private Collections*, 31, no. 216, pl. 66). F. Eckstein (*Gnomon* 31 [1959] 646) suggests a date of about 430 for the Robinson example.

E. Robinson, *Ann. Rep.* 1899, 45f.; *AA* 1900, 218.

D. M. Robinson, *AJA* 46 (1942) 182, 184f., figs. 16-18; Charbonneaux, *Les bronzes grecs*, 45; idem, *Greek Bronzes*, 63f.; E. Diehl, *Die Hydria*, 216, B 80 (the Argive prize-hydria group); F. Johansen, *Meddelelser fra Ny Carlsberg Glyptotek* 26 (1969) 60-61, fig. 6.

425

HANDLE OF A SMALL JUG, PROBABLY WITH A LONG SPOUT
Late Fifth Century B.C.
H. (max.): 0.102m.
William E. Nickerson Fund, No. 2 64.303
From Athens.

Green patina.

On the front of the handle, head of a woman; on the discs at the side, Gorgo heads; at the base, a Siren on a palmette and volutes. Rivet holes at either end mark the places of attachment to the vessel itself. The faces of the woman and the Siren are slightly crude, possibly because of the small scale of the handle, but the Gorgo heads are very elegant, paralleling the designs found in gilded terracottas of the late fifth and fourth centuries B.C.

The ornament and form of this handle make it a kind of survival in miniature of the long-spouted jug handles in the Archaic period or a parallel to the classic hydria handles of the early fifth century. Most late fifth or fourth-century handles of this type are of less complex design and refined workmanship, for they were, after all, made to be attached to small, rather utilitarian jugs (compare Richter, New York, Metropolitan Mu-

424

425

426

seum, *Handbook,* 209, pl. 49c; more generally, the handle of the trefoil oinochoe from Granada: A. García y Bellido, *Los Hallazgos griegos de España,* 24f., no. 2, pl. 2).

Several similar handles in the Karapanos Room of the National Museum in Athens come from Dodona. No. 447 has rosettes on the discs at the sides, and a lionskin in foreshortened, frontal view on the reverse, being thus presented as on the coins of the dynast Mithrapata of Lycia, about 370 B.C. Nos. 689 (the long-spouted, squat jug survives) and 338 have female heads with puffy cheeks on the discs and at the base. No. 16521, from the later excavations at Dodona, has very simple rosettes above and a plain (although broken) plate at the base. Finally no. 16170 (in the upstairs galleries) balances heads of the young Dionysos (as on coins of Thasos) on the discs above, and the mask of a Silenus on the plate attached to the body.

Vermeule, *Ann. Rep. 1964,* 33; idem, *CJ* 61 (1966) 299, 294, fig. 10.

426

TWO HANDLES, PROBABLY FROM AN AMPHORA
Fourth Century B.C.
H.: 0.152m.
H. L. Pierce Fund 99.471a & b
E. P. Warren Collection.
Bought in Athens; said to come from Macedonia.

Light green patina. The eyes were inlaid with silver.

The rings in the top are for attachment of a swinging handle; on the bar are double palmettes with lyre-form volutes between, bordered by a pair of snakes. At the bottom are classicizing heads of Medusa with ample locks and knotted snakes above. D. von Bothmer *(loc. cit.)* discusses and illustrates the best, complete bronze amphora of the type from which these handles come. The New York amphora is late archaic, roughly about 500 B.C.

A clay amphora in Cassel (no. T427) also shows handles such as these in their original positions and with the swinging bail preserved between the upper loops.

E. Robinson, *Ann. Rep.* 1899, 46; *AA* 1900, 218.

D. von Bothmer, *BMMA* 1961, 141ff., fig. 13.

427

PARTS OF HYDRIA: TWO SIDE HANDLES
AND FOOT
Greek, Fourth Century B.C.
BASE, DIAM.: 0.151m. HANDLES, L.: 0.093m.
DISCS, DIAM.: 0.057m.
H. L. Pierce Fund 99.472a-f
E. P. Warren Collection.
Bought in Smyrna.

One disc at the base of one handle is missing and restored in wood. Thick, medium green patina.

The base is decorated with an elaborate Lesbian pointed leaf pattern. The handles are fluted and flaring at the ends, and the discs by which the handles were joined to the vase are enriched with waterleaf patterns.

E. Robinson, *Ann. Rep.* 1899, 46f.; *AA* 1900, 218.

E. Diehl, *Die Hydria*, 218, B 131 (as 99.772), also 218, B 129 (as 99.742).

427

427

SITULA WITH DOUBLE HANDLES
Fourth Century B.C. (350 to 300)
H.: 0.268m. DIAM.: 0.253m.
Francis Bartlett Collection 03.1001
E. P. Warren Collection.
From South Italy; bought in Naples.

The bottom and half the body of the pail are missing. Scene B is fragmentary. Dark to medium green patina, with corrosion.

Frieze of repoussé designs between beading, wreath and thin fillet above, rosettes below.

A.: Young Dionysos caresses a panther at the left. Behind comes a satyr with a kantharos. At the right, a dancing maenad.

B.: Seated woman (Ariadne?). To the right were a panther and a maenad. At the left, a dancing satyr. The two bails (handles) are hooked into a double, palmette ring over the center of each side; these handles lie flat along the rim.

The general style, whether South Italian or Greek, and the subject are now paralleled by the large bronze krater, with Dionysos and Ariadne in repoussé amid satyrs and maenads (and freestanding Dionysiac figures on the rim), from Derveni Langadá near Salonika, also work of 350 to 300 B.C.: Vanderpool, *AJA* 66 (1962) 389f., pls. 107f.

B. H. Hill, *Ann. Rep.* 1903, 61; *AA* 1904, 194; *AJA* 8 (1904) 382f.; *BMFA* 2 (1904) 15; Chase, *Antiquities*, 100f., fig. 115; 2nd edition, 141, 152, fig. 132.

Pernice, *JdI* 35 (1920) 91ff., fig. 6; *idem, Hellenistische Kunst in Pompeji*, IV, 26, pl. 5; Rumpf, *RM* 38-39 (1923-24) 473f., fig. 19; Neugebauer, *Gnomon* 2 (1926), 472; *idem, Bilderhefte zur Kunst-und Kulturgeschichte*, II, pl. 22, 2; Lamb, *Greek and Roman Bronzes*, 175, 187f.; Wuilleumier, *Le Trésor de Tarente*, 127, pl. 16, 1; *idem, Tarente*, 332, pl. 18, 3; Jantzen, *Bronzewerkstätten*, 46; *Olynthus* X, 30; Hill, *Hesperia* 12 (1943) 97ff., figs. 1-2; G. Bruns, *Berliner Museens* NF 3 (1953) 40; Charbonneaux, *Les bronzes grecs*, 50; *idem, Greek Bronzes*, 68; Züchner, 98 *BWPr*, 19, 26, 30 note 44; H. Küthmann, *Jahrbuch des Römisch-Germanischen Zentralmuseums Mainz* 5 (1958) 132; P. J. Riis, *ActaA* 30 (1959) 12f., 20, no. 19; J. Schäfer, *Hellenistische*

428

Keramik aus Pergamon (Pergamenische Forschungen 2, Berlin, 1968) 73, note 52.

 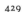

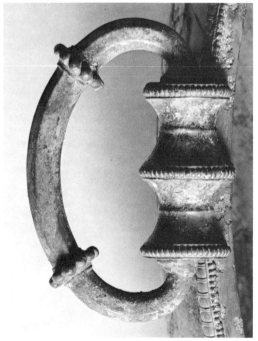

429

Louter with Figured Handles
Fifth Century B.C.
H.: 0.28m. H. (without handles): 0.195m.
DIAM.: 0.72m.
Francis Bartlett Collection 03.999
E. P. Warren Collection.
From South Italy (the Picene region).

Numerous fragments of the bowl are missing.
The rim is broken in several places and has
been strengthened in modern times by a
narrow strip of metal on the interior, fastened
by rivets. The body is also reinforced by
sheets of metal in the interior. All four han-
dles have been refastened in modern times.
Caskey (Pernice, *op. cit.*, 36, note 19) gives
detailed reasons that the handles belong.
Crusty green patina with hard surfaces and
in various shades.

Basin with plain, slightly flaring foot.
Bead and ovolo moulding on rim. Two swing-
ing handles with palmettes below, and two
handles formed by pairs of wrestlers, stand-
ing on volutes, floral stems and leaves lead-
ing to palmettes.

The wrestling youths have late archaic
faces and hair arranged like that of kouroi in
the late sixth century. Allowing for a
chronological lag in the decorative arts, this
vessel ought to have been made about
475 B.C.

429

The figures similarly posed on the shoulder of a brazier from Pompeii (Pernice, 33, fig. 44) are late Hellenistic imitations of wrestlers similar to those of the louter.

For the bobbins of the oval, ringed side-handles, Robinson cited De Ridder, Acropolis *Bronzes*, nos. 456f.

B. H. Hill, *Ann. Rep.* 1903, 61; *AA* 1904, 194; *AJA* 8 (1904) 382; *BMFA* 2 (1904) 15.

Reinach, *Rép. stat.*, IV, 318, 2 (near pair of wrestlers only); Pernice, *Hellenistische Kunst in Pompeji*, IV, 36, pl. 9; Neugebauer, *Bilderhefte zur Kunst-und Kulturgeschichte*, 8, pl. 19, 1; *AA* 1925, col. 199; *AA* 1937, col. 504; Milne, *BMMA* 1939, 24; *idem*, *AJA* 48 (1944) 34, 45f.

cut-out contours. There are remains of iron pins in the bases.

It must have come from a giant basin, the contemporary counterpart of the great Laconian or Tarentine krater discovered a decade ago in a Gallic royal tomb at Vix, southeast of Paris.

For a different handle, somewhat smaller, compare the example from the Athenian Acropolis, with rosettes at the out-turned ends and Gorgon-heads at the bases: De Ridder, Acropolis *Bronzes*, 67f., no. 206, fig. 40. Such attachments adorned Greek footbaths: see M. J. Milne, *AJA* 48 (1944) 26ff., especially figs. 1, 2, and 4.

Vermeule, *Ann. Rep.* 1966, 54.

430

HANDLE, OF A BASIN
Circa 525 to 450 B.C.
W. (max.): 0.21m. THICKNESS (max.): 0.095m.
Edwin E. Jack Fund 66.10
Bought in Boston; said to come from Crete.

Green patina with small pitting.

The curved handle with chamfered loop ends in flat bases of petal shape and is divided in the middle of the ridged curve by a lotus knot. The bases are flat on top, as if the handle were placed at or under a rim, and have incised petals or ovolos following their

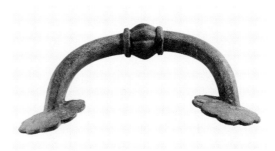

430

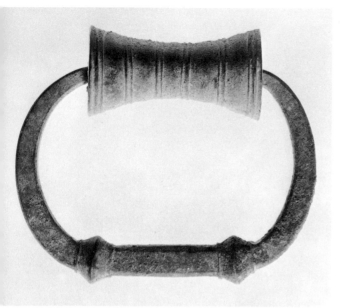

431

HANDLE OF A BOWL OR BASIN
Fifth Century B.C.
L.: 0.095m.
Gift of B. W. Crowninshield 81.196
From Athens.

Fine light green patina with brown areas and encrustation. Remains of earth.

Horizontal hanging ring, with flat band having bevelled edges. The handle swings from an hour-glass shaped attachment enriched by six double fillets in relief.

See under the following; E. Boehringer, *et al., Greifswalder Antiken*, 103f., no. 455, pl. 57; and *Olympia* IV, pl. 50, no. 843. The louter or basin just discussed shows two of these handles in situ, admittedly in a complex and unusual setting.

431

432

HANDLE OF A BOWL OR BASIN
Fifth Century B.C.
L.: 0.108m.
Gift of B. W. Crowninshield 81.197
From Athens.

Fine green encrustation, with brown areas and remains of earth.

Elliptical hanging ring of a horizontal handle, octagonal in section and with a central band. It swings from an hour-glass (double-spool) attachment.

Compare Richter, New York *Bronzes*, 243f., no. 696 (from Cyprus); *Fouilles de Delphes* V, 78, no. 340, fig. 270; and the late sixth century bronze "kothon" found at Knossos: Boardman, *BSA* 57 (1962) 28ff., pl. 2. A bronze bowl of circa 700 B.C. found at Gordion takes the design of these handles back into Phrygian art and thence, undoubtedly, to the metalwork of Urartu: E. Akurgal, *Die Kunst Anatoliens von Homer bis Alexander*, 101, pl. 3 a.

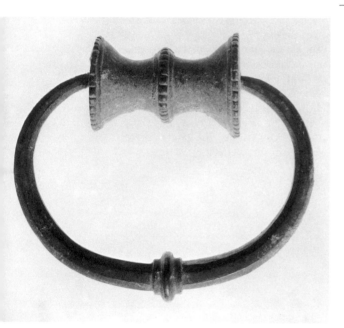

432

LION, FROM A VESSEL OR BOX (?)
Circa 525 to 500 B.C.
H. (max.): 0.058m. L. (max.): 0.097m.
Edwin E. Jack Fund 66.9
From Asia Minor via New York Art Market.
Another source states from Cerveteri via
Rome Art Market.

Green patina with reddish brown encrusta-
tion and pitting. The left ear is damaged.
Ancient pin for mounting in bottom center;
interior at rear filled with lead.

He is recumbent, with ears back and tail
curled up toward the left top of his rump.
Whiskers and ruff are modelled and incised;
the mane is incised with curving strokes like
parentheses. He seems to be partly hollow
cast with some lead filling and an iron pin
through his back, suggesting he sat on the
rim or handle-plate of a vessel, or on the lid
of a box.

He is recumbent, with ears back and tail

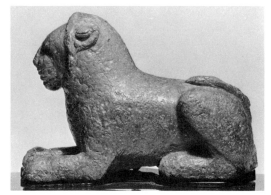

433

His counterpart in monumental stone ex-
ists at several sites along the Ionian coast of
western Asia Minor, chiefly in one or two
lions in the museum at Manisa (Magnesia ad
Sipylum) from the Hermos valley, or the
region from Larisa through Sardis to Phila-
delphia in Lydia. The slightly oriental cast to
his face, recalling in a measure Mesopota-
mian or Egyptian lions of the centuries from
650 to 450 B.C., also indicates an eastern
atelier for this bronze. A strong sense of clas-
sical plasticity and natural detail amid the
stylization points to a workshop at one of
the Ionian Greek cities from Sardis to
Miletus. Since the city near the shrine of
Hera on Samos was an archaic Greek center
of fine metalworking, it may be that this lion
was exported to the mainland from a Samian
studio. The lion was a badge of the early
coins of Samos, but he was equally at home
in the heraldic art of Miletus or Sardis or
even Halicarnassus in Caria. At this last city
the marble lion now set in the wall of the
English Tower of the Castle of St. Peter offers
another striking comparison on a monu-

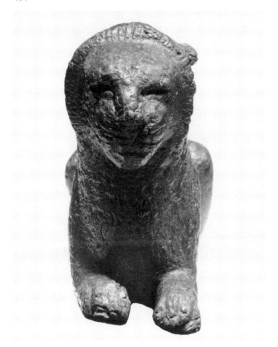

433

mental scale. See generally H. Gabelmann,
Studien zum frühgriechischen Löwenbild
(Berlin, 1965) pls. 9, 20ff.

A pair of similar although patently cruder
bronze lions was found in the excavations

of the temenos of Hera Limenia at Perachora on the Greek mainland opposite Corinth. They adorned the shoulder of a dinos and were undoubtedly cast in Greece's leading early center of commerce in imitation of a model or idea shipped from the East (H. Payne, *Perachora*, 136f., pl. 43, 8 and 9; see also W. L. Brown, *The Etruscan Lion*, 90ff., especially pl. 37a, for a discussion of the Etruscan derivations of East Greek couchant bronze lions; and D. K. Hill, Walters *Bronzes*, 117, no. 267, pl. 52, said to be Egyptian but certainly East Greek of the Archaic period; Miss Hill's parallels are mainly from mainland Greece or Olympia).

Vermeule, *Ann. Rep. 1966*, 54; *idem, CJ 62* (1966) 103f., fig. 11.

Exhibited: Cambridge (Mass.), Fogg Art Museum, *Master Bronzes*, no. 60.

433A

RECLINING LION
Fourth Century B.C. or later
L. (max.): 0.065m.
Gift of Richard R. Wagner 67.1035
From Istanbul.

Green patina.

This lion appears to have formed the attachment to the top of a vessel, for there are holes through his paws and (horizontally) through his tail. The fleecy circles of his mane, as well as his jutting face, characterize him as work of the post-Archaic period. Lions in this schema have a long tradition from

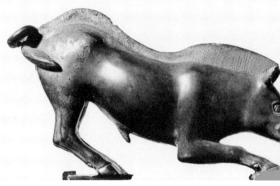

434

early iron age times onwards in the Near East and in Archaic or later Greek art.

Compare, especially, H. Gabelmann, *Studien zum frühgriechischen Löwenbild* (Berlin, 1965) 117, pl. 10, no. 4 and various others, especially from Asia Minor; also W. L. Brown, *The Etruscan Lion*, 15, pl. 61f., an eighth-century, Assyrian bronze weight from Khorsabad, that shows the Mesopotamian sources of later, Anatolian lions. This piece, because of its flatness, has a strangely post-classical look. It has been suggested that this lion was made in the Middle Ages, perhaps in the sixth or seventh centuries A.D., but the strong aspects of pre-classicism in face, body, and details indicate a much earlier date, an Anatolian provincial work in the East Greek style.

Vermeule, *Ann. Rep. 1967*, 47.

434

BOAR, FROM THE RIM OR SHOULDER OF A LARGE, CIRCULAR VESSEL (LEBES?)
Circa 480 B.C.
L. (max.): 0.162m.
James Fund and Special Contribution 10.162
E. P. Warren Collection.
Bought in Rome, from the marshes of Ancona (Sirolo, according to John Marshall).

The curved band broken away between front and hind feet. Fine, hard green patina.

On a thin, narrow, slightly curved band, a

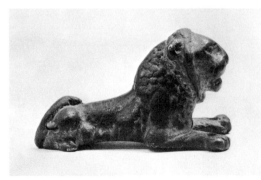

433A

boar at bay. The bristles are indicated by
fine incised lines.

L. D. Caskey, *Ann. Rep.* 1910, 60; S. N. Deane,
BMFA 8 (1910) 49f., illus.; *AA* 1911, col. 474;
AJA 15 (1911) 114, fig. 6; Barnard, *The Contem-
porary Mouse*, 40f., illus.; *Handbook* 1964, 60f.,
illus.; Burdett, Goddard, *E. P. Warren*, 240, illus.

Reinach, *Rép. stat.*, IV, 501, 3; *Festschrift für
James Loeb*, 87f., fig. 7; Richter, *Animals*, 67, fig.
109, pl. 36; Neugebauer, Berlin *Bronzes*, I, 81;
II, 58; Payne, *Necrocorinthia*, 352; idem, *Pera-
chora*, 104; Jantzen, *Bronzewerkstätten*, 27, no.
26; Blümel, *Tierplastik*, pl. 61, no. 59; Hill,
Walters *Bronzes*, 120, under no. 275; Münzen und
Medaillen, Auktion XVIII, November 1958, 10,
no. 18 (compared with a Gallo-Roman boar);
D. von Bothmer, *Archaeology* 20 (1967) 221;
H. Jucker, *AA* 1967, 628f., fig. 18c.

Exhibited: London, Burlington Fine Arts Club,
Ancient Greek Art, 1904, 53, no. 63, pl. 58;
Buffalo, *Master Bronzes*, no. 83, illus.

435

LION, PAIR WITH PREVIOUS
Circa 480 B.C.
L. (max.): 0.161m.
James Fund and Special Contribution 10.163
E. P. Warren Collection.
Bought in Rome (with No. 434 above).

As previous. Upper part of tail, which curved
upward in a loop, missing. On a similar rim, a
lion preparing to spring. The tufts of mane
are decorated with fine incised lines.

The much restored dinos from Amandola
in the Ancona Museum shows a comparable
lion and a bull in position on the shoulder
of the vessel (C. Albizzati, *Dedalo* 1 [1920]
153-161, pl., 157; H. Jucker, *AA* 1967, 628f.,
fig. 17f.). On the vessel from which comes
the pair of animals in Boston, the boar was on
the left and the lion on the right, in the
same position that he is shown on the
Amandola dinos.

L. D. Caskey, *Ann. Rep.* 1910, 60; Deane, *BMFA*
8 (1910) 49f., illus.; *AA* 1911, col. 474; *AJA* 15
(1911) 114; Burdett, Goddard, *E. P. Warren*, 240,
illus.; Barnard, *The Contemporary Mouse*, 40f.,
illus.

Reinach, *Rép. stat.*, IV, 462, 3; *Festschrift für
James Loeb*, 87f., fig. 8; Richter, *Animals*, 49,
pl. 4, fig. 12; Payne, *Necrocorinthia*, 352; idem,
Perachora, 104; Neugebauer, Berlin *Bronzes*, I, 81;
Jacobsthal, *AM* 57 (1932) 6f., pl. 2, 2 (plate pur-
posely reversed; as from the shoulder of a lebes);
Jantzen, *Bronzewerkstätten*, 27, no. 26; Blümel,
Tierplastik, pl. 61, no. 58; J. Roger, *BCH* 63 (1939)
18f., note 1; W. L. Brown, *The Etruscan Lion*,
144, pl. 52, b; D. von Bothmer, *Ancient Art from
New York Private Collections*, 37, under no. 141;
idem, *Archaeology* 20 (1967) 221; P. Amandry,
AM 77 (1962) 50f., note 100; H. Jucker, *AA*
1967, 628f., fig. 18d.

Exhibited: London, Burlington Fine Arts Club,
Ancient Greek Art, 1904, 53f., no. 65, pl. 58.

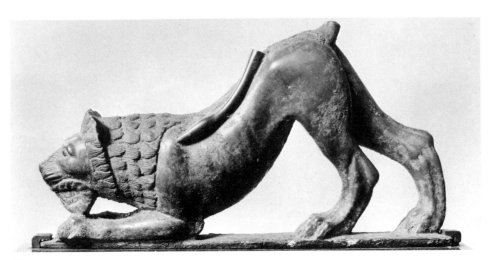

435

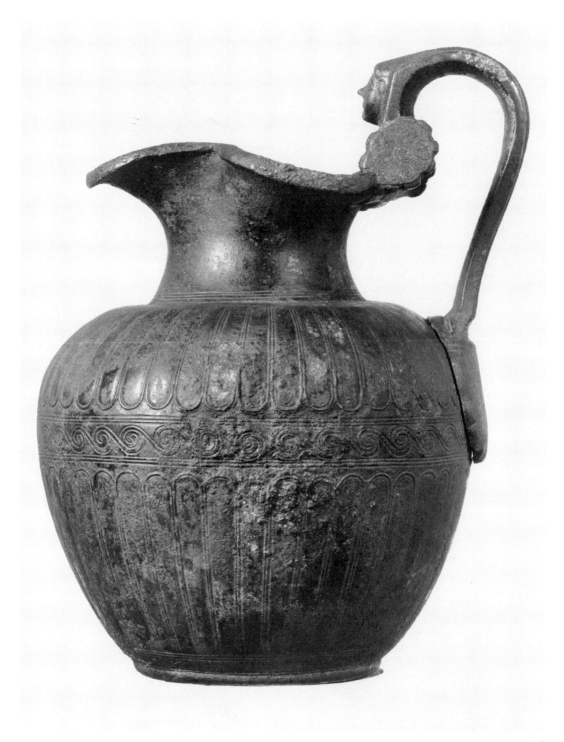

436

OINOCHOE

Early Fifth Century B.C.

H.: 0.215m. DIAM.: 0.152m.

H. L. Pierce Fund 99.479

E. P. Warren Collection.

Found at Spongano, near Vaste, South Italy, together with oinochoe (no. 423) and volute krater (no. 441).

Green and crusty patina. The handle is joined to the vase at the top by three large rivets on the inside of the lip; the heads of these rivets resemble buttons.

On the front of the handle, above the mouth, an archaic female head in high relief, with four parallel tresses at each side. Petaled circles form the ends of the handle on the left and right; these are enriched with rosettes in low relief. The base of the handle takes the form of a large, incised rosette (in palmette form). The body is enriched with long tongues and wave moulding in fillets between.

E. Robinson, *Ann. Rep.* 1899, 38; *AA* 1900, 217; *AJA* 4 (1900) 511; J. Addison, *The Boston Museum of Fine Arts*, 297.

Neugebauer, *RM* 38-39 (1923-4) 360, no. 14.

437

OINOCHOE

Fifth Century B.C., circa 480 B.C.

H.: 0.29m.

Perkins Collection 96.708

E. P. Warren Collection; Tyszkiewicz Collection.

From the Italian Adriatic coast.

Even, dark green, glossy patina.

Around the middle, a palmette band is set between fillets and beads; above and below, an enlarged ovolo is alternately inverted. Waterleaf motifs form a broad, raised fillet at the base. Beading sets off the bottom edge of a slightly flaring foot. In relief on the lower attachment of the handle a flying Nike of archaic type is running to the left in half-

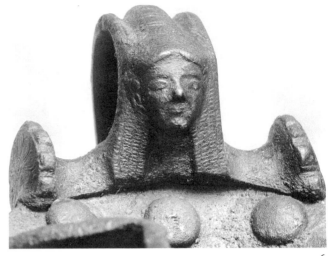

436

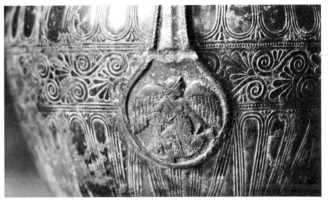

437

kneeling pose and looking to the right.

Compare van Buren, *AJA* 60 (1956) 393, pl. 129, fig. 10, an oinochoe from Padula; also Bielefeld, *Wissenschaftl. Zeitschrift . . . Greifswald* 4-5 (1955-56) 254, no. 9, pl. 7, fig. 19: "South Italian, circa 450 to 425 B.C." An oinochoe with lower handle and analogous body has been termed Campanian (?), circa 450 B.C.; it is in the archaeological collection of Winterthur: Schefold-Cahn, *Meisterwerke*, 253f., no. 322; Bloesch, *Antike Kunst in der Schweiz*, 72f., pl. 40.

E. Robinson, *Ann. Rep.* 1896, 30; *AA* 1897, 73.

Froehner, *Collection Tyszkiewicz*, pl. 14; D. K. Hill, *The Muses at Work*, ed. by C. Roebuck (Cambridge, Mass., 1969) 86, 89, fig. 13.

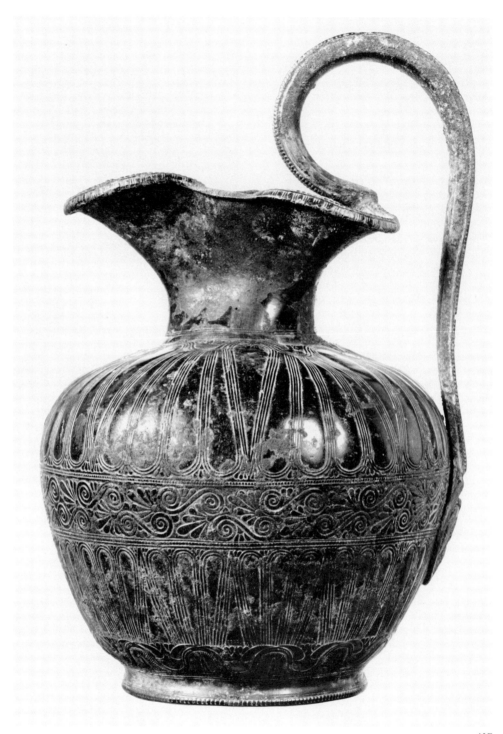

437

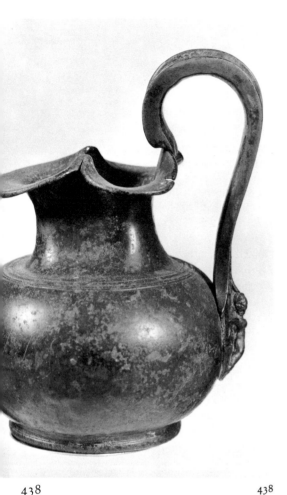

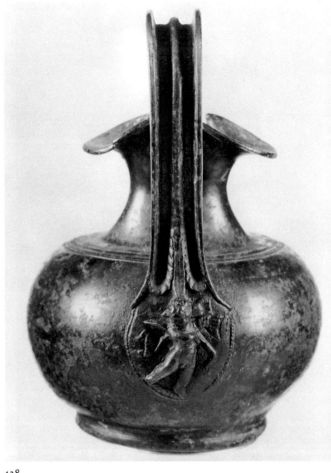

438 438 438

438

OINOCHOE
Hellenistic
H.: 0.169m.
Purchased by Contribution 01.7485
E. P. Warren Collection.
Bought in Rome.

Somewhat corroded; dark green patina.

Leaves mark the lower junction of the high handle and the body; below these leaves a fat, winged Eros dances to the right, with a torch downward in his right hand. Quadruple, moulded fillet is set at junction of the neck and shoulders.

E. Robinson, *Ann. Rep.* 1901, 36.

439

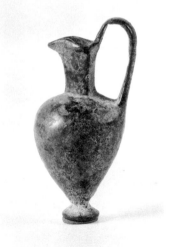

440

439

HANDLE OF AN OINOCHOE
Fifth or Fourth Centuries B.C.
L.: 0.095m.
Purchased by Subscription 72.385
General di Cesnola Collection.
From Cyprus.

Green, crusty patina.
　This consists of a square section with chamfered corners, flattened to an elliptical disc at each end. It joined at the end of the top and beneath the bottom.

440

OINOCHOE (SOLID, PERHAPS A WEIGHT)
Hellenistic Period
H.: 0.058m.
Gift of E. P. Warren 96.668
Bought in Rome.

Hard smooth green patina.
　The high handle is undecorated.
　There are other similar oinochoai, used as votives, toys or weights (?): compare Kern, *Oud Med* 36 (1955) 6, fig. 2; De Ridder, Acropolis *Bronzes*, 54f., nos. 162-164.

E. Robinson, *Ann. Rep.* 1896, 31; *AA* 1897, 73.
Olynthus X, 188, note 12.

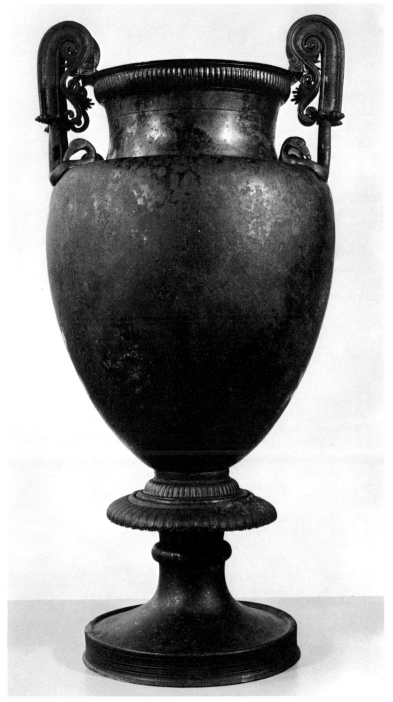

441

VOLUTE KRATER

Fourth Century B.C.

H. (including handles): 0.873m. H. (to rim):
0.807m. DIAM. (mouth): 0.303m.

H. L. Pierce Fund 99.483

E. P. Warren Collection; Mgr. Bacile, Bishop
of Leuca.

Found at Spongano, near Vaste, South Italy,
together with two oinochoai (nos. 423, 436).

Krater united to stand by corrosion. Parts of
the sides of the krater are missing. Crusty
patina in several shades of green.

The handles terminate at the base in pairs
of duck's heads. A double palmette appears
on the outsides of the handles, between the
volutes. Other details are as visible in the
photograph.

The best comparable pieces are in Naples
from Herculaneum and Pompeii (Pernice,
Hellenistische Kunst in Pompeji, IV, 9, fig. 9;
Lamb, *Greek and Roman Bronzes*, 212, pl.
82a; especially Naples, no. 73143 = Chiu-
razzi, no. 272). Another is in the Louvre:
De Ridder, Louvre *Bronzes*, II, 105, no. 2634,
pl. 95. The pair of handles in New York
(Richter, *loc. cit.*) has been dated in the fifth
century B.C.; the interior detail of the volutes
is somewhat more finished, with ridged
spirals. Such handles, even the more detailed
kind, and vases occur in terracotta, as the
example in Karlsruhe: *AA* 1928, col. 213f.,
figs. 7f., from Canosa.

All these vases, in bronze or terracotta, de-
scend from kraters comparable to the fifth-
century Ponsonby volute-krater said to come
from Rua in Campania (Burlington Exhibi-
tion, 1903, *Ancient Greek Art*, 1904, 32,
no. 51, pl. 36) and now in Munich (Lamb,
Greek and Roman Bronzes, 135, pl. 47a, dated
late sixth-century).

E. Robinson, *Ann Rep.* 1899, 40f.; *AA* 1900, 217;
AJA 4 (1900) 511; Vermeule, *AJA* 68 (1964)
328, pl. 100, fig. 11.

AA 1898, 52, illus.; Richter, New York *Bronzes*,
60, under nos. 91, 92.

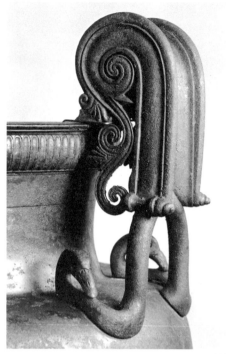

441

443

442

Two Handles from a Volute Krater
Fourth Century B.C.
H.: 0.141m.
H. L. Pierce Fund 99.470a, b
E. P. Warren Collection.
Acquired in Rome.

Green and crusty patina.

The attachment at the shoulder takes the form of swans' necks and heads. The outside surfaces have pedum-shaped volutes made up of a series of beads. One handle (a) has one V-shaped nick at the bottom of the volute; the other (b) has two. There are snail's tail knobs to the left and right.

E. Robinson, *Ann. Rep.* 1899, 46; *AA* 1900, 218.

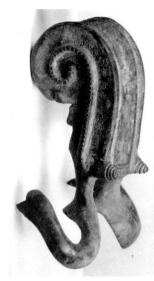

442 442

443

Olpe
Fifth Century B.C.
H.: 0.094m.
H. L. Pierce Fund 99.482
E. P. Warren Collection.

The lower part of the satyr's beard is missing. Dark olive color. The patina has been removed.

The handle is decorated with palmettes and scrolls, below which is the mask of a bearded satyr.

The work is of exceptional quality, with the mask having a modern (almost Hellenistic) look in terms of the fifth century B.C. Riis has attributed this olpe tentatively to Capua. Froehner had classed it as Etruscan.

E. Robinson, *Ann. Rep.* 1899, 39f.; *AA* 1900, 217; *AJA* 4 (1900) 511.

H. Hoffmann Sale, Paris, 15-19 May 1899, *Cat.*, 117, no. 503; P. J. Riis, *ActaA* 30 (1959) 44.

443

444

444

445

444

Olpe
Hellenistic Period
H.: 0.21m.
H. L. Pierce Fund 99.485
E. P. Warren Collection.
From Rome.

The bottom of the jug has been taken from some other object. Green and crusty patina.

The handle has a small palmette and terminates in the heads of two butting goats in flat relief. The rim is decorated with a bead and ovolo pattern.

Compare, for older work (mid-fifth century), Neugebauer, *Antiken in Deutschem Privatbesitz*, 22, no. 60, pl. 28, from Sicily. The later (Hellenistic) date for the Boston handle is suggested by the less schematic, more plastic and natural rendering of the animals' heads.

E. Robinson, *Ann. Rep.* 1899, 41; *AA* 1900, 217; *AJA* 4 (1900) 511.
Saulini Sale, Rome, 1899, *Cat.*, no. 210.

445

Olpe, Without Handle
Hellenistic Period
H.: 0.175m.
Gift of Francis B. Sayre 47.1110

Green and blue patina, encrusted.

Lip, body and foot are undecorated. Form and profile are elegant in a simple way.

G. H. Chase, *Ann. Rep.* 1947, 29; *BMFA* 46 (1948) 25.

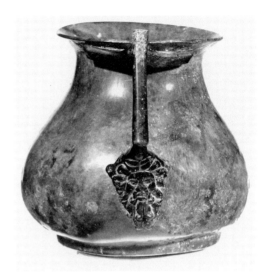

446

PITCHER

Fourth Century to Hellenistic

H.: 0.109m. DIAM.: 0.177m.

Francis Bartlett Collection 03.982

E. P. Warren Collection.

Deep green patina.

This ewer is of squat form, with a large oval mouth. The flaring, squared handle terminates in the mask of a long-bearded Dionysos or Silenus of the fourth-century "Sardanapalus" type. The bottom is decorated with several concentric circles.

B. H. Hill, *Ann. Rep.* 1903, 62; *AA* 1904, 194; *AJA* 8 (1904) 383; Vermeule, *CJ* 61 (1966) 299, 294, fig. 12.

447

HANDLE OF A SMALL JUG, OR PITCHER

Hellenistic

H. (max.): 0.112m.

Gift of Mr. and Mrs. C. C. Vermeule, III 64.84

Perhaps from Dodona.

Even light green patina. Some scratches below handle, above base.

On the upper arms, heads of waterbirds. On the lower, palmette-shaped base, stylized (incised) leaves between volutes. A leaf pattern is incised on the middle of the back of the handle.

There are also two related handles in the Karapanos Room of the National Museum in Athens (Carapanos, *Dodone et ses ruines*, pl. 46, nos. 4, 7 = nos. 380 and 361 in the Karapanos Room).

Vermeule, *Ann. Rep.* 1964, 30-31; *idem, CJ* 61 (1966) 299, 294, fig. 11.

448

ARYBALLOS, OF CORINTHIAN TYPE

Sixth Century B.C.

H.: 0.03m.

Purchased by Contribution 01.7520

E. P. Warren Collection.

Bought in Athens.

Dark green patina.

Of usual form. The top of the lip is decorated with small circles and a tongue pattern, a cable border on the outer edge. The pattern on the handle is similar to that on the lip.

E. Robinson, *Ann. Rep.* 1901, 36.

Beazley, *BSA* 29 (1927-28) 196, fig. 4.

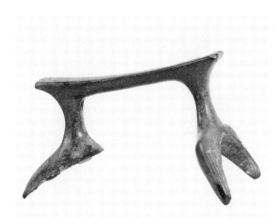

447

448

449

ARYBALLOS
Hellenistic or Roman
H.: 0.078m. DIAM.: 0.068m.
H. L. Pierce Fund 99.480
E. P. Warren Collection.
From Boeotia according to Rhousopoulos.

A piece is missing from one side. The patina
is green and somewhat crusty.

Undecorated. There is a bronze collar
around the neck to which a short chain (in
the form of two rings and the hooked loop,
broken and rejoined at the top) is attached
on either side.

Similar aryballoi exist in glass, and they
often have the same bronze attachments.
They are dated in the second and third cen-
turies A.D. (see *Glass from the Ancient
World*, 119f., no. 203).

E. Robinson, *Ann Rep.* 1899, 38f.; *AA* 1900, 217;
AJA 4 (1900) 511.

449

450

PEAR-SHAPED VASE (A PERIRRHANTERION)
Fourth Century B.C.
H.: 0.155m.
H. L. Pierce Fund 98.693
E. P. Warren Collection.

Dark green patina.

The upper part of the body is encircled by an ivy-wreath of inlaid silver. Above the lip rises what appears to be a stopper, but is in reality a part of the vase itself, the only opening of which is a small hole perforated through the top.

Compare Froehner, *Collection Hoffmann*, Paris, 28-29 May, 1888, 115, no. 432, pl. 33; also *AA* 1898, 129f., no. 2. These vases may have been used for sprinkling at funeral ceremonies. This shape also becomes popular in glass in the Graeco-Roman period (compare *Glass from the Ancient World*, 153f., no. 309).

E. Robinson, *Ann. Rep.* 1898, 35; *AA* 1899, 138.

451

THREE-LEGGED STAND
Fifth Century B.C.
H.: 0.095m. DIAM. (top): 0.236m.
Gift of E. P. Warren 96.678

450

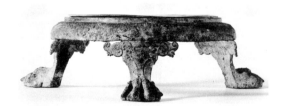

451

Crusty blue-green patina.

The feet, made separately, are lions' paws below Ionic capitals with volutes and palmettes.

It currently supports a red-figured lebes (96.720).

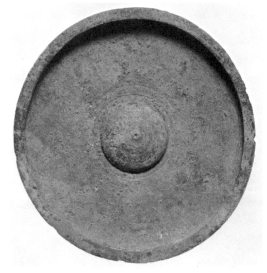

452

HANDLE OF A PATERA: WOLF'S HEAD
TERMINAL
Hellenistic Period
L: 0.131m.
H. L. Pierce Fund 99.474
E. P. Warren Collection.
Bought in Rome; said to come from near
Ascoli, Piceno.

The handle is of lead covered with a thin sheet of bronze. The eyes of the wolf are of silver. The other end is broken. Light green patina.

There are many such handles, usually of inferior quality and interest, and complete paterae from various parts of the Graeco-Roman world: compare the example from Welshpool, Wales: *JRS* 50 (1960) 211, pl. 20, 3; and the patera found near the Red Sea by a team of Israeli archaeologists: Christie's Sale, 6 December 1960, lot 179; also A. Parrot, *Syria* 40 (1963) 249ff., fig. 10, and pl. 20 (facing p. 245).

E. Robinson, *Ann. Rep.* 1899, 47; *AA* 1900, 218.

453

PHIALE
Late Fifth Century B.C.
DIAM.: 0.118m.
Gift of E. P. Warren 96.673
Said to be from a tomb in Palaeopolis, Elis.
Found with spoon fragment (no. 610),
cymbals (no. 622), and cradle (no. 661).

Rough blue-green patina.

Undecorated save for incised lines around the umbilicus and the outer side of the rim.

Compare Richter, New York *Bronzes*, 215, nos. 585f., from Cyprus.

E. Robinson, *Ann. Rep.* 1896, 31; *AA* 1897, 73.

453

INKWELL AND LID
Hellenistic Period
H.: 0.046m.
Harriet Otis Cruft Fund 65.910
Found in a tomb in Macedonia, together with
no. 455 (65.911). With them were in addition
a stylus and stylus-box (65.912, 65.913).

The lid is hinged and has a bud-shaped top.
The body and bottom have turned ridges.
Compare British Museum, *Greek and Roman
Life*, 202, fig. 222 (dice-box); 208f., fig. 229
(inkpots, with holes for similar lids).

Vermeule, *Ann. Rep.* 1965, 67; idem, *CJ* 62 (1966)
109f., fig. 22 (this and following).

INKWELL AND LID
Hellenistic Period
H.: 0.046m.
Harriet Otis Cruft Fund 65.911
As previous.

The lid is hinged and has a bud-shaped top.
The body and bottom have turned ridges.
The handle of the lid is missing.

MONEYBOX, FOR VOTIVE OFFERINGS
Circa 180 B.C.
H.: 0.094m. W.: 0.10m.
*Theodora Wilbour Fund in Memory of Zoë
Wilbour* 61.102
From Egypt; found in region of Memphis.

Crusty green patina. Nine of the coins are
similarly patinated and are stuck to the
bottom of the box. One bronze of Ptolemy VI
Philometor (181-146 B.C.) has been cleaned.

The lid has a bucket handle and a slot with
raised moulding. A mask, perhaps of Hy-
geia, appears as an appliqué on the front.
There are three holes for sealing, the upper
one also piercing the lid. A snake, coiled in a
figure-8, is fixed to the top, between the
slot and the handle. Between the lugs for the
handle is the inscription
("Be of Good Health"). ΥΓΙΑΙΝΕ

MFA, *Calendar of Events*, June 1961, 2, 2 illus.;
Vermeule, *ANSMN* 10 (1962) 77-80, pls. 15-16;
cites Michailidis, *Annales du Service* 55 (1958)
191-197; *Coin World*, 19 Oct. 1962, 68, 4 illus.;
FastiA 17 (1962) no. 3262; G. K. Jenkins,

A Survey of Numismatic Research 1960-1965
(Copenhagen, 1967) 86-87; T. W. Becker,
The Coin Makers (Garden City, New York, 1969)
48-49, 2 illus.

454 455

456

456

456

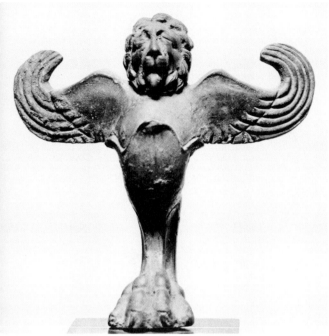

Graeco-Roman and Roman

457

FOOT OF A CISTA
Graeco-Roman
H.: 0.095m.
H. L. Pierce Fund 98.681
E. P. Warren Collection.
From Savona.

Hard green and brown patina; traces of dirt.
The head and wings of a winged lion, with tongue hanging out, emerge from a calyx, which ends in a lion's leg and paw. The lion's head is of a standard Graeco-Roman type, known best from the marble statue in the Villa Medici in Rome and from numerous small bronzes.

457

E. Robinson, *Ann. Rep.* 1898, 33f.; *AA* 1899, 138.

458

FRAGMENT OF A HANDLE
Graeco-Roman
H.: 0.098m.
Purchased by Contribution 01.7512
E. P. Warren Collection.
Bought in Rome.

The handle has been broken off above the head. Brown and green patina.
The lower end of a vertical handle, part of which still rises above the head of a horned Pan. A small volute scroll appears at the right.
Compare van Gulik, *Allard Pierson Bronzes*, 103f., no. 155, pl. 36.

E. Robinson, *Ann. Rep.* 1901, 36.

458

BASE OF A HANDLE
Graeco-Roman
L.: 0.031m.
Gift of C. Granville Way 72.4511
Hay Collection.

Pierced with a round hole. Broken at top and
at volute on left. Dark green patina.

A large volute at the right, above a facing
head of a silen with thick, curly hair, beard
and moustache.

Compare *Fouilles de Delphes* V, 88, no.
401, fig. 296; *AA* 1928, col. 189f., fig. 43,
from Tiriolo. For style, see the head of
Herakles on the handle-base of a situla, Hel-
lenistic period: Hesperia Art, *Bulletin* IV,
no. 37; also, the head of Silenus, an Arretine
puncheon in the collection: Chase, *BMFA*
45 (1947) 38ff., figs. 2, 4.

459

460

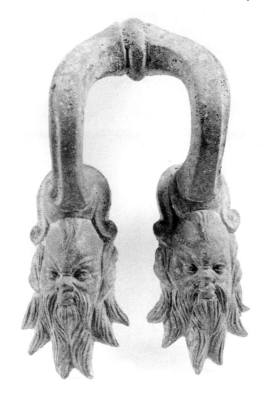

460

HANDLE OF A CALYX KRATER
Graeco-Roman
L.: 0.142m. W.: 0.088m.
H. L. Pierce Fund 99.477
E. P. Warren Collection.
Said to come from Pompeii.

Dark green patina with bluish tinge.

The horizontal handle is of twisted, vine-
stem shape with ring-shaped center. The head
of a long-bearded silen under each end
forms the point of contact with the body of
the vessel.

E. Robinson, *Ann. Rep.* 1899, 47; *AA* 1900, 218.

461

VERTICAL HANDLE
Graeco-Roman
H.: 0.152m.
H. L. Pierce Fund 99.473
E. P. Warren Collection.
Bought in Paris; probably from South Italy.

The Triton has eyes of silver, inlaid. Brownish green patina.

The handle is formed into a series of water-leaves descending to tiny volutes. Below this, there is a dog's head in frontal view and, directly beneath, the mask of a young Triton.

Compare Schumacher, Karlsruhe *Bronzen*, pl. 10, nos. 27, 29a (on Graeco-Roman jugs).

E. Robinson, *Ann. Rep.* 1899, 47; *AA* 1900, 218.

462

VERTICAL HANDLE
Graeco-Roman
H.: 0.068m.
Gift of E. P. Warren 13.111

Crusty green patina.

A young Hermaphrodite or Priapos, in girt chiton, ithyphallic, stands holding fruits in the fold of his garment. His booted feet are placed together on a cluster of leaves which forms the base of the handle.

Compare a slightly more complex handle in the Louvre: De Ridder, Louvre *Bronzes*, II, 118, no. 2792, pl. 100; also Reinach, *Rép. stat.*, II, 177, 7, in the Bibliothèque Nationale.

L. D. Caskey, *Ann. Rep.* 1913, 89; *AA* 1914, col. 494.

461

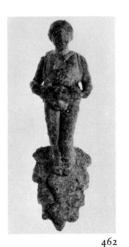

462 462

463

463

463

VERTICAL HANDLE
Graeco-Roman
H.: 0.135m.
H. L. Pierce Fund 99.478
E. P. Warren Collection.
Bought in Rome.

Green patina.
 The handle curved above the rim of the
vase. At the bottom it ends in a lion's paw.
Along the middle runs a ridge, spreading at
the lower end into a lotus and at the upper
end (on the front) into a mask of a lion with
an ox-skull in its mouth.

E. Robinson, *Ann. Rep.* 1899, 47f. (compared with
handle of the oinochoe no. 99.486); *AA* 1900,
218.

329

464

464

OINOCHOE

Graeco-Roman

H.: 0.188m. DIAM.: 0.13m.

H. L. Pierce Fund 99.486

E. P. Warren Collection.

Bought in Genoa; said to come from Pompeii.

Patina green and blue, crusty.

The handle ends below in a lion's paw on a flat disc with stylized, voluted tendrils. A ridge runs up the middle of the handle, with a lion-mask holding an ox-skull in the mouth, at the upper end. There are serrated discs to left and right on the ends of the handle.

Compare Naples, Museo Nazionale, no. 69040 (Chiurazzi, no. 325); also Tarbell, *Bronzes*, 127, nos. 159, 160, pl. 84, fig. 160, pl. 85, fig. 159.

E. Robinson, *Ann. Rep.* 1899, 41; *AA* 1900, 217; *AJA* 4 (1900) 511.

465

HANDLE OF A VASE OR SITULA

Graeco-Roman

H.: 0.063m. W.: 0.055m.

Purchased by Contribution 88.620

Purchased from R. Lanciani; from the sanctuary of Diana at Nemi.

The lower edge is rough. Dull green patina.

Two rings are set off with rope pattern scroll and bud at the top. A sleeping dog is curled up beneath.

464

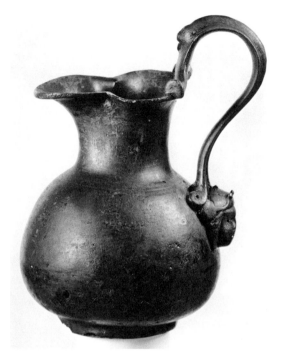
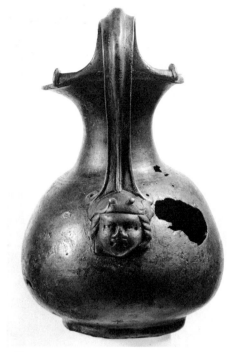

466 466

466

Oinochoe

Graeco-Roman

H.: (max. including handle): 0.165m.

Gift of Harvard University – Museum of Fine Arts Expedition 24.958

From Meroë, Tomb W109, no. 24.

Electrolytically cleaned, no patina. Holes from corrosion, and handle worn.

The vase has a trefoil mouth and a high handle. On the upper part, a lion's head lies between the two arms which are soldered to the lip. A ridge runs on the outside center to a maenad-mask with mitra and ivy leaves. The bottom, made separately, has a series of concentric circles.

Compare De Ridder, Louvre *Bronzes*, II, 114, no. 2754, pl. 99 (from Herculaneum).

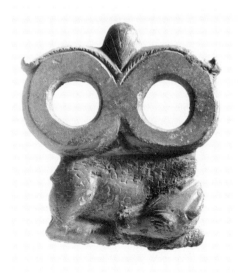

465

467

OINOCHOE

Roman, or possibly Italic

H. (max.): 0.12m. DIAM. (max. of vase): 0.05m.

Bequest of Charles H. Parker 08.539
Alfred Greenough Collection.

Crusty green patina.

The handle of this trefoil pitcher has three serrated ridges on the outside and terminates in an acorn at the base.

Vermeule, *Ann. Rep.* 1965, 68.

468

OINOCHOE

Roman

H. (rim.): 0.092m. DIAM.: 0.082m.

Gift of Horace L. Mayer Res. 59.16

Heavily encrusted; shades of medium to light green.

Small, round-mouthed pitcher with high, looped handle.

469

HANDLE OF AN OINOCHOE

Graeco-Roman, First Century A.D.

H. (max): 0.21m.

Gift of Mr. and Mrs. Benjamin Rowland, Jr. 63.2763
New York Art Market.

Green patina, with ear stains. Some repainting.

At the rim, the points of contact with the vessel are formed into cranes' heads (one broken at the beak), leading to a foliate scroll. On the body, there appear a filleted garland, a maenad head (?), a cista, cymbals on an orb, and (on the base) Eros feeding a panther from a kantharos.

Compare Tarbell, *Bronzes*, 125, fig. 152 (bulbous pot), 129, fig. 177 (oinochoe). For general style, De Ridder, *Louvre Bronzes*, II, 119, nos. 2797, 2798, pl. 100. For Eros and panther, Richter, New York *Bronzes*, 121, no. 230.

Vermeule, *Ann. Rep.* 1963, 38; *idem, CJ* 60 (1965) 298, fig. 12.

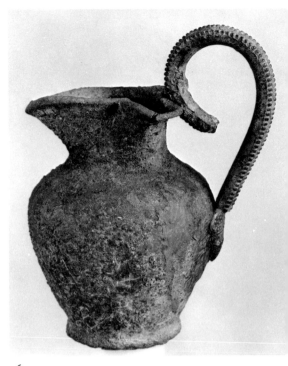

467

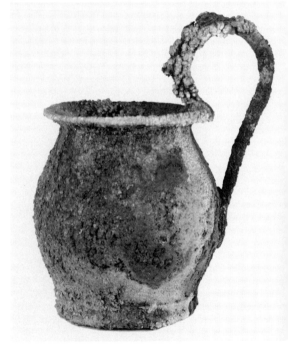

468

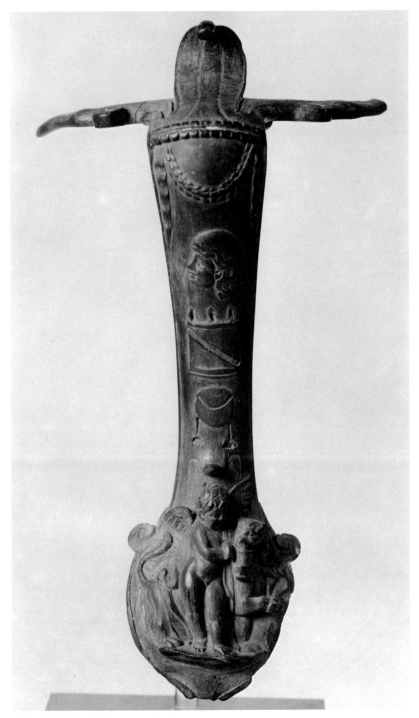

469

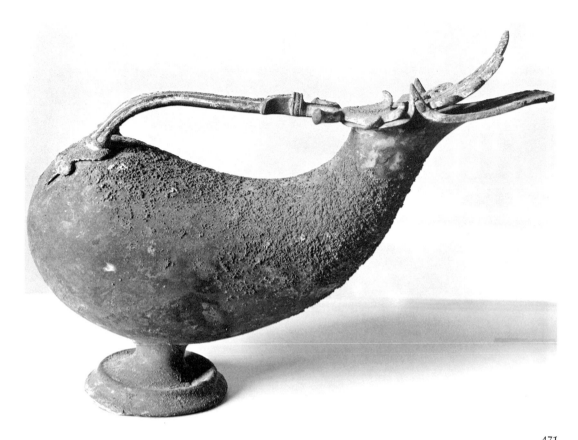

471

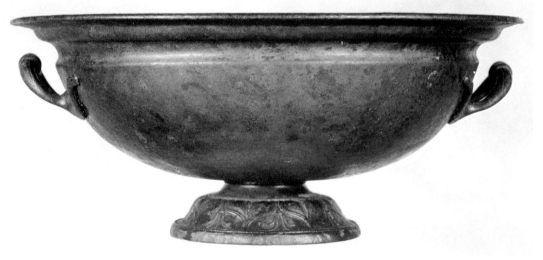

472

470

Askos

Graeco-Roman

L.: 0.21m. H.: 0.175m.

Alfred Greenough Collection; Bequest of Charles H. Parker 08.250

Broken and mended. Crusty green patina.

Vegetable-stem handle with rudimentary volute at the base.

Compare Pernice, *Hellenistische Kunst in Pompeji*, IV, 14, fig. 18 (Berlin; of different form); De Ridder, Louvre *Bronzes*, II, 128, no. 2930, pl. 103; and the following. An example with similar handle is in the Walters Art Gallery (no. 54.182; University of Wisconsin Memorial Library, *Rome An Exhibition of Facts and Ideas*, 28f., no. 42). For general bibliography in connection with an askos discovered in a tomb at Tirlemont, see Renard, *Musée de Mariemont*, 145, no. R 36, pl. 52.

L. D. Caskey, *Ann. Rep.* 1908, 60; *AA* 1909, col. 428.

470

471

Askos

Graeco-Roman ("Meroitic")

H.: 0.264m. L.: 0.370m.

Gift of Mrs. Oric Bates 24.366

From Gamai, Tomb 115, no. 16 B.

Greenish brown patina.

Pitcher of askos shape, with a long, projecting spout. The vegetable-stemmed double handle starts from rudimentary leaves with volutes at the base and ends in a long, large acanthus leaf over the spout. The foot is integral.

BMFA 22 (1924) 46, illus.; O. Bates, D. Dunham, "Excavations at Gammai," *Varia Africana* IV, *Harvard African Studies* (1927) 42, no. 16, pl. 32, 2 and 4.

472

Basin with Two Handles and Relief Medallion

472

473

Graeco-Roman

DIAM.: 0.346m.

Gift of Harvard University – Museum of
Fine Arts Expedition 24.979

From the tomb of Queen (?) Amanikhatashan
at Meroë.

Brown and dark green patina. Small hole in
bowl.

The flat bowl has a large, flaring rim with
a foot and two vegetable-stemmed handles,
terminating in duck's heads at the bowl.
There is waterleaf moulding on the foot. The
medallion set in the bottom of the bowl has
a scene of Actaeon, stag's horns on his head,
defending himself from his own hounds. The
style is pseudo-Transitional.

There is a comparable basin, with medal-
lion showing a heroic warrior and a woman
("Mars and Venus") among the Pompeiian
bronzes in the Museo Nazionale, Naples
(Tarbell, *Bronzes*, 131, no. 195, pl. 93). For
the composition of Actaeon, one going back
at least to 400 B.C. in bronzes, see R. Lullies,
AA 1954, cols. 277f., fig. 9, a hydria or lid
attachment of the years 400 to 375 B.C. in
Munich.

G. A. Reisner, *BMFA* 21 (1923) 23f., illus. of

medallion, uncleaned; W. S. Smith, *Ancient Egypt*
(1952) 163; (1960) 185; D. Dunham, *The Royal*
Cemeteries of Kush, vol. IV, *Royal Tombs at*
Meroë and Barkal, 149f., no. 643, fig. 97,
pl. 54 C, D.

473

TWO-HANDLED DISH
Graeco-Roman

H.: 0.08m. DIAM.: 0.255m.

Alfred Greenough Collection; Bequest of
Charles H. Parker 08.247

Much corroded and encrusted. Two holes in
bowl. Crusty green patina.

Swinging handles of flaring, nearly rec-
tangular shape are attached beneath the rim,
which has nine projections ending in knobs
and a raised lip.

L. D. Caskey, *Ann. Rep.* 1908, 60; *AA* 1909,
col. 428.

474

MINIATURE VASE
Hellenistic or early Roman imperial, prob-
ably 50 B.C. to A.D. 50
H.: 0.035m.
Gift of Richard R. Wagner 65.1185
From Istanbul.

Black green patina.
On the lip there are two holes, probably for
handles; they are on opposite sides. Below the
lip there is a rolled fillet moulding between
two grooves. In the center of the bottom is an
engraved dot, or turning mark, and outside
this, halfway to the outer curve of the profile,
an incised, circular groove.

Vermeule, *Ann. Rep.* 1965, 68.

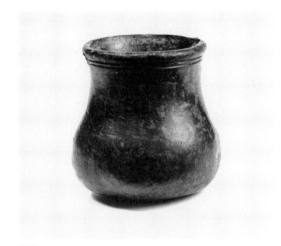

474

475

CIRCULAR PYXIS WITH LID
Graeco-Roman, A.D. 50 to 250
H.: 0.043m. DIAM.: 0.077m.
Gift of Richard R. Wagner 65.1186
From Istanbul.

Crusty green and dark brown patina.
On the body is a moulded band in the mid-
dle and another above the curved base.
There is a fillet and, above, an inset area or
band at the lip. On the bottom are three
sets of moulded, concentric circles.
Compare, generally, for work and en-
graved or moulded fillets on the drum of the
body, an object very like an inkwell, in the
Louvre: De Ridder, Louvre *Bronzes*, II, 183,
no. 3538, pl. 118.

Vermeule, *Ann. Rep.* 1965, 68.

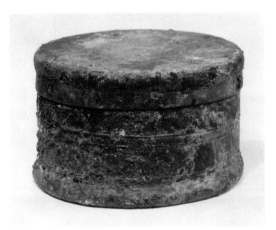

475

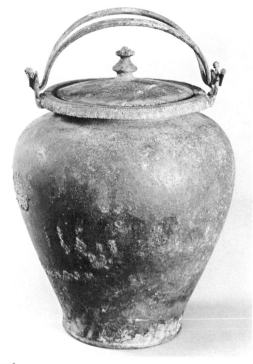

476

476

SITULA WITH COVER
Graeco-Roman
H. (with cover): 0.30m.
Purchased by Contribution 01.7522a, b
E. P. Warren Collection.
Bought in Rome.

Somewhat corroded. The patina varies from green to purple.

There are two bails, side by side, bent rods with knobs at the ends. The attachments to the body have palmettes in low relief on their lower parts. Inverted waterleaf moulding on the finial of the lid; bead and ovolo on the lip of the bucket.

Compare Aurigemma, Alfieri, *Museo Nazionale Archeologico di Spina in Ferrara*, pl. 18: termed Greek fourth-century B.C.

E. Robinson, *Ann. Rep.* 1901, 36.

BELL-SHAPED SITULA
Graeco-Roman, perhaps 50 B.C. to A.D. 50
H.: 0.375m. DIAM. (max.): 0.345m.
Samuel Putnam Avery Fund 65.394
Said to have been found in the River Tiber.

Handles, loops at rim, and three feet missing, the latter attached with lead or similar solder. Some holes from corrosion, especially in the handle-plates; the moulding of the bottom has been dented and broken. "Tiber" patina.

Between the fillets below the moulded lip there is a guilloche pattern in relief. The two elaborate handle-plates take the form of inverted honeysuckle with tendrils, a mass of volute scrolls, and rosettes at the upper corners. The bottom has inset and moulded concentric circles.

Such bell situlae are collected by P. J. Riis, *ActaA* 30 (1959) 18ff., especially the list on p. 21, section C, c, figs. 15f.: *with* volute and palmette ornament below the handle rings. The rolled, double-fillet moulding just below the rim is also characteristic.

The Hellenistic prototype is seen in an example from Brezovo in Thrace: *CAH, Plates,* III, pl. 70c; and the situla from Prusias in Bithynia, in the collection of Walter Baker, has been dated 350 to 300 B.C.: D. von Bothmer, *Ancient Art in New York Private Collections,* 37, no. 142. The shape also derives from South Italian vases, as the Apulian situla with plastic spout: M.F.A. 01.8098; T. B. L. Webster, *Antike Kunst* 3 (1960) 32, pl. 8, figs. 4f.; see generally, E. Pernice, *Hellenistische Kunst in Pompeji,* IV, 14f., figs. 19f., and the early imperial situlae, figs. 34, 35, and 37. The general concept of the Graeco-Roman situla has been termed an Apulian motif, occurring also in Etruscan-Praenestine mirrors, and thence transmitted to Rome from southern Italy.

Vermeule, *Ann. Rep.* 1965, 67; *idem, BMFA* 63 (1965) 212, illus.

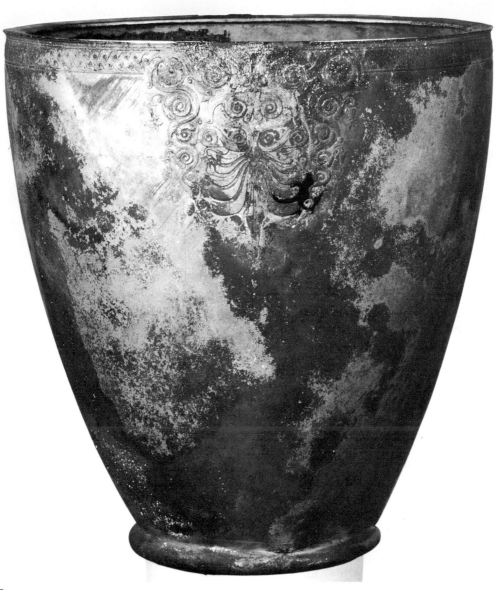

477

478

PROTOME OF A BOAR, PROBABLY FROM A
SITULA
Roman
L.: 0.035m.
Gift of Mrs. Cornelius C. Vermeule, Jr.
59.999

Dark green patina.

Head of a boar, with one fore-leg attached
at the throat; the bristles are represented by
small incisions. There are three holes for at-
tachment in the circular base.

Compare the example found at Augusta
Raurica, the end of an ornamental elephant's
tusk: R. Laur-Belart, *National Zeitung*, 18
Nov. 1960. Similar appliqués are used circa
100 B.C. and later on small pails, water heat-
ers or rectangular pans. The quality of the
work is very high, the expressiveness of the
boar's head being enhanced by careful cast-
ing and finishing of the incised surface lines.

Vermeule, *Ann. Rep.* 1959, 26; *idem, CJ* 56 (1960)
7f., fig. 8; *FastiA* 17 (1962) no. 243.

478

479

479

COOKING (?) VESSEL
Circa A.D. 200 to 250
H.: 0.165m. DIAM. (max. incl. handle):
0.43m. CAPACITY (to line inside rim): 7 qts.
Theodora Wilbour Fund in Memory of
Zoë Wilbour 63.2644
From Western Asia Minor.

Dented, broken, and with one coin (eight
o'clock from handle) missing. Evidences of
burning on the bowl. Green patina with
whitish, lime-like deposit.

The trulla-shaped handle is pierced by a
rimmed circle, for suspension. The edge of the
handle continues into a broad lip below
which is a double-fillet moulding. Concentric
circles in relief on the bottom.

For the Roman vessel ("casserole"), com-
pare De Ridder, Louvre *Bronzes*, II, 139, no.
3040, pl. 107, with Latin inscription, and
parallels; J. H. C. Kern, *Hommages à Albert
Grenier*, II, 871-883, pls. 180ff., signed ex-
amples in Leiden.

Coins in place at time of acquisition:

4	2		1
5	3	A	
	B		

479

On handle:

1. AE 33mm. Reverse. Dionysos seated on
 pantheress, holding thyrsos.

 ΣΤΡΑ ΚΑΜΟΥ ΣΕΒΗΡΟΥ
 In exergue: ΚΥΖΙΚΗΝΩ/ΝΕΟΚ
 BMC, no. 240 (diff. magistr.): Com-
 modus. Cyzicus in Mysia.
 R. Münsterberg, *Die Beamtennamen auf
 den Griechischen Münzen*, Vienna, 1914,
 66: magistrate listed under Marcus
 Aurelius.

2. AE 39mm. Reverse. Artemis with a
 quiver or bowcase on shoulder facing
 Apollo (?) with lyre and cloak; they
 shake hands over an altar.

 ΕΠΙ • ΑΡΧ • ΠΡ • ΓΕΣΦΙ
 ΛΙΠΠΟΥ [ΤΒ ΙΕΡΟΚΑΙΣ]
 ΑΡΕΩΝ (in exergue)

 Cf. BMC, no. 20 (same magistr.): time of
 Commodus. Hierocaesarea in Lydia.
 See also F. Imhoof-Blumer, *Kleinasia-*

tische Münzen, Vienna, 1901, 173 for
discussion of legend.

3. AE 32mm. Reverse. Artemis standing
 to right discharging arrow. Stag running
 at left, beside her.

 AE
 ΙΕΡΟΚΑΙΣΑ-ΡΕΩΝ

 Cf. M. Babelon, *Inventaire Sommaire de
 la Collection Waddington*, Paris, 1897,
 no. 5006 (19 mm.) Faustina I, no. 5007
 (22 mm.) Marcus Aurelius: Hierocae-
 sarea in Lydia.

4. AE 35mm. Reverse. Bull standing right.

 AE
 ΠΟΛΕΜΩΝ ΑΝΕΘΗΚΕ
 ΣΜΥΡΝΑ ΙΟΙΣ

 BMC, no. 339: Antinous. Smyrna in
 Ionia. M.F.A. no. 62.229.

5. AE 35mm. Reverse. As previous.
 Coins acquired later but evidently from
 the ensemble.

A. AE 39mm. Laureate, draped, cuirassed
 bust right.

ΑΥ ΚΑΙ ΜΑΡ Α
ΥΡΗ ΑΝΤΩΝΕΙ ΑΥΓ

Reverse. Aeneas right bearing on left arm
Anchises and looking left at Ascanius
right wearing a Phrygian cap, whom he
leads by the hand. In exergue: ΙΛΙΕΩΝ
See A. Bellinger, *Troy The Coins,* Supple-
mentary Monograph 2, Princeton, 1961,
no. T148: Marcus Aurelius.

B. AE 33mm. (Laureate) bust right.

ΑΥΤ ΚΑΙΣ ΤΡΑΙ
ΑΔΡΙΑΝΟΣ ΣΕΒ

Reverse: Distyle temple with star in pedi-
ment; Hadrian stands between Bithynia
and Roma, who crowns him.

ΚΟΙ-ΝΟΝ ΒΕΙΘΥΝΙΑΣ (in exergue)

W. H. Waddington, *Recueil Général des
Monnaies Grecques d'Asie Mineure,* I, 2,
Paris, 1908, nos. 35 (rev.), 43 (obv.):
Hadrian.

Vermeule, *Ann. Rep.* 1963, 42f.; *idem, PAPS* 109
(1965) 365f., fig. 8.

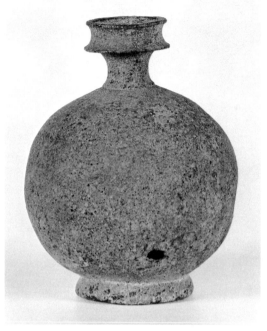

480

480

Bottle (Aryballos Shape)

Graeco-Roman

H.: 0.08m.

Gift of the Misses Norton 12.794
Marked "Milos" (i.e. Melos).

Crusty greenish-grey patina.
 Spherical body with low base and small
mouth with concave-filleted lip. Concentric
circles in relief on bottom. The parallels have
two small handles from the lower part of the
lip to the shoulder; these have loops for
hanging.
 Compare Richter, New York *Bronzes, 196,*
no. 516 and Möbius, *Antike Kunstwerke aus
dem Martin von Wagner-Museum,* 21f., no.
13, pl. 13.

481

481

Vase in the Form of a Satyr's Head

Graeco-Roman

H.: 0.089m.

Purchased by Contribution 01.7468

E. P. Warren Collection.

Bought in Rome.

The vase is dented and cracked. The bottom
and cover are missing. Much corroded; dark
green patina.

 The face is bearded, and the eye-sockets are
hollow. Part of the attachment for the cover's
hook survives at the rear. The features are
slightly Negroid, and the lips were inlaid.
Two small horns, one mostly broken away,
provide the identification.

E. Robinson, *Ann. Rep.* 1901, 36.

482

Box in the Form of an Old Man's Head

Graeco-Roman

L.: 0.05m.

Gift of E. P. Warren 01.8377

482

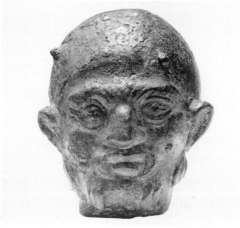

482

Sliding cover on the bottom is corroded.
There is a large hole in the right side of the
head. Dark green patina.

 The man is bald, with stringy beard and
moustache. His nose is hooked, his brow
wrinkled and his features are generally com-
pressed almost to form a caricature.

 Compare De Ridder, Louvre *Bronzes*, II,
130, no. 2942, pl. 103; also no. 2947 =
MonPiot 51 (1960) 76f., fig. 4; Froehner,
Collection Bammeville, Paris, 11 June 1893,
58, no. 372, pl. 22.

E. Robinson, *Ann. Rep.* 1901, 36; Vermeule,
TAPS 50 (1960) 34, under no. 522.

481

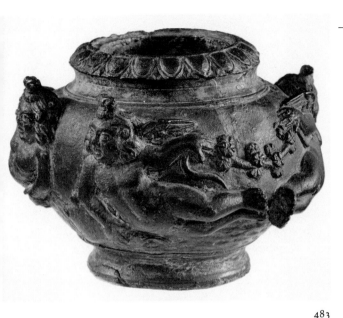

483

483

INCENSE BOWL

Roman, circa A.D. 300
H.: 0.08m.

Gift in Memory of Dr. Jacob Hirsch by the Trustees of his Estate and Seth K. Sweetser Fund 58.704

From Panticapaeum.

Slight crack in foot. Dark green patina, with some encrustation. Lid missing.

On the bowl, seasonal genii or Erotes in high relief. One pair of Erotes, flying left and right, hold ends of a floral chain between them, and torches in their other hands. Of the other pair, holding a similar garland, the figure on the left rests his elbow on a wineskin, and the right figure on an amphora. Below their bodies, the sea is symbolized by irregular oval indentations.

The sloping rim of the bowl has an ovolo pattern in relief.

The irregular indentations may also symbolize the vapors of time. The faces and bodies of the Erotes, as well as their grouping as they fly around the bowl, in a manner recalling the Winds on the Tower of the Winds in Athens, date the jar in the period A.D. 300 to 350, the classical Renaissance under Constantine the Great and his sons. In his studies of the Four Seasons in ancient art, G. M. A. Hanfmann has demonstrated that this motif was appropriate to jars in terracotta and metal from Attic vases of the sixth century B.C. to late antique craftsmanship such as this (*The Season Sarcophagus in Dumbarton Oaks*, II, 135, no. 4, fig. 79; 167f., nos. 363f.; see also Babelon-Blanchet, *Bronzes*, 577, no. 1423; Walters, British Museum *Bronzes*, 148, no. 823). This bowl or pyxis was probably filled with incense or spices and placed in a tomb.

Vermeule, *Ann. Rep.* 1958, 32; idem, *CJ* 56 (1960) 12f., fig. 15.

Langlotz, in *Bedeutende Kunstwerke aus dem Nachlass Dr. Jacob Hirsch*, Lot 63, pl. 31; *FastiA* 15 (1960) no. 665; H. Sichtermann, *Späte Endymion-Sarkophage*, Deutsche Beiträge zur Altertumswissenschaft, vol. 19, 21, note 17.

Exhibited: Detroit, *Small Bronzes of the Ancient World*, 11, no. 81.

484

VASE WITH SITULA HANDLE
Late Roman or Byzantine, A.D. 400 or later
H.: 0.10m.
Gift of Richard R. Wagner 65.1187
From Istanbul.

Dark, greenish-black patina.

On the neck there are moulded bands, and on the body a series of moulded lines with concentric circles, linked like Geometric fibulae, between. The base has turned, concentric ridged areas and moulded lines.

Similar concentric circles are on a bottle of uncertain date in New York, from Syria: Richter, New York *Bronzes*, 196f., no. 517. There is also much in common between this vase with situla handles and a silver vase in the Louvre from Emesa in Syria; the vase in Paris has been attributed to a workshop in Constantinople (W. F. Volbach, M. Hirmer, *Early Christian Art*, pl. 246). Here tondo busts of prophets or apostles replace the concentric circles.

Vermeule, *Ann. Rep. 1965*, 68; idem, *CJ* 62 (1966) 110f., fig. 24.

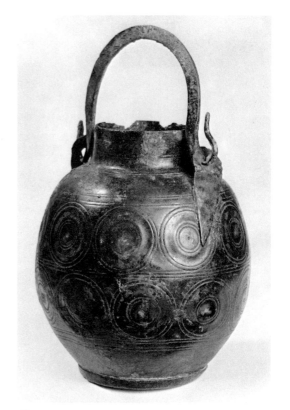

484

485

CYLINDER AND COVER: PROBABLY AN INKWELL
Graeco-Roman
H. (of cylinder): 0.048m. DIAM.: 0.027m.
DIAM. (of cover): 0.03m.
Gift of the Archaeological Institute of America 84.83a, b
From sarcophagus No. 102, at Assos.

A is heavily encrusted and b just normally so.

The mounting of a case in which an ivory stylus was found:
a) Thin, plain cylinder, flaring a little at one end, with an open longitudinal slit.
b) Circular disc with rim, and hole in the middle.

Despite the fact that an ivory stylus was

485 485

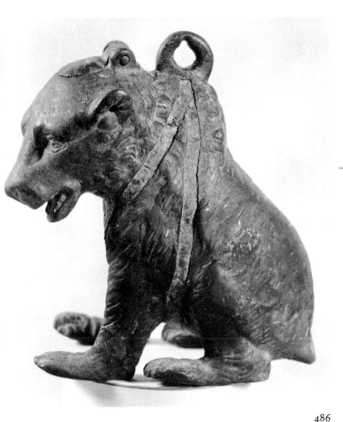

found within, this container seems to have been an ancient inkwell rather than a stylus or pen box. The knob on the lid, the hinge from lid to body, and the bottom of the cylinder are missing. The body, fashioned from a rectangular strip of sheet bronze, has come apart where the metal was soldered, at the vertical seam.

486

AMPULLA, IN THE FORM OF A SEATED BEAR
Late Roman or Byzantine (A.D. 200 to 500 ?)
H.: 0.125m. L.: 0.115m.
Gift of Burton Y. Berry 62.1203
From the East Greek world.

Green and brown patina, with remains of earthy encrustation, especially on the feet.

He has a swivel-pin lid on the top of the head and a ring for suspension in the middle of his back. There are remains (the channels) of inlaid (silver?) sling-like straps to indicate a harness around the stomach and between the forelegs. Holes in the ears offset the vacuum created in pouring through the hole in the mouth.

486

Compare the ampulla in the form of a bear in Brooklyn and the example that was Brummer Sale II, Parke-Bernet, May 1949, no. 164. See also A. Sambon Sale, no. 76 = Dattari Sale, no. 463 = Reinach, *Rép. stat.*, V, 429, no. 1. Two others from Asia Minor were in the Zurich Art Market in 1963. The Brooklyn bear is seated, with paws raised. The head and neck are cast separately and lift up on a swivel pin. The inside thus forms a container. Compare also New York, Metropolitan Museum, Chapman Fund, 1966, a more canine rendering, with a rope collar and stomach band in bronze (*BMMA* 25 [1966] 87).

Toward the end of the second century A.D. bears became popular in the contests of the Roman arena. After the suppression of such spectacles harnessed bears continued as popular performers, much as one sees dancing bears in Anatolia today. This beast is based on one of these. The bear, who hibernates, also

became a symbol of the Resurrection in Christian times, and as such he would be most appropriate as a vehicle for dispensing holy oil. On dancing bears in art, through the ages, see T. Falk, *Berliner Museen* 12 (1962) 2f.

J. T. Green, *BMFA* 59 (1961) 111, illus.; Vermeule, *Ann. Rep.* 1962, 32; idem, *CJ* 60 (1965) 298f., fig. 13; *FastiA* 17 (1962) nos. 239, 244; Vermeule, *CJ* 63 (1967) 63.

Exhibited: Cambridge (Mass.), Fogg Art Museum, *Master Bronzes*, no. 300.

487

LAMP

Roman, First Century A.D.

L.: 0.172m.

Harriet Otis Cruft Fund 60.1451
Said to have come from Alexandria.

End of one rosetted volute and edge of spout broken off. Dark, olive green patina with small areas of light green corrosion.

The lamp is circular, with a ringed medallion and boss on the bottom, volute and rosette details at the spout. Around the circle of the top, a greyhound is curled up asleep, with a puppy snuggled up against her.

Lamp and cameo designers in antiquity were fascinated by the opportunity to place a long, lean canine curled up asleep in relief in the tondo surface of a container for oil or a gem. This is one of the best surviving examples of this class of lamp; another in bronze is in the British Museum, from Crete, and shows a mastiff with heavy collar curled up and biting his hind leg. Two more in London, in the more usual terracotta, have single greyhounds asleep. They also come from Alexandria, further indication that this Graeco-Roman metropolis was the center for design and manufacture of such dog lamps (H. B. Walters, *Catalogue of Greek and Roman Lamps,* no. 26, fig. 5, no. 430f., pl. 11; for the breed of greyhound shown here, see O. Keller, *Die antike Tierwelt*, I, 100ff., fig. 38).

Vermeule, *CJ* 57 (1962) 150, fig. 6; *FastiA* 17 (1962) no. 243.

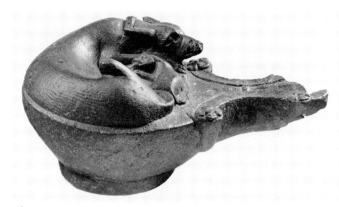

487

Exhibited: Cambridge (Mass.), Fogg Art Museum, *Master Bronzes*, no. 296.

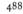

488

LAMP WITH TWO SPOUTS

Graeco-Roman

L.: 0.225m.

Purchased by Subscription 72.392

General di Cesnola Collection.

From Cyprus.

The lower part, the medallion in the bottom, is missing. Lid and swivel-pin also gone. Some encrustation; even light green patina beneath. Boss in center of griffin's head is also broken away.

The handle, cast separately and joined at double rings of base and body, ends in the head of a griffin; the stem forms his neck and tufted mane.

This is a fairly common form of monumental Graeco-Roman lamp, continuing into the Byzantine period. The griffin was originally the solar symbol of Apollo; his presence as the lamp's handle is perhaps due to his general popularity in Roman imperial decorative arts, on the breastplates of cuirassed statues and the like.

489

LAMP

Graeco-Roman

L.: 0.257m.

Gift of Harvard University – Museum of Fine Arts Expedition 24.967

From the tomb of King Amanitenmēmide at Meroë.

Brown, cleaned surface.

The handle, cast separately, ends in the protome of a horse, harness and bulla around his neck; he springs from a lotus leaf, and the lower part of the handle is in the form of a vegetable stem. The body has a horseshoe top with two holes. The profiled foot was also cast separately.

This is a more elaborate version of the

bronze horsehead lamps from Pompeii.

G. Reisner, *BMFA* 21 (1923) 25; W. S. Smith,
Ancient Egypt (1952) 163; (1960) 185;
D. Dunham, *The Royal Cemeteries of Kush*, IV,
Royal Tombs at Meroë and Barkal, 149f., no. 645,
fig. 97, pl. 51 A.

490

LAMP

Graeco-Roman

L.: 0.037m.

Classical Department Purchase Fund 59.962
Probably from Syria.

The top of the handle is pierced, perhaps to
attach missing lid. Olive green patina, with
earthy encrustation.

The lamp takes the form of an Indian ele-
phant's head, the trunk serving as nozzle.
The filling hole is on the top of the head, and
there is a ring handle at the back. The base
is small and circular.

The closest parallel, a lamp once in the
Fouquet collection in France, has a lid in the
form of a female mahout or goddess seated
behind the elephant's head (Reinach, *Rép.
stat.*, V, 456, no. 1). Compare also the bronze
lamp with elephants' head spouts, from
Meroë (*BMFA* 21 [1923] 21, illus.) and the
terracotta example from Sicily (Richter,
Animals, 11, illus).

Vermeule, *CJ* 56 (1960) 8f., fig. 9; *FastiA* 15
(1960) no. 665.

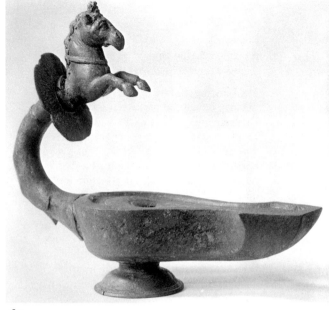

489

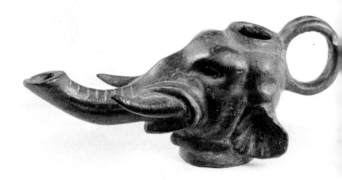

490

491

LAMP
Roman (possibly Early Christian)
H.: 0.088m. L.: 0.09m.
Source unknown 06.1925

The Christogram is a modern addition, as is the loop by which the chain is attached to it. The lamp and lid have a crusty green patina. The dove may or may not belong.

A dove is attached to the cover of the body. The chain joins the body at a ring between cover and spout, and a section leading off its middle has been hooked to the center of the Christogram.

The Early Christian qualities of the lamp depend on the connection of the dove with it in antiquity and whether or not the Christogram is a restoration rather than merely an addition to add interest. For lamp with dove and cross, see *Antiken aus dem Nachlass des Prof. Mirko Roš, et al.*, 13, no. 192, pl. 4; the Christogram is incised on the top of the body.

492

LAMP
Roman
H.: 0.093m. H. (with chain): 0.60m.
DIAM.: 0.33m.
Francis Bartlett Collection 03.984
E. P. Warren Collection.
Bought in Paris; said to be from Syria.

The foot, cast separately, is missing and has left a circular hole in the bottom. Even green, medium-dark, patina.

Six spouts and a large, circular opening, with rolled-fillet rim. There are three chains for suspension, attached by hooks which pierce the concave outer edges of the top.

Inscribed:

ΘΕΩ ΑΓΙΩ ΑΡΕΛ ΣΕΛ
ΩΛΕΙΟΣ ΜΑΓΝΟΣ

ΚΟΔΡΑΤΟΣ ΚΑΙ ΥΙΟΙ
ΤΟΝ ΛΥΧΝΟΝ

ΣΥΝ ΑΛΥΣΙ
ΑΝΕΘΗΚΕΝ

"To the holy God have Aurelius Sellius Oleios Quadratus Magnus and his sons dedicated this lamp with its chain."

For the shape, compare Istanbul: *Guide Illustré*, no. 894 (from Salonika).

B. H. Hill, *Ann. Rep. 1903*, 62; *AA 1904*, 194; *AJA 8* (1904) 383; J. Addison, *The Boston Museum of Fine Arts*, 275.

491

492

493

494

495

493

Lamp
Roman
L.: 0.134m.
Purchased by Contribution 88.629
Purchased from R. Lanciani; from the bed
of the Tiber.

Part of the middle has broken away. Fine
green patina.

On the outside there are four bucrania in
low relief. The large, fan-like handle has
radial panels. The wick end has an intaglio
leaf pattern. Sets of triple vent holes pierce
the medallion in the top, and there is a
small vented boss in the center of this top
medallion.

Compare the examples in Dumbarton
Oaks, from Laodicea in Syria and dated sixth
century A.D.: M. C. Ross, *Catalogue of the
Byzantine and Early Mediaeval Antiquities,*
I, 35, no. 36, pl. 26. Also Helbing Auction,
Munich, 22 Feb. 1910, 44, no. 578.

494

Lamp
Roman
L.: 0.098m.
Purchased by Contribution 88.630
Purchased from R. Lanciani.

Dark green encrustation.

The handle is spade-shaped, and there are
two lugs on the body, two rudimentary
volutes just before the hole for the wick.

LAMP
Renaissance or later
H.: 0.054m. L.: 0.103m. DIAM.: 0.061m.
Gift of the Estate of Alfred Greenough
85.229

Even, artificial dark green-to-black patina.

The circular medallion on top has concentric rings on the edge. Within two nude figures stand on either side of a tall tripod louter. The handle terminates in a grotesque, Pan-like face.

496

LAMP STAND OR CANDELABRUM
Roman
H.: 1.38m.
H. L. Pierce Fund 98.692
E. P. Warren Collection.
From Boscoreale.

The feet have been re-attached. Dark green patina, with light green encrustation.

Below the circular cup and its bands of moulding, there is a plain shaft leading to two rings in relief at the bottom and mounted on three lion's paw feet. Large leaves project between these.

There are a number of comparable candelabra in Naples: Tarbell, *Bronzes*, 107ff., figs. 44-59. Two examples in Paris, the first from Pompeii, are particularly cogent: De Ridder, Louvre *Bronzes*, II, 153f., nos. 3170, 3164, pl. 113.

E. Robinson, *Ann. Rep.* 1898, 34; *AA* 1899, 138.

496

497

497

BASE OR STAND FOR A LAMP
Graeco-Roman
H.: 0.168m.
Purchased by Subscription 72.390
General di Cesnola Collection.
From Cyprus.

One large and one small hole near the top.
Spots of bright green.

Four animal-paw feet support the bottom,
below various stages of hammered and
turned moulding.

Compare the so-called Syrian candelabrum
in Paris: De Ridder, Louvre *Bronzes*, II, 155,
no. 3183, pl. 113. This could well have been
the base for the wooden shaft surmounted by
lotus petal, saucer-lamp supports, found on
Cyprus: see Richter, New York *Bronzes*,
366ff.

498

LAMP IN THE FORM OF A DOVE OR PARTRIDGE
Probably about A.D. 500
H. (max.): 0.11m. L. (max.): 0.135m.
Otis Norcross Fund 64.2171
From Athens.

Lid on bird's head and separately cast plug
for circular base of the lamp are missing.
Even, dark, black patina, overlaid with con-
siderable encrusted earth.

The lamp was suspended by a chain at-
tached to the ring in the strip of bronze ris-
ing out of the bird's back. The lid on top of
the bird's head was attached to the swivel-pin
which remains between the little knobs at
the back of the head.

The bird is very stylized. His beak and
prominent side feathers *seem* to make him a
partridge rather than a dove or pigeon. His
tail is not elaborate enough for a peacock,
although the missing lid could have included
a peacock's crest, and one could think of the
peacock's tail being formed by the smoke
and flame rising from the spout.

There are a number of other such lamps,

498

and they come mainly from Early Christian
Egypt (Berlin: O. Wulff, *Altchristliche und
Mittelalterliche Byzantinische und Italien-
ische Bildwerke*, 172, nos. 769ff., pl. 36: dated
fifth or sixth centuries A.D.; J. Strzygowski,
*Catalogue général du Musée du Caire, Kop-
tische Kunst*, 291f., nos. 9139ff., pl. 33;
Athens, National Museum: *Collection
Hélène Stathatos, Les objets byzantins et
post-byzantins*, 63f., no. 64, pl. 6 E: dated
fifth century). Despite incompleteness, the
eye set off like that of a partridge, the
picked-out plumage of the breast, and the
curved form of the body give this bird a
good place in the repertory.

Vermeule, *Ann. Rep.* 1964, 34; *idem, CJ* 61 (1966)
309f., 308, fig. 27.

499

VESSEL IN THE SHAPE OF A LAMP-FILLER
Late Antique or Mediaeval
H.: 0.044m. DIAM. (with spout and handle):
0.09m.
Gift of Richard R. Wagner 65.1705
From Istanbul.

Brownish, green patina with encrustation.
 The body has ovolo fluting in relief, small

upcurved spout and volute-shaped handle.
On the bottom are incised lines and a medal-
lion with an inscription, probably Islamic.

Vermeule, *Ann. Rep.* 1965, 68.

500

PYXIS OR SMALL JAR
Late Antique or Mediaeval
H.: 0.042m. DIAM.: 0.062m.
Gift of Richard R. Wagner 65.1706
From Istanbul.

Patina as previous.
 This is evidently a pair with the previous
(65.1705), but the bottom is concave, and
there are no traces of handles.

Vermeule, *Ann. Rep.* 1965, 68.

499

500

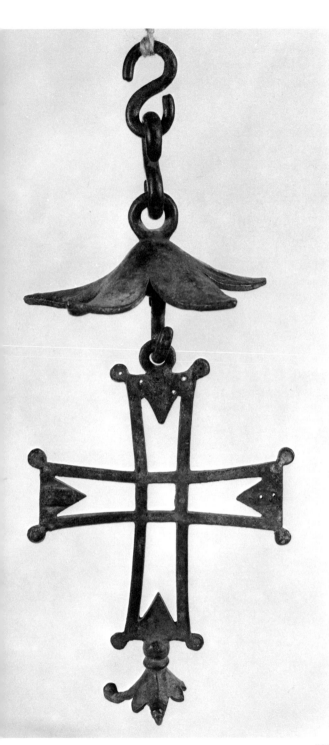

501

**PENDANT CROSS SUPPORT FOR A
CANDELABRUM (OR INCENSE-HOLDER)
(POLYCANDILON)**
Byzantine, perhaps Eighth Century A.D.
H. (max.): 0.185m. (top part).
H. (max.): 0.0245m. (bottom).
William E. Nickerson Fund, No. 2 64.704
Acquired in Istanbul; said to come from
Constantinople.

Attachments to surface of cross now missing.
Green patina; one petal of flower suspended
at bottom of cross now broken away.

The pendant is in two parts: three "S"-
shaped hooks, two above and one below a
flower petal (inverted) with loops. The cross
hooks onto the lower "S" and has, in turn,
its own eye for a hook at the bottom.

Compare P. Orsi, *Sicilia Bizantina* I, 181,
fig. 86. There is a polycandilon with a cross
in the Byzantine Museum, Athens. An ex-
ample in Berlin, dated seventh century and
from the general region of Smyrna, has a
similar but simpler chain (O. Wulff, *Alt-
christliche und Mittelalterliche Byzantinische
und Italienische Bildwerke*, 211, no. 1007,
pl. 49).

Vermeule, *Ann. Rep. 1964*, 34f.; *idem, CJ* 61
(1966) 310, 308, fig. 28.

501

502

PATERA
Graeco-Roman
DIAM.: 0.16m.
H. L. Pierce Fund 99.487
E. P. Warren Collection.

Much of the crusty green patina has been
removed.
 Umbo in center; undecorated.
 There is a similar example in the collection
in terracotta (P8383).

E. Robinson, *Ann. Rep.* 1899, 42; *AA* 1900, 217;
AJA 4 (1900) 511.

503

504



503

PATERA
Graeco-Roman
DIAM.: 0.184m.
*Gift of the Archaeological Institute of
America 84.82*
From sarcophagus No. 102 at Assos.

Green encrustation and rust.
 Has foot-rim and moulded rings under-
neath.

504

BOWL
Roman, circa A.D. 50
DIAM. (max.): 0.23m.
Gift of Mrs. Henry Lyman 62.187

Green patina.
 This large, flat bowl has a turned rim and
two raised, concentric circles in the center.
 Compare Richter, New York *Bronzes*,
219ff., nos. 607, 608, 613 (from Cyprus), and
Naples, no. 68763 = Chiurazzi, no. 350
(from Pompeii).

Vermeule, *Ann. Rep. 1962*, 32.



Etruscan

505

PLASTIC VASE: HEAD OF APHRODITE
Hellenistic Period
H.: 0.105m.
H. L. Pierce Fund 98.682
E. P. Warren Collection.
From a tomb between Ferentinum and
Bomarzo; found with two other vases (no.
508 and 518).

The eyes were inserted, in white paste with
stones (?). The handle and cover are missing.
Dark and light green patina with heavy
earth encrustation.

 She wears a diadem, earrings, and a neck-
lace of pendants. The handle was attached by
figures of two doves on the diadem.

 This class of plastic vase has been dis-
cussed *in extenso* by S. Haynes and H.
Menzel *(Jahrbuch des Römisch-Germanischen
Zentralmuseums Mainz 6* [1959] 110-127,
especially pl. 49, 2). The closest examples,
classified according to style of the hair and
the subsidiary decorations, are in Group III
(117f.). Compare, also, S. Haynes, *Etruscan
Bronze Utensils*, The British Museum, 27, pl.
16.

E. Robinson, *Ann. Rep.* 1898, 34; *AA* 1899, 138.

The Pomerance Collection of Ancient Art, 111,
under no. 129 (wrong acc. no.).

505

505

506

507

506

SUPPORT FOR A BASIN
Seventh Century B.C.
L.: 0.089m.
Gift of Mrs. James P. Tolman 22.728
Buffum Collection.
From Praeneste.

Somewhat crusty green patina.

The support curves out and down to a lug
and a foot. On the horizontal section is the
figure of a horse, with piggy snout and ser-
rated mane.

Compare H. Hencken, *AJA* 61 (1957) 1-4,
especially figs. 5, 7, 10, 12 and 14: Archaic
III, at Tarquinia, supports for bronze basins;
for the Eastern relationships of these Italic
rider tripod supports, in connection with the
Peabody Museum (Cambridge) example, see
G. M. A. Hanfmann, *Critica d'Arte* 10 (1937)
163, 161, pl. 123, fig. 13. Also C. Hopkins,
CJ 60 (1965) 218f., fig. 6; *BMMA* 1954, 61,
illus. (a cauldron with six legs of this general
type).

507

HANDLE OF AN AMPHORA
Fifth Century B.C.
H.: 0.197m.
H. L. Pierce Fund 99.464
E. P. Warren Collection.
Bought in Milan.

Smooth blue-green patina.

The base is in the form of a bearded satyr
sitting on the ground and playing the syrinx.
Small volutes support his feet, and there is
a cockleshell where these join. At each end of
the upper attachment is a deer, curled up asleep.

A near-duplicate handle, from Vulci, is in
a private collection in Haverford, Pennsyl-
vania (*Archaeology* 11 [1958] 292, then with
Hesperia Art: *Bulletin V*, no. 59, dated ca.
450 B.C.), and an amphora in Berlin (Frieder-
ichs 674; Gerhard, *AZ* 14 [1856] col. 161, pl.
85; Baldes, Behrens, *Birkenfeld*, 51f., pls. 3f.)

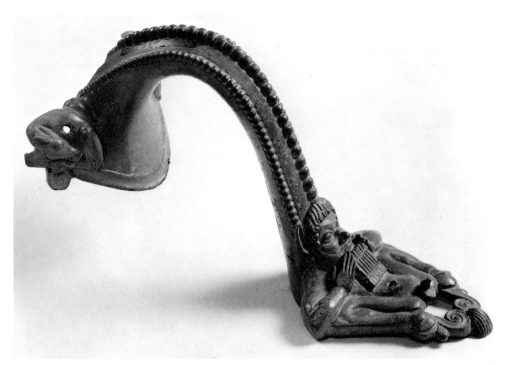

507

gives the setting. Compare also a pointed amphora in the Vatican, also from Vulci (Banti, *Die Welt der Etrusker*, pl. 58; *Museum Etruscum Gregorianum*, I, 2, pl. 8, 2; Neugebauer, *Bilderhefte zur Kunst-und Kulturgeschichte*, II, pl. 20, 1), and tripod supports in the Gillet collection, Lausanne; also Neugebauer, *RM* 38-39 (1923-24) 351ff. and Reinach, *Rép. stat.*, II, 59, nos. 3-4 (the Berlin example).

On squatting satyrs as handle attachments of bronze vases, see H. Bulle, *Die Silene in den archaischen Kunst*, 37ff.

E. Robinson, *Ann. Rep.* 1899, 44; *AA* 1900, 218.

Mitten-Doeringer, *Master Bronzes*, under no. 199.

Exhibited: Worcester Art Museum, *Masterpieces of Etruscan Art*, 73-74, no. 62, 166, fig. 62.

508

508

AMPHORA

Fourth Century B.C.

H.: 0.12m.

H. L. Pierce Fund 98.684

E. P. Warren Collection.

From a tomb between Ferentinum and Bomarzo; found with two other vases (no. 505 and 518).

The cover is missing. A piece of twisted wire, the remains of a chain, is attached to each handle by a link. Crusty medium green patina, with gray areas.

The body and foot are undecorated. The spiral handles, made separately, were attached with solder; they are made of solid rectangular, heavy wire.

E. Robinson, *Ann. Rep.* 1898, 34; *AA* 1899, 138.

509

509

HANDLE, PROBABLY OF A STAMNOS (OR LARGE, OPEN BOWL)

Fifth Century B.C.

H. (max.): 0.13m. W. (max.): 0.14m.

William E. Nickerson Fund, No. 2 64.280

Deep green patina, with light areas.

The attachments are in the form of lanceolate leaves and are decorated with Silenus masks below pairs of volute-scrolls, all in ogee mouldings.

The mate is in a private collection in Haverford, Pennsylvania (G. Roger Edwards, University of Pennsylvania, The University Museum, *What we don't know*, no. 21).

This type of handle seems to have been one of the most common for Etruscan funerary purposes, the stamnoi no doubt having been used for the ashes of the deceased. Generally, these handles are of lesser quality than the example illustrated here. They usually feature the motif of a Silenus head and foliage. Some have very plastic Silenus heads or masks, while others are reduced to showing mere volutes and palmettes in low relief (whole vases: De Ridder, Louvre *Bronzes*, II, 108, no. 2659, pl. 97; Schumacher, Karlsruhe *Bronzen*, pl. 9, no. 16, 116, nos. 616ff.; see also Richter, New York *Bronzes*, 32, nos. 50f.). A pair of handles in the British Museum, work of the third or second centuries B.C., demonstrates where these designs led in the period of transition from late Etruscan classical to Italic or Roman Republican art of the Hellenistic period. Two well-modeled heads wearing Phrygian caps, probably the Dioskouroi, rise from leafy calyxes (Walters, British Museum *Bronzes*, 323, no. 2480). The best examples of these Silenus-faced handles must have been made by men trained in the craftsmanship of the Greek cities around Naples or Capua, while those of lesser technical skill and clumsier design testify to workshops in various small Etruscan towns. The finest handles no doubt come from the rich and famous Etruscan cemeteries, principally Vulci, Cerveteri, and Tarquinia.

Vermeule, *CJ* 61 (1966) 299ff., 294, fig. 13.

ArtQ 27 (1964) 370; Mitten-Doeringer, *Master Bronzes*, under no. 201.

Exhibited: *Our Ancient Heritage*, Philbrook Art Center, 7 Oct. - 27 Nov. 1963, no. 314.

510

HANDLE OF A (LARGE BASIN) STAMNOS
Late Fifth to Fourth Century B.C.
H.: 0.141m. W.: 0.13m.
Purchased by Contribution 01.7488
E. P. Warren Collection; Forman Collection.

Somewhat corroded. Pale green patina.

The tubular, horizontal handle has a
raised, beaded band in the center. At each
end, there is a group of two figures in relief:
A: Youth with lyre, strapped to his left
wrist, seated on his chlamys; a crouching
woman in girt chiton is cutting his throat.
Plectrum on ground between them. B: Youth
in chlamys and Attic helmet stabs a draped
woman in the throat. She places her right
hand on his knee and clutches her breast
with the left.

These two violent scenes could have their
basis in Greek mythology, one being
Orpheus meeting death at the hands of a
Thracian woman and the other Orestes
slaying Clytemnestra.

E. Robinson, *Ann. Rep.* 1901, 36.

Forman Sale II, *Catalogue*, no. 575.

511

HANDLE
Fourth Century B.C.
H.: 0.16m. L.: 0.15m.
Gift of Denman W. Ross 04.3
One of a pair found at Città della Pieve.
(The other is in the Berlin Antiquarium, inv.
no. 7900.)

Green patina; much corroded.

A nude youth, in sandals, lies with his
right hand under his head and his left on his
thigh, making his body a bridge between
two supports which rise from a plaque in
the shape of a half-ellipse decorated with two
rams' heads left and right of an inverted
palmette.

For the possibilities that this youth, ap-
parently asleep rather than dead, is Endy-
mion or Adonis, see under the following.

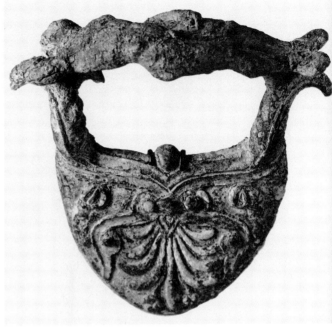

511

B. H. Hill, *Ann. Rep.* 1904, 64; *AJA* 9 (1905) 372;
AA 1906, col. 262; Vermeule, *CJ* 56 (1960) 7.

Worcester Art Museum, *Masterpieces of Etruscan
Art*, 82, under no. 72.

512

PAIR OF HANDLES FROM A STAMNOS
Circa 400 B.C.

L.: 0.17m.

William E. Nickerson Fund No. 2 60.232a, b
From the Florence Art Market.

The dog is missing at the foot of one handle.
The bottom and most of the rim of the
stamnos are preserved; the former has line-
moulding and the latter a bead and ovolo
pattern on the outer edge. Brown patina with
light surface corrosions, sometimes in
gray. Evidence of burning, presumably in
antiquity.

On each handle, a long-haired youth re-
clines asleep, his head on the chlamys
wrapped around his left arm and high boots
or sandals with straps around his ankles
and on his feet. Head and feet are attached

by lotus buds to large, inverted palmettes
and volutes. On the rectangular plinths
above each palmette, a seated dog faces in-
ward.

In both instances the young hunter's body
turns and curves in making a transition
between the convex surface of the jar and
the artistic demands of the human figure in
repose above complex attachments. The
youth's face, and he may be Endymion, or
Adonis, shows the distinct freshness impart-
ed to a Greek type of about 400 B.C. by
Etruscan or Campanian artists with ability
both aesthetic and technical. The jar was
evidently a cinerarium, and the sleeping hero
made an appropriate double decorative
guardian for the remains of the Etruscan
who had been consigned to the eternal repose.

MFA, *Calendar of Events*, November 1960, 2,
illus.; Vermeule, *Ann. Rep.* 1960, 36; idem, *CJ* 56

(1960) 7, figs. 6, 7; *FastiA* 15 (1960) no. 665.

W. Merkel, *Worcester Sunday Telegram*, Jan. 29, 1961, C 7, illus.; Münzen und Medaillen, Auktion XXXIV, May 6, 1967, under no. 187.

Exhibited: Worcester Art Museum, *Masterpieces of Etruscan Art*, 81-82, no. 72, 175, fig. 72.

513

HANDLE OF A JUG (OINOCHOE)
Circa 580 B.C.
H.: 0.14m.
Seth K. Sweetser Fund 63.788
From Vulci.

Green patina, with bluish areas.
 At the top, a human head (beardless?) between two snake-like duck's (?) heads at the ends. At the bottom, the mask of a goddess between snake's heads. The handle is ridged and is decorated with incised lines.
 Compare D. von Bothmer, *BMMA* 1961, 145, fig. 18, 148f., and Rolley, *L'Écho d'Auxerre* 46 (1963) 3f. Others are in the Villa Giulia Museum.

Vermeule, *Ann. Rep. 1963*, 42; *idem, CJ* 60 (1965) 304f., fig. 20.

513

513

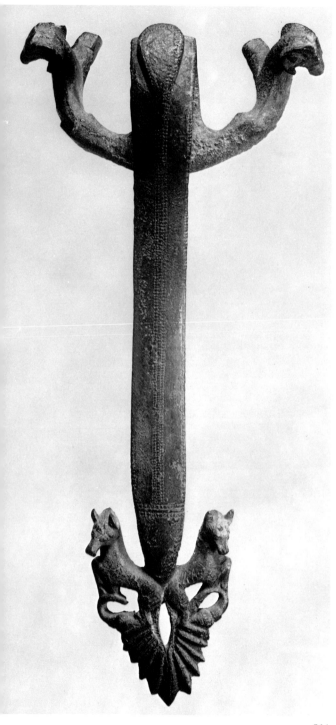

514

514

HANDLE, PERHAPS OF AN OINOCHOE
Fifth Century B.C.
H.: 0.305m.
H. L. Pierce Fund 99.459
E. P. Warren Collection.
Bought in London.

Dark green crusty patina.

At the upper end a crescent, on each arm
of which is a couchant ram. The base is
in the form of two rearing colts, back to
back, on an inverted palmette.

Brown termed this handle "non-Vulcian,"
and G. Ortiz (verbally) has suggested that
it is Etruscan. Edward Robinson had already
noticed, in his *Report* for 1899, its identity
with the example in the Louvre (from
Reinach, *Rép. stat.*, II, 744, no. 5).

E. Robinson, *Ann. Rep.* 1899, 42f.; *AA* 1900, 217.

De Ridder, Louvre *Bronzes* II, 107, no. 2647;
W. L. Brown, *The Etruscan Lion*, 124.

515

LONG-SPOUTED JUG (BEAKED OINOCHOE)
Early Fifth Century B.C.
H.: 0.268m.
Perkins Collection 96.711
E. P. Warren Collection.
Bought near S. Maria di Capua.

Part of the surface has a crusty blue-green
patina.

The handle ends on the rim in two re-
cumbent leopards and at the base in double
volutes and a large palmette. Bead,
ovolo and volute patterns are represented on
the rim or lip, and the latter has an ovolo
pattern leading to a stylized waterleaf and
bud design on the neck under the handle. The
base or foot has a rolled-fillet moulding
with cable design. There is a pair of seated
lions of mid-archaic type facing each other
on the top of the lip at the base of the spout.

Compare the jug in Munich: Jacobsthal,
Die Bronzeschnabelkannen, pl. 3, no. 27;

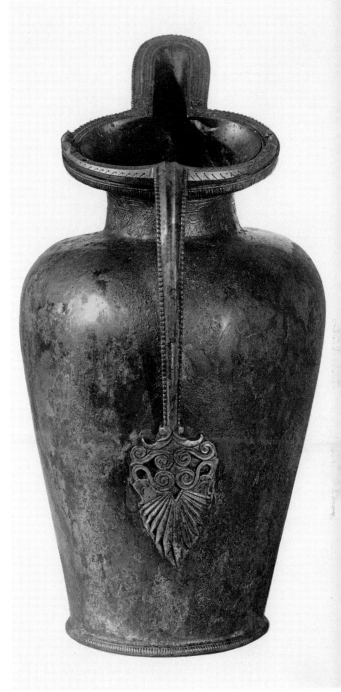

515

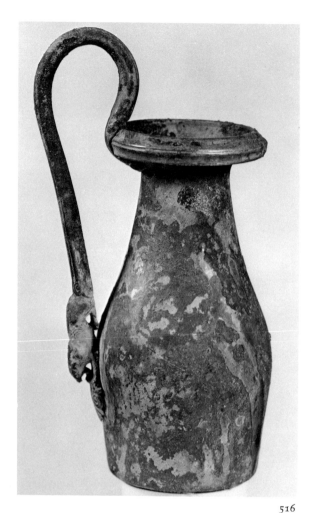

516

517

and Paul I. Ilton Collection, Sale, Lot 663, pl. 10.

E. Robinson, *Ann. Rep.* 1896, 30; *AA* 1897, 73; Vermeule, *TAPS* 50 (1960) 32, under no. 488.

P. Jacobsthal, A. Langsdorff, *Die Bronzeschnabelkannen*, 90, pl. 4, no. 38.

516

JUG WITH HIGH HANDLE (ROUND-MOUTHED OINOCHOE)
Circa 500 to 450 B.C.
H. (to lip): 0.138m. H. (to top of handle): 0.18m.
Perkins Collection 95.71

E. P. Warren Collection.
Bought in Rome.

Gilded. Dark and light green patina, with various encrustation.

Below two small volutes at the base of the handle, a lion crouches downwards, his paws resting above two Ionic scrolls and a palmette.

Brown lists twenty-one such jugs and/or handles. This handle and that in Geneva (no. 1), characterized as the finest in the group, show the lion marked off by a series of wave-spirals in the transition from animal to handle (see also Amandry, *AM*

77 [1962] 50f., note 100).

P. Jacobsthal, A. Langsdorff, *Die Bronzeschnabel-kannen*, 95, pl. 29 a; *The Pomerance Collection of Ancient Art*, 114, under no. 133; Magi, *La raccolta Benedetto Guglielmi*, II, 197, under no. 38; W. L. Brown, *The Etruscan Lion*, 130, pl. 47 b (not Tyszkiewicz); D. K. Hill, *The Muses at Work*, ed. by C. Roebuck (Cambridge, Mass., 1969) 83, 86, 87, fig. 11.

517

PITCHER OR JUG
Circa 450 to 400 B.C.
H.: 0.195m. H. (max. incl. handle): 0.227m.
Bequest of Charles H. Parker 08.540
Alfred Greenough Collection, no. 197.

Crusty green patina with much plaster restoration.

A substantial section of the body has been crudely restored in plaster. There are a number of fragments set in this plaster. The handle belongs, a fact evidenced by the rivet on the inside, at the lip. The handle is fashioned with lotus stem moulding and terminates at the base in an archaic Gorgomask on a circular disc. The mask has protruding tongue and rosette earrings. It is the type of elegant but distorted Campanian or South Etruscan creation after Greek models that leads in later years to the designs on Etruscan coins.

Compare De Ridder, Louvre *Bronzes*, II, 112f., nos. 2713-2730, pl. 98; Richter, New York *Bronzes*, 191, no. 495.

Vermeule, *Ann. Rep. 1965*, 68.

518

VASE WITH COVER
Fourth Century B.C.
H.: 0.14m.
H. L. Pierce Fund 98.683
E. P. Warren Collection.
From a tomb between Ferentinum and Bomarzo; found with two other vases (no. 505 and 508).

518

Irregular green patina.

The vase is pear-shaped, and the turned, knob-topped lid is connected to the neck at either side by a chain which continues to a small bail for suspension.

E. Robinson, *Ann. Rep. 1898*, 34; *AA 1899*, 138.

D. M. Robinson, *Olynthus* X, 77.

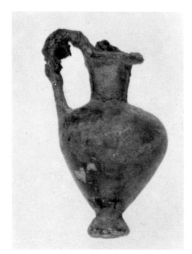

519

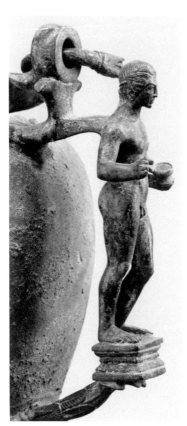

520

519

ToY OiNOCHOE
Fourth Century B.C. or later
H.: 0.049m.
Gift of Mrs. James P. Tolman 22.727
Buffum Collection.
From Praeneste.

Green patina and encrustation.
This tiny, solid vase has a trefoil lip; body and handle are undecorated.

520

SiTULA AND COVER
Circa 400 B.C.
H.: 0.368m.
Gift of E. P. Warren 91.228a, b

The situla and cover are thickly covered with green corrosion; earth encrustation remains in spots.

The vertical handle at the back takes the form of a standing youth, of Polykleitan proportions, with fillet in his long, athlete's hair and open pyxis in his left hand. He stands on a small, rectangular, moulded plinth; honeysuckle ornament above and below forms the connection to the body of the bucket and (above) also the loop for the handle. The spout takes the form of a griffin's head with a hoof protruding from its mouth. The swinging handle of situla type passes through attachments on the shoulder (front) and on the rear handle. The ends of the bail form closed lotus buds. In the center of the circular lid there is a crouching panther.

This bucket was long thought to have been Greek in workmanship and may well be the product of Campanian craftsmen working for the central Etruscan market. D. K. Hill has observed, however, that such vessels and especially a group of handles from them (see also the following) can be identified with a workshop in or near Bologna. The bizarre combination of youth with pyxis, griffin's head with foot in its mouth, and sinuous,

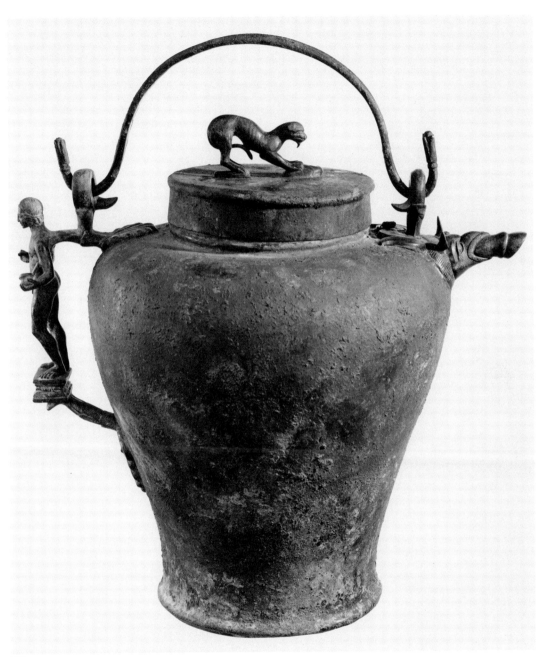

520

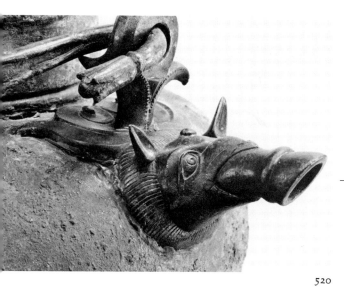

520

520

crouching feline seems Etruscan rather than South Italian Greek in taste.

E. Robinson, *Ann. Rep.* 1891, 11f.; Chase, *Antiquities*, 2nd edition, 193f., 206, fig. 194.

Reinach, *Rép. stat.*, IV, 468, 1 (panther only); 44, no. 9 (seems to be this rather than the following); D. K. Hill, *AJA* 69 (1965) 117f., pl. 28, figs. 5-7; B. Goldman, *Ipek* 22 (1966/1969) 75, pl. 49, fig. 20.

521

HANDLE OF A SITULA
Fourth Century B.C.
H.: 0.154m.
Purchased by Contribution 01.7500
E. P. Warren Collection.
Bought in Rome.

Somewhat corroded. Reddish brown color. The head of the youth and the outer side of his left leg are worn, as if the handle had been grasped on frequent occasions.

The handle is in the form of a nude youth standing in hipshot pose on a semi-circular base, leading down to an arrow-shaped attachment to the body. From the shoulders springs the curved support which attached it to the vase. In the middle of this is the loop for the bail. The youth holds an animal's foot (?) or plectrum in his right hand and rests his left arm on his hip.

E. Robinson, *Ann. Rep.* 1901, 36.

D. K. Hill, *AJA* 69 (1965) 119, pl. 29, fig. 10.

522

HANDLE-BASES OF A SITULA
Fourth Century B.C.
H.: 0.091m. W.: 0.11m.
Harriet Otis Cruft Fund 63.1516a, b
George Ortiz Collection; Hirsch Sale,
Lucerne, 7 Dec. 1957, Lot 53.

Each is missing one of the wing-ends beyond the handle rings. Rich, even green patina, with slight pitting on one example.

In each instance, a female head with dia-

dem or stylized wreath and necklace rises
from the rings of the situla handles. Below
are a pair of volutes and a flat, crescent-
shaped plate. The latter has a Gorgo with
vines, tendrils, and palmettes springing left
and right in relief.

There is a similar handle in the Museo
Archeologico, Venice. Langlotz noted the
comparison (of the Gorgo?) with coins of
Populonia. The style of the head seems akin
to that of an Etruscan votary in the British
Museum (Lamb, *Greek and Roman Bronzes*,
pl. 66, b) and a lifesized terracotta head
of a diademed female in Boston, from Cer-

veteri (88.358; *CJ* 61 [1966] 296, fig. 16, 301).

For a most elaborate situla handle and
plate "in Etruscan style," see Babelon-
Blanchet, *Bronzes*, 587, no. 1463. The situla
from Carmignano, in the Museo Archeo-
logico, Florence (A. Ciasca, *Il capitello detto
eolico in Etruria*, 46, no. 15, pl. 19) shows
the amphoroid shape which permits such a
broad, slightly curving base plate. The
plates rested on the shoulder, and the hori-
zontal sections rose up beside the short neck.

Giant Etruscan gold ceremonial earrings
in Florence and elsewhere show similar
heads, either side of the central egg-like

521

521

bosses (G. Becatti, *Oreficerie antiche, dalle minoiche alle barbariche*, no. 415, pl. 111). Jewelry enables one to trace the Greek sources of this widespread late Etruscan style to Tarentum, for it occurs in tiny Tarentine "head-vases" (Becatti, *op.cit.*, no. 388 a-b, pl. 102; also C. Carducci, *Ori e argenti dell'Italia antica*, 34, pl. 35 b).

Vermeule, *Ann. Rep. 1963*, 42; idem, *CJ* 61 (1966) 301, 295, fig. 14; H. Hoffmann, M.F.A., *Calendar of Events*, March 1964, 2, illus.

Langlotz in *Bedeutende Kunstwerke aus dem Nachlass Dr. Jacob Hirsch*, *loc. cit.*

Exhibited: Worcester Art Museum, *Masterpieces of Etruscan Art*, 80-81, no. 71, 192, fig. 71.

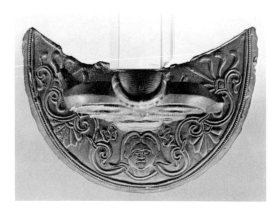

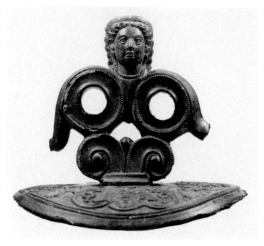

CISTA WITH COVER
Fourth Century B.C.

H.: 0.30m. DIAM.: 0.24m.

Gift of E. P. Warren 93.1439a, b

From Palestrina.

The body has been mostly cleaned of a mild encrustation; beneath, there is a rich green patina.

The three feet are in the form of lion's paws, and there is a crouching lion on each.

On the cover, Dionysos, satyrs and maenads.

On the body, a camp scene with various activities, and a vista of a young man clutching or carrying a child and being pursued by two Furies, while a woman (asleep or dying) breathes out flame or smoke in the left foreground.

The first scene may be the slaughter of a Trojan captive in the presence of Achilles, who is arming to set off to war. The second scene could be the infant Dionysos being carried off from his dead mother by Hermes.

Possibly found in the cista were a sponge, a glass alabastron, a wooden box in the shape of a horse's head, an ivory double comb, a cylindrical wooden ointment box with cover (93.1440-93.1442, 93.1444), an oval bronze box (93.1443) and two bronze hairpins with spatulate ends (93.1445).

E. Robinson, *Ann. Rep. 1893*, 17-19; *BMFA* 1 (1903) 15; J. Addison, *The Boston Museum of Fine Arts*, 297; Chase, *Antiquities*, 133f., fig. 169; 2nd edition, 194, 208, fig. 197; H. Palmer, *Archaeology* 7 (1954) 179, illus.; *FastiA* 9 (1954) no. 2587.

S. Reinach, *RA* 25 (1894) 117; Matthies, *Die Praenestinischen Spiegel*, 59f., note 1; R. Herbig, *RM* 42 (1927) 119f.; L. B. Warren, *AJA* 68 (1964) 42, pl. 16, fig. 15; *The Pomerance Collection of Ancient Art*, 109, under no. 126.

523

523 523

524

HANDLE OF A SMALL CISTA
Fourth or Third Centuries B.C.
L.: 0.08m.
H. L. Pierce Fund 99.476
E. P. Warren Collection.
Bought in Rome, together with three cista
feet (no. 526).

Dark bluish-green patina with brown crust
on the back.

A youth lies face upward, with body
arched, arms raised beside the head and palms
upwards. The legs are together, and the feet
are correspondingly so, on the small circu-
lar plinth above the rear tenon. Both
tenons are pierced for attachment within
the lid.

Compare the acrobat as a cista handle:
Bielefeld, *Wiss. Zeitschr. . . . Greifswald* 7
(1957-58) 192, 199, fig. 11 and refs.;
Münzen und Medaillen, Auktion XXII, May

1961, 39, no. 73; Sieveking, *Bronzen der
Sammlung Loeb*, 23f.; Collection Borelli Bey,
32, no. 272, pl. 31.

Cista no. 13133 in the Villa Giulia Mu-
seum shows just such an acrobat *in situ*: R.
Herbig, *Charites*, 182ff., pl. 32. He also
appears as the handle on a rectangular cista
in the Louvre, but this may be a restoration:
De Ridder, Louvre *Bronzes*, II, 40f., no.
1671, pl. 74: and on a cista in Copenhagen:
Bildertafeln des Etruskischen Museums,
pls. 100f.

E. Robinson, *Ann. Rep.* 1899, 47; *AA* 1900, 218.

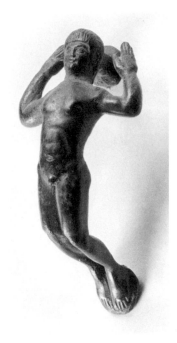

524

525

525

525

Two Feet of a Cista
Fifth Century B.C.
H. (of a): 0.108m. H. (of b): 0.11m.
H. L. Pierce Fund *99.466a, b*
E. P. Warren Collection.
Bought in Paris.

Green crusty patina. A bit of wood was to be seen inside of one of them.

On top of each, a winged female clad in chiton and himation runs to the right carrying a similarly clad, wingless female in her arms. Below a bead and fillet moulding, the foot itself is in the form of a lion's foot, resting on a fringed cushion.

E. Robinson, *Ann. Rep. 1899*, 45; *AA 1900*, 218.
Exhibited: Dayton, *Flight Fantasy, Faith, Fact*, 5, no. 32.

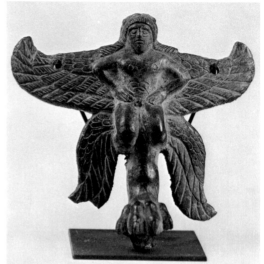

526

THREE FEET OF CISTA
Late Fifth or early Fourth Centuries B.C.
H.: 0.078m. W.: 0.087m.
H. L. Pierce Fund 99.475a-c
E. P. Warren Collection.
Acquired in Rome, together with a cista
handle (no. 524).

One of the lower wings on two of the feet is
slightly broken. Bright green patina.

In each case, a wreathed or filleted boy
with large wings is kneeling, hands on his
hips, on a winged lion's paw. Nipples,
stomach muscles, and both sets of feathers
are represented by incision.

Compare the foot of a thymiaterion in
Copenhagen: *Bildertafeln des Etruskischen
Museums*, pl. 95, a.

E. Robinson, *Ann. Rep.* 1899, 47; *AA* 1900, 218.

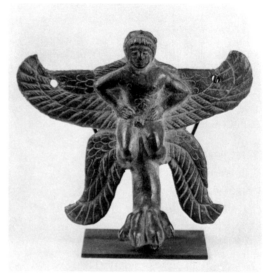

527

JAR

Early Fifth Century B.C.

H.: 0.078m. DIAM.: 0.068m.

H. L. Pierce Fund 99.484

E. P. Warren Collection; Tyszkiewicz
Collection.

From Città Castellana.

The high, ear-shaped handle is missing.
Turquoise patina.

The offset lip has a bead and fillet mould-
ing above an ovolo pattern. On the lower
part, there is a guilloche, incised, between
two thin fillets and bead mouldings. The
groove where the handle was attached is
visible on the lip.

Other examples are in the Metropolitan
Museum: Richter, New York *Bronzes*, 179,
206ff., under no. 570 (also nos. 571, 572),
and in the Museum at Spina, with single
handles: Aurigemma, Alfieri, *Museo Nazion-
ale Archeologico*, pl. 18.

E. Robinson, *Ann. Rep.* 1899, 41; *AA* 1900, 217;
AJA 4 (1900) 511.

Froehner, Tyszkiewicz Sale, *Catalogue*, 43f., no.
127.

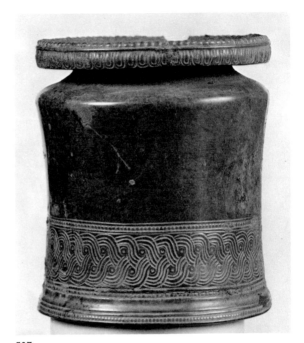

527

528

Bowl

Archaic Period

H.: 0.06m. DIAM. (inside rim): 0.225m.

Gift of Miss Elizabeth W. Perkins 97.499

Marks indicate attachments for two handles, now missing. Cracked along the rim. Crusty green patina.

Hemispherical and undecorated.

Compare in the sixth or fifth century, Ars Antiqua Sale, Lucerne, 14 May 1960, 45, no. 115, pl. 47.

529

Girl

Third Century B.C. "Faliscan"

H.: 0.18m. H. (of figure): 0.148m.

H. L. Pierce Fund 98.679

E. P. Warren Collection.

Rich green patina.

She is a support for some large object, probably a patera handle. She carries its base on her head. She wears a fillet, a necklace with tooth-shaped pendants and a bulla, and low shoes. The back of the base or support is decorated with a large palmette in relief.

A cruder version of this figure has been dated in the fourth century B.C.: Ars Antiqua Sale, Lucerne, 14 May 1960, 38f., no. 89, pl. 40.

E. Robinson, *Ann. Rep.* 1898, 33; *AA* 1899, 138; Chase, *Antiquities*, 132f., fig. 168; 2nd edition, 193, 205, fig. 193.

Exhibited: Worcester Art Museum, *Masterpieces of Etruscan Art*, 93, 96, no. 87, 195, fig. 87.

529

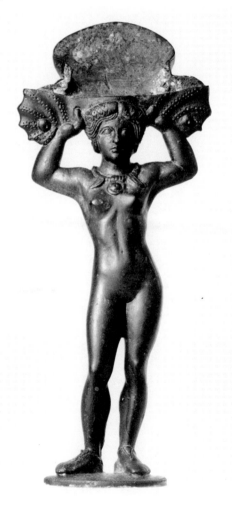

529

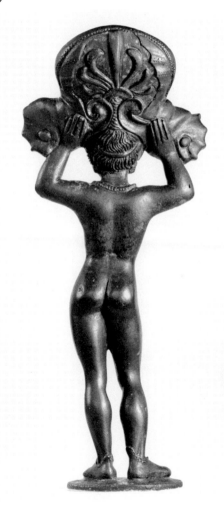

530

PATERA
Hellenistic Period
L.: 0.383m. DIAM.: 0.206m.
Francis Bartlett Collection 03.989
E. P. Warren Collection.
Bought in Rome.

Pale green patina.

The shallow bowl has a ring and bracket on the upper rim. At the opposite or lowest part is attached a yoke supported by a nude girl holding a strigil (?) in the right hand and placing the left on her hip. She wears her hair done up in a cloth, a necklace, and low shoes. She stands on a triangular plinth, with another ring for suspension attached to its bottom.

Compare De Ridder, Louvre *Bronzes*, II, 137, no. 3019, pl. 106 and references; Giglioli, *L'Arte etrusca*, pl. 313. This is a fairly common late Etruscan or Italic dish and handle. One example has been known in artists' sketches made in Rome since about 1620. Here the dematerialized, rubbery anatomy is characteristic of central Italian figural style before Hellenistic influences make themselves felt in Roman Republican decorative and minor art.

B. H. Hill, *Ann. Rep.* 1903, 62; *AA* 1904, 194; *AJA* 8 (1904) 383.

Reinach, *Rép. stat.*, IV, 197, no. 6 (figure alone).

531

SIX PATERAE OR BOSSES
Archaic Period
AVERAGE DIAM.: 0.21m.
H. L. Pierce Fund 98.687 – 98.691 &
98.691a
E. P. Warren Collection.
Bought in Rome; said to have been found in a tomb at Ferentinum, together with two gold rings (98.774-775), six gold dress ornaments (98.778-783), two gold buttons (98.800-801) and an Attic black-figure amphora (98.918).

Crusty green patina. One has a hole in the outer or curved area and several have chewed-up edges.

They are undecorated and have been made to be attached to a wall.

E. Robinson, *Ann. Rep.* 1898, 34; *AA* 1899, 138.

531

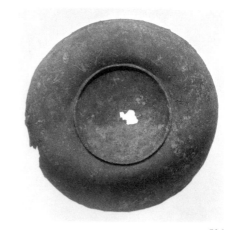

531

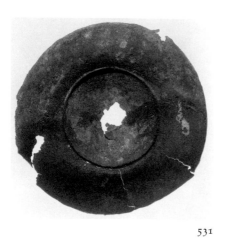

531

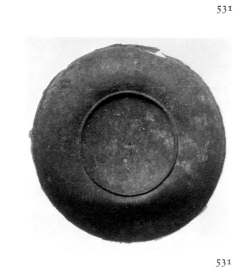

531

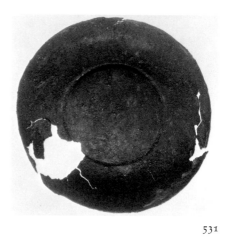

531

531

LAMP AND STAND
Roman Republican Period
H. (including handle): 0.19m.
Gift of Miss Margaret H. Jackson 18.320

Dark green patina.

The stand has a triangular base resting on three animals' hoofs and supporting a shaft made up of three snakes (?) with their heads resting on the base and the tips of their tails joined and holding a spike which fits into a socket in the lamp. The lamp has a twisted spout also decorated with a head, and a circular opening in the top, the lid of which is also decorated with a head.

L. D. Caskey, *Ann. Rep.* 1916, 97; *idem, Ann. Rep.* 1918, 87.

532

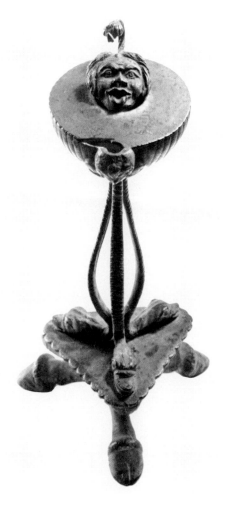

532

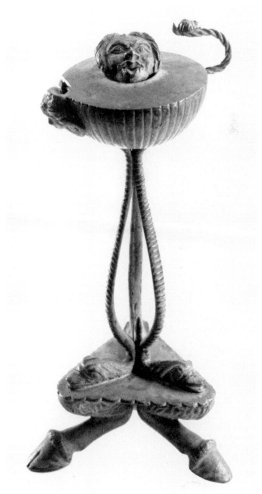

TOOLS,
WEAPONS,
ARMOR,
INSTRUMENTS

Bronze Age

533

SWORD

Late Bronze Age, 1300 to 1200 B.C.

L. (max.): 0.64m.

Classical Department Purchase Fund, in Memory of Miss Grace Nelson 61.376

Found near Bologna, with helmet (no. 586), greave (no. 587) and strigils (nos. 588-589).

Excellent preservation, with yellow (cleaned) Tiber patina.

There is a flanged tang for insertion in the hilt. Six rivets remain at the flaring portion of the blade.

In Central Europe this type of sword is termed Sprockhoff I (a).

Vermeule, *Ann. Rep.* 1961, 47 (the group); *idem, CJ* 57 (1962) 145-147, fig. 1; *FastiA* 17 (1962) no. 243.

534

SHORT SWORD OR DAGGER

Mycenaean (Helladic) 1200 to 1100 B.C.

L.: 0.424m.

Edwin E. Jack Fund 64.511

Said to come from Macedonia.

Inlaid (bone) handles and seven rivets are missing. Green patina, with abrasion (scratching) below the last surface. Edges slightly jagged.

There are two parallel, raised metal ribs on the metal binder outlining the grip and pommel.

Compare N. K. Sandars, "Late Aegean Bronze Swords," *AJA* 67 (1963) 117ff., pl. 25, no. 36 (Mycenae, Acropolis, 1890 hoard); also the dagger and double axe (see below) from the bronzeworker's hoard, found just south of the Fountain House at Mycenae: A. J. B. Wace, *Archaeology* 6 (1953) 78, figs. 7, 8; F. H. Stubbings, *BSA* 49 (1954) 292ff.; 48 (1953) pl. 2 (d) and (c) = Late Helladic III B-C.

533 534

Vermeule, *Ann. Rep.* 1964, 32; *idem, CJ* 61 (1966) 289f., fig. 1.

535

SPEAR HEAD

Mycenaean (Helladic) 1200 to 1100 B.C.

L.: 0.37m.

Edwin E. Jack Fund 64.512

Said to come from Macedonia.

Green patina.

The circular neck was joined to the shaft by a rivet, two holes surviving in the metal. The spear was cast solid, but the circular neck was hammered into its tubular form, leaving a split lengthwise along one of the flat sides.

Compare N. K. Sandars, *AJA* 67 (1963) 121, pl. 22, no. 8 (near Plovdiv) and no. 11 (near Sofia). The examples from the Agios Ioannis chamber tomb and the Acropolis tomb at Knossos are more at home in the Aegean world, although Bulgarian and Aegean spear heads are identical.

Vermeule, *Ann. Rep.* 1964, 32; *idem, CJ* 61 (1966) 289f., fig. 1.

535 536 537

536

SPEAR HEAD

Mycenaean (Helladic) 1200 to 1100 B.C.

L.: 0.35m.

Edwin E. Jack Fund 64.513

Said to come from Macedonia.

Green patina.
As previous.

Vermeule, *Ann. Rep.* 1964, 32; *idem, CJ* 61 (1966) 289f., fig. 1.

Green patina.
As previous.

Vermeule, *Ann. Rep.* 1964, 32; *idem, CJ* 61 (1966) 289f., fig. 1.

537

SPEAR HEAD

Mycenaean (Helladic) 1200 to 1100 B.C.

L.: 0.275m.

Edwin E. Jack Fund 64.514

Said to come from Macedonia.

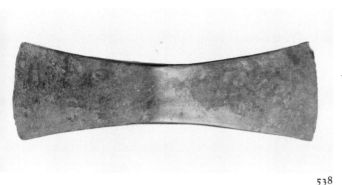

538

DOUBLE-AXE
Mycenaean (Helladic) 1200 to 1100 B.C.
L.: 0.205m.
Edwin E. Jack Fund 64.515
Said to come from Macedonia.

Green patina.
 The center is pierced ovally for the shaft,
and there are grooves at the bottom in either
edge of the hole.
 Compare N. K. Sandars, *AJA* 67 (1963)
136 (Mycenae hoard); Richter, New York
Bronzes, 433, no. 1630 (Gournia).

Vermeule, *Ann. Rep.* 1964, 32; *idem, CJ* 61
(1966) 289f., fig. 1.

Cypriote

539

DAGGER
Early to Middle Cypriote
L.: 0.117m.
Purchased by Subscription 72.401
General di Cesnola Collection.
From Cyprus.

The edges are ragged and of irregular flat-
ness. Dull green encrustation.
 The blade is flat with a ridge in the middle.
Compare Catling, *Cypriot Bronzework*, fig.
3, no. 4.

540

SPEAR HEAD
Early to Middle Cypriote
L.: 0.137m.
Purchased by Subscription 72.4884
General di Cesnola Collection.
From Cyprus.

Green patina, heavily encrusted.
 There are two rivets in the shank end, and
a ridge down the middle of the blade. As
previous.

541

SPEAR HEAD OR DAGGER BLADE
Early to Middle Cypriote
L.: 0.126m.
Purchased by Subscription 72.4883
General di Cesnola Collection.
From Cyprus.

Crusty, green patina.
 There are two rivets in the shank.

542

DAGGER
Early to Middle Cypriote
L.: 0.083m.
Purchased by Subscription 72.402
General di Cesnola Collection.
From Cyprus.

Heavy white and dull green encrustation.
 There is a ridge in the middle and three
wire attachments on each side of the handle
end.
 Compare Catling, *Cypriot Bronzework,*
fig. 3, no. 8.

543

DAGGER
Early to Middle Cypriote
L.: 0.124m.
Purchased by Subscription 72.403
General di Cesnola Collection.
From Cyprus.

Encrusted with white and green.
 This example is flat and thin, with wire
attachments at one side of the handle end.
 Compare Catling, *Cypriot Bronzework,*
fig. 3, especially nos. 3, 14 and 15.

544

DAGGER
Early to Middle Cypriote
L.: 0.127m.
Purchased by Subscription 72.404
General di Cesnola Collection.
From Cyprus.

Point gone. Green encrustation.
 The head is flat, and there is a small at-
tachment at each side of the handle end.
 Compare Catling, *Cypriot Bronzework,*
fig. 3, no. 4.

539 540 541

542 543 544

545

SPEAR HEAD
Early to Middle Cypriote
L.: 0.104m.
Purchased by Subscription 72.4885
General di Cesnola Collection.
From Cyprus.

Green patina, encrusted.
The end is spatulate; two rivets remain in
the shank.

546

SPEAR HEAD OR DAGGER BLADE
Early to Middle Cypriote
L.: 0.142m.
Purchased by Subscription 72.405
General di Cesnola Collection.
From Cyprus.

Green patina and earthy encrustation.
There are three rivets and a flat, central
ridge.
Compare Richter, New York *Bronzes*,
383f., nos. 1360ff., Type I, without tang;
see also the previous.

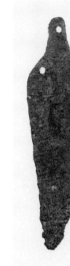

547

545　　　　　546

547

DAGGER
Early to Middle Cypriote
L.: 0.07m.
Purchased by Subscription 72.407
General di Cesnola Collection.
From Cyprus.

Dull, thin encrustation.
The blade is flat and thin. There are three
rivet holes at the shank end.
Compare Catling, *Cypriot Bronzework*,
fig. 3, nos. 1, 5, etc.

548

DAGGER
Early to Middle Cypriote
L.: 0.140m.
Purchased by Subscription 72.4879
General di Cesnola Collection.
From Cyprus.

Crusty, green patina.
There is one rivet in the shank end.
Compare Catling, *Cypriot Bronzework*,
fig. 3, no. 4.

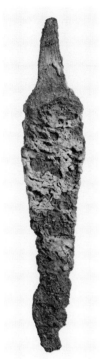

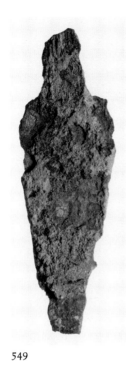

549

548

549

SPEAR HEAD
Early to Middle Cypriote
L.: 0.08m.
Purchased by Subscription 72.4888
General di Cesnola Collection.
From Cyprus.

Heavily encrusted with greenish white. The
point is broken off.
There are no attachments. As previous.

550

RAZOR (OR DAGGER WITH END BROKEN OFF)
Early to Middle Cypriote
L.: 0.114m.
Purchased by Subscription 72.4880
General di Cesnola Collection.
From Cyprus.

Crusty, greenish and whitish brown patina.
Compare Catling, *Cypriot Bronzework*,
fig. 5, no. 2, or fig. 3, nos. 3, 5.

551

SPEAR HEAD
Early to Middle Cypriote
L.: 0.115m.
Purchased by Subscription 72.4886
General di Cesnola Collection.
From Cyprus.

Greenish white patina.
The blade has a slight ridge; one rivet is
in the shank end. Compare the previous.

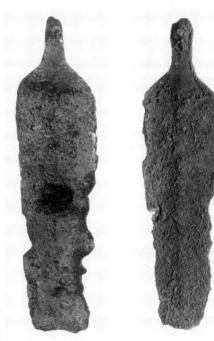

550 551

552 553 554

552

SPEAR HEAD
Early to Middle Cypriote
L.: 0.098m.
Purchased by Subscription 72.4887
General di Cesnola Collection.
From Cyprus.

Thick green and white patina. The shank is
broken off.
 There are no attachments. The blade has
a slight ridge, as the previous.

553

RAZOR
Early to Middle Cypriote
L.: 0.083m.
Purchased by Subscription 72.4881
General di Cesnola Collection.
From Cyprus.

Crusty green patina.
 Compare Catling, *Cypriot Bronzework*,
fig. 5, no. 5.

554

RAZOR
Early to Middle Cypriote
L.: 0.104m.
Purchased by Subscription 72.4882
General di Cesnola Collection.
From Cyprus.

Crusty green patina.
 Compare Catling, *Cypriot Bronzework*,
fig. 5, nos. 3 and 6 (?).

555

SPEAR (RAT-TANGED WEAPON)
Early to Middle Cypriote
L.: 0.395m. W. (max.): 0.04m.
Purchased by Subscription 72.406
General di Cesnola Collection.
From Cyprus.

Dull, thin green encrustation.
 Each side rises to a ridge which is pointed
and runs the whole length of the blade.
 Compare Catling, *Cypriot Bronzework*,
fig. 2, no. 1, etc.

556

ARROWHEAD (PROBABLY A RAT-
TANGED WEAPON)
Middle or Late Cypriote
L.: 0.114m.
Purchased by Subscription 72.400
General di Cesnola Collection.
From Cyprus.

The edges are ragged, and there is a dull
green encrustation. The tip end appears to
have been broken off.
 The blade is flat, and the shaft is square.
 Compare Catling, *Cypriot Bronzework*,
fig. 2, no. 8 (Middle) and especially fig. 12,
no. 11 (Late).

557

Arrowhead
Late Cypriote
L.: 0.083m.
Purchased by Subscription 72.409
General di Cesnola Collection.
From Cyprus.

Crusty, green patina.
The blade is flat with a curved profile and a slight ridge.
Compare Catling, *Cypriot Bronzework*, fig. 16, no. 6.

558

Awl
Early to Middle Cypriote
L.: 0.121m.
Purchased by Subscription 72.379
General di Cesnola Collection.
From Cyprus.

Greenish brown patina. Slight encrustation.
Compare Catling, *Cypriot Bronzework*, fig. 4, nos. 13-15.

559

Awl or Similar Tool
Late Cypriote (or later)
L.: 0.076m.
Purchased by Subscription 72.410
General di Cesnola Collection.
From Cyprus.

Bright green patina.
The smaller part begins with a square section and changes to a cylinder where it meets the head, which is square in section.

Olynthus X, 392, note 66, as Cypriot Type E.

556 557

555 558 559

560

560

SECTION OF A TOOL
Middle Cypriote (?)
L.: 0.09m.
Purchased by Subscription 72.396
General di Cesnola Collection.
From Cyprus.

Section broken away. Heavy encrustation.
 The shaft is circular, terminating in a flat,
rectangular area.
 Compare Catling, *Cypriot Bronzework*,
figs. 4, no. 14, 5, no. 1 (not exact parallels).

561

FRAGMENT OF A TOOL OR TWEEZER
Middle or Late Cypriote (?)
L.: 0.069m.
Purchased by Subscription 72.4898
General di Cesnola Collection.
From Cyprus.

Encrusted and green patina. One corner of
the blade is broken off, as is part of the shaft.
 This may be some kind of spatula type
tool or one pincer of a tweezer.

562

FRAGMENT OF A TOOL OR TWEEZER
Middle or Late Cypriote (?)
L.: 0.07m.
Purchased by Subscription 72.4899
General di Cesnola Collection.
From Cyprus.

Heavily encrusted. The blade end is broken,
as is the end of the handle.
 As previous.

561 562

563

FRAGMENT OF A TOOL OR CLASP (?)
Middle or Late Cypriote (?)
L.: 0.026m.
Purchased by Subscription 72.4900
General di Cesnola Collection.
From Cyprus.

Encrusted, green patina. Most of the handle and part of the blade are broken off.

This is thin and flat; it may be the hook part of a clasp but more probably a portion of a tool.

563

564

BLADE OF A CHISEL OR AXE
Early to Middle Cypriote
L.: 0.114m.
Purchased by Subscription 72.375
General di Cesnola Collection.
From Cyprus.

Crusty green patina. The surface has been cleaned.

The blade is triangular and tapers at both ends.

Compare Catling, *Cypriot Bronzework*, fig. 4, no. 1.

Olynthus X, 346, note 44.

564

565

BLADE OF A CHISEL OR AXE
Early and Middle Cypriote
L.: 0.079m.
Purchased by Subscription 72.376
General di Cesnola Collection.
From Cyprus.

Crusty green patina, with bright green spots of encrustation.

The blade is triangular and tapers at both ends.

Compare Catling, *Cypriot Bronzework*, fig. 4, no. 4.

565

566

ONE PINCER OF A PAIR OF TWEEZERS
Middle or Late Cypriote
L.: 0.07m.
Purchased by Subscription 72.381
General di Cesnola Collection.
From Cyprus.

Dull green patina.
 Most of the curved section is also missing.
 Compare Catling, *Cypriot Bronzework*,
fig. 5, no. 10 (general parallel).

567

ONE PINCER OF A PAIR OF TWEEZERS
Middle or Late Cypriote
L. (max.): 0.051m.
Purchased by Subscription 72.4873
General di Cesnola Collection.
From Cyprus.

All of the curved section is missing. Green
patina, with encrustation.
 Compare Catling, *Cypriot Bronzework*,
fig. 5, no. 10 (general parallel).

568

ONE PINCER OF A PAIR OF TWEEZERS
Middle or Late Cypriote
L.: 0.054m.
Purchased by Subscription 72.382
General di Cesnola Collection.
From Cyprus.

The curved end is gone, and there is deep
green encrustation.
 The "blade" is flat. Compare the previous.

569

ONE PINCER OF A PAIR OF TWEEZERS
Middle or Late Cypriote
L.: 0.048m.
Purchased by Subscription 72.383
General di Cesnola Collection.

566 567

569

568

From Cyprus.

The curved end is gone, and there is white
encrustation on one side, black and green
on the other.
 The "blade" is flat.
 Compare the previous.

570

ONE PINCER OF A PAIR OF TWEEZERS
Middle Cypriote
L.: 0.07m.
Purchased by Subscription 72.386
General di Cesnola Collection.
From Cyprus.

White encrustation on one side.
 Most of the curved section is missing.
 Compare Catling, *Cypriot Bronzework*,
fig. 5, no. 10 (general parallel).

571

HALF OF A PAIR OF TWEEZERS
Middle Cypriote (?)
L. (max.): 0.087m.
Purchased by Subscription 72.4874
General di Cesnola Collection.
From Cyprus.

The curved section of the top is preserved.
Green and white encrustation.
 Compare Catling, *Cypriot Bronzework*,
figs. 5, no. 8 (Middle), 22, no. 1 (Late).

572

ONE PINCER OF A PAIR OF TWEEZERS
Middle Cypriote (?)
L.: 0.089m.
Purchased by Subscription 72.387
General di Cesnola Collection.
From Cyprus.

Greenish patina, encrusted.
 Compare Catling, *Cypriot Bronzework*,
figs. 5, no. 8 (Middle), 22, no. 1 (Late).

573

ONE PINCER OF A PAIR OF TWEEZERS
Middle or Late Cypriote
L.: 0.09m.
Purchased by Subscription 72.4889
General di Cesnola Collection.
From Cyprus.

Thick encrustation and green patina.
 This is possibly the pincer which belongs
with no. 572 (72.387). It has a spatulate
end also.

570

571 572 573

574

One Pincer of a Pair of Tweezers
Middle Cypriote (?)
L.: 0.083m.
Purchased by Subscription 72.388
General di Cesnola Collection.
From Cyprus.

Crusty green patina.
 Compare Catling, *Cypriot Bronzework,*
figs. 5, no. 8 (Middle), 22, no. 1 (Late).

575

One Pincer of a Pair of Tweezers
Middle or Late Cypriote
L. (max.): 0.053m.
Purchased by Subscription 72.4872
General di Cesnola Collection.
From Cyprus.

All of the curved section is missing; crusty
green patina.
 This is the type with one broad and one
rectangular pincer (compare no. 577
[72.414]; Catling, *Cypriot Bronzework,* fig.
5, no. 10, a very general parallel).

576

Pair of Tweezers
Late Cypriote
L.: 0.061m.
Purchased by Subscription 72.4871
General di Cesnola Collection.
From Cyprus.

Heavily encrusted with a marine (?) deposit.
 Compare Catling, *Cypriot Bronzework,*
fig. 22, no. 2.

575

574

577

576

579

580

578

577

PAIR OF TWEEZERS
Late Cypriote
L.: 0.048m.
Purchased by Subscription 72.414
General di Cesnola Collection.
From Cyprus.

End broken off (?); thick, dark green encrustation.
 The object is flat and thin.
 Compare Catling, *Cypriot Bronzework*, fig. 22, no. 2.

578

PAIR OF TWEEZERS
Late Cypriote
L.: 0.076m.
Purchased by Subscription 72.416
General di Cesnola Collection.
From Cyprus.

The clasp has been twisted out of plane. Dull green and white encrustation. The end of one pincer is broken slightly.
 There is a spring, like sugar tongs.
 Compare Catling, *Cypriot Bronzework*, fig. 22, no. 2.

579

HINGE OF A CLASP
Date undetermined
W.: 0.027m.
Purchased by Subscription 72.4877
General di Cesnola Collection.
From Cyprus.

Green patina with earthy encrustation.
 The hinge joins two circular rims. Perhaps it is part of a buckle or brooch.

580

FRAGMENT OF A CLASP
Date undetermined
L.: 0.044m.
Purchased by Subscription 72.389
General di Cesnola Collection.
From Cyprus.

Thin, pale green encrustation.
 This is rectangular, with diagonal cross-bars. There appears to be a tang at the corner.

581

Greek, Etruscan and Roman

581

Helmet
Sixth Century b.c.
H.: 0.22m. DIAM.: 0.25m. WEIGHT: 1180 gm.
(2 lbs., 9 7/8 oz.)
H. L. Pierce Fund 98.664
E. P. Warren Collection.
Bought in Athens; from Elis.

There are no visible signs of attachment for a crest. The bowl has been broken through, apparently by blows; there is a round hole in the back of the neck. Dark green patina.

Little pins show that this helmet, of Corinthian type, was lined with leather.
A greave, described below (no. 584), was found with it.

E. Robinson, *Ann. Rep.* 1898, 29; *AA* 1899, 137; G. H. Chase, *BMFA* 48 (1950) 8off., figs. 3a, 3b; W. J. Young, *BMFA* 48 (1950) 83ff.

K. Herbert, *Ancient Art in Bowdoin College*, 123, no. 445; D. K. Hill, *Reallexikon für Antike und Christentum*, col. 446.

582

Helmet
Sixth to early Fifth Centuries b.c. (probably shortly before 500 b.c.)
H.: 0.172m. DIAM.: 0.165m. WEIGHT: 531 gm. (1 lb., 2 3/4 oz.)
Helen and Alice Colburn Fund 48.498a-d
From a tomb at Valenzano near Bari.

Type of full development, with division of back and front, flare at bottom. On the front, a palmette; on either side, a bull with lowered head. The plain "crest" with two pieces for attachment, said to have been found with it, though ancient, is not original. This crest may have been added to the helmet in antiquity and is meant to represent a

581

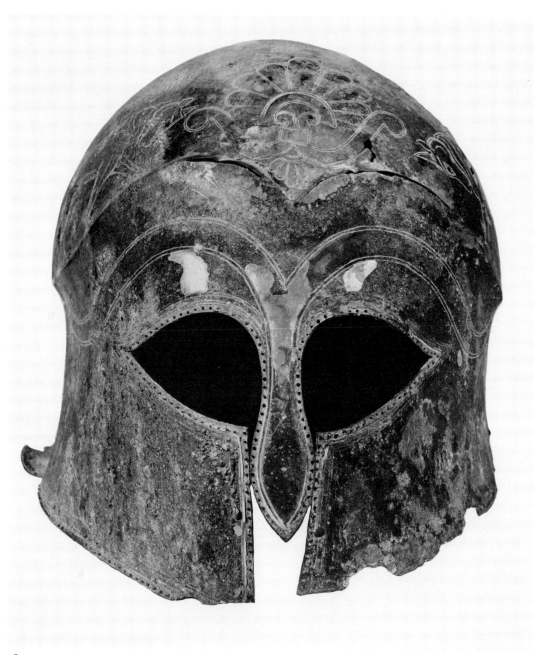

582

bull's horn (Chase, fig. 4).

The helmet is characterized not only by its engraving but by a series of small holes along the edges of the nose-piece, the eye-holes, and lower edge, with many bronze pins being preserved. These holes and pins were used to fasten a lining of leather, inside and out, and overlapping at the outer edges.

Engraved helmets are scarce, other than those with inscriptions; about twenty-five are known: P. Amandry, *BCH* 73 (1949) 437-446; see also, particularly, *Olympiabericht* 3 (1938-39) 111, fig. 97f. The bull appears also on two fifth-century helmets in Karlsruhe, confronted in one case by a lion and in the other by a boar (Schumacher, Karlsruhe *Bronzen*, 131, pl. 19). The hole of the bulls' eyes served to fasten the lining more securely.

For the type of the crest, see the Andokides amphora, Louvre F 203 (Hoppin, *Handbook of Attic Red-Figured Vases*, 38f.), where such a crested helmet lies on the ground.

Chase, *Ann. Rep. 1948*, 26; idem, *BMFA* 48 (1950) 80ff., figs. 1a, 1b, 2, 4; W. J. Young, *BMFA* 48 (1950) 83ff.; *FastiA* 5 (1950) no. 1447, fig. 14; 6 (1951) no. 1643.

ILN, 10 Feb. 1951, 201, 2 illus.; D. K. Hill, *Reallexikon für Antike und Christentum*, col. 446; E. Kunze, *Olympiabericht* 8 (1958-1962) 141, note 25.

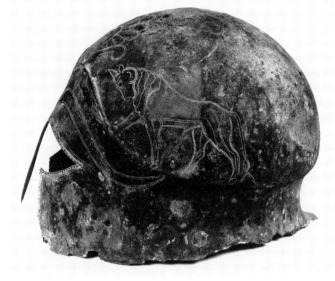

582

582

582

583

HELMET FRAGMENT

Sixth Century B.C., probably 550 to 500 B.C.

DIAM. (max.): 0.25m.

Purchased by Contribution 01.7479

E. P. Warren Collection.

Bought of Rhousopoulos; from Olympia.

The lower part of the right cheekpiece and almost all of the right eyehole are preserved. There are small holes (for the leather lining) around the edge, and two additional holes on the side. Dark green patina.

 The inscription is incised, retrograde and is in the Laconian alphabet (Jeffery):

TO ΔΙΟΣ ΟΛΥΜΠΙΟ ("of Olympian Zeus").

E. Robinson, *Ann. Rep.* 1901, 36; *AA* 1902, 132; *AJA* 6 (1902) 377; G. H. Chase, *BMFA* 48 (1950) 80ff., fig. 5; W. J. Young, *BMFA* 48 (1950) 83ff.;

583

Furtwängler, *Olympia*, IV, 168; D. K. Hill, *Reallexikon für Antike und Christentum*, col. 446; E. Kunze, *Olympiabericht* 8 (1958-1962) 87f.; Jeffery, *Local Scripts of Archaic Greece*, 191, 202, 407, pl. 39, no. 64 (Jeffery cites Kukahn, *Der griech. Helm* [1939], 34a, p. 66).

584

GREAVE

Archaic Period

L.: 0.295m. W.: 0.13m.

H. L. Pierce Fund 98.665

E. P. Warren Collection.

Bought in Athens; from Elis.

Row of holes along outer edge by which leather lining was sewed in. Dark green patina.

 The right half is preserved and is undecorated. This greave was bought with the helmet described above (no. 581).

 Compare *Fouilles de Delphes* V, 98, nos. 486f., figs. 340f.

E. Robinson, *Ann. Rep.* 1898, 29; *AA* 1899, 137.

Exhibited: Cambridge (Mass.), Fogg Art Museum, *Greek Art and Life*, no. 25.

585

CHESTPIECE
400 to 300 B.C.
H. (max.): 0.32m. W. (max.): 0.245m.
Gift in Memory of George H. Chase 64.727
From Vulci.

Broken and repaired; sections missing. Crusty green patina.

There are two ideal heads (Helios and Selene?) in medallions above and a head of Herakles, clad in his lion's skin, below. The hooks for fastening to shoulder-straps survive above and, at the right, there is the base of the hook for fixing under the left arm.

Such medallions occur in a number of similar surviving chestpieces. (Compare A. Hagemann, *Griechische Panzerung*, 108ff., figs. 111-121.) The style is that of Italo-Etruscan terracottas influenced by Greek decorative art in the lifetime of Alexander the Great, that is in the generation after 350 B.C. Decorative bosses or phalerae, probably emblems of prowess in battle, had a long tradition in Italic art, starting with the rings worn by the so-called Warrior of Capestrano and ending ultimately in the medallions worn by Roman legionaries under Augustus and the Julio-Claudians (L. A. Holland, *AJA* 60 (1956) 243ff.; F. Matz, *Die Lauersforter Phalerae, passim*). This fragmentary chestpiece marks the fusion of the old Italic desire to display military emblems with the new pre-Hellenistic ability to show faces of the gods in three-dimensional, foreshortened frontality.

Vermeule, *Ann. Rep. 1964*, 31; idem, *PAPS* 109 (1965) 367, fig. 11; idem, *CJ* 61 (1966) 301f., 297, fig. 17.

ArtQ 27 (1964) 370.

584

586

Helmet

Late Archaic Period

H. (max.): 0.21m. L. (max.): 0.28m.

Classical Department Purchase Fund, in Memory of Miss Grace Nelson 61.375

Found near Bologna, with the Bronze Age sword (no. 533) and the following three objects (greave and two strigils).

There is an ancient repair over the left eye-hole. The top contains two holes to attach the crest, now missing. There are two similar holes off center at the right rear. These and the following have been cleaned electrolytically.

The helmet is an Italic version of the Corinthian type, with two holes in the top for a crest and a ridge dividing the upper part from the lower.

Vermeule, *Ann. Rep.* 1961, 47 (the group); *idem, CJ* 57 (1962) 145ff., fig. 1 (the group); *FastiA* 17 (1962) no. 243 (the group).

The Pomerance Collection of Ancient Art, 84, under no. 97 (the group); E. Kunze, *Olympia-bericht* 8 (1958-1962) 141f., note 25.

587

Greave

Circa 500 B.C.

H. (max.): 0.44m.

Classical Department Purchase Fund, in Memory of Miss Grace Nelson 61.377

Yellow ("Tiber") patina, cleaned.

This greave for the right leg has crescent-shaped grooves to outline the large muscle of the calf. There is a hole at the top center, for suspension.

For a similarly delineated greave, see Hagemann, *Griechische Panzerung*, 134ff., figs. 148ff.

587

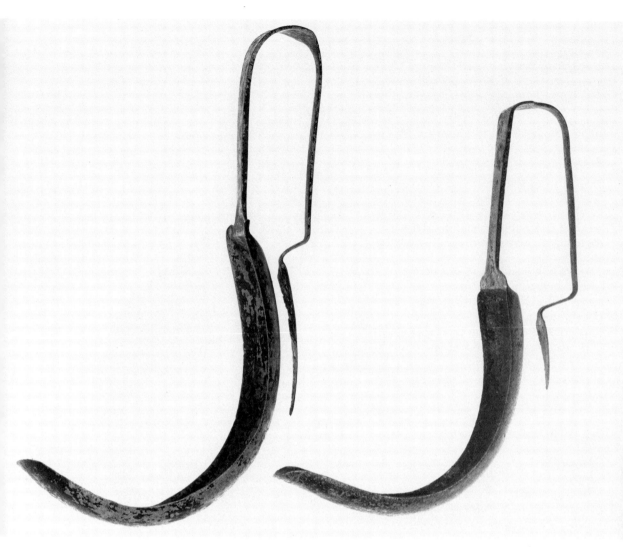

588

STRIGIL

Circa 500 B.C.

L. (max.): 0.22m.

Classical Department Purchase Fund, in
Memory of Miss Grace Nelson 61.378

Patina as previous. The end was soldered to
the blade.

 The handle has a long, tapering end and
two sets of three grooves on top, before the
curve.

589

STRIGIL

Circa 500 B.C.

L. (max.): 0.18m.

Classical Department Purchase Fund, in
Memory of Miss Grace Nelson 61.379

Patina as previous. The end was also solder-
ed to the blade.

 The handle has a relatively short, tapering
end.

Triton

Roman imperial

L.: 0.108m. H.: 0.11m.

Purchased by Contribution 01.7490

E. P. Warren Collection.

Bought in Rome.

Partly corroded. Gilded.

The Triton, of the Hellenistic type, advances to the right. The back part of the fishy body is hollow, as if attached to some object.

This appliqué appears to have come from the right side of the breastplate of a life-sized cuirass or cuirassed statue in metal. It curves slightly to suit the contour of a piece of body armor.

E. Robinson, *Ann. Rep.* 1901, 36; *AA* 1902, 131; Vermeule, *Berytus* 13 (1959) 4, note 3, no. D.

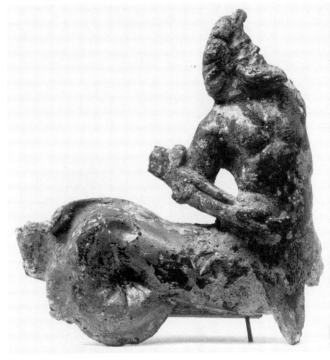

590

591

Two Lion's Heads

Roman imperial

H. (of each): 0.041m.

Anonymous Gift in Memory of Dr. C. T. Seltman 57.749, 57.750

Brown patina with green spots.

These heads or protomes are of heavy-cast bronze; the mouth is pierced through, and on each side of the mouth a small indentation was perhaps intended for the attachment of a chain.

The appliqués appear to have formed part of the fastenings for the shoulder straps of a metal cuirass from a statue of heroic size.

Compare the spouts in New York: Richter, New York *Bronzes*, 166f., nos. 406 to 409, and the lion's heads similar to these, collected in E. von Mercklin, *Jahrbuch der Hamburger Kunstsammlungen* 3 (1958) 221ff., figs. 4-6. The closest parallel, perhaps once used in the same fashion, is Schumacher, Karlsruhe *Bronzen*, 52, no. 293. Also, for style, compare the lion's head on a herm shaft for a bust, once in the Sambon

591

collection: Sale, Paris, 25-28 May 1914, 22, no. 78.

Vermeule, *Ann. Rep.* 1957, 28; *idem, Berytus* 13 (1959) 4f., note 3, no. H.

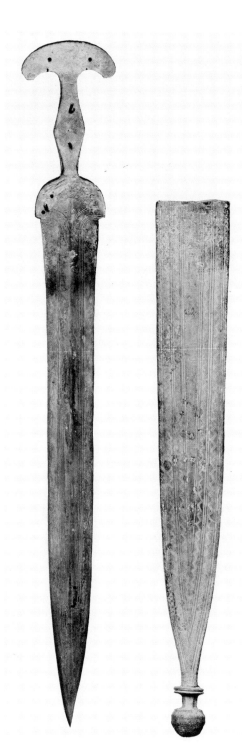

592

592

DAGGER AND SHEATH
(Italic or Syrian) Geometric to Archaic
L. (dagger): 0.379m. L. (sheath): 0.293m.
Francis Bartlett Collection 03.998a, b
E. P. Warren Collection.
From a Scottish collection, possibly the
Carfrae.

The inlaid wood or bone of the hilt is missing.
Medium green patina.

The dagger comprises a hilt with cross-
piece which has rounded corners and a blade
with engraved lines parallel to the edges.
The sheath has a knob on the point and is
engraved with zigzags and a maeander.

Compare Åkerström, *Der geometrische Stil
in Italien*, 120ff.; NSc 1888, pl. 19, fig. 11.
Further research has strengthened the Italic
provenance of this short sword. It may
have been made as early as late in the
ninth or early eighth centuries, in the period
termed Villanovan II A.

B. H. Hill, *Ann. Rep.* 1903, 62f.; *AA* 1904, 194;
AJA 8 (1904) 383.

593

MACEHEAD
Circa A.D. 300 or later
L.: 0.083m.
Edward Jackson Holmes Collection 65.1335

Black patina with green encrustation.

The circular, tube-shaped object is hollow
from end to end, to fit over a wooden or
metal shaft. There are fifteen solid spikes,
the top row curving downwards to form a
series of claws. On the body there are two
rows of rinceau decoration, between single
and double fillets in relief. At either end are
collars to aid in securing the bronze mace-
head to its shaft.

Compare De Ridder, *Louvre Bronzes*, II,
10, no. 1189, pl. 68.

Vermeule, *Ann. Rep.* 1965, 68; idem, *CJ* 62
(1966) 111, fig. 25.

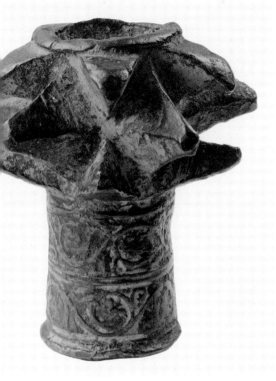

593 594 594

594

HANDLE (OF A KNIFE, PERHAPS A
HOOF-CLEANER)
Graeco-Roman
L.: 0.082m. W.: 0.029m.
Purchased by Contribution 88.622
Purchased from R. Lanciani; from the sanc-
tuary of Diana at Nemi.

Deep green patina, with pitting and earth
deposit. The face is worn.
 The lower part is of cornucopia shape, with
a slit or groove on the edge of the outer
curve. On the top sits a rude sphinx with a
large ring on its back. The sphinx has a thick,
rolled collar. Almond eyes and feathers on
the chest are incised.

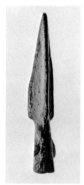

595

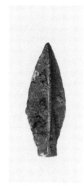

596

595

ARROWHEAD
Greek
L.: 0.037m.
Gift of Edward Robinson 88.3
From near Athens.

Green patina, with earth encrustation.
 Three long, pointed flanges project from a cylindrical shank; a hole and a barb are on the latter.
 There are a number of parallels from the the Athenian Agora. Compare also, British Museum, *Greek and Roman Life*, 96ff., figs. 96, 99.

596

ARROWHEAD
Greek
L.: 0.036m.
Gift of the Archaeological Institute of America 84.570
From Assos.

Green patina, and some encrustation.
 It has a trilobate blade and a hole in the end into which the shaft fitted.
 Compare the ones in the British Museum (*Greek and Roman Life*, 100, fig. 102).

597

ARROWHEAD
Greek
L.: 0.019m.
Gift of Edward Robinson 88.4
From near Athens.

There is a long hole on one side. Green patina, with earth encrustation.
 The lower ends of a three-sided pyramid are barbed.

597

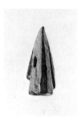

598

599

600

598

ARROWHEAD
Greek
L.: 0.017m.
Gift of Edward Robinson 88.5
From near Athens.

Green patina, with earth encrustation.
Three-sided pyramid, with no barbs.

599

ARROWHEAD
Greek
L.: 0.016m.
Gift of Edward Robinson 88.6
From near Athens.

There is a hole in one side. The corners are worn off at the bottom. Green patina, with earth encrustation.
Three-sided pyramid which becomes a cylinder below.

600

ARROWHEAD
Greek
L.: 0.013m.
Gift of Edward Robinson 88.7
From near Athens.

There is a hole on one side. Green patina, with earth encrustation.
The point and arrises are surfaces of the pyramid, while between is the cone.

601

AXE
Etruscan (Italic) circa 600 B.C.
L.: 0.21m.
Gift of Edward W. Forbes 63.2402
Bought near Assisi, at "excavations" 10 to 20 miles to the south (amber beads and the Dumbarton Oaks "Hephaistos" were shown with it).

601

602

Dark green patina.
This axe takes the form of a "winged" celt, with side flanges and stop-ridge. The handle fitted into the recess thus formed, and the stop-ridge prevented the blade from being driven too far into the handle.
Compare Montelius, pl. 66, no. 8 (from the great bronze deposit found at San Francesco, Bologna, 14,800 bronzes: Montelius, I, 332ff., pls. 66-72); Richter, New York Bronzes, 434, no. 1640.

Vermeule, *Ann. Rep.* 1958, 33; *idem, Ann. Rep.* 1963, 37; *idem, CJ* 60 (1965) 303ff., fig. 19.

602

SPEAR
Late Italic
L.: 0.134m.
Purchased by Contribution 88.628
Purchased of R. Lanciani; from the sanctuary of Diana at Nemi.

The shaft is bent. Pale green patina.
This consists of a cylindrical shaft and point with fish-hook barbs.

603

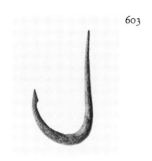

603

FISH HOOK
Greek
L.: 0.033m.
Gift of Edward Robinson 88.8
From near Athens.

Rusted. Green patina.

There is a flat disc at the attachment end;
the hook comprises one slender barb.

Roman fish hooks were found in the early
imperial galleys from Lake Nemi: see
G. Ucelli, *Le navi di Nemi*, 130f., figs. 136f.

Olynthus X, 365f., note 93 (cites "one from a
grave near Athens").

604

ASPERGILLUM
Hellenistic
H.: 0.217m.
H. L. Pierce Fund 99.497
E. P. Warren Collection.
Bought from a Sicilian.

A piece is missing from the bottom, and the
tube has been rejoined to the body. Green
patina.

This vessel is perforated at the bottom
with many holes. Around the body are
tongue patterns; near the middle is a band
of lozenges. The tube is octagonal in section,
and the outer or upper end is rounded to
receive a stopper.

Compare the bronze klepsydra dipper:
Meroë Tomb W 27: Exp. 22-2-467 (D.
Dunham, *Royal Cemeteries of Kush*, V, 105f.,
no. 467, fig. 79, t).

E. Robinson, *Ann. Rep.* 1899, 50; *AA* 1900, 218;
AJA 4 (1900) 511.

605

LADLE
Early Hellenistic
L.: 0.255m. DIAM. (of bowl): 0.058m.
Gift of E. P. Warren 90.187

Much encrustation.

The ensemble comprises a long, narrow
handle with incised lines on the back, a
shallow, circular bowl, and a swan's head on
the end of the handle.

Compare the Roman development of this
type in gilded silver, East Greek work of the
first century A.D.: MFA 61.159; Vermeule,
Antike Kunst 6 (1963) 33, pl. 15, 4; in
bronze: S. Casson, *Descriptive Catalogue of
the Warren Classical Collection of Bowdoin
College*, 16, no. 135; K. Herbert, *Ancient
Art in Bowdoin College*, 123, no. 447.

E. Robinson, *Ann. Rep.* 1890, 21.

Olynthus X, 195f., note 25.

Exhibited: University of Wisconsin Memorial
Library, *Rome, An Exhibition of Facts And Ideas*,
58, no. 112.

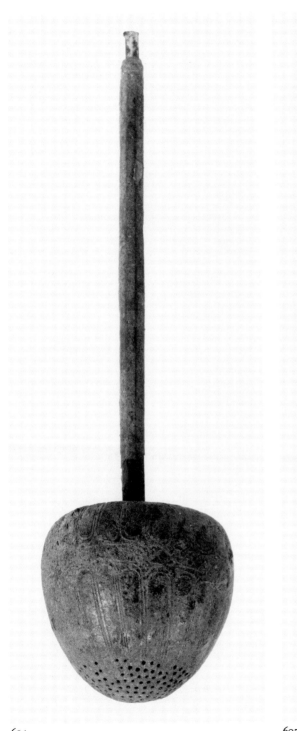

604

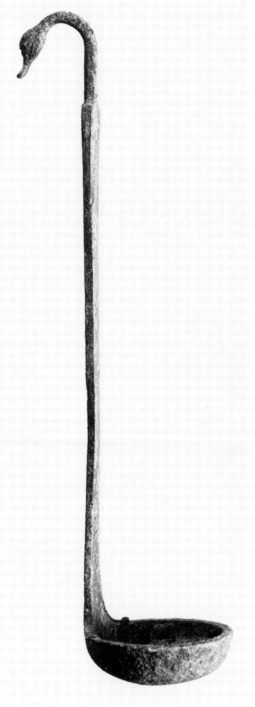

605

419

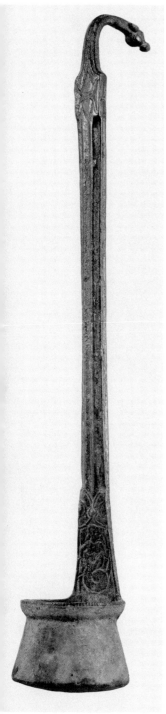

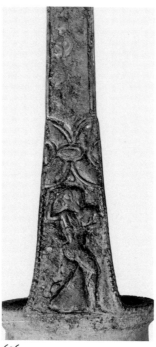

606

606

606

606

606

LADLE

Etruscan, Fifth Century B.C. or later
L.: 0.32m. DIAM. (of bowl): 0.054m.
Seth K. Sweetser Fund 52.58
Said to have belonged to the Roumanian
royal family.

Side of bowl missing. Green patina, with
corrosion and earth deposit.

The long handle has a tip ending in the
head of an ass; at the base of the handle,
there is a mermaid to right on the obverse,
and a nude boy walking to right, head left,
on the reverse; above each figure and high
on the handle appears a floral design. The
deep bowl is sharply carinated near the
the bottom and has a beaded rim.

H. Palmer, *Ann. Rep.* 1952, 20; *BMFA* 50 (1952)
33.

607

STRAINER

Italic, Fourth to Third Centuries B.C.
L.: 0.296m. DIAM. (bowl): 0.134m.
H. L. Pierce Fund 99.498
E. P. Warren Collection.
Bought in Rome.

Bluish patina.

The bowl has a flat rim and is perforated
with many small holes. There is also a flat
handle, and a hook-shaped projection from
the opposite side.

The type is rare, and found only in central
Italy, at Monte Fortino, Filottiano, and An-
cona (see D. K. Hill, *JWalt* 1942, 50). A simi-
lar strainer, badly preserved, is in the
Metropolitan Museum (Richter, New York
Bronzes, 230f., no. 639). (See the list given by
Wilson, *AJP* 28 [1907] 451ff.) Also, Münzen
und Medaillen, Auktion XXII, May 1961,
41, no. 78. For the (presumably) Greek
counterpart, from Metsovo (in Jannina), see
N. M. Verdelis, *BCH* 73 (1949) 27, no. XV,
pl. I.

E. Robinson, *Ann. Rep.* 1899, 50; *AA* 1900, 218;
AJA 4 (1900) 511.

Richter, New York *Bronzes*, 230f., under no. 639.

608

HARPAGO (ΚΡΕΑΓΡΑ) OR MEAT HOOK
Etruscan
L.: 0.422m.
H. L. Pierce Fund 99.496
E. P. Warren Collection.

One prong is missing and the tips of two are
broken. Green patina, somewhat crusty.

The shaft ends in a ring from which radi-
ate six large and one small curved prongs;
another is missing. A ring is attached to
the small prong extending along the shaft.
Compare the example in New York:
Richter, New York *Bronzes*, 236f., no. 665
and references; also, De Ridder, Louvre
Bronzes, II, 193, nos. 3722, 3724, pl. 121;
Aurigemma, Alfieri, *Il Museo Archeologico
di Spina in Ferrara*, pl. 18; Copenhagen,
Bildertafeln des Etruskischen Museums, pl.
103; F. Magi, *La raccolta Benedetto Gugliel-
mi*, II, nos. 86-88, pl. 63. Another is in the
Museo Archeologico in Venice, and several
were in the Swiss art market in 1964.

These hooks were evidently used to pull
meat out of cauldrons, whether in domestic
cooking or at sacrifices.

E. Robinson, *Ann. Rep.* 1899, 49f.; *AA* 1900, 218;
AJA 4 (1900) 511; J. Addison, *The Boston Mu-
seum of Fine Arts*, 297.

607

607

608

608

609

609

HOOK
Late Roman or Byzantine (?)
L.: 0.292m.
Gift of the Archaeological Institute of America 84.84
From near the gymnasium, Assos.

Dark green patina.
The hook has three pendant hooks.

610

610

SPOON FRAGMENT
Greek Archaic (?)
L.: 0.05m. W.: 0.037m.
Gift of E. P. Warren 96.672
Said to be from a tomb in Palaeopolis, Elis.
Found with cymbals (no. 622), phiale (no. 453) and cradle (no. 661).

Rich, medium green patina.
The handle is broken off near the bowl.

E. Robinson, *Ann Rep.* 1896, 31; *AA* 1897, 73.

611

SPOON
Roman
L.: 0.157m.
Gift of Mrs. F. M. Carhart 36.630

Dark brownish green patina.
There is a spatula-shaped bowl, and the pick-like handle ends in a sharp point.

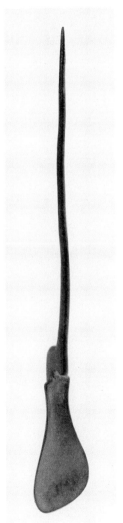

611

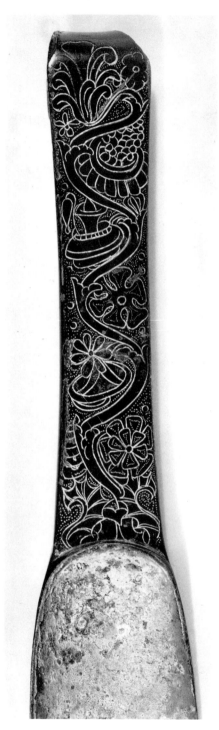

612

612

612

STRIGIL
Sixth to Fifth Centuries B.C.
L.: 0.27m.
Purchased by Contribution 01.7478
E. P. Warren Collection.
From Cumae.

The handle has been joined to the scraper. The patina of the former is dark green and the latter more blue.

The front of the handle is decorated with a conventional flower, while the back is in the form of a tree stem. On the reverse of the front part there is the stamped inscription (retrograde): ΑΠΟΛΛΟ[Δ]ΩΡΩ. (The delta is omitted.)

Compare Walters, British Museum *Bronzes*, 320, no. 2429, with a knotted stem;

Karlsruhe *Bronzen*, 33, no. 215; Friederichs, *Kleinere Kunst und Industrie im Altertum*, 89f., no. 206, with palmettes. For strigils and their uses, see the discussion by De Ridder, Société Archéologique d'Athènes *Bronzes*, 104ff., before nos. 531-575; the owner's name, Diotimos of Athens, is inscribed on a similar strigil at Bowdoin: S. Casson, *Descriptive Catalogue of the Warren Classical Collection*, 15, no. 120; K. Herbert, *Ancient Art in Bowdoin College*, 123, no. 449.

E. Robinson, *Ann. Rep.* 1901, 36; *AA* 1902, 132; *AJA* 6 (1902) 377.

Olynthus X, 173, note 49; *Corinth*, XIII, *The North Cemetery*, 94, note 9.

613

STRIGIL
Late Sixth or early Fifth Centuries B.C.
L.: 0.218m.
Gift of Mrs. F. H. Bacon 03.1152
From the Troad, near Hissarlik.

The end of the scraper is broken off. Green patina.

On the upper center of the handle, as if produced from an intaglio ringstone, there is a small inset oval in which appears in relief an athlete scraping himself. He holds a strigil close to his head in his raised right hand and perhaps another strigil in the lowered left.

B. H. Hill, *Ann. Rep.* 1903, 83; J. Addison, *The Boston Museum of Fine Arts*, 297.

Olynthus X, 173, note 49.

613

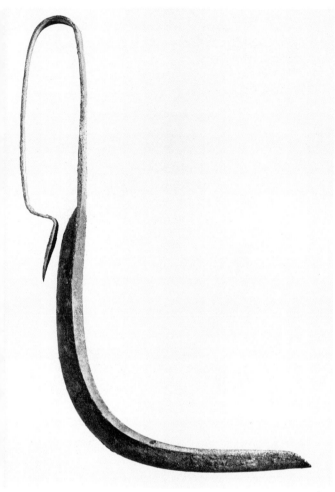

614

615

STRIGIL

Hellenistic (?)

L.: 0.20m.

Gift of Mrs. Edward Jackson Holmes 52.191

Green and brown patina.

This strigil comprises a narrow, deeply curved blade; a narrow handle with a squared turn; elongated tip: two leaf-shaped finials connected by a thin member, both finials being riveted to the blade.

H. Palmer, *Ann. Rep. 1952*, 19.

616

STRIGIL

Graeco-Roman (?)

L.: 0.193m.

Gift of Richard R. Wagner 66.932

From Bursa.

Crusty green patina.

The blade has a sharp curve and is wide, tapering towards the end. The handle folds back on itself by a squared turn and ends in another at the juncture of the blade. A long slit is left open on both sides of the handle; two parallel incised lines decorate the center back, running lengthwise, and around both ends of the handle.

Vermeule, *Ann. Rep. 1966*, 55.

617

STRIGIL HANDLE

Graeco-Roman

L.: 0.121m. W.: 0.029m.

Gift of the Archaeological Institute of America 84.85

From the Necropolis, Assos.

Nearly all the blade is broken away. Green encrustation.

See *Investigations at Assos*, 290.

614

STRIGIL

Fifth Century B.C.

L.: 0.188m. W.: 0.03m.

Gift of E. P. Warren 90.186

Much encrustation.

This strigil is perfect in form, with a deeply hollowed blade and a lozenge-pointed end to the handle.

J. Addison, *The Boston Museum of Fine Arts*, 297.

Olynthus X, 173, note 49.

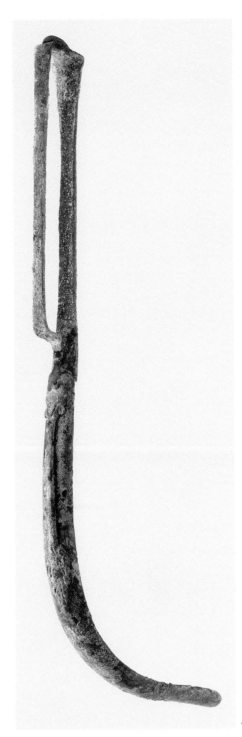

615

618

HANDLE OF A STRIGIL
Graeco-Roman (?)
L.: 0.073m.
*Gift of the Archaeological Institute of
America 84.568*
From Assos.

Green patina, with brown encrustation. The
blade is almost entirely missing, and the
handle is broken at the end.

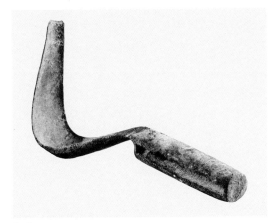

616

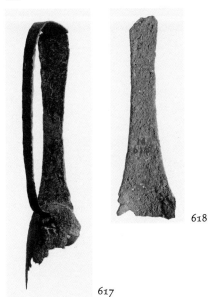

617

618

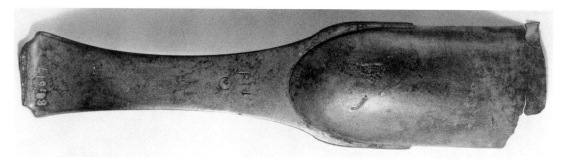

619

STRIGIL
Late Italic (to Roman)
L.: 0.164m.
Purchased by Contribution 88.617
Purchased of R. Lanciani; from the sanctuary
of Diana at Nemi.

Handle beyond curve and outer half of blade
broken away. Smooth patina, green and
brown.
 Inscribed: F I V. Incised beneath this: Θ.

620

TWO CASTANETS
Hellenistic (?)
DIAM.: 0.058m.
Anonymous Gift 06.2373, 06.2374
Bought in London; from Egypt.

 The handles are of wood. One castanet
has muddy encrustation and a light colored
handle. The other has whitish spots and a
dark handle.

S. N. Deane, *Ann. Rep. 1906*, 59; *AA 1907*,
col. 395.
Olynthus X, 499, note 56.

621

TWO CYMBALS OR CASTANETS
Graeco-Roman
DIAM.: 0.12m.
*Gift of Richard R. Wagner 65.1346,
65.1347*
From Istanbul.

Crusty green patina.
 There are two holes in the center for at-
tachment to the handles. Compare Richter,
New York *Bronzes*, 455f., nos. 1785ff.
Vermeule, *Ann. Rep. 1965*, 68.

622

CYMBALS
Fifth Century B.C.
DIAM.: 0.093m.
Gift of E. P. Warren 96.670

620

Said to have been found in a tomb at Palaeopolis, Elis. Found with phiale (no. 453), spoon fragment (no. 610) and cradle (no. 661).

Green patina, somewhat crusty.

Each has a ring handle and is inscribed: ϜΑΝΑΞΙΛΑΣ.

Compare the inscribed examples in the British Museum, dated by Neugebauer in the fifth century B.C.: Neugebauer, *Bilderhefte zur Kunst-und Kulturgeschichte*, pl. I, 1. Cymbals, with holes in the centers, are also found mounted on iron forks: see Hesperia Art, *Bulletin* XIV, no. 17.

E. Robinson, *Ann. Rep. 1896*, 31; *AA 1897*, 73.

621

621

622

622

623

PLECTRUM HANDLE
Hellenistic, perhaps Etruscan (Italic)
H.: 0.056m.
Gift of E. P. Warren Res. 08.32q
Bought in Rome; found not far from Lake
Bolsena.

Light green patina.
A youth sits in the lap of a bearded man.
Both are wearing palaestric caps, and the
youth also wears a bulla.

624

PLECTRUM HANDLE
Graeco-Roman
H.: 0.047m.
Gift of E. P. Warren Res. 08.32h
Bought in Rome.

Lance missing from right hand. Green patina.
A bearded dwarf kneels on a stand; his
right hand is raised, and there is a tiny
shield on the left arm. A frog is at the left
foot.

625

625

PLECTRUM HANDLE
Graeco-Roman
H.: 0.053m.
Gift of E. P. Warren Res. 08.32i
Bought from a Greek.

As previous.
Similar to the previous.

626

TWEEZERS
Greek
L.: 0.156m.
Purchased by Contribution 01.7511a, b
E. P. Warren Collection.
From Cumae; bought in Naples.

Loop much corroded, and broken across the
top; another break at shoulder of tweezer
A. Green patina.
They are flat and flare at the end:
A: decorated with a sphinx, eagles, and a
panther pursuing a goat.
B: with a griffin and an animal pursuing
another.
See J. S. Milne, *Surgical Instruments in
Greek and Roman Times*, 24ff., pls. 1-3.

E. Robinson, *Ann. Rep. 1901*, 36.

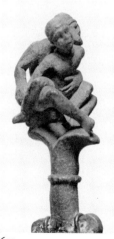

623 624

626

626

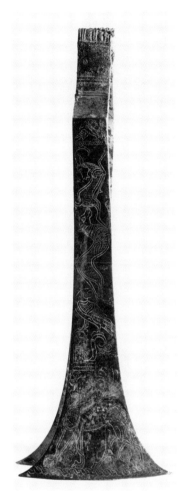

626

626

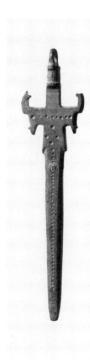

627 628

627

TWEEZERS
Graeco-Roman
L.: 0.091m.
*Gift of the Estate of Alfred Greenough
Res. 08.37*

Green and brown patina.

There is a small loop at the top of the handle. Narrow arms end in a square plate, the edges of which turn inward. No decoration.

Exhibited: Hartford, *The Medicine Man Medicine in Art*, 38, no. 195.

628

TWEEZERS
Graeco-Roman, Late Antique or Byzantine,
A.D. 400 or later
L.: 0.076m.
Gift of Richard R. Wagner 65.1345
From Istanbul.

Hard green patina.

The body is in the form of a very stylized human figure with raised arms (in orans gesture), drapery hanging from them. At the end is a loop for suspension.

Vermeule, *Ann. Rep. 1965*, 68.

629

SURGICAL INSTRUMENT
Graeco-Roman
L.: 0.136m.
Gift of E. P. Warren 13.160
Bought in Rome.

Light green patina, somewhat corroded.

This is shaped like a tiny spatula, with spade-shaped end.

There are a number of similar objects, including groups from Pompeii (see Tarbell, *Bronzes*, pl. 115; Chiurazzi, Naples, no. 615; Schumacher, Karlsruhe *Bronzen*, 157f., nos. 814ff.; M. Johnston, *Roman Life*, 48). See also the group of twelve: Ars Antiqua Sale, Lucerne, December 1962, 29, no. 121;

and *Instruments de chirurgie gréco-romains*.

L. D. Caskey, *Ann. Rep.* 1913, 89; *AA* 1914, col. 494; *AJA* 18 (1914) 414 (this and eight following).

Olynthus X, 364, note 90.

Exhibited: Hartford, *The Medicine Man Medicine in Art*, 38, no. 195.

630

SURGICAL INSTRUMENT
Graeco-Roman
L.: 0.119m.
Gift of E. P. Warren 13.161
Bought in Rome.

Light green patina.
 The end is curved.

Olynthus X, 364, note 90.

Exhibited: Hartford, *The Medicine Man Medicine in Art*, 38, no. 195.

631

SURGICAL INSTRUMENT
Graeco-Roman
L.: 0.19m.
Gift of E. P. Warren 13.162
Bought in Rome.

Light green patina.

Olynthus X, 364, note 90.

Exhibited: Hartford, *The Medicine Man Medicine in Art*, 38, no. 195.

632

SURGICAL INSTRUMENT
Graeco-Roman
L.: 0.149m.
Gift of E. P. Warren 13.163
Bought in Rome.

Light green patina.

Olynthus X, 364, note 90.

630

629 632

631

633

Surgical Instrument
Graeco-Roman
L.: 0.13m.
Gift of E. P. Warren 13.164
Bought in Rome.

Light green patina.
This is like a long, double-ended needle.

Olynthus X, 364, note 90.

Exhibited: Hartford, *The Medicine Man Medicine in Art*, 38, no. 195.

634

Surgical Instrument
Graeco-Roman
L.: 0.124m.
Gift of E. P. Warren 13.165
Bought in Rome.

Light green patina.
This is pointed at one end and has a knob at the other.

Olynthus X, 364, note 90.

Exhibited: Hartford, *The Medicine Man Medicine in Art*, 38, no. 195.

635

Surgical Instrument
Graeco-Roman
L.: 0.152m.
Gift of E. P. Warren 13.166
Bought in Rome.

Light green patina.
This has a two-pronged fork at either end.

Olynthus X, 364, note 90.

Exhibited: Hartford, *The Medicine Man Medicine in Art*, 38, no. 195.

633 634 635 636 637

636

Surgical Instrument
Graeco-Roman
L.: 0.128m.
Gift of E. P. Warren 13.167
Bought in Rome.

Light green patina.
One end is pointed, and near the other there are two sets of double ridges.

Olynthus X, 364, note 90.

Exhibited: Hartford, *The Medicine Man Medicine in Art*, 38, no. 195.

637

S<small>URGICAL</small> I<small>NSTRUMENT</small>
Graeco-Roman
L.: 0.16m.
Gift of E. P. Warren 13.168
Bought in Rome.

Light green patina.
 One end is in the form of a flat, rectangular spatula (like an oar), and the other is shaped like a small, oval teaspoon.

Exhibited: Hartford, *The Medicine Man Medicine in Art*, 38, no. 195.

638

K<small>EY</small>
Fifth Century B.C.
L.: 0.405m.
Purchased by Contribution 01.7515
E. P. Warren Collection.
Bought in Athens from a man living near Sikyon; from the temple of Artemis at Lousoi in Arcadia.

Even, green patina
 The shape is "something like a bayonet" (B. H. Hill), and the handle ends in the head of a serpent with beard or protruding tongue.
 Inscribed:

ΤΑΣ ΑΡΤΑΜΙΤΟΣ
ΤΑΣ ΕΝ ΛΟΥΣΟΙΣ.

For early wooden locks, their keys and their survivals, see Dawkins, *BSA* 9 (1902-03) 190-195.

E. Robinson, *Ann. Rep.* 1901, 36; Beazley, in Caskey-Beazley III, 50.

H. Diels, *SBPreuss* 1908, I, 27-30, pl. 1; *AJA* 12 (1908) 470; L. H. Jeffery, *The Local Scripts of Archaic Greece*, 212, 215, no. 23 (Jeffery cites *IG* V, 2, no. 399; and E. Schwyzer, *DGE*, no. 670); A. Greifenhagen, *Gnomon* 41 (1969) 187.

638

639

KNUCKLEBONE
Roman
L.: 0.032m.
Gift of Richard R. Wagner 65.1184
From Istanbul.

Black patina.
 Compare British Museum, *Greek and Roman Life*, 200f., fig. 221.

Vermeule, *Ann. Rep.* 1965, 68.

640

SCALES OF STEELYARD TYPE
Graeco-Roman
L.: 0.073m.
H. L. Pierce Fund 99.502
E. P. Warren Collection.
Bought in Athens; said to be from Messenia.

Rich green, dark brown patina.
 Only the central section of the balance survives, without the rod, the scales or the chains and pans. On the flat semicircular area, a stylized lotus bud with flowering petals. The small size suggests these were jeweler's or apothecary's scales.
 For whole balances from Pompeii and Herculaneum, with their rods, chains, pans and weights, see Tarbell, *Bronzes*, 139f., figs. 256-260; British Museum, *Greek and Roman Life*, 152ff., figs. 170ff.; M. C. Ross, *Catalogue of the Byzantine and Early Mediaeval Antiquities in the Dumbarton Oaks*

Collection, I, 61f., under no. 71. The Greeks used only balance scales for weighing but the Greeks and Romans of the late Republic and Empire used steelyards as well.
 Robinson noted that these scales seemed to be based upon the Aeginetic standards of weights, as they correspond approximately to 4, 8, 16, 32, 40 and 48 grains Troy, which would represent respectively ¼, ½, 1, 2, 2½ and 3 Aeginetan obols.

E. Robinson, *Ann. Rep.* 1900, 31; *AJA* 5 (1901) 361.

641

STEELYARD WEIGHT
Late Hellenistic, circa 100 B.C. to A.D. 50
H.: 0.123m.
William E. Nickerson Fund No. 2 58.16
From near Izmir (Smyrna).

Corroded; green and black patina.
 Bust of Artemis, head turned to right and hair piled high in two parts with suspension hole between. Eyes hollow. Over right shoulder, fawn skin; beneath, chiton; on back of right shoulder, a quiver.
 Artemis appears in a concept which recalls how like the French Rococo were certain phases of late Hellenistic art. Lead set in the base of the bust made Artemis suitable for a balance against the pan in which items to be weighed were placed. The hollowed eyes may have been set with colored pastes.
 Compare the bust found in 1958 at Kyparissia, in the southwestern Peloponnesus (*BCH* 83 [1959)] 649, fig. 36); also Winnefeld, *Priene*, 381, fig. 482; Babelon-Blanchet, *Bronzes*, 65, no. 140, 176, no. 393 (comparable steelyard bust of Silenus); Reinach, *Rép. stat.*, III, 119, 2 = Collection Briot at Smyrna: perhaps the Boston piece? Busts from similar moulds were also used as medallic appliqués for furniture: e.g. Burlington Exhibition, 1903, *Ancient Greek Art*, 1904, 57, no. 81, pl. 59.

Vermeule, *Ann. Rep.* 1958, 32; idem, *BMFA* 56 (1958) 96, illus.; *FastiA* 14 (1959) no. 715; Vermeule, *Greek and Byzantine Studies*, I, 117, pl. 7, fig. 21; Chase, *Antiquities*, 2nd edition,

639

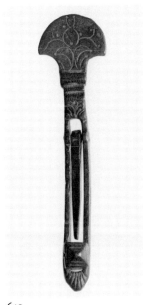

640

226, 260, fig. 246.

Rolley, *Monumenta Graeca et Romana*, V, fasc. 1, 20, no. 194, pl. 64.

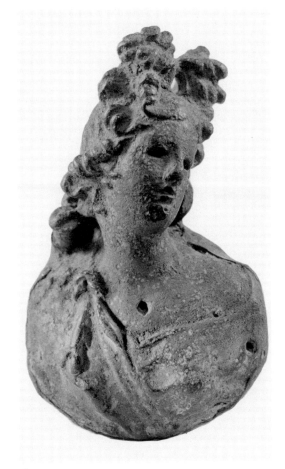

641

642

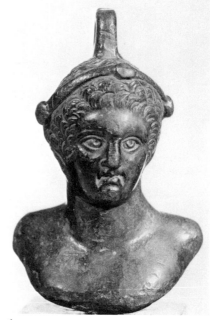

642

STEELYARD WEIGHT
Circa A.D. 280 to 310
H.: 0.082m.
Classical Department Purchase Fund 60.153

Even dark green patina, rubbed and chipped
in places.

The balance takes the form of a bust of
Herakles, wearing a rolled fillet with three
rosettes around the head. The pupils of the
eyes are deeply incised.

The incised pupils produce that almost
frozen, staring look characteristic of
imperial portraits in the age of Diocletian
(A.D. 284 to 305). The dating of minor
bronzes is always very difficult, but this ex-
ample seems to fall in the last generation of
the third century A.D. The bust is solid
bronze, the whole object being small enough
not to have needed a lead insert to correct
the weight (and save more costly bronze).

Herakles is rare as a subject for a weight.
Perhaps his appeal lay in the suggestions
of labor, that is commercial labor, involved.
This particular representation of Herakles
goes back directly to a statue created about
350 B.C. by Skopas and set up in the
gymnasium at Sikyon, to be seen in this
location a half-millennium later by Pausanias
(2.10.1). The head is known from the Gen-
zano herm in the British Museum and many
other marble replicas or variants (Smith,
Catalogue of Sculpture, III, 93f., no. 1731).
The best copy of the whole statue is in the
Los Angeles County Museum, and a late
Hellenistic statue echoing the original is at
Osterley Park House, near London (Ver-
meule, *AJA* 59 [1955] 134, 144, pl. 45, fig.
26).

The cult of Herakles enjoyed a great re-
vival at the hands of Diocletian's imperial
colleague, Maximianus (Herculeus), and
statues of Herakles as far back in Greek art
as those of the sculptor Myron, about 450
B.C., were copied in all media, especially on
coins. The patronage of the Tetrarch Maxi-

438

mianus may further explain this use of Herakles as a steelyard bust which we have tried to date at the end of the third century A.D. on stylistic grounds.

Vermeule, *CJ* 56 (1960) 11f., fig. 14.

643

STEELYARD WEIGHT

A.D. 150 to 275

H.: 0.09m.

Classical Department Purchase Fund 59.653
Acquired in Paris.

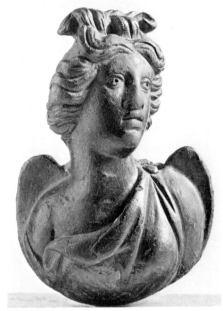

643

Dark green to black patina.

The balance is in the form of a bust of Nike, the hair being knotted on top of the head with a hole for suspension. She is shown with a chiton pinned on the left shoulder and draped loosely across her chest; her wings are represented in almost rudimentary fashion, without the feathers being indicated. The pupils of the eyes are drilled, and the back of the bronze is filled with lead.

On stylistic grounds, this steelyard weight can be dated between the middle of the second century and the advent of the Tetrarch style. It may have been made in Roman Gaul. Nike or Victoria is a rare subject for one of these balances. The iconographic and stylistic parallel for the bust shown here lies not among steelyard weights but in appliqué busts from chests and other items of furniture (Babelon-Blanchet, *Bronzes*, 296, no. 684; Schumacher, Karlsruhe *Bronzen*, 50, no. 276, pl. 7, no. 5).

A monumental version of the design, a bronze in high relief on a plaque with mouldings (0.28m. square), is in the Fogg Art Museum (accession number 1966.12; Hanfmann, Fogg Art Museum *Newsletter*, vol. 3, no. 5 [June 1966] 3, illus.). It is said to come from Asia Minor and to have adorned a warship. Screwholes in the neutral background of the plaque indicate it was mounted on a ship's side, a cabin, or the wall of a building.

Vermeule, *CJ* 55 (1960) 202f., fig. 11.

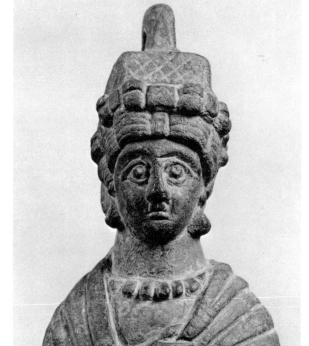

644

644

STEELYARD WEIGHT
Fifth Century A.D.
H. (with ring): 0.178m.
William E. Nickerson Fund No. 2 59.961
Purchased by the former owner in Istanbul.

Green and dark brown to black patina.

Bust of an empress wearing a cloak held in front by the right hand and a tunic beneath. The hair is in an elaborate, high coiffure with a diadem of large stones; she wears large earrings and a heavy necklace. The bottom is weighted with lead, and a ring for suspension is cast on top of the head.

Her himation is incised with small circles to represent a pattern in fine linen or silk, and her left hand holds a scroll or rotulus against the robe. The lead filling projects below the moulded base, and the hairnet on top forms a logical transition to the loop for suspension.

This bust belongs in a class of nearly twenty similar steelyard weights, scattered throughout museums and private collections from Istanbul to Dumbarton Oaks. The majority come from the eastern Mediterranean, indicating this region as principal place of manufacture and use (see M. C. Ross, *Catalogue of the Byzantine and Early Mediaeval Antiquities in the Dumbarton Oaks Collection*, I, 61f., nos. 71f.). This example is a very good casting and is paralleled most closely by a bust in the Benaki Museum in Athens. The bust in the Victoria and Albert Museum, London, also clearly shows the rotulus in the left hand, but a note of Christianity rather than just authority and learning is imparted in specimens in Munich and in the collection of Mrs. W. Murray Crane (New York), where the right hand is raised in gesture of Benediction (R. Delbrueck, *Spätantike Kaiserporträts*, 229ff.).

Among several possible imperial candidates in the fifth century, Aelia Eudocia, wife of Theodosius II (A.D. 408-450), best suits these half-figure busts on the (tenuous)

grounds of numismatic iconography and from religious, political, and intellectual suitability. Although the type of these weights continued and was repeated by successive castings throughout the Byzantine period, this example appears to belong among the earliest survivors of the type, presumably to the lifetime of Aelia Eudocia herself.

Vermeule, *Ann. Rep. 1959*, 29; idem, *CJ* 56 (1960) 13f., fig. 16.

Hoving in D. von Bothmer, *Ancient Art from New York Private Collections*, 82f., under no. 315.

645

SUPPORT FOR A CROSS
Circa A.D. 1300
H.: 0.32m.
Seth K. Sweetser Fund 63.789
Said to have been found in Istanbul.

Two of the crosses in the lower storey are missing. Green patina.

This support takes the form of a two-storeyed church with windows in the roof and cupola. The handle is hollow, probably to fit over a wooden staff.

Compare M. C. Ross, *Catalogue of the Byzantine and Early Mediaeval Antiquities in the Dumbarton Oaks Collection*, I, 59f., no. 69, pl. 41; also W. F. Volbach, Berlin Museum, *Mittelalterliche Bildwerke aus Italien und Byzanz*, 165f., no. 2487, illus., and Hamburg, *Jahrbuch der Hamburger Kunstsammlungen* 10 (1965) 191f., illus.

M.F.A., *Calendar of Events*, May 1963, 3, illus.; Vermeule, *Ann. Rep. 1963*, 42; idem, *CJ* 60 (1965) 303f., fig. 18.
ArtQ 26 (1963) 483, 488, illus.

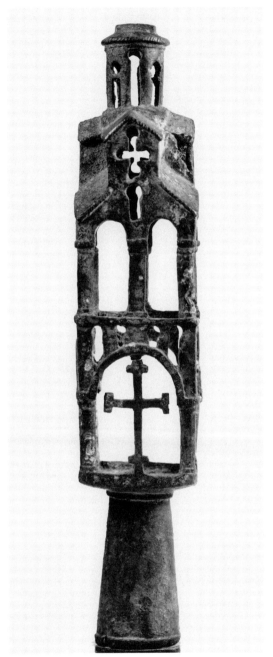

645

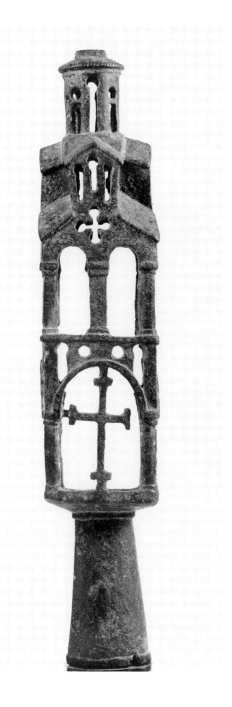

645

MISCELLANEOUS

Greek and Graeco-Roman

646

Caduceus
Circa 530 B.C.
L.: 0.393m.
Purchased by Contribution 01.7501
E. P. Warren Collection; Forman Collection.

The iron shaft is badly corroded and the bronze top is somewhat corroded. Light green patina.

In the bronze top, rams' heads face each other after joining in a square knot and forming a loop which springs from a lotus palmette above two turned knobs with a tubular shaft between. The iron shaft or rod extends from this.

Compare C. de Simone, *ArchCl* 8 (1956) 15ff., pls. 7-8, an inscribed example from near Brindisi; another comes from Crete: Schefold-Cahn, *Meisterwerke*, 180, 225, no. 184, and is dated about 450 B.C.

These staffs are not only votives to Hermes but herald's staffs.

E. Robinson, *Ann. Rep. 1901*, 36; *AA* 1902, 132; *AJA* 6 (1902) 377; G. H. Chase, *Greek Gods and Heroes*, 38f., fig. 36; 1962 edition, 51, fig. 37.

Forman Sale II, *Catalogue*, no. 598; Crome, *AM* 63-64 (1938-39) pl. 18, 2, 117ff.

Exhibited: Cambridge (Mass.), Fogg Art Museum, *Greek Art and Life*, no. 7.

647

Buckle
Greek
DIAM.: 0.045m.
Gift of T. A. Fox 94.42
From Argive Heraeum.

Crusty green patina.

This comprises a hollow disc with cross bar and ring attached to the rim for fastening.

646

647

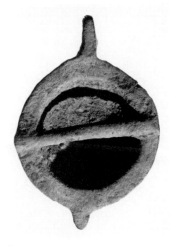

647

E. Robinson, *Ann. Rep.* 1894, 16.

648

DISC
Greek
DIAM.: 0.102m.
Gift of H. P. Kidder 81.325
Purchased by W. J. Stillman; from Crete?

Dark green encrustation.
 The outer rim is slightly raised.

649

DISC
Greek
DIAM.: 0.095m.
Gift of H. P. Kidder 81.324
Purchased by W. J. Stillman; from Crete?

Green encrustation.
 Incised rings around edge of upper side.
Evidences of spinning on the reverse.

648

649

650

Disc
Greek
DIAM.: 0.153m.
Gift of H. P. Kidder 81.326
Purchased by W. J. Stillman; from Crete?

Thick light green encrustation.
 Incised rings at outer edge, and slight rim,
turned downwards.

651

Disc
Greek
DIAM.: 0.121m.
Gift of H. P. Kidder 81.327
Purchased by W. J. Stillman; from Crete?

Light green encrustation, partially cleaned.
Cracked and bent.
 There are several incised, concentric cir-
cles, within an upturned rim. Impressions of
a textile pattern are evident on all the
surfaces.

652

Disc
Greek
DIAM.: 0.111m.
Gift of H. P. Kidder 81.328
Purchased by W. J. Stillman; from Crete?

Thick light green encrustation. Part of
edge ragged.
 Remains of knob underneath; indications
of incised lines at outer edge.

653

Disc
Greek
DIAM.: 0.102m.
Gift of H. P. Kidder 81.329
Purchased by W. J. Stillman; from Crete?

Thick light green encrustation.
 Outer rim slightly turned up.

650

651

652

653

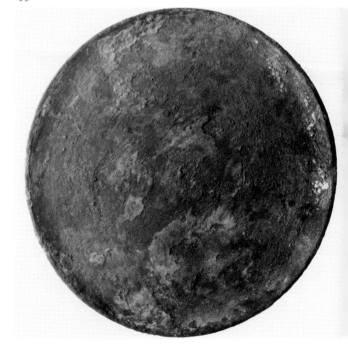

654

Disc
Greek
DIAM.: 0.095 x 0.029m.
Gift of H. P. Kidder 81.330
Purchased by W. J. Stillman; from Crete?

The edge is ragged. Thick light green
encrustation.
 This example has no rim.

655

655

Mirror or Disc
Greek (?)
DIAM.: 0.071m.
*Gift of the Archaeological Institute of
America 84.562*
From Assos.

Green patina and heavily encrusted.
 It is flat and undecorated. At least one
other similar to this was found with it.

654

656

657

656

Boss

Greek (?)

DIAM.: 0.044m. H.: 0.017m.

Gift of the Archaeological Institute of America 84.563

From Assos.

Green patina, encrusted.

In shape, a flattened hemisphere. Concentric raised circles decorate the convex side. Rings were attached to the bottom at opposite points near the rim.

657

Boss (?)

Greek (?)

DIAM.: 0.042m. H.: 0.015m.

Gift of the Archaeological Institute of America 84.565

From Assos, Sarcophagus no. 102.

Green patina, encrusted.

It is hollow and hemispherical; the rim is slightly flanged.

658

659

658

RING
"Cypriote"
DIAM.: 0.022m.
Purchased by Subscription 72.411
General di Cesnola Collection.
From Cyprus.

Green encrustation.

The ends are bent so that they are side by side. The body is cylindrical in shape and section.

659

RING OR BELT ATTACHMENT
Greek
L.: 0.038m. W.: 0.013m.
Gift of C. G. Loring 83.421
From Cos.

Worn and rusted.

The shape is a flat curve, concave on one side and slightly convex on the other. The ends widen into two broad discs.

660

FRAGMENTARY RELIEF
550 to 500 B.C.
H.: 0.247m. W.: 0.172m.
H. L. Pierce Fund 98.652
E. P. Warren Collection.
Bought from Xylokastro, in the Peloponnesus, not far from Sikyon.

Upper left corner of a rectangular plate, broken on bottom and right. Rich green patina.

This hammered and incised relief shows a facing head of Medusa, of Archaic type. She has flattened ears, tight curls over the forehead, teeth, fangs, and at least five snakes visible in her hair.

E. Robinson, *Ann. Rep.* 1898, 24f.; *AA* 1899, 136; J. Addison, *The Boston Museum of Fine Arts,* 295.

660

661

661

CRADLE
Greek
L.: 0.096m. W.: 0.061m.
Gift of E. P. Warren 96.671
Said to be from a tomb in Palaeopolis in Elis;
found with phiale (no. 453), spoon fragment
(no. 610) and cymbals (no. 622).

Broken through and cracked in the center
in two places. Rich, medium green patina.

This model of a cradle is fashioned from
a thin sheet, undecorated. Each end has two
pairs of semicircular incisions cut into the
rim. The walls of the cradle slope gradually
to the slightly rounded bottom. The two
small points at one end may have been for
attachment of rockers.

A similar cradle, although flatter and
more summary, is used by Tyro for her
twins Pelias and Neleus in a fourth-century
terracotta in Boston (01.7826).

E. Robinson, *Ann. Rep.* 1896, 31 (with other
finds from same tomb); *AA* 1897, 73; H. Palmer,
Archaeology 5 (1952) 118, illus.; *FastiA* 7
(1952) no. 938.

662

TRIPOD FIXTURE OR FOOTSTOOL SUPPORT
Graeco-Roman, A.D. 50 or later
L.: 0.065m. H.: 0.07m.
Emily Esther Sears Fund 03.1656
From Abydos.

Brown and black surfaces.

A half-figure bust, probably female,
springs from an acanthus calyx. A bulla or
necklace with locket adorns the neck, not
unlike comparable experiences in Fayoum
portraits (K. Parlasca, *Mumienporträts und
verwandte Denkmäler* [Wiesbaden, 1966], pls.
F, 31, nos. 2, 4). A maenad or symbol of
the seasonal cycle is probably intended. The
double row of curls over the forehead is a
feature taken from Julio-Claudian or later
portraits. Compare van Gulik, Allard Pier-
son *Bronzes*, 74, no. 111, pl. 27, bust of a
boy from Egypt and parallels.

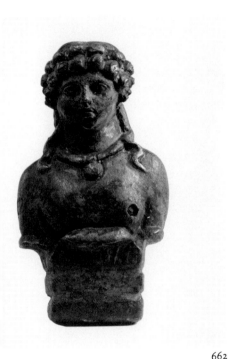

662

663

PAIR OF SUPPORTS FOR A FOOTSTOOL

A.D. 100 to 250

H. (max.): 0.10m. DEPTH (max.): 0.075m.
Gift of Charles S. Lipson 67.609, 67.610
Allegedly from Alexandria in Egypt.

There are remains of lead filling in the hollow bottoms of both pieces, as if they were set on rectangular rods or a plate. Irregular green and brown patina, with remains of earth on the surfaces.

Two half-figures of youths with long, curly locks spring from acanthus buds on small, rectangular plinths. They are clad in full himations, with a large brooch on the left shoulder. Hands and arms are hidden beneath the drapery, which forms large zigzags in front and is completely smooth in back.

A bronze footstool in the Palazzo dei Conservatori shows sphinxes seated on square plates which are attached to circular

662

663

663

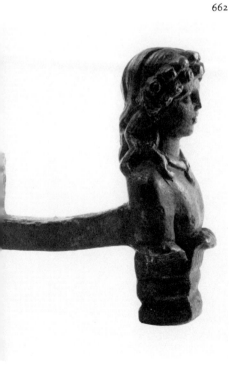

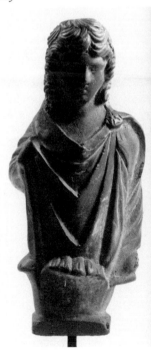

plinths and which support the rectangular
stool in a fashion similar to what must have
existed here (G. M. A. Richter, *The Furniture
of the Greeks Etruscans and Romans*, 105,
fig. 519). A small bronze statue of Fortuna
in Naples with a sphinx-supported footstool,
a cult-image from a household shrine, sug-
gests these lifesized bronze stools could
have been used with statues in shrines as
well as by Romans of wealth, if not of taste
(Richter, 105, fig. 487). The youths seen
here are probably general symbols of the
seasons, or perhaps attendants at the
temple of a goddess such as Demeter or
Persephone. Compare the various figures on
season sarcophagi of the third and early
fourth centuries A.D. (G. M. A. Hanfmann,
*The Season Sarcophagus in Dumbarton
Oaks*, II, no. 464, fig. 37; no. 492, fig. 59;
etc.). The form derives from supports for the
upper parts of tripods (Babelon-Blanchet,
Bronzes, 195, no. 439), and at least one tri-
pod has been reconstructed with similar
objects in the shape of satyrs' busts (De Rid-
der, Louvre *Bronzes*, II, 99f., no. 2577). De
Ridder has suggested that similar figures
of youths in the Louvre might have been
representations of Bonus Eventus (Louvre
Bronzes, II, 100, nos. 2585 and especially
2586).

A tripod and a tetrapod from a grave at
Wehringen in Bavaria have such supports,
one holding up the rings of the tripod
(*Münchner Jahrbuch der bildenden Kunst*
16 [1965] 268ff., fig. 8).

Vermeule, *Ann. Rep. 1967*, 47; idem, *CJ* 63
(1967) 6off., fig. 13.

ArtQ 30 (1967) 266, illus.

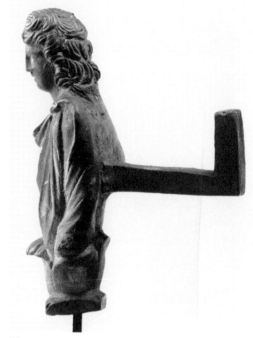

663

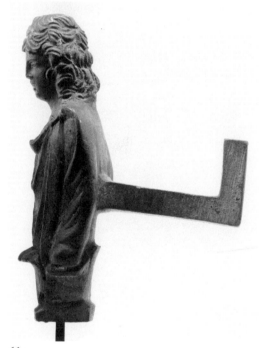

663

FAUCET IN THE FORM OF AN APE'S HEAD
Graeco-Roman
DEPTH (max.): 0.04m. DIAM. OF SHIELD:
0.043m.
Gift of Jerome M. Eisenberg 67.644

Greenish patina with areas of red and brown.

The animal's head emerges from a circular "shield," with a section of offset moulding, making the head and neck into a form of *imago clypeata*. A spout protrudes from the open mouth, and the remains of the tap's handle run from the moulding forming a hat on the head to the corresponding area at the base of the neck.

Pupils of the small eyes are incised, and the hair all over the face, especially the tufts in front of the ears, is carefully represented. A similar type of faucet has the form of a negro's head (Ars Antiqua Auction II, 14 May 1960, 42, no. 102, pl. 45). This ape is particularly interesting because it is a factual, Graeco-Roman rendering of simian features rather than a caricature or a presentation designed to provide a source of humor (see W. C. McDermott, *The Ape in Antiquity* [Baltimore, 1938], 192ff., section on bronzes). It belongs, as a work of art, to the full repertory of Roman imperial interest in animals from all corners of the globe.

This faucet probably comes from a water heater, as the two examples in Naples, one with a very complex handle above the mechanism (Tarbell, *Bronzes*, 116, figs. 97f.).

Vermeule, *Ann. Rep. 1967*, 47; *idem, CJ 63* (1967) 63f., fig. 16.

664
664

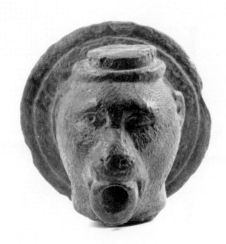

665

SPOUT IN FORM OF A LION'S HEAD
Graeco-Roman

H.: 0.099m. L.: 0.082m.

H. L. Pierce Fund 99.499
E. P. Warren Collection.
Bought in Rome; recorded in a drawing of
circa A.D. 1650.

Bluish green (river?) patina, with remains
of calcareous coating.
 The lower jaw is formed into the spout;
there is a hole at the back for the insertion
of the pipe. The mane is roughly brushed,
upwards and to left or right.

E. Robinson, *Ann. Rep.* 1899, 50; *AA* 1900, 218;
AJA 4 (1900) 511.

Dal Pozzo-Albani Drawing, London, British Museum, no. 521: Vermeule, *TAPS* 50, 1960,
Part 5, 34.

665

665

665

666

SPOUT IN FORM OF A PANTHER'S HEAD
Graeco-Roman

H.: 0.04m.

Purchased by Contribution 01.7519
E. P. Warren Collection; Forman Collection.

Brown patina.
 The animal's mouth is wide open, and the
ears are turned back. The face is framed by
leaf-shaped locks.
 A replica, of less good casting, is in
the Museo Archeologico in Venice.
 Compare, on a more monumental scale,
Sieveking, *Bronzen der Sammlung Loeb*,
76, pls. 33f.

E. Robinson, *Ann. Rep.* 1901, 36.

Forman Sale II.

667

Appliqué: Head of a Panther
Roman
L.: 0.045m.
Gift of Horace L. Mayer 56.1267
Purchased in Florence.

Green patina.
 The head is hollowed for fitting to an
object of furniture. The animal is shown
with open mouth, four prominent teeth, and
tongue lolling out between them. Spots are
indicated by incised circles and rough lines
delineate the wrinkles of the nose and the
hair of the ruff below the ears.

666

668

Ram's Head, from a Pole
Graeco-Roman
H.: 0.057m.
Purchased by Contribution 01.7521
E. P. Warren Collection.
Bought in Paris.

Color nearly black.
 This hollow casting has a flange at the
back, pierced by a hole behind each horn.
Fleece is shown on the throat.
 The style is that of the ram-headed patera
handles: as Münzen und Medaillen, Auktion
XIV, June 1954, 13, no. 43 (a whole patera).

E. Robinson, *Ann. Rep.* 1901, 36.

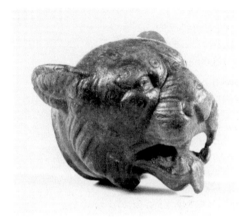

667

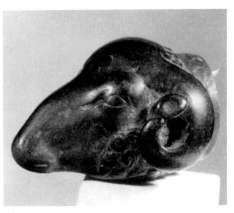

668

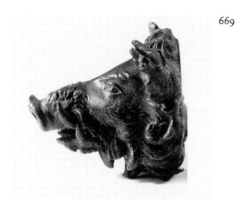

669

669

BOAR'S HEAD
Graeco-Roman
L.: 0.051m.
Francis Bartlett Collection 03.985
E. P. Warren Collection.
Bought in London.

Dark green patina.

This spirited rendering of a boar's head was probably attached to a piece of furniture. His hair is imaginatively curly, and his tongue shows amid teeth and tusks.

An example from the Athenian Agora (B254) is executed in the same style. It is probably from a pole.

B. H. Hill, *Ann. Rep.* 1903, 62; *AA* 1904, 194; *AJA* 8 (1904) 383.

670

(LITTER) CARPENTUM OR CHARIOT POLE: FOREPART OF A BOAR
Graeco-Roman
L.: 0.13m.
Gift of Mr. and Mrs. J. J. Klejman 60.1392
Prof. Vladimir Simkhovitch Collection.

Hollow cast. Dark brown patina, with encrustation scaled away.

The boar is shown as if running, with his forelegs extended.

As the functional protome of a vehicle, this boar was probably an owner's symbol,

perhaps a Roman family badge. Men named Aper (=Boar) often had the boar as an emblem. As the most ferocious beast in the pantheon of the hunt, the boar was an apt symbol of Roman virtus.

Vermeule, *Ann. Rep.* 1960, 39; Comstock, *BMFA* 58 (1960) 91, illus.; *FastiA* 15 (1960) nos. 208, 2224; Vermeule, *CJ* 57 (1962) 149, fig. 5.

Schauenburg, *JdI* 81 (1966) 300, note 135 (wolf?).

671

REIN-GUIDE FROM A CARPENTUM OR CHARIOT
Roman, about A.D. 200
H.: 0.217m.
Francis Bartlett Collection 03.983
E. P. Warren Collection.

Dark brown to blackish patina, covering some corrosion. Missing: the second handle, giant on it; most of the god or hero on the right, head of divinity (?) on the left; and arms of the giant at the left.

An enriched plinth and rocky mountain support a gate tower in which stand a goddess (Selene or Diana Lucifera, with crescent and veil over her head) and a male figure (Helios or Sol), repelling the attacks of snake-legged

670

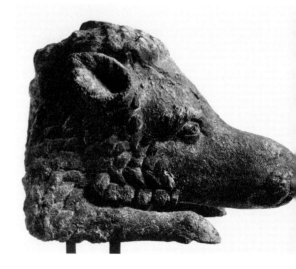

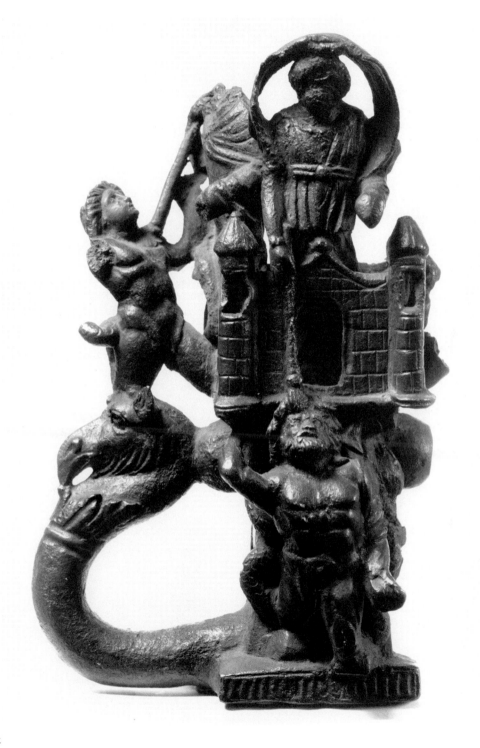

671

giants. One of these is below the tower in front, and the other is on the side-handle formed by a griffin's head.

For the type, see also Venedikov, *The Thracian Chariot* (in Bulgarian). A reconstructed cart in the Karapanos Room of the National Museum in Athens shows the setting for an ensemble such as this.

B. H. Hill, *Ann. Rep.* 1903, 62; *AA* 1904, 194; *AJA* 8 (1904) 383; Chase, *Antiquities*, 2nd edition, 226, 260, fig. 247.

F. Vian, *Répertoire des Gigantomachies*, no. 476, pl. 57; A. Fernandez de Aviles, *ArchEspArq* 31 (1958) 3ff., fig. 6a.

Exhibited: Waltham, Rose Art Museum, *Art of the Late Antique*, 53, no. 36.

672

HANDLE OF A CHEST: STYLIZED LION'S HEAD
Roman
DIAM.: 0.115m.
Classical Department Purchase Fund 59.654
Bought in Paris.

Badly cracked and somewhat encrusted over a green patina; iron pins or nails remain at left and right. Dark green patina, with reddish spots and traces of rust from the iron.

The facing head has the large, heavy ring cast separately in the mouth and hung through two very large holes. There are two smaller holes below the nose. Details of the eyes and fur are incised.

A splendid pair of handles in this style is in the Wadsworth Atheneum at Hartford.

Vermeule, *CJ* 55 (1960) 203, fig. 12.

673

HANDLE OF A CHEST: LION'S HEAD
Roman, circa A.D. 200
DIAM. (of lion): 0.125m. L. (max.): 0.185m.
Gift of Mrs. Cornelius C. Vermeule Jr.
61.1235
From Syria (with three companions).

Iron rust (from the three nails) on green patina.

This flamboyant lion and his three companions from the same series of moulds were attached by iron rivets to the body of a wooden chest or sarcophagus. One is described as the following.

The pupils, deeply hollowed out, as well as the flamelike treatment of the mane as a sort of solar disk background, indicate a date in the third century A.D. The lion with a ring in his mouth for lifting the lid or body of a sarcophagus was a standard decoration in the second and third centuries A.D. Besides those from Syria, examples have been found as far northwest as Ephesus (Istanbul, *Guide Illustre*, no. 4312). They vary greatly in quality and style of workmanship. Some are very flat and linear, almost un-animal in concept. This example belongs among the plastic, baroque manifestations of Antonine and Severan Roman decorative art.

Vermeule, *Ann. Rep.* 1961, 44; *idem, CJ* 58 (1962) 13ff., fig. 18; *FastiA* 17 (1962) nos. 238, 244.

Schauenburg, *JdI* 81 (1966) 271, note 47; *CJ* 64 (1969) 186, illus.; also in following issues (in advertisement for Ginn and Company).

672 673

674

Vermeule, *Ann. Rep. 1963*, 37.
ArtQ 26 (1963) 483.

675

HALF-FIGURE BUST OF ISIS
Graeco-Roman
H.: 0.125m.
Emily Esther Sears Fund 03.1662
From Dendera.

Greenish patina. Corroded and cleaned.
Lead filling in the back of the bust.

She is a Hellenistic lady draped in a
fringed garment with Isiac knot and adorned
with the conventional Egyptian headdress.

The ensemble was made as an appliqué to
be fitted on the surface of a chest or similar
piece of furniture. The workmanship was
once excellent and spirited, Isis having a
face related to the Maenad of Skopas. A simi-
lar bust in Paris is reversed, the head being
turned to the right instead of the left
shoulder: Babelon-Blanchet, *Bronzes*, 275,
no. 641.

676

STRAP HANDLE OF A BOX (?)
About A.D. 150 to 300
L.: 0.165m.
Gift of Mrs. C. C. Vermeule Jr. 64.83

Hole for swivel or loop above; locking loop
on lower reverse broken off. Yellowish
metal surface, with green and reddish en-
crustation.

In high relief, Attis (?) or, equally likely,
Paris stands with legs crossed, leaning on
a staff.

A chest connected with religious cults
would suggest Attis, but Paris would be
more appropriate to a lady's wardrobe or
vanity chest. This functional piece of decora-
tion was probably made in Asia Minor,
most likely in the third century A.D. The
design was fairly common in the decorative
arts of the eastern part of the Roman
Empire. The motif of Paris or Attis in his
Trojan or Phrygian winter costume, standing

674

LION'S HEAD FROM A SARCOPHAGUS
As previous.
L. (max.): 0.175m.
Gift of Mrs. C. C. Vermeule Jr. 63.631

Stains from iron rust. Green patina.

There are remains of three iron pins for
attachment in the mane. The pupils of the
eyes have not been hollowed out.

From the same sarcophagus as the
previous. The other two handles from this
set were in the Art Market in Philadelphia
before 1961.

with legs crossed and leaning on a staff, often came merely to symbolize the cycle of life and the seasons in a very general way. On the ends of sarcophagi of about A.D. 200, the figure is the shepherd watching Endymion and Selene; its appearance on mythological sarcophagi may reflect use purely as a decorative or filling figure, one originating in painting as early as Hellenistic landscapes echoing Theocritus. On a monumental niche or small arch from the Palace of Galerius at Salonika, work of about A.D. 300, it is used twice in the archivolts for the figures of Attis as a winter and as an autumn season (R. F. Hoddinott, *Early Byzantine Churches in Macedonia and Southern Serbia,* pl. 9b, c).

There may be an object in the left hand, but it may be merely that the figure is grasping the end of the staff on which he leans. Attis, in similar pose, usually holds the

675 675

knife symbolic of the orgies of his cult. Pairs of large, marble architectural figures, pillars and high reliefs, from cities or sites as far apart as Cyzicus in Mysia and Salerno in Italy show the popularity of representations of Attis in the monumental arts. This class of marble reliefs inspired decorators such as the man who made this handle (see Reinach, *Rép. stat.,* II, 471, nos. 1, 3, 4 and 5; H. von Fritze, *Nomisma* 4 [1909] 33ff., pl. 3).

Vermeule, *Ann. Rep.* 1964, 31; idem, *CJ* 61 (1966) 307ff., 304, fig. 24.

Hesperia Art, *Bulletin* XI, no. 188 (as a dagger handle).

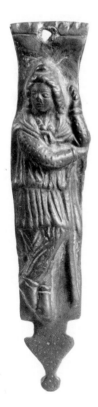

676

677

ATTIS OR MITHRAS
Graeco-Roman
H.: 0.077m.
Gift of Richard R. Wagner 65.1344
From Istanbul.

Green patina with earth encrustation. The
back is partly hollow, grooved.

In high-relief appliqué, the figure is Attis,
Mithras, or (less likely) a winter season.
He wears a hooded cape, sleeved tunic,
leggings, but seems to have bare feet.

This is possibly from a Phrygian work-
shop. It is impossible to say with certainty
to what use this plaque was put. In all likeli-
hood this Attis or Mithras enriched a
small chest or box in another material,
probably in wood.

Vermeule, *Ann. Rep. 1965*, 68.

678 678

677

678

HANDLE OR SUPPORT
Graeco-Roman
H.: 0.09m.
Gift of E. P. Warren Res. 08.32v
Bought from a Greek.

Green patina.

A herm-like figure has shoulder struts
and a phallos. A head of Pan with very long
horns supports the hollow cone.

464

679

IONIC CAPITAL, FOR A LAMP STAND
Greek

L.: 0.097m. W.: 0.081m. TOP: 0.09 x 0.083m.

Gift of E. P. Warren 13.173

Medium green patina.

On the face, between the volutes, there is a rosette in relief.

This seems to be earlier and simpler than the Ionic capitals surmounting the shafts of Pompeiian lamp stands: as De Ridder, Louvre *Bronzes*, II, 155, no. 3185, pl. 113.

L. D. Caskey, *Ann. Rep.* 1913, 88; *AA* 1914, col. 493; *AJA* 18 (1914) 414.

Richter, New York *Bronzes*, 74 (in connection with support for Hermachos).

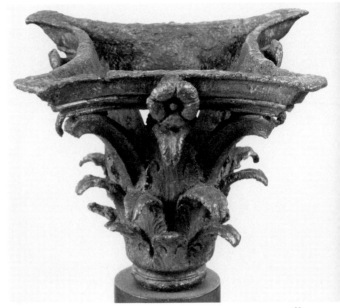

680

680

CORINTHIAN CAPITAL, POSSIBLY A
LAMP STAND
Greek

H.: 0.105m. DIAM. (bottom): 0.034m.
W. (top): 0.106m.

Francis Bartlett Fund 13.208
E. P. Warren Collection.
Bought in Munich.

The ends of the spirals have been broken off. Dark green patina.

There are two rows of acanthus leaves from which spring four tendrils ending in spirals supporting an abacus with strongly concave sides. Between each pair of tendrils, a larger acanthus leaf, above which is a flower.

Compare De Ridder, Louvre *Bronzes*, II, 156, no. 3193, pl. 113, which is a complete candelabrum, the Corinthian capital being surmounted by a lotus bud (?) and a flat dish. This capital grows out of a spiralled column. The date seems to be Hellenistic or Roman.

L. D. Caskey, *Ann. Rep.* 1913, 88; *AA* 1914, col. 493; *AJA* 18 (1914) 414.

679

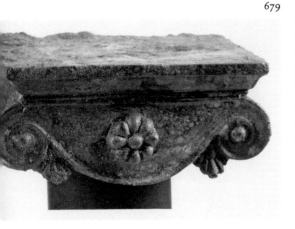

681

681

VOTIVE WHEEL
Archaic Period, circa 525 to 500 B.C.
DIAM.: 0.16m.
William Amory Gardiner Fund 35.61
Said to be from near Delphi (Galaxidi, or
ancient Chaleion).

Medium green patina.

There are four spokes, pierced at the center
for an axle. A dedication to Apollo is in-
scribed on the rim, in a central Greek
alphabet:

ΦΑΛΑΣ ΠΕΔΙΑΡΧΕΙΟΝ
ΑΝΕΘΕΚΕ ΤΟΠΟΛΟΝΙ.

The script, according to Miss Jeffery,
belongs to Boeotia or, most likely, Opountian
Lokris.

For other votive wheels, see De Ridder,
Acropolis *Bronzes*, 132f., nos. 404-406;
Olympia IV, 68f., nos. 498-510.

L. D. Caskey, *Ann. Rep.* 1935, 19; *idem, AJA* 40
(1936) 310f., fig. 5.

Payne, *Perachora*, 176, no. 19, pl. 78; *Olynthus*
X, 512, note 110; Bousquet, *BCH* 80 (1956) 591ff.,
fig. 12; *FastiA* 11 (1956) no. 1830; D. K. Hill,
AJA 60 (1956) 41, note 57; L. H. Jeffery, *The
Local Scripts of Archaic Greece*, 106ff., pl. 15
(Jeffery cites Wade-Gery, *Greek Poetry and Life*,
64, no. 3; L. Lerat, *Les Locriens de l'ouest*, I, xi;
and *SEG* 16, 336).

682

WEIGHT
Greek, Attic, probably Hellenistic
(Mabel Lang)
0.045m. SQUARE
Henry Lillie Pierce Fund 01.8282
E. P. Warren Collection.

Brownish patina, with some encrustation.
The weight is 2484.55 grains. It is square.
On the face, the letter Γ is inscribed.

E. Robinson, *Ann. Rep.* 1901, 36.

682

683

WEIGHT
Greek, Attic, probably Hellenistic
(Mabel Lang)
0.038m. SQUARE
Henry Lillie Pierce Fund 01.8317
E. P. Warren Collection.

As previous.
The weight is 1825 grains. The face is
slightly depressed and is inscribed:

E. Robinson, *Ann. Rep.* 1901, 36.

684

NAIL OR PIN
Greek (?)
L.: 0.19m.
Gift of the Archaeological Institute of
America 84.573
From Assos.

Encrusted, green patina.
 The head is domed, the shaft octagonal in
section. It is similar to nails found by
Schliemann at Troy (H. Schliemann, *Ilios*,
505, illus., nos. 929, 936 especially; see also
Blegen, *Troy* I, pl. 358).

685

NAIL
Greek (?)
L.: 0.043m.
Gift of the Archaeological Institute of
America 84.574
From Assos (the lower town).

Green patina.
 The head is circular; the shaft is quad-
rangular in section and blunt at the end.

686

DOWEL
Greek (?)
1884 App. M 580
From Assos.

685

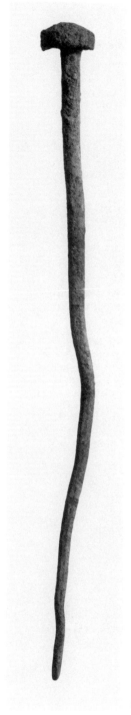

684

Etruscan, Italian
and Roman

688

687

FRAGMENTS OF TILE
Roman, Late Republic
a.: 0.93 x 0.047 x 0.07m. b.: 0.108 x 0.11m.
Purchased by Contribution 01.7489a & b
E. P. Warren Collection.
Bought in Rome; from the temple of Diana at
Nemi.

The tile was gilded. Green patina in places.
One piece is rectangular and slightly
687 warped; the other is triangular.

E. Robinson, *Ann. Rep.* 1901, 36.

688

THIN BAND WITH STAMPED DECORATION:
BATTLE OF THE GODS AND THE GIANTS
Etruscan, Archaic Period
L.: 0.247m. W.: 0.063m.
Purchased by Contribution 01.7528
E. P. Warren Collection.
Bought in Rome; from a tomb in the
necropolis of Bomarzo.

Slightly corroded; copper colored. Pieces
missing as illustrated.
The figures are stamped from behind.
There are eight figures of gods and giants
besides the animals. From the left, an
armed, armored god in a quadriga with a
charioteer spears a running giant. In the cen-
tral scene another youthful god has
wrenched the right arm off a fire-breathing
giant, and at the right Herakles, wearing
his lion's skin, brandishes his club at two
fleeing giants. A border of large dots is
above, and a wave pattern runs from left to
right below.

E. Robinson, *Ann. Rep.* 1901, 36; *AA* 1902, 132;
AJA 6 (1902) 377.

Waser, *Pauly-Wissowa*, Suppl. III, col. 719, nos.
197-98; Hanfmann, *ArtB* 19 (1937) 463-484,
fig. 1 and Headpiece; Vian, *Répertoire des Gigan-
tomachies*, no. 411, pl. 49; *idem, REA* 51 (1949)
28ff., pl. 2, 2 (dated at beginning of fifth century).

THIN BAND WITH STAMPED DECORATION:
BATTLE OF THE GODS AND THE GIANTS
Etruscan, Archaic Period
L.: 0.231m. W.: 0.06m.
Purchased by Contribution 01.7529
E. P. Warren Collection.
Bought in Rome; from a tomb in the
necropolis of Bomarzo.

See below. Partly copper-colored, partly
green.
 This band has been stamped or beaten
from the same mould as the previous. Save
for fragments, it lacks the figures at either
end and almost all the central group.

E. Robinson, *Ann. Rep.* 1901, 36; *AA* 1902, 132;
AJA 6 (1902) 377.

Hanfmann, *ArtB* 19 (1937) 463-484; Vian, *Réper-
toire des Gigantomachies*, no. 411; *idem*, *REA*
51 (1949) 28.

689

690

690

690

THIN BAND WITH STAMPED DECORATION:
RUNNING FIGURES AND A HUNTING SCENE
Etruscan, Archaic Period
L.: 0.247m. W.: 0.335m.
Purchased by Contribution 01.7530
E. P. Warren Collection.
Bought in Rome; from a tomb in the
necropolis of Bomarzo.

Badly corroded and with areas missing; the
patina is light green.

From left to right, there are a vertical
fillet, a palmette and tendrils, a dog (?), two
clothed, youthful figures running to the
left, and a similar figure attacking a large
feline. Five vertical divisions of beads,
volutes, and palmettes follow, and then the
scene is repeated in reverse.

E. Robinson, *Ann. Rep.* 1901, 36; *AA* 1902, 132;
AJA 6 (1902) 377.

691

DISC, FOR ARMOR
Etruscan, 700 to 675 B.C.

DIAM.: 0.235m.
Purchased by Contribution 01.7502
E. P. Warren Collection.
Bought in Rome.

Green patina.

This disc was designed to be sewed on a
shield, breastplate, or cuirass. The perforated
and incised decoration is grouped in two
concentric bands. In the center, there is a
boss with a small, perforated and riveted
disc. Three bosses on one side of the rim are
secured by rings, and the two on the other
side are riveted.

Compare, for this and the following,
especially the latter, the example in the
Metropolitan Museum, termed Early Iron
Age (Villanova period) and described as
being for a breastplate of cloth or leather:
Richter, New York *Bronzes*, 422, no. 1575.
On the other hand, Richter (408ff., nos.
1523-1525) links the knobbed and (some-
times) perforated discs of slightly convex
shape with shield bosses.

E. Robinson, *Ann. Rep.* 1901, 36 (this and four
following).

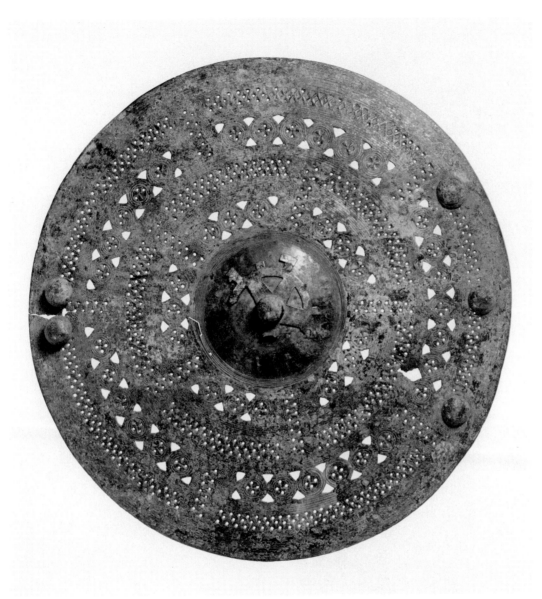

691

692

DISC, FOR ARMOR
Etruscan, Early Seventh Century B.C.
DIAM.: 0.218m.
Purchased by Contribution 01.7503
E. P. Warren Collection.
Bought in Rome.

A small piece is missing at the edge. Green patina.
 The design is perforated and incised, in concentric bands. There are two holes for suspension at the edge.

693

DISC, FOR ARMOR
Etruscan, Early Seventh Century B.C.
DIAM.: 0.23m.
Purchased by Contribution 01.7504
E. P. Warren Collection.
Bought in Rome.

692

693

A large piece is missing from one side. Green patina.
 This is a shield or cuirass (or helmet) boss, with perforated and incised decoration in concentric circles.

694

DISC, FOR ARMOR
Etruscan, Early Seventh Century B.C.
DIAM.: 0.113m.
Purchased by Contribution 01.7505
E. P. Warren Collection.
Bought in Rome.

Green patina, with some corrosion.
 This disc was also designed to be sewed
on a leather or cloth breastplate or fixed on
a wooden shield. It has perforated, incised,
and knob decoration in concentric circles
about a stamped, five-pointed star in the
center. A rivet and a square ring fasten a
circular disc on the front.

695

DISC, FOR ARMOR
Etruscan, Early Seventh Century B.C.
DIAM.: 0.12m.
Purchased by Contribution 01.7506
E. P. Warren Collection.
Bought in Rome.

Greenish black patina.
 As previous. There is perforated and in-
cised decoration in concentric bands. In the
center, a small convex disc with a rivet
holds in place a wheel-shaped ornament
with serrated edge. There is a circular loop,
from the wheel, on the inside center.

694

695

475

696

696

BUTTONS
Late Roman Republic
88.624 & 88.625: DIAM.: 0.029m.
H.: 88.624: 0.012m.; 88.625: 0.014m.
88.626 & 88.627: DIAM.: 0.025m.
H.: 0.015m.
Purchased by Contribution 88.624 – 88.627
Purchased of R. Lanciani; from the sanctuary of Diana at Nemi.

Dark green and brown patina.

They are convex on one side, and a bar in the shape of a circular segment runs across on the lower side.

697

BELL-GONG
Roman
DIAM.: 0.19m.
H. L. Pierce Fund 99.500
E. P. Warren Collection.
Bought in London; from the Purnell Collection.

Green patina, mostly removed. The hole in the center was enlarged by friction of the iron hoop (indicating long use).

The instrument's form is that of a disc with a hole in the center, through which passed an iron hoop, to the ends of which chains were attached for suspension. Each face is decorated with four concentric circles, incised.

There are four comparable examples in Naples, from Pompeii (see Daremberg-Saglio, II, 280, fig. 2467: Discus; Neugebauer, *Bilderhefte zur Kunst-und Kulturgeschichte,* II, pl. 11, 2). The bell was hung in a vertical position on a rod or bracket which projected from a wall. The striker, of iron, hung by another chain from the same rod. The disc gives a clear, musical tone when struck.

E. Robinson, *Ann. Rep. 1899,* 50f.; *AA* 1900, 218; *AJA* 4 (1900) 511; J. Addison, *The Boston Museum of Fine Arts,* 298.

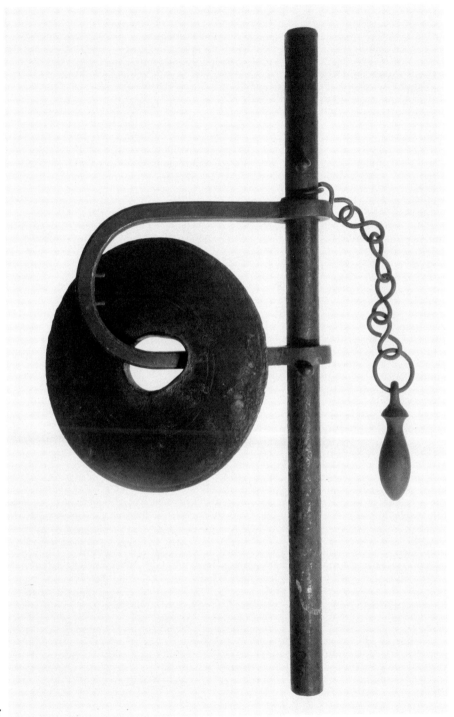

697

698

698

HORSE-BIT

Circa 800 to 700 B.C.

H. (max.): 0.075m. W. (max.): 0.30m.

Gift of Horace L. Mayer 63.2762

One ear of each horse and the filigree between the legs of the beast against the left cheek are missing. Pea-green patina, with some chipping.

The side bars are formed of two Geometric horses, with little horses on their backs. The filigree is in the form of two more tiny, very stylized horses. The mouthpiece is broken, swinging from interlocking rings. There are further eye-rings at the ends of the mouthpiece. Places for the guide reins are visible in the rectangular, key-like projections at the ends of the rings and bars at the sides. The smaller checkreins were attached to the small eyes at the bottom front of the vertical side bars or cheekpieces, where the force would be broken by the swing or pivot of these bars. Two further small eyes, at the bottom rear, were probably for a thin iron chain which passed under the horse's lower jaw or mouth.

See generally, D. Randall-MacIver, *Villanovans and Early Etruscans*, 24f., 32.

Compare Münzen und Medaillen, Auktion XXII, 1961, 36, no. 65 and detailed bibliography (of finds from nearly every major Etruscan site); Hoffmann, *Norbert Schimmel Collection*, no. 39; Hesperia Art, *Bulletin* XXII, no. 18; Queens College, *Man in the Ancient World*, 21f., no. 136 and cover. C. Hopkins, *Archaeology* 11 (1958) 94f., terms the horse-on-horse, waterbird-below motifs early Etruscan; see also, *idem*, *Berytus* 11 (1954-55) 75-84; *idem*, *CJ* 60 (1965) 216ff., and fig. 5.

Vermeule, *Ann. Rep.* 1963, 35; MFA, *Calendar of Events*, March 1965, 1; Vermeule, *CJ* 61 (1966) 292ff., fig. 5.

699

PART OF SNAFFLE
Italic, Fifth to Fourth Centuries B.C.
H.: 0.041m. DIAM.: 0.062m.
Purchased by Subscription 88.623
Purchased of R. Lanciani; from the sanctuary
of Diana at Nemi.

Light green patina.
 The object is cylindrical and hollow, with
four spiral bands in slight relief, each
band having three spikes projecting from it.
 Compare De Ridder, Louvre *Bronzes*, II,
10, no. 1201, pl. 68; also, especially, Helbing
Auction, Munich, 22 February 1910, 14,
no. 179 (illus.).
 A Greek "severe" snaffle bit from
Achaia, dated in the fifth or fourth cen-
turies B.C., conforms to Xenophon *De. re.
eq.* X, 6, and shows that this is one of the
"hedgehogs" (ἐχῖνοι) or prickly cylinders at
the sides of the "wheels" (Τροχοι) of the
central, snaffle bars.

699

700

BRIDLE-TRAPPING
Italic
L.: 0.065m. W.: 0.041m.
Gift of E. S. Morse 00.622

The left ring is worn on the under surface.
Deep green patina, with light corrosion.
 There are three long spines; the front one
is straight and triangular in section; the
other two are flat and bent away from the
front. There is rudimentary decoration in
relief on the front. The left ring is consider-
ably worn on the under surface.
 Compare De Ridder, Louvre *Bronzes*, II,
14, nos. 1319, 1321, pl. 69.

E. Robinson, *Ann. Rep. 1900*, 31f.; *AA 1901, 166*;
AJA 5 (1901) 361 ("so-called bow-pullers":
this and three following).

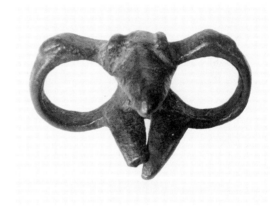

700

701

701

BRIDLE-TRAPPING
Italic
L.: 0.06m. H.: 0.031m.
Gift of E. S. Morse 00.623

Deep green patina, with light corrosion.
 There are two curved rings, roughly
rounded and three long, rather slender spines.
On the front face of each ring, rudimentary
decoration in relief.
 Compare Schumacher, Karlsruhe *Bronzen*,
153, no. 790, pl. 16, 14.

702

702

BRIDLE-TRAPPING
Italic
L.: 0.065m. H.: 0.01m.
Gift of E. S. Morse 00.624

Deep green patina, with light corrosion.
 Two flat rings, roughly rounded; four
short spines, in pairs. The only decoration
is an incised ✕ on the underside of the bar.

703

703

BRIDLE-TRAPPING
Italic
L.: 0.07m. H.: 0.05m.
Gift of E. P. Warren 00.625

Deep green patina, with light corrosion.
 The bottom of the two loops and the three
long spines has a pronounced curve. At
the base of the front spine is a steer's head
in high relief.

704

BRIDLE-TRAPPING
Italic
L.: 0.078m. H.: 0.035m.
Gift of E. S. Morse 02.328
From Florence.

Deep green patina, with light corrosion.
There are the usual two loops and three
upright spikes, noticeably blunt and thick,
and separated from one another.

E. Robinson, *Ann. Rep. 1902, 67* (this and four
following); *AA 1903, 156* (same).

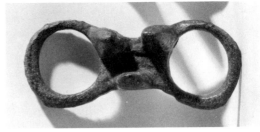

704

705

BRIDLE-TRAPPING
Italic
L.: 0.069m. H.: 0.03m.
Gift of E. S. Morse 02.329
Probably from Italy.

Deep green patina, with light corrosion.
Between the loops there are three upright
spikes, bent in and tending to come to a
point.

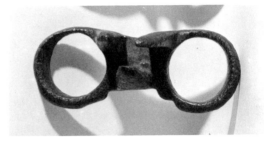

705

706

BRIDLE-TRAPPING
Italic
L.: 0.075m. H.: 0.032m.
Gift of E. S. Morse 02.330
From Florence.

The tip of one spike has broken off. Deep
green patina, with light corrosion.
There are the inevitable two loops. The
three spikes are short and wide at the bottom
and bent in; that by itself on one side has
the end broken away.

K. Herbert, *Ancient Art in Bowdoin College*, 123,
no. 443.

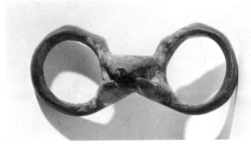

706

707

707

BRIDLE-TRAPPING
Italic
L.: 0.064m. H.: 0.024m.
Gift of E. S. Morse 02.331
Probably from Italy.

Deep green patina, with light corrosion.
Two of the three spikes are taller than
the third, and bent outward. The short and
blunted one bends in.

708

708

BRIDLE-TRAPPING
Italic
L.: 0.062m. H.: 0.013m.
Gift of E. S. Morse 02.332
From Florence.

Deep green patina, with light corrosion.
The projections between the rings are four
in number, being so short that they are
really only knots with square bases.

709

709

BRIDLE-TRAPPING
Italic
L.: 0.058m.
Anonymous Gift 06.2449

Deep green patina, with light corrosion.
The three spikes have incurved points.

L. D. Caskey, *Ann. Rep. 1906, 59; AA 1907,*
col. 395.

710

HORSE'S TRAPPING (FRAGMENT)
Greek
H.: 0.028m. L.: 0.05m.
Gift of Emil C. Hammer 92.2619

One ring and spike broken. Entirely
encrusted with speckled brown green rust.

710

711

RAM'S HEAD: BOSS OF A VOTIVE SHIELD
Etruscan, Archaic Period
DIAM.: 0.085m.
Alfred Greenough Collection 08.534

Two small fragments are missing from the nose. Crusty green patina.

The metal is very thin. The small holes in the flange around the neck indicate the relief was attached to a larger surface, probably a wooden votive or funerary shield.

A similar piece is in the Rhode Island School of Design in Providence (22.206). The ram combines Greek formality and native naturalism, characteristic of animals in early Etruscan sculpture. Here the ram's long nose and broad lips have caught the artist's eye. Orderly treatment of fleece and curved horn recall Greek work of the sixth century B.C.

The Etruscans must have derived the idea for these shield bosses ultimately from the large lions (or cats) in the Cretan examples. There are similar ram's heads in the British Museum, the centerpieces of bosses which look like paterae but are small, votive shields (see nos. 49 5-19 2; and 67 5-8 375, 376). Compare, also, the shield with lion emblem from Tarquinia (*Studies Presented to D. M. Robinson*, I, pl. 93, b = Giglioli, *L'Arte etrusca*, pl. 97, 2), and the lion-mask exhibited in New York (Emmerich, Cahn, *Classical Works of Art*, no. 40).

Vermeule, *BMFA* 56 (1958) 96, illus.; *FastiA* 14 (1959) no. 715.

The Pomerance Collection of Ancient Art, 105, under no. 119.

711

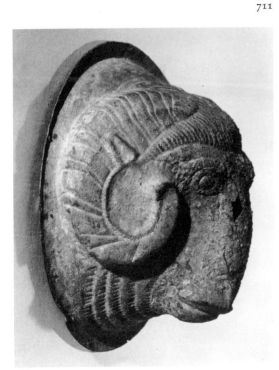

711

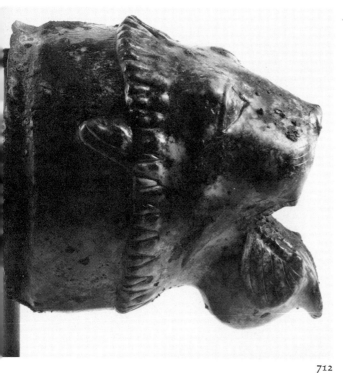

712

712

LION'S HEAD: END OF A CHARIOT POLE
Early Fifth Century B.C.
L.: 0.105m. DIAM.: 0.09m.
Gift of the Estate of Dr. Jacob Hirsch 55.497
From near Orvieto.

Lower part of flange missing; two small holes on left side of neck; nose cracked; otherwise well preserved. Rich green patina, with glossy, mottled surface in shades leading almost to onyx.

The piece is hollow and terminates at the neck in a narrow flange pierced by nail-holes.

Compare van Buren, *AJA* 60 (1956) 396, pl. 132, fig. 21, the finial of a chariot pole with a ram's head. Richter, New York *Bronzes*, 27ff., fig. 40, shows two axle-ends of a chariot, in the form of lions' heads, and another (a boss) is illustrated as no. 1 in C. Blümel, *Antike Kunstwerke*; these are earlier.

H. Palmer, *Ann. Rep.* 1955, 12f., illus.; Chase, *Antiquities,* 2nd edition, 194, 207, fig. 195.

W. L. Brown, *The Etruscan Lion,* 99f., pl. 40 c.

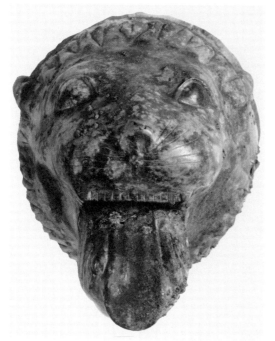

712

713

713

<u>713</u>

PLATE

Italian, Archaic

L.: 0.035m. W.: 0.03m.

Gift of Miss C. Wissmann 02.303

Buffum Collection.

From Palestrina.

Broken, filled with wax (?). Green patina.
There is a design of dots on one side.

SUPPLEMENT

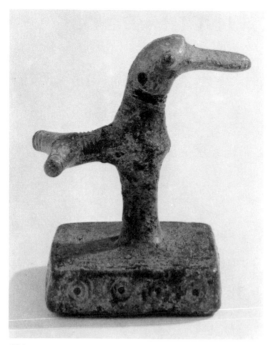

10A

BIRD

Circa 725 B.C.

H.: 0.036m.

Gift of Mr. and Mrs. John Dane, Jr. 1970.413

Green and blackish patina.

There is a hole, vertically, through the neck for suspension and parallel rows of incised straight lines on the neck, body and tail. The bill is elongated. Straight and zigzag lines are incised on the top of the stand with open spirals on the sides. The stamp on the base is a snake-like design.

The high, rectangular form of the base, as well as the suave handling of the incised ornament, suggest a date about 725 B.C. For a similar bird of the eighth century B.C., from Olympia, see Schefold-Cahn, *Meisterwerke*, 131, no. 64.

Vermeule, *Ann. Rep. 1970*, 42.

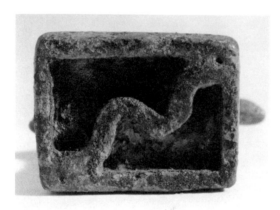

10A

DIONYSOS

First to Second Century A.D.

H.: 0.157m.

Gift of Professor and Mrs. Benjamin Rowland, Jr. 69.1257

Probably from Alexandria or Rome.

Left hand and left foot missing. Hand of Ampelos remains under Dionysos' upraised right arm. Brown and red patina.

Dionysos wears a chlamys over his shoulders and left arm, a wreath, and travelling boots. He was part of a group, probably with the satyr Ampelos.

For the iconography of the Dionysos-Ampelos group in the Hellenistic and Graeco-Roman periods, see P. Amandry, *Collection Hélène Stathatos, Les Bijoux antiques* (Strasbourg, 1953) 91 ff., under the gold naiskos no. 232, pl. 35, figs. 51-58. The group is an excellent example of the developed "Hellenistic rococo," the Dionysos going back through several statues of that young god or of Apollo in the third century B.C. to creations by Praxiteles about 350 B.C. The notion of the tipsy Dionysos supported by a satyr (Ampelos, meaning "the chap from the vineyard") was popular in all forms of Roman decorative arts, from Dionysiac sarcophagi to small bronzes. The bronze group in the Walters Art Gallery, Baltimore gives a good idea of how this ensemble once appeared (M. Bieber, *The Sculpture of the Hellenistic Age*, 140, fig. 572; Hill, Walters *Bronzes*, 26, no. 46, pl. 14).

Vermeule, *Ann. Rep.* 1970, 42.

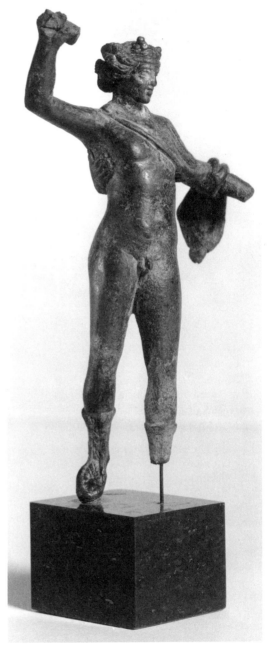

100A

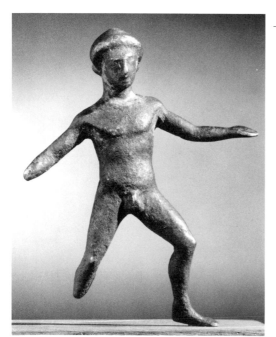

355A

355A

EROS FROM A MIRROR WITH STAND
Circa 470 B.C.
H.: 0.073m.
*Gift of Theodore Ladoulis in Memory of
Vassilios Ladoulis 69.56*
From Kyparissia in Arcadia (ancient Basilis ?).

Missing right hand, right foot, and wings.
There is a groove on the top of the head
where the figure joined the mirror disc.
Extremities and features are much worn.

The Eros was flying to the right and there-
fore came from the left side between mirror
and figure stand, as if he were about to alight
on Aphrodite's shoulder. Compare the
similar figure from the Spencer-Churchill
collection: Sotheby Sale, 18 June 1968,
no. 176; Christie's Sale, 21 June 1965, 116,
no. 464, pl. 54, where the piece was identified
as coming from a standing mirror. With his
rolled hair and carefully articulated body,
this Eros from Arcadia is an excellent specimen
of the Transitional Style in decorative
metalwork.

Vermeule, *Ann. Rep.* 1970, 42.

357A

MIRROR AND HANDLE
Tarentine, circa 325 B.C.
H. (max.): 0.279m. DIAM.: 0.145m.
Gift of Paul E. Manheim 1970.239
Jerome M. Eisenberg Collection. Ex Münzen
und Medaillen A.G., Auktion 34,
6 May 1967, 12, no. 17, pl. 6, 3 illus.
(with discussion).

Light green patina with heavy encrustation
on the polished surface of the disc. Sections
of the figured surface restored in wax.

The reverse of the disc has a series of con-
centric mouldings culminating in a point
at the center. The attachment at the upper
back of the handle takes the form of a tall
palmette with volutes. The openwork scene
on the front of the handle, below the ovolo
and tongue mouldings and between the
flaring acanthus, is set on wavy ground above
the Ionic capital. Achilles, wearing helmet,
cloak, and his shield over his shoulder, has
dragged the panic-stricken young Troilos
by the hair from his horse and is about to stab
him with a short sword. The youth's cloak
trails on the ground beneath his body, and
the horse is about to gallop away, reins
flying free.

The pose of the figures and the pathetic
gesture of Troilos are derived from older
Greek paintings and sculptures, notably the
scenes of combat between Greeks and
Amazons on the frieze of the temple of Apollo
at Bassae. From South Italian Greek metal-
work, such as this mirrror handle, the
composition passed into late Etruscan or
native Italian art to the northwest, where
variations on the theme were popular in
a number of decorative works.

Vermeule, *Ann. Rep.* 1970, 42.

357A

357A

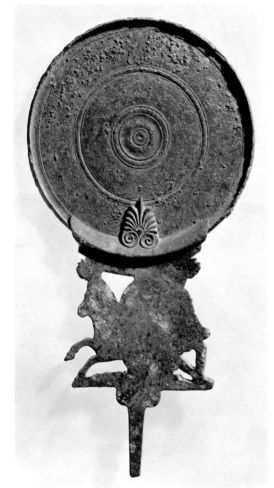 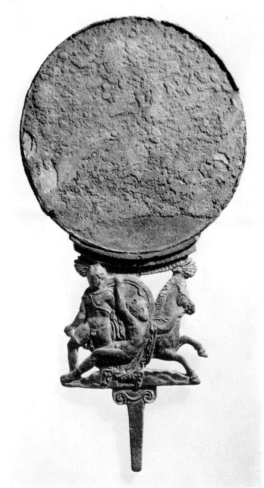

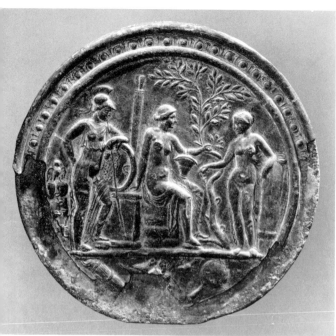

400A

flanked by a torch and a mirror. Rolled fillets and an egg-and-dart moulding enframe the scene.

A mirror with the "Three Graces" in orthodox schema, in the Seattle Art Museum from Spink and Son, exhibits a similar technique of applied surfaces and gilding: see *ArtQ* 31 (1968) 91. A bronze drachma of Alexandria struck under Antoninus Pius, A.D. 141 or 142, suggests this scene may be excerpted from a larger, more-complex composition: J. G. Milne, *JEA* 29 (1943) 63, pl. 4, fig. 9; *Sammlung Walter Niggeler, 2. Teil,* Basel auction, 21-22 October 1966, no. 729. Torch and pomegranates on the mirror might make us think of preparations for the springtime return of Adonis.

Vermeule, *Ann. Rep. 1970,* 40.

432A

HANDLE-PLATE OF A BASIN (LOUTER)
Circa 450 B.C.
H.: 0.102m. W.: 0.081m.

432A

400A

MIRROR
Circa A.D. 100 to 200
DIAM.: 0.164m.
Theodora Wilbour Fund in Memory of Zoë Wilbour 69.71

Extensive remains of gilding. Rim of the lower half is broken off. The backing with the reliefs has been mounted on a disc which has a polished outer surface.

The scene may be part of the Judgment of Paris. Athena, Aphrodite, and a nymph are seen in a landscape setting. Athena, in helmet and chiton, holds her spear and rests against shield and aegis, the former on the balustrade of the steps (an altar?) where Aphrodite sits. Aphrodite, holding a sprig of pomegranates (?) has a kalathos on her left arm. The nymph rests her left arm against a pillar. Behind Athena, an owl sits on the rocks. In the area below the groundline are two birds

Otis Norcross Fund 1970.7
From Southern Italy (Metapontum).

The left ear of the Gorgon is chipped.
Green patina.

The handle-plate was cast as one piece, the
back left in rough incuse, with a broad rim,
all for soldering to the bowl of the vessel.
The upper, functional part of the design con-
sists of a three-quarters circle with three raised
mouldings. Below appears the somewhat-
stylized, pseudo-Archaic head of the Gorgon
Medusa, with staring eyes and tongue
protruding from her mouth.

See the various iconographic parallels,
R. Blatter, "Zu einem griechischen Henkel-
typus," *AA* 1966, 48-58. Examples in the
Acropolis Museum show how the ring fitted
in the upper groove and how the Gorgon's
head was welded or soldered to the bowl:
Deltion I (1915), Parartema, 25, fig. 17. For a
different type of traditional Gorgon in Greek
decorative metalwork see: D. G. Mitten,
"A Gorgon at the Fogg," *Fogg Art Museum,
Acquisitions 1962-1963*, 11-16.

Vermeule, *Ann. Rep.* 1970, 40.

451A

HANDLE OF A LIBATION DISH
Circa 450 to 350 B.C.
L.: 0.19m.
John Wheelock Elliot Fund 69.956
Boston and Basel Art Markets.

Greenish-brown patina, uncorroded.

The outer part terminates in the head of a
waterbird, while a lion's mask enriches
the inner end, at the base.

For the type of mask in functional
bronzes, see *Deltion* 1 (1915), Parartema, 24f.,
fig. 17, Acropolis Museum. For a later, less
attractive example, with dish preserved:
De Ridder, Louvre *Bronzes*, II, pl. 107,
no. 3030.

Vermeule, *Ann. Rep.* 1970, 40.

451A

ungen 17 (1967) pl. 14. Compare also,
B. Schröder, "Thrakische Helme," *JdI* 27
(1912) Beilage 10, figs. 1-3.

Vermeule, *Ann. Rep. 1970,* 42.

589B

HELMET

South Italian Greek, circa 350 to 250 B.C.
H.: 0.285m.
Gift of Landon T. Clay 69.1075
Ex Sotheby Sale, 1 July 1969, 31, no. 72, illus.
Perhaps from the Chiucchiari necropolis at
Melfi: see *JHS, Archaeological Reports for
1966-67,* 35f., fig. 10 (Trendall).

Brown patina with some green, corroded areas.

The helmet has a flat area behind to
protect the neck, a hole in each side for
attaching a lining, a plume-holder on top,
side-holders on the left and right, and a
separate nose-guard. The ridge of the nose-
guard and "eyebrows" are shown in relief to
a "hairline" above.

The prongs on either side of the holder for
a plume or plumes on top may have held
animal horns, in the manner of certain
Mycenaean helmets and the familiar headgear
of the Norsemen. Support for this occurs in
the plumed and horned headgear of the
warriors returning from battle in the painted
frieze from an Italiote tomb at Porta Aurea,
Paestum, of 330 to 310 B.C., now in Naples:
P. P. Kahane, *Ancient and Classical Art*
(New York, 1968) 173.

There are several other similar helmets
from the same find as this one, one being
in the Dallas Museum of Fine Arts.

Vermeule, *Ann. Rep. 1970,* 42.

P. Wilson, *Art at Auction, The Year at Sotheby's &
Parke-Bernet 1968-69* (New York, 1970) 19, illus.

589A

589A

HELMET OF PHRYGIAN TYPE

Circa 450 B.C.
H.: 0.27m.
Gift of Landon T. Clay 69.1077
Ex Sotheby Sale, 12 June 1967, 71, no. 157,
illus.; ex Sotheby Sale, 13 June 1966, 22,
no. 35, illus.
From Western Asia Minor.

The greenish surface and the marine encrus-
tations within indicate a find from the sea
or the land nearby. Part of the upper end has
been restored in plaster, where the crest
broke away (?).

The peak curves forward in the approved
manner, and there is a neckpiece at the
back of the curving edge. A contemporary
view of soldiers wearing helmets such as this,
with crests, occurs in Relief III of the
Heroon at Lymra in Lycia: *Istanbuler Mitteil-*

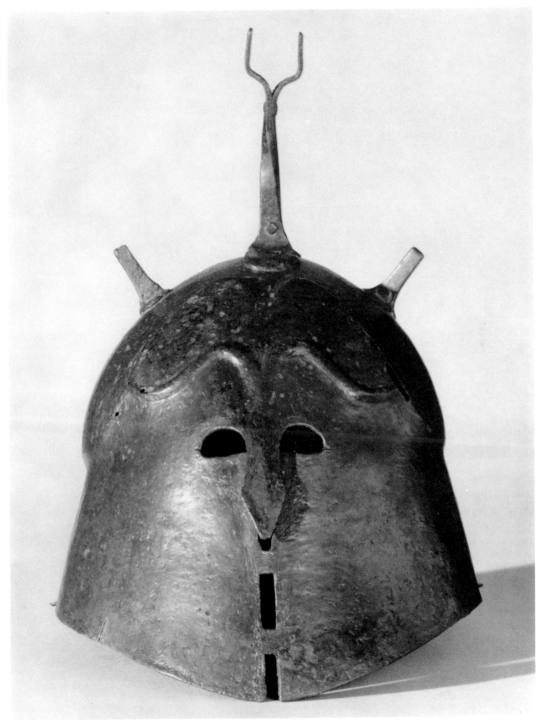

589B

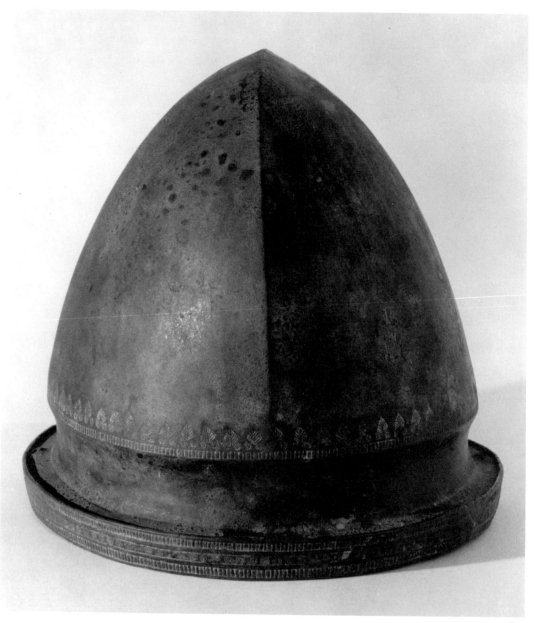

589c

589C

HELMET

South Italian Greek, Fifth Century B.C.
H.: 0.227m. W.: 0.256 x 0.24m.
Gift of Landon T. Clay 1970.35
Ex Münzen und Medaillen A.G., Auktion 40,
13 December 1969, 89, no. 143, 2 illus.;
ex Sotheby Sale, 26 November 1968, 61,
no. 151, illus.

Two holes on opposite sides of rim, perhaps
for chin-strap. Small crack on one side of
rim. Green and brown patina.

The helmet has a domed form with a central
ridge and with a concave section above
the flanged rim. There is a row of stamped
upright palmettes along the edge of the
crown, with a row of short vertical strokes
below. On the rim two rows of short
vertical strokes are separated by a row of
running spirals.

Compare the helmet in the Lipperheide
Collection, Berlin: Baron von Lipperheide,
Antike Helme, 183f. (with palmettes from
same punch as the MFA helmet). There
is another specimen in Vienna. (Both refer-
ences from H. A. Cahn.)

In judging between South Italian Greek
work and bronzes created by Greeks in
Etruria, only firm provenances or excavation
can provide the answer. On the evidences of
style and workmanship, it seems safe to
classify this helmet as the product of a
South Italian Greek armorer.

Vermeule, *Ann. Rep.* 1970, 42.

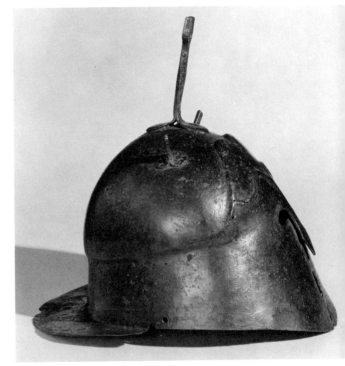

589B

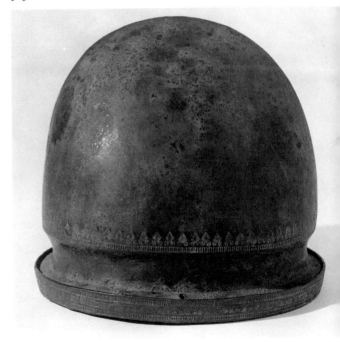

589C

Index

Concordance

Accession number	Catalogue number	Accession number	Catalogue number	Accession number	Catalogue number	Accession number	Catalogue number
72.361	238	72.405	546	72.4894	237	84.574	685
72.362	229	72.406	555	72.4895	241	1884 App.	
72.363	235	72.407	547	72.4896	227	M580	686
72.364	230	72.409	557	72.4897	228	85.229	495
72.365	239	72.410	559	72.4898	561	85.248	262
72.366	240	72.411	658	72.4899	562	85.515	410
72.367	221	72.413	250	72.4900	563	87.7	97
72.368	226	72.414	577	77.251	135	88.3	595
72.369	222	72.415	251	81.136	285	88.4	597
72.370	223	72.416	578	81.137	148	88.5	598
72.371	224	72.4439	84	81.196	431	88.6	599
72.373	225	72.4440	73	81.197	432	88.7	600
72.374	252	72.4441	101	81.324	649	88.8	603
72.375	564	72.4449	12	81.325	648	88.610	295
72.376	565	72.4452	403	81.326	650	88.611	296
72.379	558	72.4511	459	81.327	651	88.612	297
72.381	566	72.4871	576	81.328	652	88.613	157
72.382	568	72.4872	575	81.329	653	88.614	159
72.383	569	72.4873	567	81.330	654	88.615	156
72.384	244	72.4874	571	81.333	253	88.616	160
72.385	439	72.4875	248	83.421	659	88.617	619
72.386	570	72.4876	249	84.79	270	88.618	162
72.387	572	72.4877	579	84.80	293	88.619	163
72.388	574	72.4878	231	84.82	503	88.620	465
72.389	580	72.4879	548	84.83	485	88.621	164
72.390	497	72.4880	550	84.84	609	88.622	594
72.391	374	72.4881	553	84.85	617	88.623	699
72.392	488	72.4882	554	84.562	655	88.624-627	696
72.393	245	72.4883	541	84.563	656	88.628	602
72.394	247	72.4884	540	84.564	259	88.629	493
72.395	242	72.4885	545	84.565	657	88.630	494
72.396	560	72.4886	551	84.566	260	90.185	254
72.398	243	72.4887	552	84.567	294	90.186	614
72.399	246	72.4888	549	84.568	618	90.187	605
72.400	556	72.4889	573	84.569	261	90.238	255
72.401	539	72.4890	232	84.570	596	91.228	520
72.402	542	72.4891	233	84.571	399	92.2619	710
72.403	543	72.4892	234	84.572	398	92.2740	377
72.404	544	72.4893	236	84.573	684	93.1439-1445	523

Accession number	Catalogue number	Accession number	Catalogue number	Accession number	Catalogue number	Accession number	Catalogue number
94.42	647	96.714	364	98.681	457	99.491	59
94.43	281	96.715	379	98.682	505	99.492	360
94.44	257	96.716	356	98.683	518	99.493	380
94.45	258	97.499	528	98.684	508	99.494	381
94.46	282	98.643	264	98.685	318	99.495	382
94.47	284	98.644	265	98.686	378	99.496	608
94.48	279	98.645	267	98.687-691	531	99.497	604
94.49	280	98.646	268	98.692	496	99.498	607
95.69	44	98.647	271	98.693	450	99.499	665
95.71	516	98.648	272	99.458	402	99.500	697
95.72	391	98.649	274	99.459	514	99.502	640
95.73	376	98.650	3	99.460	411	00.313	65
95.74	25	98.651	351	99.461	416	00.622	700
95.75	64	98.652	660	99.462	414	00.623	701
95.76	106	98.653	178	99.463	415	00.624	702
95.176	269	98.654	179	99.464	507	00.625	703
96.662	99	98.655	180	99.465	418	01.7309	373
96.663	136	98.656	409	99.466	525	01.7467	383
96.664	94	98.657	21	99.467	419	01.7468	481
96.665	36	98.658	19	99.468	358	01.7469	218
96.667	147	98.659	33	99.469	424	01.7470	219
96.668	440	98.660	195	99.470	442	01.7471	406
96.669	132	98.661	199	99.471	426	01.7472	408
96.670	622	98.662	198	99.472	427	01.7473	127
96.671	661	98.663	57	99.473	461	01.7474	413
96.672	610	98.664	581	99.474	452	01.7475	46
96.673	453	98.665	584	99.475	526	01.7476	47
96.674	273	98.666	45	99.476	524	01.7477	31
96.675	263	98.667	355	99.477	460	01.7478	612
96.676-677	256	98.668	55	99.478	463	01.7479	583
96.678	451	98.669	52	99.479	436	01.7480	42
96.703	175	98.670	40	99.480	449	01.7481	29
96.704	76	98.671	361	99.481	423	01.7482	197
96.705	119	98.672	366	99.482	443	01.7483	353
96.706	43	98.673	362	99.483	441	01.7484	96
96.707	168	98.674	93	99.484	527	01.7485	438
96.708	437	98.675	134	99.485	444	01.7486	34
96.709	50	98.676	112	99.486	464	01.7487	48
96.710	51	98.677	139	99.487	502	01.7488	510
96.711	515	98.678	122	99.488	28	01.7489	687
96.712	87	98.679	529	99.489	23	01.7490	590
96.713	217	98.680	169	99.490	75	01.7491	151

Accession number	Catalogue number	Accession number	Catalogue number	Accession number	Catalogue number	Accession number	Catalogue number
01.7492	187	01.8282	682	03.987	67	Res. 08.32e	146
01.7493	375	01.8317	683	03.988	109	Res. 08.32f	138
01.7494	370	01.8375	107	03.989	530	Res. 08.32g	108
01.7495	149	01.8376	196	03.990	98	Res. 08.32h	624
01.7496	371	01.8377	482	03.991	385	Res. 08.32i	625
01.7497	54	01.8476	171	03.992	372	Res. 08.32j	144
01.7498	170	02.41	102	03.993	32	Res. 08.32k	145
01.7499	354	02.293	303	03.995	90	Res. 08.32l	154
01.7500	521	02.294	304	03.996	27	Res. 08.32m	129
01.7501	646	02.295	305	03.997	15	Res. 08.32o	131
01.7502	691	02.296	302	03.998	592	Res. 08.32p	130
01.7503	692	02.297	306	03.999	429	Res. 08.32q	623
01.7504	693	02.298	308	03.1001	428	Res. 08.32u	349
01.7505	694	02.299	309	03.1152	613	Res. 08.32v	678
01.7506	695	02.300	310	03.1656	662	Res. 08.37	627
01.7507	41	02.301	311	03.1662	675	Res. 08.38	332
01.7508	214	02.302	317	04.3	511	09.291	181
01.7509	152	02.303	713	04.6	22	10.162	434
01.7510	77	02.304	320	04.7	352	10.163	435
01.7511	626	02.305	321	04.8	61	10.164	190
01.7512	458	02.306	307	04.9	110	10.165	62
01.7513	365	02.307	322	04.1713	114	10.166	80
01.7514	368	02.308	323	05.59	367	10.167	89
01.7515	638	02.309	324	06.1925	491	10.168	86
01.7516	363	02.310	325	06.2372	113	10.169	81
01.7517	88	02.311	326	06.2373-2374	620	10.170	85
01.7518	60	02.312	327	06.2449	709	10.171	142
01.7519	666	02.313	328	08.247	473	12.794	480
01.7520	448	02.314	329	08.250	470	13.110	153
01.7521	668	02.315	330	08.253	386	13.111	462
01.7522	476	02.316	331	08.328	186	13.112	182
01.7523	357	02.317	348	08.370	117	13.121	278
01.7524	176	02.328	704	08.371	140	13.126	333
01.7525	384	02.329	705	08.372	189	13.127	334
01.7527	188	02.330	706	08.534	711	13.128	337
01.7528	688	02.331	707	08.535	111	13.129	347
01.7529	689	02.332	708	08.539	467	13.139	194
01.7530	690	03.982	446	08.540	517	13.141	286
01.7531	288	03.983	671	Res. 08.32a	141	13.160	629
01.7532	290	03.984	492	Res. 08.32b	133	13.161	630
01.7533	289	03.985	669	Res. 08.32c	369	13.162	631
01.8214	39	03.986	128	Res. 08.32d	143	13.163	632

Accession number	Catalogue number	Accession number	Catalogue number	Accession number	Catalogue number	Accession number	Catalogue number
13.164	633	22.715	342	52.187	183	61.380	412
13.165	634	22.716	343	52.188	417	61.940	185
13.166	635	22.717	344	52.189	91	61.1235	673
13.167	636	22.718	345	52.191	615	61.1257	388
13.168	637	22.719	346	54.145	20	61.1258	389
13.173	679	22.720	312	55.497	712	62.187	504
13.182	63	22.721	313	56.1267	667	62.188	421
13.207	387	22.722	314	57.749-750	591	62.511	7
13.208	680	22.723	301	58.16	641	62.971	74
13.2886	392	22.724	315	58.696	16	62.978	72
13.2887	393	22.725	300	58.704	483	62.1105	420
13.2888	395	22.726	316	58.968	116	62.1189	359
13.2889	396	22.727	519	58.1189	4	62.1203	486
13.2890	394	22.728	506	58.1281	193	62.1204	177
13.2891	397	22.730	298	59.9	319	63.631	674
15.859	161	22.731	299	59.10	155	63.788	513
15.860	158	23.601	287	59.11	82	63.789	645
18.320	532	24.366	471	59.30	103	63.1039	66
18.495	210	24.878	79	59.298	123	63.1397	10
18.496	211	24.896	70	59.552	56	63.1516	522
18.497	201	24.897	69	59.653	643	63.2402	601
18.498	202	24.957	68	59.654	672	63.2644	479
18.499	203	24.958	466	59.692	100	63.2755	2
18.500	204	24.967	489	59.961	644	63.2761	120
18.501	212	24.979	472	59.962	490	63.2762	698
18.502	206	27.748	292	59.999	478	63.2763	469
18.503	209	28.26	275	Res. 59.16	468	64.6	104
18.504	207	34.42	83	60.41	78	64.83	676
18.505	205	34.211	26	60.137	71	64.84	447
18.506	200	34.223	49	60.153	642	64.280	509
18.507	208	35.61	681	60.232	512	64.302	266
18.508	192	36.630	611	60.233	422	64.303	425
18.517	291	47.1110	445	60.530	137	64.316	105
19.314	390	48.498	582	60.1392	670	64.510	92
19.315	350	48.1093	400	60.1450	125	64.511	534
21.2302	283	50.144	407	60.1451	487	64.512	535
21.3099	126	51.2469	35	61.102	456	64.513	536
22.710	216	52.58	606	61.375	586	64.514	537
22.711	338	52.183	336	61.376	533	64.515	538
22.712	339	52.184	335	61.377	587	64.702	174
22.713	340	52.185	215	61.378	588	64.704	501
22.714	341	52.186	191	61.379	589	64.727	585

Accession number	Catalogue number	Accession number	Catalogue number	Accession number	Catalogue number	Accession number	Catalogue number	Accession number	Catalogue number
64.1460	11	65.1186	475	66.933	404	68.39	150		
64.1461	18	65.1187	484	66.951	95	68.41	213		
64.2171	498	65.1292	6	66.972	9	68.42	276		
64.2173	1	65.1316	5	67.282	17	68.43	277		
64.2197	220	65.1335	593	67.609-610	663	68.732	176A		
65.100	118	65.1340	404	67.627	172	69.56	355A		
65.101	8	65.1341	405	67.643	53	69.71	400A		
65.394	477	65.1342	38	67.644	664	69.956	451A		
65.462	121	65.1343	37	67.645	173	69.1075	589B		
65.565	184	65.1344	677	67.730	124	69.1077	589A		
65.910	454	65.1345	628	67.742	13	69.1257	100A		
65.911	455	65.1346-1347	621	67.743	58	1970.7	432A		
65.1179	115	65.1705	499	67.1024	9A	1970.35	589C		
65.1180	14	65.1706	500	67.1025	96A	1970.239	357A		
65.1181	165	66.9	433	67.1033	170A	1970.413	10A		
65.1182	166	66.10	430	67.1034	172A	1971.138	376A		
65.1183	167	66.182	401	67.1035	433A				
65.1184	639	66.251	30	67.1036	118A				
65.1185	474	66.932	616	67.1185	174A				